The Afro-American Tradition in Decorative Arts

S0-BNA-396

JOHN MICHAEL VLACH

The Afro-American Tradition

Brown Thrasher Books
The University of Georgia Press
Athens and London

BASKETRY

MUSICAL INSTRUMENTS

WOOD CARVING

in Decorative Arts

QUILTING

POTTERY

RECEIVED

JUL 1 3 1998

MSU - LIBRARY

BOATBUILDING

BLACKSMITHING

ARCHITECTURE

GRAVEYARD DECORATION

Published in 1990 as a Brown Thrasher Book by
The University of Georgia Press
Athens, Georgia 30602

Copyright 1978 by the Cleveland Museum of Art
Preface to the Brown Thrasher Edition copyright 1990
by the University of Georgia Press

All Rights Reserved

The paper in this book meets the guidelines for permanence
and durability of the Committee on Production Guidelines
for Book Longevity of the Council on Library Resources.

Printed in the United States of America

94 93 92 91 90 C 5 4 3 2 1
94 93 P 5 4 3 2
Text design by Merald E. Wrolstad

Library of Congress Cataloging in Publication Data

Vlach, John Michael, 1948–
 The Afro-American tradition in decorative arts / John
 Michael Vlach.
 p. cm.
 Reprint, with new pref. Originally published: Cleveland :
 Cleveland Museum of Art, c1978.
 Catalog of an exhibition held Feb. 1–Apr. 2, 1978 at the
 Cleveland Museum of Art and other museums later.
 "Brown Thrasher books."
 Includes bibliographical references.
 ISBN 0-8203-1232-0 (alk. paper). —
 ISBN 0-8203-1233-9 (pbk. : alk. paper)
 1. Afro-American art—Exhibitions. 2. Afro-American
 art—African influences—Exhibitions. 3. Afro-
 American art—European influences—Exhibitions.
 4. Afro-American decorative arts—Exhibitions.
 I. Cleveland Museum of Art. II. Title.
 N6538.N5V57 1990
 745′.089′96073—dc20 89-20574
 CIP

British Library Cataloging in Publication Data available

N
6538
.N5
V57
1990
c.2

20753813
C2
7-15-98

Contents

Preface to the Brown Thrasher Edition

A little more than a decade ago this book and the museum exhibition that it accompanied appeared before the public with a great deal of fanfare. Receptions, banquets, special showings, and even a press conference were held in conjunction with the first opening held in Cleveland in February 1978. For the next two years, as the exhibit traveled across the country from coast to coast, similar rituals of acclamation were performed at six other museums. By conservative estimate perhaps as many as a quarter of a million people saw the exhibition and thousands certainly obtained copies of this book. It was a heady experience to bring the story of traditional black American culture into some of the most prestigious institutions in the land—the Cleveland Museum of Art, the Milwaukee Art Center, the Birmingham Museum of Art, the Boston Museum of Fine Art, the St. Louis Art Museum, the Henry Gallery at the University of Washington, the Smithsonian Institution's National Museum of American History—but at the same time there was a surprisingly muted reaction from the academic community.

Only a handful of reviews appeared in the professional scholarly journals. Academics seemed to ignore this event judged by the public, especially the black public, to be a major occurrence. The reasons for this lack of response may be due, in part, to the fact that the book's title confusingly signaled a subject matter different from the volume's content. The phrase "decorative arts" conjures up visions of silver, porcelain, mahogany, and other precious materials. But the book is filled with examples of grass baskets, patchwork quilts, wrought-iron gates, stoneware pots, and roughly hewn canoes, things that are not expressly decorative. Art historians no doubt saw these artifacts as beyond their interests, while historians, geographers, anthropologists, and other social scientists were not sufficiently alerted to the fact that this was a book about Afro-American folk art and craft. Consequently, various scholars may have turned away from the volume thinking that it was not germane to their research.

Over the past decade, however, this book has proved itself useful to a number of disciplines. Once historians, for example, inspected its content rather than its cover, they found it filled with artifactual data that could support the revisionist portrait of black America that they were developing from more conventional written documentation. Anthropologists have also read this book with approval, gathering from it examples of the acculturative processes by which New World cultures were created. Geographers found visible proofs of the diffusion of specific African peoples via the transatlantic slave trade. Sociologists of art encountered case studies of the tactics that minority communities use to shape stronger identities through traditions of artistry. That this book is now being reprinted is testimony to the fact that it was finally noticed by the scholars for whom it was initially intended. Academe seems, at last, to have discovered what a Smithsonian curator whispered in my ear in 1979, "This book is not about decorative arts, it's really about crafts."

This preface is not the place to explain how and why something as crucial as a book's

title could be so misleading. It is enough to say that the choice was the act of a committee and thus was a negotiated compromise reflecting the awkwardness encountered in most committee actions. Happily, the information and perspectives contained in this volume were finally recognized. Kenneth L. Ames certainly grasped my chief goal when he wrote in 1983 that I had presented black culture as a "living, dynamic, and often subtle fusion of African and European ingredients." The following year historian John B. Boles depended heavily on *The Afro-American Tradition in Decorative Arts* to challenge the notion that the Middle Passage of slavery completely obliterated any and all traces of African heritage in the United States. Thomas J. Schlereth, in his assessment of material culture scholarship in the United States, placed this work among a select group that he labeled "daring," "pioneering," and "essential reading for the serious student of the subject." Most recently this book was listed in David Park Curry's "time line" of significant developments in the history of American folk art.[1] There have been other congratulatory and assuring comments, both written and verbal, but most gratifying have been the insistent calls over the past year and a half from colleagues eager to use this book as a classroom text. With the appearance of this new edition, their demands will be satisfied and a second round of reading will begin.

2.

Instead of revising the text of *The Afro-American Tradition in Decorative Arts* to incorporate all the new discoveries of the past twelve years, I have chosen instead, at least for now, to provide the new generation of readers with a bibliographic commentary that will direct them where to look for the most current information. Because the claims made in this book have stood up well over the past decade, a complete revision is not called for. By reading this volume in conjunction with the more recent works cited in this preface, interested students should be well prepared to embark on their own investigations of Afro-American material culture.

Since the spring of 1977 when the manuscript for the original edition was completed several important studies have appeared that are now regarded as indispensable readings on Afro-American history and culture. Three works very broad in scope that must be mentioned are: Lawrence W. Levine's *Black Culture and Black Consciousness: Afro-American Folk Thought from Slavery to Freedom* (1977), John W. Blassingame's *The Slave Community: Plantation Life in the Ante-bellum South* (rev. ed., 1979), and Leon F. Litwak's *Been in the Storm So Long: The Aftermath of Slavery* (1979). While *The Afro-American Tradition in Decorative Arts* was not written with these books in mind, there is nonetheless an interesting fit with their direction and strategy. From the late 1970s through the 1980s social history writing has become increasingly more textured, and accounts bulk large with the specific details of daily life. Moreover, unconventional evidence such as oral histories and folk legends frequently serve as the primary grist for the historian's mill. My descriptions of the creation and use of certain domestic objects by African slaves and their descendants provided then an artifactual account that paralleled other sets of data like newspaper stories, tax lists, or census records. My findings helped complete the picture of black American cultural history by revealing that the

full account must include things as well as words and deeds. This perspective continues to meet growing acceptance among historians. One certainly finds this point of view in such recent discussions of slave culture as Rhys Isaac's *The Transformation of Virginia, 1740–1790* (1982), Charles Joyner's *Down by the Riverside: A South Carolina Slave Community* (1984), and Mechal Sobel's *The World They Made Together: Black and White Values in Eighteenth-Century Virginia* (1988). In the future other scholars are likely to be as mindful as these authors are of the artifact's value as historical evidence.

Important new research also has appeared specifically on Afro-American art and craft, the foremost work being *Flash of the Spirit: African and Afro-American Art and Philosophy* (1983) by Robert Farris Thompson. This book by one of the most eloquent advocates of black American artistry capped a fifteen-year-long episode in an ongoing and multi-pronged scholarly campaign on behalf of transatlantic black creativity. The book summarizes thoughts Farris first expressed in numerous articles and four museum exhibitions that grew out of field expeditions in Africa and black America. While the main focus of *Flash of the Spirit* is the Caribbean and South America, its usefulness in establishing the flow of artistic traditions from Africa to the United States cannot be over-emphasized. For one of Thompson's more explicit examinations of black folk traditions in the American South, readers should consult his essay "The Structure of Recollection: The Kongo New World Visual Tradition" in *The Four Moments of the Sun: Kongo Art in Two Worlds* (1981), edited by Robert Farris Thompson and Joseph Cornet.

An overview of Afro-American material traditions can be found in a special issue of the *Southern Folklore Quarterly* (1978) edited by William Ferris. The outstanding contributions included a broad historical survey of black craftsmanship by Phil Peek and two assessments of Afro-American pottery and basketry by John Burrison and Mary Arnold Twining respectively. These last two items were subsequently grouped by Ferris with seventeen other essays and two bibliographies in *Afro-American Folk Arts and Crafts* (1983). This anthology of previously published articles written between 1969 and 1978 brought together in one reference volume essays on the quilting, wood carving, musical instrument making, basketry, pottery, blacksmithing, and carpentry of black Americans—most of the topics covered in the present book.

During the past few years several new reference works have been published that also cover aspects of black material culture. The *Dictionary of Afro-American Slavery* (1987) edited by Randall M. Miller and John David Smith, for example, contains entries on arts and crafts, clothing, housing, material culture, and other pertinent topics. The *Encyclopedia of Southern Culture* (1989) edited by Charles R. Wilson and William Ferris has sections devoted to folk culture and to Afro-Americans. The two-volume annotated bibliography by John F. Szwed and Roger D. Abrahams, *Afro-American Folk Culture* (1978), is now the required starting point for any research question concerning New World black cultures. For a selection of the most current writings by John Michael Vlach on black artifacts, artisans, and architecture, readers should consult his *By the Work of Their Hands: Studies in Afro-American Folklife* (1990).

While *The Afro-American Tradition in Decorative Arts* is generally described as a survey of Afro-American material culture, it is expressly an attempt to trace and substantiate African influences in the traditional arts and crafts of black Americans. Consequently there are many sorts of domestic objects that are not examined, even though

they were commonly found in black households. They have been excluded either because they were European or Anglo-American in origin or because they were developed by black Americans without reference to African antecedents. Artifacts produced under such conditions are black mainly by association rather than by cultural intent. They were imposed on the black population, not willingly generated by them. The food, shelter, and clothing provided for slaves by their masters—examples of the sort of black material culture not covered in this book—are considered in *Reckoning with Slavery: A Critical Study in the Quantitative History of American Negro Slavery* (1976) by Paul A. David, Herbert G. Gutman, Richard Sutch, Peter Temin, and Gavin Wright. Readers should also consult Philip Morgan's article "The Ownership of Property by Slaves in the Mid-Nineteenth Century Low Country," which appeared in the *Journal of Southern History* (1983). *The Other Slaves: Mechanics, Artisans, and Craftsmen* (1978), edited by James E. Newton and Ronald L. Lewis, surveys the work experience of numerous artisans who provided the labor for white businesses.

3.

Each chapter of *The Afro-American Tradition in Decorative Arts* is devoted to a different craft or artistic tradition. In the following paragraphs I will review the contemporary scholarship on each topic in the same order in which it occurs in the book.

Basketry

In 1980 Doris Adelaide Derby completed a doctoral dissertation entitled "Black Women Basket Makers: A Study of Domestic Economy in Charleston County, South Carolina." This study, along with another dissertation by Kay Young Day, "'My Family Is Me': Women's Kin Networks and Social Power in a Black Sea Island Community" (1983), probe deeply into the dynamics of daily life that profoundly affect basket production in the Mt. Pleasant community of South Carolina, the prime contemporary locale where African-derived coiled baskets are made. But most explicitly targeted at black basketmaking was *Row Upon Row: Sea Grass Baskets of the South Carolina Lowcountry* (1986) by Dale Rosengarten, a volume that served as the catalog for an exhibition mounted by the McKissick Museum. This book, flavored with numerous direct quotes from basket makers and illustrated with many historic and contemporary photographs, not only honors the tradition but is now the starting point for further research on the topic. The specific African antecedents of this tradition remain to be traced, but whoever undertakes this task will no doubt benefit from the findings presented by Daniel C. Littlefield in his book *Rice and Slaves: Ethnicity and the Slave Trade in Colonial South Carolina* (1981).

Musical Instruments

Research on black music, both sacred and secular, continues at a swift pace but little has been written about the instruments with which this music is played. Consequently

the study of the black tradition for musical instrument making remains in its infancy. The one striking exception involves the banjo, which was the subject of a museum exhibition at the Massachusetts Institute of Technology in 1984. The catalog for this exhibition, *Ring the Banjar!: The Banjo from Folklore to Factory* by Robert Lloyd Webb, illustrates how this African-derived instrument was gradually transformed into an artifact with a wide popular following, particularly among Anglo-Americans. The shift in the racial allegiance of the instrument is also analyzed by Robert Cantwell in his *Bluegrass Breakdown* (1984).

Wood Carving

The subject of Afro-American wood carving has yet to attract the focused attention of any scholar. More activity seems to be directed toward locating pieces of sculpture and furniture than toward studying them. New examples of carved canes, small figures, and decorated wooden utensils continue to turn up, but they usually lack a confident provenance and thus constitute a problematic sort of evidence. One outstanding piece, discovered in North Carolina and dated to the mid-nineteenth century, is a table supported by four legs sculpted into what are apparently African statues. The piece is made more intriguing by the fact that its top takes its lines from furniture in the Empire style that would have been in fashion in the southern piedmont area. The story behind this table, yet to be fully unraveled, would certainly seem to suggest a cultural encounter between black and white worldviews.[2]

Quilting

Afro-American quilting is a topic that has received increasing attention over the past decade. Indeed, the current enthusiasm for black quilts is surpassed only by the energy of the quilters who make them. In my chapter on quilting I proposed that the aesthetic system employed by Afro-American quilters was significantly different from that used by Anglo-American quilters. In brief, I suggested that black quilters frequently used a distinctive improvisatory style to overturn the rules of geometry, balance, and order commonly expected in the design of a quilt top. Many black quilts were then bicultural since they often featured white motifs and elements that were arranged and rendered in an Afro-American manner. This formula for the fusion of divergent cultural ideals rests at the center of the ongoing scholarship on black American quilting.

In 1980 Maude Southwell Wahlman completed a three-volume dissertation, "The Art of Afro-American Quiltmaking: Origins, Development, and Significance." She has since mined this study to produce a stream of articles on various aspects of the topic, although to date she has concentrated mainly on describing the African antecedents of black American quilts and on codifying the aesthetic principles employed by their makers. One of her essays, "The Aesthetics of Afro-American Quilts," appeared in the catalog to the exhibition *Something to Keep You Warm: The Roland Freeman Collection of Black American Quilts from the Mississippi Heartland* (1981) sponsored by the Mississippi State Historical Museum. This catalog also contained an essay by Gladys-Marie Fry entitled "Slave Quilting on Ante-bellum Plantations," which subsequently was expanded

to a book-length treatment entitled *Stitched from the Soul: Slave Quilts from the Ante-Bellum South* (1989). Rich ethnographic descriptions of black quilters are provided by Mary Anne McDonald in her essay "Jennie Burnett: Afro-American Quilter," which appeared in the exhibition *Five North Carolina Folk Artists* (1986) sponsored by the Ackland Art Museum, and by Susan Roach-Lankford in her doctoral dissertation, "The Traditional Quiltmaking of Northern Louisiana Women: Form, Function, and Meaning" (1986). The research and writing of Eli Leon has recently culminated in a stunningly beautiful exhibition and catalog entitled *Who'd a Thought It: Improvisation in African-American Quiltmaking* (1987). Currently engaged in field study across the Deep South, Leon is almost certain to produce other works of equally high caliber. Another high point among the new publications on quilting is *Hearts and Hands: The Influence of Women and Quilts on American Society* (1987) by Pat Ferrero, Julie Silber, and Elaine Hedges. While this book is not exclusively about black quilts, it effectively weaves a vibrant Afro-American strand into a broader, more encompassing narrative.

Pottery

The saga of Afro-American ceramics is confined to only a few specific sites because slaves were generally not trained to make pottery. Making wheel-thrown pottery in rural America was principally a family operation and knowledge about potting was fiercely protected as a family secret. The chief exception to this rule occurred in the Edgefield District of South Carolina, where between 1820 and 1860 the pottery industry grew at such a pace that slaves had to be trained as turners of ware if white entrepreneurs were to seize their share of the market. The social and economic conditions in the Edgefield District, where more than fifty slaves were making pottery by 1860, were presented in an exhibition entitled *Crossroads of Clay* (1990) sponsored by the McKissick Museum. In one of the essays in the exhibition's catalog, "Cultural Encounters at the Crossroads of Clay," John Michael Vlach suggests the specific pathways by which African influences, among others, made their way into the South Carolina backcountry. From Edgefield, local traditions for pottery forms and glazes made their way across the South, as far west as Texas. I mention briefly in this volume a site in Guadalupe County, Texas, where slaves were making Edgefield-derived stoneware. The current authority on this site is E. Joey Brackner, Jr., who in 1981 wrote a master's thesis, "The Wilson Potteries," which chronicles the making of ceramic wares by blacks from slavery times through Reconstruction.

If by pottery one means only stoneware, the sites where one can find Afro-American pottery are few. But if the hand-built earthenware vessels that frequently turn up in the excavations of seventeenth- and eighteenth-century plantations could be claimed as black, there would be scores of sites to investigate. This is precisely what has happened because of the research of archaeologist Leland Ferguson. In 1978 he determined that much of the earthenware found on plantations and previously credited to Indians of the hypothetical "Colono" or colonial group was actually made by African slaves. His crucial essay "Looking for the 'Afro' in Colono-Indian Pottery" can be found in the anthology *Archaeological Perspectives on Ethnicity in America: Afro-American and Asian American Culture History* (1980) edited by Robert L. Schuyler. In addition to the utili-

tarian bowls and cups identified by Ferguson, Matthew Emerson has recently suggested in his doctoral dissertation, "Decorated Clay Tobacco Pipes from the Chesapeake" (1988), that the ornamental patterns impressed or marked on numerous pipe fragments found at fifteen seventeenth-century Virginia plantation sites can be traced to West African origins. Early earthenwares constitute an exciting new area in the study of Afro-American artifacts.

Boatbuilding

The treatment of maritime traditions among black Americans in the earlier edition of *The Afro-American Tradition in Decorative Arts* had few precedents. Scholars had rarely noted how often slaves were involved in water-oriented tasks and fewer still had recognized that most of the Africans brought to the United States were from coastal or riverine areas where they were intimately aware of small water craft. The idea that blacks might have had a boatbuilding tradition of their own had never been considered, and it remains to be researched in depth. At present the activities involving the use of boats rather than boatbuilding itself have received closer scrutiny. Philip Morgan, for example, in his article "Black Life in Eighteenth-Century Charleston," published in *Perspectives in American History* (1984), demonstrated, among other things, that slave fishermen exercised almost a complete monopoly over the local waterways. Horace P. Beck's "'Belows': The Whaling Complex in Bequia," published in the *Folklife Annual* (1986), while it specifically details the contemporary maritime traditions of a small Caribbean island, effectively presents some of the techniques and practices employed by Afro-American watermen along the Atlantic coast during the eighteenth and nineteenth centuries.

Blacksmithing

In terms of new scholarship, ironworking by Afro-Americans has not fared much better than boatbuilding. John Michael Vlach did, however, produce a life history of Philip Simmons, the acknowledged Afro-American master of the decorative ironwork trade in Charleston, South Carolina. This book, *Charleston Blacksmith: The Work of Philip Simmons* (1981), covers more than a half century of the man's professional career as a blacksmith. It not only presents a selection of the thirty works out of more than two hundred that Simmons considers his most outstanding, but in its text, taken mainly from tape-recorded interviews, Simmons essentially tells his own story.[3]

Architecture

My treatment of the buildings and landscapes created by black Americans in this volume is largely an attempt to identify formal or symbolic links to African precedents. Over the past few years, scholarship on vernacular architecture has, however, shifted away from this line of interpretation toward the analysis of everyday life on southern plantations. A particularly noteworthy study is George McDaniel's *Hearth and Home: Preserving a People's Culture* (1982), which surveys black folk housing in southern

Maryland from slavery times to the present. Similar buildings studied by Bernard L. Herman are presented in his "Slave Quarters in Virginia: The Persona Behind Historic Artifacts," which appeared in *The Scope of Historical Archaeology* (1984), edited by David G. Orr and Daniel G. Crozier. Steven L. Jones points out that many aspects of black architecture need to be studied and calls for more research on all fronts in "The African-American Tradition in Vernacular Architecture," an essay published in *The Archaeology of Slavery and Plantation Life* (1985), edited by Theresa A. Singleton.

Archaeological investigation of plantations, while not expressly directed toward architectural data, often produces significant information on black folk housing, particularly from the earlier periods when African influences would have been more pronounced. Readers should consult the various studies found in Singleton's volume mentioned above and two other book-length studies: John Otto's *Cannon's Point Plantation, 1784–1860: Living Conditions and Status Patterns in the Old South* (1984) and William M. Kelso's *Kingsmill Plantations, 1619–1800: Archaeology of Country Life in Colonial Virginia* (1984). As more plantation soil continues to be sifted, archaeologists are gradually taking the lead in the study of Afro-American vernacular buildings although their evidence is confined largely to foundations and marks on the ground.

Specialists in the study of vernacular architecture have not, however, abandoned Afro-American structures or their builders. John Michael Vlach suggested techniques for creating a history of black building tradesmen in his essay "'Us Quarters Fixed Fine': Finding Black Builders in Southern History," which appeared in *Perspectives on the American South* (1985). Catherine Bishir, in fact, followed many of his suggestions in "Black Builders in Antebellum North Carolina," an article published in the *North Carolina Historical Review* (1984). The power relationships expressed in built form are the core concern of Dell Upton's thoughtful analysis "White and Black Landscapes in Eighteenth-Century Virginia," published in *Places* (1985). Elaborating on Rhys Isaac's notion of "terrain," Upton shows how blacks created domains of their own both within and outside their masters' estates. Similar points are made by John Michael Vlach in "Afro-American Housing in Virginia's Landscape of Slavery," an essay included in his *By the Work of Their Hands* (1990). The architectural dimensions of the black urban experience were explored in detail by James Borchert in his book *Alley Life in Washington: Family, Community, Religion and Folklife in the City, 1850–1970* (1980).

Currently museums are playing an important role in the study of Afro-American architecture. Two current exhibitions at the Smithsonian Institution's National Museum of American History, "After the Revolution: Everyday Life in the Eighteenth Century" and "Field to Factory," prominently feature examples of slave quarters, sharecropper housing, and urban tenements occupied by black Americans. At Carter's Grove, a plantation site now part of the restoration at Colonial Williamsburg, slave cabins have been painstakingly recreated above completed archaeological excavations. Thus the location, size, orientation, and spatial relationships of the buildings are absolutely correct.[4] A recent exhibition produced by the Valentine Museum in Richmond, Virginia, examined the urban housing of free blacks. Those structures were analyzed in the exhibition catalog *In Bondage and Freedom: Black Life in Richmond, Virginia* (1988) by Marie Tyler-McGraw and Gregg D. Kimball.

Graveyard Decoration

This survey of black folk traditions ends with the domain of death; the end of life symbolically closes discussion. Funerary rituals and the landscapes created by their enactment are, however, quite dynamic and deserve much more scholarly attention. Robert Farris Thompson provided a good model to follow with his richly detailed interpretation of a black graveyard, "Siras Bowens of Sunbury, Georgia: A Tidewater Artist in the Afro-American Visual Tradition," published in *Chant of Saints* (1979) edited by Michael S. Harper and Robert B. Stepto. He also described black American mortuary customs in great detail in *The Four Moments of the Sun* (1981), identifying seven elements traceable to Kongo practice. Terry Jordan included black cemeteries in his study *Texas Graveyards: A Cultural Legacy* (1982), but he interpreted their contents more as expressions of southern regionalism than as signs of a distinctive black culture. Black burial practices from the Caribbean that parallel to some extent those found in black North America are presented in *Plantation Slavery in Barbados* (1978) by Jerome S. Handler and Frederick W. Lange.

While the mortuary customs of many ethnic groups in the United States have been thoroughly investigated, the practices of blacks continue routinely to be ignored. The misfortune of this oversight is compounded by the fact that, by all evidence, customs reported among African slaves during the eighteenth century continue, in some places, to remain in force.

4.

Many kinds of artifacts are omitted from this book. Still there is much that is included: baskets, grain mortars, fiddles, fifes, drums, banjoes, walking sticks, animal sculptures, wooden chains, spoons, quilts, blankets, jugs, cups, crocks, gates, fences, boats, houses, funerary landscapes. In this assemblage are objects of utility and celebration, things for the home and things for the fields, things omnipresent, things well-made. Collectively these objects marked the experience of slavery and the society formed in its aftermath, impressing an Afro-American signature on an institution that, as Robert Farris Thompson has written, was "designed to make children forever of men."[5]

The skills manifested under slavery did not fade during the period of Reconstruction or during the later nineteenth century. They provided free men and women with a passport into the free-market economy. Ace Jackson, an Afro-American mason from Mobile, Alabama, explained in 1979 how his choice of work connects directly to a geneaology of craftsmanship: "I was raised into the trade. My father was a brick mason. My mother's father was a brick mason. My father's father was a full-blood African, and he was a brick mason. He was a slave."[6] In cases like this one, craft skills provide black Americans with the inspiration and encouragement to endure and prevail over their misfortunes. The spirit of self-sufficiency that is usually credited to the Pilgrims, the westering pioneers, and hardy farming folk flows equally strong in the descendants of black artisans. Indeed, it is surprising to find that so many people still practice their inherited traditions. There are, just in the hinterlands of Charleston, South Carolina, alone, over

a thousand basketmakers ranging from the very old to the very young. The total number of black quilters in the United States will never be known; even one hundred thousand would be a ridiculously low estimate. Beyond these artisans, there are numerous whittlers, metal workers, carpenters and all-around handymen capable of making all sorts of useful objects out of readily available materials. And then there are stars like Philip Simmons. These modern craftspersons are not ancients somehow mysteriously transported to our time. They are contemporary citizens belonging to the modern world who refuse to give up the lessons learned from their ancestors. They enact traditions of skill because the old forms of art and craft not only make sense to them but prove to be emotionally satisfying. These modern craftspersons hope to instill confidence in their children and other young followers; they hope that one day the next generation will know the same sense of well-being and fulfillment that they find in these traditional arts and crafts. The Afro-American tradition described in this book continues to provide inspiration in much the same way that it must have in the eighteenth and nineteenth centuries.

John Michael Vlach
The George Washington University
1990

Notes

1. Kenneth L. Ames, "American Decorative Arts / Household Furnishings," *American Quarterly* 35 (1983), p. 290; John B. Boles, *Black Southerners, 1619–1869* (Lexington: University Press of Kentucky, 1984), pp. 143, 232; Thomas J. Schlereth, ed., *Material Culture Studies in America* (Nashville: American Association for State and Local History, 1982), pp. 35, 72, 349; David Park Curry, "Time Line," in *An American Sampler: Folk Art from the Shelburne Museum* (Washington: National Gallery of Art, 1987), p. 205.

2. For an illustration of this table see *The Clarion* (Spring 1980), p. 59.

3. This study was written both as a record of Afro-American craftsmanship and as a model of how to sensitively present ethnographic data on living craftspersons. That both of these goals were met is indicated by Simon J. Bronner's review of the book in *Material Culture* 14 (1982), pp. 41–43.

4. For a description of the slave quarter restoration at Carter's Grove, see Patricia Leigh Brown, "Away from the Big House: Interpreting the Uncomfortable Parts of History," *History News* 44, no. 2 (1989), pp. 8–11. For the two exhibitions at the National Museum of American History, see Barbara Clark Smith, *After the Revolution: The Smithsonian History of Everyday Life in the Eighteenth Century* (New York: Pantheon, 1985), and Spencer R. Crew, *Field to Factory: Afro-American Migration, 1915–1940* (Washington, D.C.: Smithsonian Institution, 1987).

5. Robert Farris Thompson, "African Influence on the Art of the United States," in Armstead L. Robinson, Craig C. Foster, and Donald H. Ogilvie, eds., *Black Studies in the University: A Symposium* (New Haven: Yale University Press, 1969), p. 172.

6. Ben Fewel, "Ace Jackson," *Southern Exposure* 8, no. 1 (1980), p. 11.

Foreword

In the twentieth century we have witnessed the culmination of efforts by humanistic and scientific disciplines to widen and deepen the horizons and levels of what is recognized as art. If artists such as Picasso, Klee, Miró, and Dubuffet, among others, have found inspiration in tribal and folk productions, the anthropologists have logically and purposefully led us to the understanding that art exists in all cultures and that varying levels of creativity are revealed by careful analysis to be very much the same beneath the skin. We are by now familiar with the movement of works of art made by diverse social units, whether Haida, Baoule, Olmec, Solomon Islands, Ainu, or others, from the museums and collections of ethnology and anthropology into the previously sacrosanct realms of the art collection or museum. To cite a cogent example, the Mayan head from Copan in The Cleveland Museum of Art was acquired in 1953 from the Peabody Museum of Harvard University, through the intermediary of a dealer in "primitive *art*," more than fifty years after it had been collected as a document of the material culture of pre-Columbian Indian America. And what art historians of the past called "decorative arts," often going so far as to include much sculpture under this rubric and leaving painting as the sole repository of the highest aesthetic values, is now very close in meaning to the anthropologist's "material culture"—though the works merit some qualitative value judgments that these students of society (not art) are unwilling to accept. Both disciplines, I believe, are correct as long as one remembers that they often study these same things for quite different purposes.

Nothing was more influential than World War II in forcibly broadening the horizons of a complacent Western culture. The global nature of that conflict, or more accurately, its operations, put the seal of pragmatic approval on the previous widespread but undervalued activities of innumerable anthropological and ethnological field workers whose relatively obscure publications and collections had tried to tell us of these new worlds and of their relevance to modern man. Psychology, psychoanalysis, sociology, archaeology, intellectual history, prehistory, and many other disciplines found basic materials for their studies in the art and activities of so-called primitive man. Oriental studies demonstrated that folk art could have profound effects on what was accepted as high art—witness the tea ceremony cult in Japan, a studied absorption of folk art qualities of roughness and accident into the most sophisticated and literate levels of society.

All of this is simply to indicate that the word "art" now embraces far more than ever before. This is not to say that one cannot identify levels of technique and sophistication in image making; one can demonstrate the development and deterioration of accomplishment in the remarkable bronze art of the Benin in Africa. But we do say that the qualities inherent in art—the honesty of a technique dealing with a recalcitrant material, the clear projection of a socially needed image, the need for man to deal artistically with his real or imagined environment—are to be found in all cultures, whether defined geographically, socially, or economically. Thus the Japanese-Americans, cruelly imprisoned during World War II, found the means within the limitations of *that* culture to produce art that later found its way into

the exhibition halls of our museums. Art everywhere is, and always has been, a witness to the continuing need for anyone, "high" or "low," to prove his humanity.

Surely these qualities of survival through art are to be found in the Afro-American tradition under involuntary conditions as enervating and difficult as any that can be imagined—slavery and its long aftermath. This exhibition is intended to present one significant facet of this ritual of survival through art—the tradition of Afro-American decorative arts. Whether humble or exuberant, whether evident or cloaked, the works shown reveal little-known or unknown aspects of art in America. Since this artistic production was, in large part, underground or in the hidden byways of culture, the text of this book is an integral part of the exhibition, explaining, revealing, persuading one to look carefully, often to search for traces that might otherwise be lost. In performing this task the author has succeeded in welding anthropology, sociology, and art history into a tool for revealing often hidden or lost meanings. Without these Afro-American contributions we would all be poorer.

Many are to be thanked for making this exhibition and book-catalog possible. Dr. John M. Vlach, in particular, attacked a difficult task and, after a labor of more than two years, conquered it. As guest curator for the exhibition, he is both its architect and builder. The initial impetus for the exhibition came from The Links of Cleveland, Inc.; and they have continued their support with energy and imagination. Following their initiation of the concept of an exhibition on some aspect of Afro-American art, Henry H. Hawley, the Museum's Curator of Post-Renaissance Decorative Arts, suggested the decorative arts as a relatively unexplored area of black art, especially in the interrelationships of techniques and styles derived from Africa and impinging upon the European tradition in America. Dr. Vlach was well qualified to consider this question, and from these beginnings the idea grew into the exhibition and book we are privileged to present, first here in Cleveland, and then in Milwaukee, Birmingham, Boston, St. Louis, Seattle, and Washington. The staff committee for the exhibition, including Edward B. Henning, Henry H. Hawley, and James A. Birch, provided effective advice. The principal burden for the logistics of the exhibition fell upon James A. Birch, the Project Director, who was ably assisted by others in the Department of Art History and Education: John L. Moore, Supervisor of Education Programs; Martin L. Linsey, Photographer; Kathleen M. Coakley, Assistant to Mr. Birch; and Meri Cornblath, Secretary to Mr. Birch. William D. Wixom, Curator in Charge of African Art, was also most helpful. In addition to these, one must acknowledge the installation by the Museum Designer, William E. Ward; the invaluable services of the Registrar, Delbert R. Gutridge; and the efforts of the Museum's Publications Department, Merald E. Wrolstad, designer of the catalog, and Sally W. Goodfellow and Norma Roberts. Many others effectively participated in the development and completion of the project. To all of them we owe many thanks.

Finally, the financial support of the National Endowment for the Humanities was essential for the success of this exhibition, so clearly combining many of the humanistic disciplines within the Endowment's purview as defined by the Congress of the United States.

Sherman E. Lee, Director
The Cleveland Museum of Art
1978

Preface

A historical survey usually carries with it an air of finality. Vast periods of time and numerous human acts are neatly parceled into manageable bundles, tucked away into a logical order, and given memorable, sometimes poetic, labels. In brief, complexity is reduced to simplicity; the last word is given. This book, while it is a survey, is by no means the last word on the subject of traditional Afro-American art and craft. Rather, I hope it will provide inspiration for more investigation, for rechecking materials and findings, for further discovery, and that it will ultimately help develop a richer and more complete understanding of Afro-American culture.

I cannot claim to be the first to present a case for Afro-American art. Certainly pioneers such as W. E. B. Du Bois in sociology, Alaine Locke and James Porter in art history, and Melville Herskovits in anthropology were the ones who blazed the pathway for contemporary scholars to follow. Moreover, at black universities such as Fiske, Howard, Tuskegee, Dillard, and Hampton the importance of Afro-American art has always been recognized, and these institutions and others have long fostered an academic tradition for its study. Yet, there has remained up to now a dimension of Afro-American art that has been overlooked in an apparent enthusiasm for, and well-placed desire to celebrate, the creative genius of such masters as Tanner, Bannister, Lewis, and Duncanson. Obscured by an emphasis on fine art were the equally sophisticated, though less conventional (in art terms), achievements of the folk artist and craftsman. Studies of black art have mentioned the works of this class of creators but have not given special attention to them. This, then, is the contribution of this book—to at last turn the full attention of our scholastic endeavors to the folk culture of black America. Summarized under the rubric of "decorative arts" are my attempts to examine some of the premises which serve as the bases of Afro-American traditions.

The two years spent in bringing the materials for this book together can be readily compared to a voyage. I have seemingly sailed the uncharted interdisciplinary waters of academia seeking a safe harbor for my ungainly rig which flies many flags. Indeed, I have made three "voyages" across the country, mostly in the South, in search of objects to serve as illustrations and people who could educate me. Wherever I went I found generous people with information they wanted to share. Some were already friends, others became friends. I therefore take this opportunity to thank them for their advice, their criticism, and their encouragement.

Throughout my research I have received direction from Professor John Burrison, Professor Robert Farris Thompson, Professor William Ferris, Anna Wadsworth, Professor Franklin Fenenga, Georgeanna Fletcher, Malcolm Bell, Professor Mary Twining, Professor Milton Newton, Elaine Thomas, Patti Carr Black, Professor Mildred Bailey, Jeffery Camp, Robert Burgess, Terrence and Stephen Ferrell, Professor Charles Zug, Professor Roderick Moore, Henry Williams, Kip Lornell, Julius Ross, Professor Charles Bird, Professor William Wiggins, Steven Jones, and Professor Roy Sieber. All suggestions have been greatly appreciated.

In writing this book I have drawn upon the expertise and experience of many others in addition. Interviews with black artisans, including Mrs. Mary Manigault, Mrs. Queen Ellis,

Philip Simmons, Silas Sessions, Ronnie Pringle, Mrs. Clementine Hunter, Samuel Hylton, James Thomas, and E. M. Bailey, gave me some important insights into their work. Gregory Day set me straight about Sea Islands baskets. Professor Barry Lee Pearson read and commented on the musical instruments section. Dell Upton took me to inspect some slave quarters in Virginia and also critiqued the architecture chapter. Terrence Ferrell added important new data to the pottery chapter. Claudia Reese provided technical data on clay and glaze characteristics, and Georgeanna Greer clarified developments in Texas pottery. Robert Thompson read the entire manuscript and enthusiastically prodded me into revisions—as did Henry Hawley, Edward Henning, and William Wixom, all of the Cleveland Museum. Not least were the efforts of those who labored to prepare the catalog for publication—my thanks go to all, but especially to Frances Terry, who typed the manuscript, and to Norma Roberts, who edited it. I must especially thank my mentor, Professor Henry Glassie, who intermittently visited me during the course of research and writing and gave wise counsel; most importantly, he wrote me a letter when my work seemed most chaotic to tell me to relax and do well.

The exhibition which gave rise to this book is in large part to be credited to James A. Birch. He has performed nobly as administrator and trouble-shooter, tying together the many loose ends that inevitably crop up in a project as extensive as this one. It was his search that brought me out of the cornfields of Iowa to take up the challenge of four centuries of black art history, and my debt is indeed great.

Finally, I must thank The Links of Cleveland, Inc., and The Cleveland Museum of Art for entrusting me with this project. I hope I have served them as well as I have been served by this experience.

John Michael Vlach
The University of Texas at Austin
1978

Introduction

There are important expressions of black American art that as yet lie unrecognized. These consist of works set mainly in the realm of craft and skill. Traditionally crafted artifacts—baskets, walking sticks, pottery jars, quilts—are commonplace items that fail to attract immediate attention, particularly when we are conditioned to accept only painting and sculpture as "art." While the expertise of black artisans has long been acknowledged, it has not been extensively analyzed. We have been given only cursory summaries, statements in passing. Cedric Dover in *American Negro Art* gives all of three pages to four centuries of what he calls the "manual arts."[1] A more detailed account of black achievement in the pragmatic arts is given by James A. Porter, who introduces his book, *Modern Negro Art,* with a chapter entitled "Negro Craftsmen and Artists of Pre-Civil War Days."[2] But here again the attention given to traditional creativity is minimal. Porter quickly rushes on to highly individualistic works of art and, in fact, devotes more than half of his book to pieces done in the twentieth century. Emphasis on the modern and the elite is also found in recent studies by Elsa Honig Fine and David Driskell.[3] Driskell strongly underscores this trend by dividing two centuries of black American art into two periods: the first, from 1750 to 1920; the second, from 1920 to 1950. There is thus a tendency in Afro-American art history to obscure the efforts of the early black artisan, to lose sight of the roots of the Afro-American tradition.

Not only do we find the early phases of black creativity being pushed aside, but we are also given the impression that soon after black artists put paint to canvas crafts ceased to exist. Regenia A. Perry says as much when she describes how black artists adopted Euro-American features of form and content.[4] While it is true that the likes of Joshua Johnston, Henry O. Tanner, Edward M. Bannister, and Edmonia Lewis followed the directions of European tradition in the nineteenth century, Afro-American crafts continued to be practiced, and they continue to exist today. And this is the most significant fact about the Afro-American tradition in the decorative arts: it is a living tradition. As anthropologist Sidney Mintz remarked, "that it exists at all is what is important about Afro-American art."[5] The continuity that we find in black folk art and craft is a proof of strength, it is testimony of cultural stamina and endurance in the face of sometimes brutal oppression. The history of the whole aesthetic program of Afro-American decorative art is a fascinating story that has never been fully told. As Driskell has written: "These functional forms provide a rich record of black achievement that is worthy of further study."[6]

The remarkable epic that describes the evolution of Afro-American crafts cannot be recovered by conventional art historical methods. The nature of the works requires that attention be focused not simply on the objects and their makers but on broad historical and cultural issues. We do not have in this instance a cadre of like-minded artists who derive inspiration from each other. Afro-American crafts cannot be approached in the same way we would seek to understand the art of the Harlem Renaissance. Because decorative arts of black America were practiced over so long a period and in so many different places, an analysis of objects alone might only produce a false pattern. Black artisans maintained their alternative sense of creativity only through working out a complex amalgam of cultural influences. Even when we simplify the cultural history of Afro-America we find that two basic strands are interwoven, African and European. Out of this interaction a new cultural reality was forged—the black American. In some instances the admixture of cultural sources favors African elements; in other cases European features seem to dominate. While the particular combination varies, we are keenly aware that the differences are a matter of degree rather than kind.

Most historical treatments of black art consider the unity in Afro-American creation in a linear perspective, but this is far too simple and prone to error.[7] It is postulated that skill in the crafts, say in carpentry, leads to expertise in cabinetmaking, which may then lead to an opportunity to work in architecture, and then later open the door for recognition in the areas of painting and sculpture. It is suggested that Joshua Johnston (1765-1830), for example, was accepted in Baltimore as a black portrait painter because he had been preceded by a generation of expertly adept black craftsmen. The ceramic jars of Dave the Potter are offered as an example, but the bulk of Dave's work was done after 1840 and exclusively in South Carolina. If there is a unity to Afro-American art, it is a cultural unity,

1

and it is confined to specific traditional genres. The traditions and customs which inform the decorative arts are not necessarily the same as those expressed in the fine arts.

The crucial cultural source that gives black crafts their special identity is, of course, their African heritage. This heritage, this cultural legacy, has long been the source of scholarly debate and social tension. Generally, its presence has been denied, and often the deep motive behind that denial was racial exploitation. As Melville J. Herskovits has shown, a people bereft of a history—without a past—has no source of identity. When Blacks were considered to have lost their heritage, he argued, they were then looked upon as a commodity and a tool. Thus he warned: "A people that denies its past cannot escape being prey to doubt of its value today and of its potentialities for the future."[8] In the last decade the awareness of Africa among American Blacks has increased, while at the same time awareness of African influences in their own history has not developed fully. This may be due to the widespread influence of sociologist E. Franklin Frazier, who, in his masterwork *The Negro Family in the United States*, effectively portrayed black domestic life as the product of white domination.[9] Africa became a heritage denied.

While there may be few elements of African kinship patterns in Afro-American family affairs, the survival of African influences has long been noted in the areas of religion, music, oral literature, and dance. It was Herskovits who first systematically identified the presence of African influences in contemporary black American culture and coined the term "Africanism." His work is often rebuked as mere trait chasing, as an assemblage of odd facts and idiosyncracies, but this criticism is misplaced. An Africanism is not an isolated cultural element but an assertive proof of an alternative history. It is a link to an unwritten past; it is an index of the existence of African influences. Paul Bohannon has written that all elements of a culture are encoded twice, once in reality and once in the mind.[10] A black folktale with African characteristics is then more than an entertaining story; it is an indication of the continued maintenance of an African mentality. It is because of the continued existence of African ideas in America that Afro-American traditions continue to flourish.

Africanisms have been more difficult to discover in material expressions than in the performing arts. It has been generally assumed that Africans were divested of material reminders of their homeland and prevented from making objects that would help them recreate something of the life they had lost. Even Herskovits writes:

If, then, the acculturative situation be analyzed in terms of differing opportunities for retention of Africanisms in various aspects of culture, it is apparent that African forms of technology . . . had but a relatively slight chance for survival. Utensils, clothing, and food were supplied the slaves by their masters, and it is but natural that these should have been what was most convenient to procure, least expensive to provide, and other things being equal, most like the types to which the slave owners were accustomed. Thus African draped cloths were replaced by tailored clothing, however ragged, the short-handled broad-bladed hoe gave way to the longer, slimmer-bladed implement of Europe, and such techniques as weaving and ironworking and wood carving were almost entirely lost.[11]

This dreary evaluation would seem to eliminate all hope of ever identifying an Afro-American tradition in the decorative arts. Yet the tradition does exist. First, there are some pure retentions of African items, many of which were unknown when Herskovits did his study. Second, because material artifacts—like verbal and musical creations—are based on ideas, an African idea may motivate the making of an object which itself is perceived as Anglo-American. Objects which are describably African starkly and directly assert themselves as black creations. Where Afro-American influences are of a stylistic nature, the impact of black traditions is more subtle. Throughout this study we will examine both kinds of objects in order to document the entire struggle of black artisans to attain cultural self-determination. What is common to objects that are overtly Afro-American and those that manifest only subtle traces of black influence is the retention of a similar creative philosophy. If we are truly to understand Afro-American art and craft, we must understand the intellectual premises upon which their creation is based.

When dealing with the materials of Afro-American culture one unavoidably confronts what W. E. B. DuBois called "the two-ness of the Negro."[12] By this he meant to describe a kind of complexity that has been intimately a part of the black experience. In terms of culture history (the metaphor we employ here for art history), we also note a certain duality. Black art can claim the heritage of a distant past reaching back to Africa and simultaneously a more recent historical source of inspiration—the re-

sponse to America. Two reservoirs of creativity were available to be tapped by black artisans. Perhaps the same could be said of most craftsmen in the New World, but Afro-American artists worked within a set of circumstances that were special in the American experience. As slaves they had new patterns of performance imposed upon them; the European world was thrust into their consciousness. The objects they made were, then, a result of dual historical influences, distant past and recent past, and twin cultural influences, African and European.[13]

Anthropologists have given the name "syncretism" to the process by which a group of people renders the chaos of merging cultures into an intelligible pattern. Basically, what happens is that the new culture is comprehended by degrees. Those features of the novel pattern which are most similar to the established cultural ethos are understood and accepted first. After a shared groundwork is established, the more confusing elements of the new culture may be approached. The syncretic process is essentially a technique for preserving one's identity, a method of intelligent and cogent problem-solving under harsh social pressures. For example, Africans in the New World had little problem accepting Catholic saints; they reinterpreted them as the gods of a pantheon. Thus they acquired a Western religion while at the same time preserving their ancestral heritage.

The complexity of Afro-American culture certainly must carry over into the decorative arts. We must be prepared to evaluate examples of art and craft on several levels, for each object will likely be the end product of a syncretic process. To properly appreciate these works, the viewer has to appreciate the piece not only as it is but also in the ways that it is reinterpreted. If, for example, modern plastic dolls were placed on a voodoo altar in Mobile, Alabama, we should be prepared to read them as both the product of petrochemical technology and the physical referent of Yemaja, Yoruba goddess of sea water.

Less difficult to understand, but exceedingly less common, are objects of craft and art which are directly retained from the African heritage—a few tools, a few musical instruments, some rare textiles, and examples of graveyard decoration. These items are so much like African works that it is not difficult to identify their source of inspiration. Rather, it is difficult to explain how they have remained so pure in form and content. Many factors must be considered. Among these are the degree of contact between Afro- and Euro-American groups, the length of separation

from the African homeland, the degree of acceptance among Euro-Americans of Afro-American customs, and the demographic composition of the Afro-American community. The Sea Islands off the coasts of South Carolina and Georgia, and sections of the piney woods of Mississippi and Alabama are areas of relative isolation where African-derived custom has been able to flourish without the imposition of white disapproval. In South Carolina, where Blacks outnumbered Whites five to one throughout most of the eighteenth century, the colony looked "more like a Negro country than a country settled by white people."[14] British settlers were generally inept at dealing with their new semitropical environment and apparently turned much of the actual conduct of the work over to their enslaved African laborers. In this situation several elements of African agricultural technology were put to use, including tools that are still made today.[15] Thus we see that a complex array of factors did at times promote the retention of African-derived material culture. We must then be aware of other instances in which factors of geography, history, and population combine in a necessary sequence to give support to an Afro-American tradition in the decorative arts.

Given the multi-level nature of Afro-American art works and the complex network of supportive social circumstances in which these works exist, we soon come to realize that black creativity is marked by constant, individuating change. While improvisation is a universal characteristic of imaginative humans, the extensive sense of improvisation commonplace in the Afro-American experience is rather special. In this case spontaneous change represents a cultural norm rather than single, independent inventions. It is an integral part of the process of African art to constantly reshape the old and the familiar into something modern and unique, to simultaneously express one's self and reinforce the image of the community. This is particularly true in the verbal arts. Among the Limba of Sierra Leone, action elements that are the basic stock and trade of the taleteller are constantly recombined in ways never heard before.[16] Consequently, every time a story is told, it is a novel creation even though it will also share some features with previous works of oral literature. The same principle of verbal artistry holds among the Xhosa of South Africa, whose gifted narrators rework "core cliches" to create "expansible images" that add elaborate linguistic embroidery to simple tales.[17] Among the Ashanti of Ghana

there exists a cycle of narratives that feature a spider hero named *Ananse*. The stories are never the same, for Ashanti narrators have acquired the skill of cleverly balancing the old and new. The spider hero remains a central figure of the oral tradition, but his exploits grow in number and content.[18]

Improvisation is not restricted to the verbal arts; nor is it restricted to one tribe or one area— it is a pan-African reality. African music also demonstrates this inclination toward free-form improvisation. The melodic line in West African music is extremely variable and moves loosely, almost randomly, over a rock-steady base line.[19] Other instances of an improvisational aesthetic could be pointed out in textiles and decorative arts[20] or in architecture.[21]

When we look for African influences in Afro-American art, we should be mindful not only of the content of art but of the process of art also. In other words, we must develop a sense of style and performance in addition to a competence for judging form and content. Stylistic consistency (i.e., the ability to retain a succinct identity) appears to be a major source of strength for Afro-American art. In Afro-American oral literature it is not always the content of the story that makes it Afro-American but the way it is performed. The same holds for the Delta bluesman. Singing alone to the accompaniment of a guitar is not a particularly African format, but through inventive phrasing and elaborate melodic and rhythmic embellishment the blues singer produces a song fraught with African texture and feeling. This is also true of the black craftsman whose media and forms may be borrowed from Euro-American sources: the end product of his struggle to wrestle media into object will reflect more of his black heritage than the source of his cultural borrowing.

The adversities which Afro-Americans have endured have encouraged them to be resourceful. They, more than other newcomers to this land, had to reinterpret what for most was commonplace. More than other immigrants they had to seek strategies to retain their rightful cultural heritage. But they more than others may have been better equipped for that struggle and the perplexing problems of cultural disequilibrium, because theirs was the inheritance of improvisation. Afro-American blacksmith Philip Simmons spoke for many craftsmen when he said to me, "You've got to change to stay alive." Constant modification of the daily art of living, "the art of culture,"[22] gives a sense of dynamism to the commonplace and humdrum. In the realm of the decorative arts dynamic resourcefulness gives rise to a quality of excitement which is impressed on otherwise ordinary objects, giving them the imprint of ethnic identity.

For black art and craft, then, improvisation is the touchstone of creativity. Whether manifested boldly or subtly, it is ever present, transforming the American into the Afro-American. Should we fail to recognize and understand this, we risk the danger of mistaking imagination for error, variation for imprecision.

This survey of Afro-American decorative arts calls attention to broad dimensions of black skill and talent as well as to the diverse contexts in which those skills are manifested. Some pieces represent the purest retention of African custom: coiled grass baskets and some musical instruments are examples of uninterrupted survival. With the genre of quilting we find the incorporation of African design patterns into the tops of Euro-American objects. A highly animated black style has also been maintained in the carving of wooden walking sticks and other practical implements. A notion of African-derived ceramic sculpture and pottery survives. Skills of a more pragmatic nature are demonstrated in the making of certain small boats found along the eastern seaboard, and in the forging of wrought-iron gates and balconies. Architecture has gone largely unconsidered as an area of Afro-American expertise, but many buildings were raised by the labor of black carpenters, masons, and plasterers; more importantly, one of the most common house types in the United States, the "shotgun house" (see chapter on architecture), results from the implementation of African and Afro-American architectural philosophies. In addition to these practical examples of black talent, we will also survey decorative impulses of a religious and spiritual nature. Black burial grounds remain today the context for the practice of African-derived custom: grave sites carry markers and various types of embellishment that clearly represent an Afro-American approach to the other world. By analyzing basketry, quilting, boatbuilding, musical instrument making, ironworking, pottery, architecture, wood carving, and grave decoration we can develop a sense of the tangible material creations of black Americans. There are other areas of art and craft, to be sure (coiffure, costume, doll making, sign painting, carpentry), that might be added to this survey, but nine are enough to make clear the imprint of Afro-American traditions.

The examples presented here have been selected because they represent the widest histori-

cal and geographical contexts of Afro-American decorative art. The earliest items originated in the seventeenth century, shortly after the arrival of African peoples. While most of the artifacts that have been preserved and are available for our consideration were made in the middle of the nineteenth century, they are linked to eighteenth-century practices. Hence, a log canoe built in the 1850's gives us an insight into the making of a coastal craft that was invented in the 1780's. It is altogether appropriate that most of the works we are analyzing should have been made after 1850. After this point a positive Afro-American identity had been forged—the delicate cultural balance between the African past and the American present had been achieved. The aesthetic perceptions of this cultural mixture were to motivate black artisans well into the twentieth century. The Afro-American tradition itself, however, reaches back over four centuries —back over almost four hundred years of change and modification, preservation, and survival.

Afro-American arts and crafts are not restricted to one region of this country. An earlier survey by Robert Farris Thompson has given the impression that a tradition for African-influenced art exists mainly along the coast of Georgia and South Carolina.[23] Despite the fact that Thompson also included an example of wood carving from upstate New York and a spectacular walking stick from central Missouri in addition to mentioning the artistic potential of the Upland South, Afro-America is considered to exist only in the southeastern corner of the United States. We, too, find our attention focused in South Carolina because it is there that the influences of Africa are so striking and easy to detect. But with an eye for subtlety of expression, we have been able to bring under our scrutiny objects from Maryland, Virginia, and Texas. Black forms of basketry, carving, and quilting, although found in coastal South Carolina and Georgia, can also be traced into the interior of the South—to Alabama, Mississippi, and Tennessee.

Furthermore, wherever that special brand of black Christianity exists, with its highly emotional fervor, its moving music, and its exciting preaching, graveyards are often the realm of art as well as the resting place of the departed. Consequently, most of rural black America has fostered the Afro-American tradition in the decorative arts. Although most of the objects presented here have southern origins, a few forms found their way beyond that vast region—to the North and the West. Wood carvings, architectural traditions, and artifacts migrated with southern Blacks to their new homes in urban America. In the 1950's Blacks from Mississippi who had gone north were telling unmistakably southern style folktales in Michigan.[24] They could have carried with them southern material skills as well. Thus the Afro-American tradition in decorative art is widespread. It encompasses as much territory as black Americans have been able to populate. The implication of this vast distribution is very significant because it suggests that Afro-America is not a place as much as it is a state of mind. It exists as a culturally determined perspective which can be asserted in tangible objects that manifest skill and expertise, competence and ability.

The significance of Afro-American traditions in the history of American art has heretofore not been appropriately recognized. Thompson was absolutely right when he wrote: "Mankind must applaud Afro-American art in the United States for its sheer existence, a triumph of creative will over the forces of destruction."[25] While it may be too soon to make a summary statement about the importance of black art and craft, one thing is definite: after looking at the works that follow, the existence, the being and reality of the Afro-American tradition, will never be denied again. If eyes are opened, understanding and perhaps appreciation may follow.

Hugh Honour has written that Europeans who saw America from afar envisioned a world of fantasy, which potentially could nourish an ideal society.[26] Black people, too, had a vision, but it was a vision from within America. Their ideal world was the one they had left behind rather than a world newly discovered. In their works of art and craft they endeavored to recover something of their lost ideal and thereby to achieve a cherished dream of their own.

Numbers in brackets (example: [43]) refer to catalog entries which are found in the Catalog section, beginning on page 159.

Figure numbers refer to illustrations of comparative material.

In some of the captions for illustrations, book and article references have been shortened; for full details on a book or article cited see the Bibliography (beginning on page 169).

1. Basketry

The coiled baskets of the Sea Islands are perhaps the most noteworthy examples of distinctly Afro-American craft. Hundreds of basket sewers continue to ply their trade in Mt. Pleasant, South Carolina, a small town just north of Charleston. Many of them still flavor their conversation with elements of Gullah, a Creole language that features numerous African words.[1] They also continue to employ techniques of basket making which have changed very little over the last two centuries. It is clear that many Africans who were brought to America came with a supply of useful skills; among these was the art of basketry. The coiled grass basket is known all across the continent of Africa,[2] and although a similar technology is also found among Euro- and Native Americans, the relationship between African and Afro-American examples is particularly striking. A unity of appearances links black craftsmen from both sides of the Atlantic. Senegambian baskets [1, 2] could, for example, be interchanged for Sea Islands baskets.[3] Gloria Roth Teleki has cited

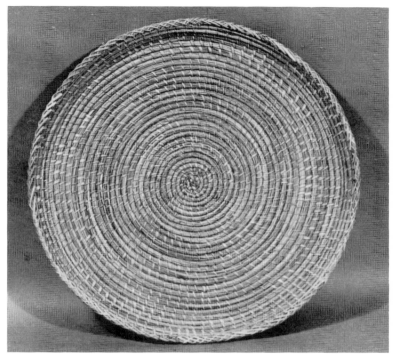

2 *Rice Fanner Basket,* Senegal.

1 *Food Storage Basket,* Yacina Diof.

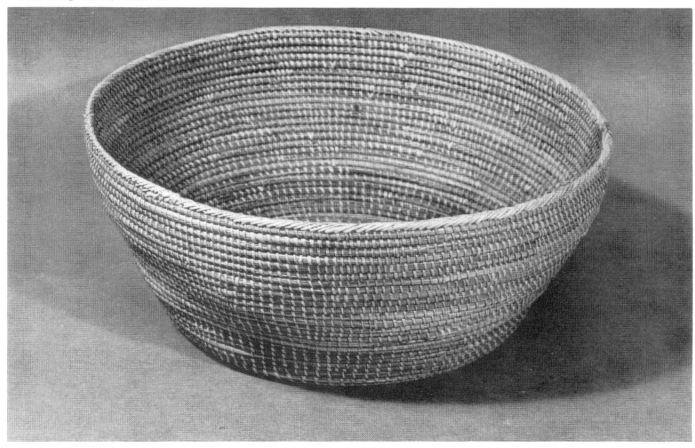

Angola as another African source of inspiration: "A new Ovambo basket, from a tribe living in the territory covering part of both Angola and Southwest Africa, resembles Gullah work, even to the decorative incorporation of dark brown fibers."[4]

While we may claim the coiled-grass basket as an Africanism, our analytical efforts should not stop with the recognition of resemblances. The coiled basket was but one element in an extensive system of African agricultural technology that was successfully incorporated into the colonial economy of the American South. In order to fully comprehend the significance of the continued maintenance of an African craft pattern in basketry, we must also consider the wide influence that African skills had on farming practices. The baskets, as they survive today, are but a slight indication of the broad imprint of African practical talent.

African Agriculture and the New World

Africans and their New World descendants made important contributions to the development of American agriculture that were crucial for the success of early South Carolina. They played a dominant role in both the settlement of the colony and the development of a plantation economy. The main reason for this black dominance is the African ability to cope with the semitropical climate of the coastal lowlands. While the New World was alien and hostile to the European, it was apparently familiar and hospitable to the African. Peter H. Wood gives this assessment of the Afro-American competence:

> In Carolina their ability to cope with this particular natural world was demonstrated, and reinforced by the reliance Europeans put upon them to fend for themselves and others. Instances of black self-sufficiency made a lasting impression upon less well acclimated Whites, and as late as 1775 we find an influential English text repeating that in Carolina "The common idea . . . is that one Indian, or dextrous negroe, will, with his gun and netts, get as much as five families can eat."[5]

Thus by British standards the black pioneer was in many ways better prepared to face life in the colonies than the yeoman farmer.

Not only was much of the initial success of South Carolina owed to its black population, but subsequent agricultural advances depended in no small measure upon African contributions.[6] The new plants imported from Africa to Carolina plantations include rice, guinea corn (used extensively as fodder for hogs and poultry), the "guinea melon" (a variety of muskmelon), "guinea grass," guinea squash, and indigo. A common domestic fowl, the "guinea hen," was also brought over from Africa. These new flora and fauna to some degree changed the physical environment of South Carolina, giving it more of the feel of West Africa—certainly the new plants and animals did not conjure up the image of Cornwall or Sussex.

Of all the African agricultural imports, rice had the most profound impact. Coastal South Carolina remained a rice-producing area long after most of the South had turned to cotton as a main crop. Rice was to Carolina what sugar was to Barbados and Jamaica and what tobacco was to Virginia and Maryland.[7] The fortunes of colonial investors in South Carolina were made in rice: white rice produced by black labor. Fieldhands, of course, required tools in order to do their work, and the implements they employed were the same type they had known in West Africa. It is with the cultivation and particularly the harvesting of Carolina rice that an Afro-American tradition in basketry begins.

Rice cultivation was begun in earnest around 1680, but planters remained "ignorant for some years how to clean it."[8] Because English settlers knew very little about rice, they were at first totally dependent on enslaved Africans for their expertise as well as their labor. It appears that by 1730 (and possibly as early as 1690) the first baskets were made by Blacks in South Carolina.[9] These were fanners, wide circular trays almost two feet across, used to winnow the rice after it had been hulled. Although such baskets are also found in European grain-growing peasantries, their production was not easily transmitted to the American South. Moreover, the mortar and pestle [3] used in South Carolina to husk rice were not carry-overs from Europe, as some have suggested; rather, they were imported from Africa along with the rice and the laborers who tended it.[10]

Some slave cargoes entering Charleston harbor were advertised as being "accustomed to planting rice." The only group of slaves to be extensively interviewed about their ethnic backgrounds and former occupations was the rebel cargo of the *Amistad,* which mutinied at sea in 1839 under the leadership of Cinque and eventually was tried in New Haven. Many of this group mentioned that rice was planted in their homeland, that they themselves were rice planters, or that they had been captured while plant-

ing rice.[11] The cultivation of rice has been known all across West Africa since the first century AD;[12] hence it is not at all surprising that Blacks should have been better rice farmers than Whites. Their superiority in these matters allowed African-derived technology not only to enter the United States but to flourish. The control of rice growing by Africans is best summarized by Wood:

> These Africans who were accustomed to growing rice on one side of the Atlantic, and who found themselves raising the same crop on the other side did not markedly alter their annual routine. When New World slaves planted rice in the spring by pressing a hole with the heel and covering the seeds with the foot, the motion used was demonstrably similar to that employed in West Africa. In summer, when Carolina blacks moved through the rice fields in a row, hoeing in unison to work songs, the pattern of cultivation was not one imposed by European owners but rather one learned from African forebears. And in October when the threshed grain was "fanned" in the wind, the wide winnowing baskets were made by black hands after an African design.[13]

The baskets are all that actively survive today, but they should remind us of a deeper heritage and a broader set of African cultural influences.

Fanners and Storage Baskets: "Old-Time" Baskets

The oldest Afro-American basket types were simple forms. The fanner [4] was very wide with a shallow splayed edge. Storage baskets also had the same wide, flat base, but the side walls were built up much higher, sometimes as much as a foot.[14] While the sides of storage baskets tended to be more vertical than the edges of the fanners, the two basket forms are so similar they can be considered as one type of the Afro-American coiled basket: the agricultural tool. These older, larger, more pragmatic baskets were also made with different materials than are commonly employed today, even though the techniques for making them remain the same. In place of the soft, pliant "sweetgrass," a harder, stiffer rush plant was used. Thin strips of palmetto butt or white oak were used to bind the coils instead of palmetto strips.[15] A rush and palmetto or oak basket is a very durable object; it can withstand the wear and tear of many seasons of field use. Since rice fanners and storage and carrying baskets were intended to be used primarily for practical ends, they had to be made with the sturdiest fibers available. These "old-time"

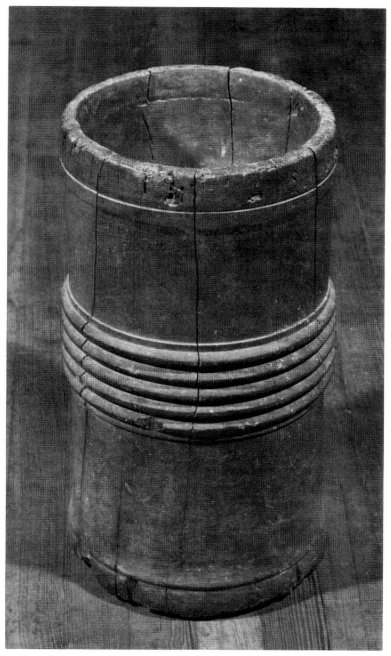

3 *Rice Mortar,* South Carolina.

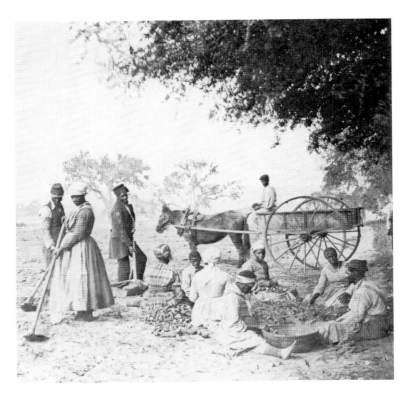

Afro-American baskets were thus, both in form and content, functional items; they were, moreover, men's baskets (Figure 1).[16]

Rice fanners are rarely made today; there is no need for them. But the enlightened tourist does ask about them. Rush baskets (called locally in South Carolina "rushel" baskets) are remembered but are infrequently sewn. Contemporary artisans continue to use rushes but break with tradition by using palmetto leaf strips and colored cord as a binding material. In the last five years there has been a revival of rushel baskets due to increased competition and the need for greater design variation, and because of the scarcity of sweetgrass.[17]

Figure 1. Freed slaves near Beaufort, South Carolina, harvesting sweet potatoes, ca. 1865. Note the large coil basket in the lower right corner. Photograph, collection of The New-York Historical Society, New York City.

4 *Rice Fanner Basket,* South Carolina.

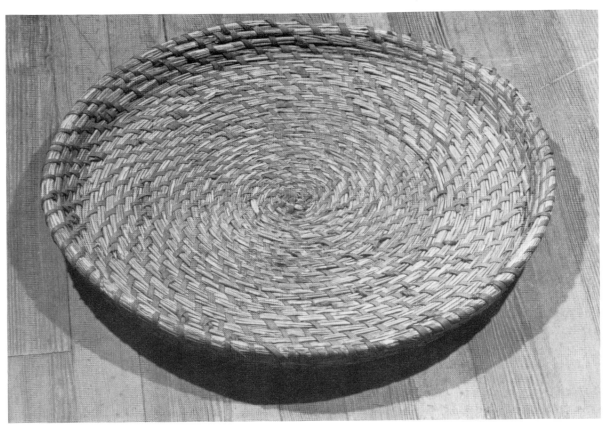

Commercial Coiled-Grass Baskets

The old-time basket tradition continues today largely in modified form. Coiled baskets made of sweetgrass, pine needles, and palmetto are turned out daily in Mt. Pleasant at numerous stands all along Route 17. These current examples of Afro-American craftsmanship are, however, not all newly invented forms. The coiling technique is the same as that used in the making of rush baskets. Although coiled-grass basket sewing did not become an extensive commercial enterprise until the twentieth century, the techniques for making grass baskets were already known among Blacks in the nineteenth century. Women and children had previously sewn "show" baskets with pliable grass. Contemporary basket sewers can name an extensive list of items which they classify as old-time work: hot pads (both round and oblong), church collection baskets [5], cord baskets, sewing baskets [6], cake baskets [7], clothes baskets [8], traveling baskets, market baskets, picnic baskets, and "spittoon" baskets [9] (these are shaped like a bulbous cuspidor).[18] Although the technique of coiled basketry is simple and the materials commonplace, we cannot fail to recognize that the limits of the basket maker are chiefly the boundaries of imagination.

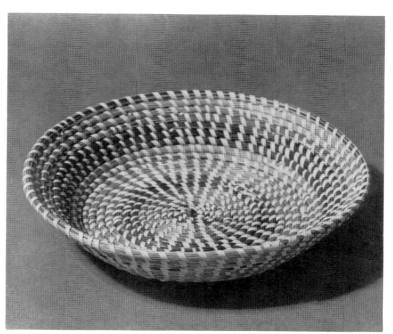

5 *Church Collection Basket,* South Carolina.

6 *Sewing Basket,* South Carolina.

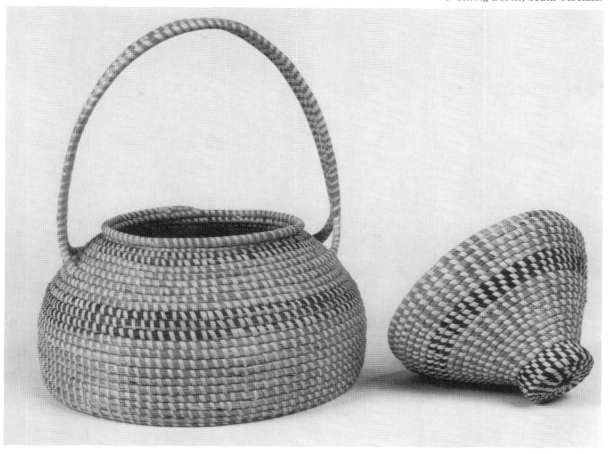

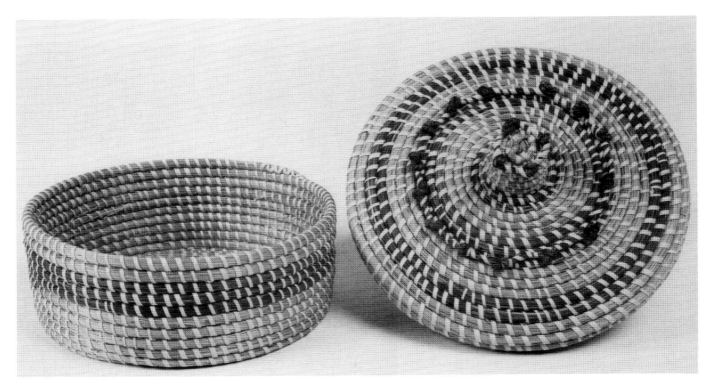

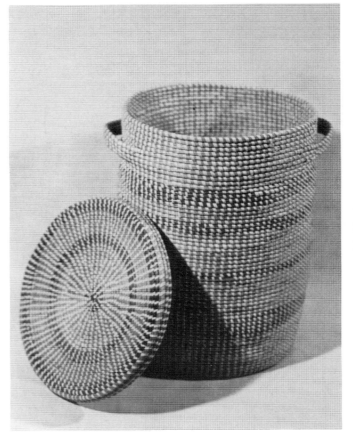

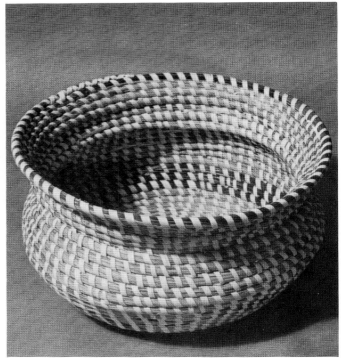

Above: 7 *Cake Basket,* South Carolina.

Left: 8 *Clothes Basket,* Mary Manigault.

Below: 9 *Spittoon Basket,* South Carolina.

Many of the old-time baskets, like the rice baskets, are round. But the spittoon baskets show the degree of variation that is possible by means of subtle changes in the angle of attachment for successive grass coils. The sewing and cord baskets with their conical lids have a nipple shape, a radical departure from the old tools of rice cultivation. Another change in Afro-American basketry was the addition of strap handles. All through the eighteenth and nineteenth centuries (even into the first decade of the twentieth century) black women in South Carolina and Georgia carried their loaded baskets on their heads (Figure 2) in the manner of their African ancestors.[19] As this trait of motor behavior became less frequent, hand-carried baskets probably became more common. Functional baskets, such as market and egg baskets, provided an early model for the fancy purses or pocket books, flower baskets, and fruit baskets which today are the mainstay of the trade. One commentator has claimed that these new forms show extensive African influences.[20] But what we are really seeing in an "in-and-out" basket with its scalloped walls [10], or a flare-bottomed fruit basket [11], or a tall cylindrical flower vase [12] is actually the American influence, the response to

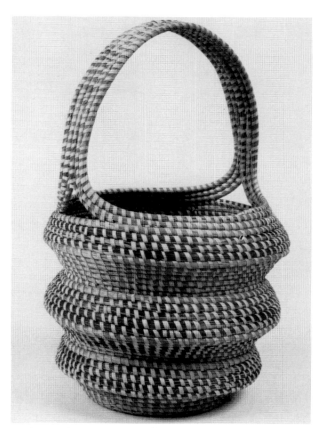

10 *In-and-Out Basket,* South Carolina.

11 *Fruit Basket,* South Carolina.

Figure 2. Adelaide Washington of St. Helena Island, South Carolina, on her way to the fields carrying a loaded coil basket on her head, ca. 1910. Photograph, collection of Penn Community Services, Inc., St. Helena, South Carolina.

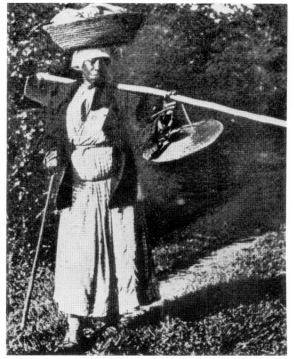

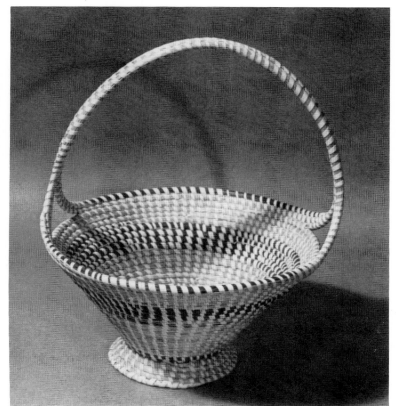

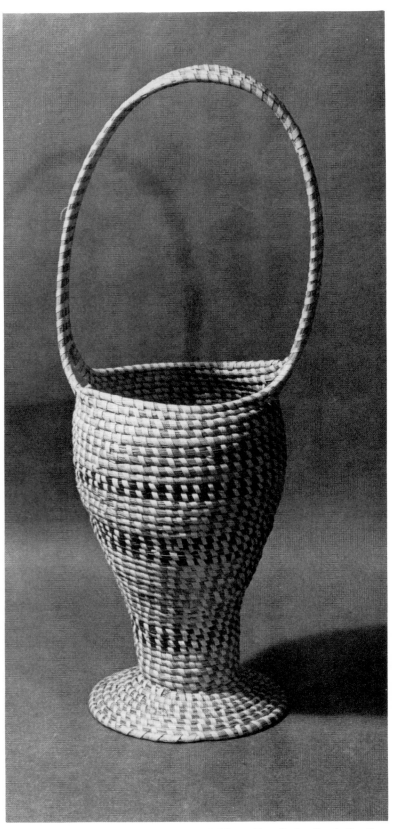

12 *Flower Vase Basket,* South Carolina.

changing circumstances. As Afro-American basket sewers have become less concerned with the old forms in their repertoire and more interested in their new monetary value, they have freed their decorative urges from traditional pragmatic restraint. The cautious experiment that led to nipple-topped sewing baskets and spittoons in the nineteenth century has given way to extensive innovation in twentieth-century Afro-American basketry.

The blend of old and new influences in coiled-grass basketry can be seen clearly in the work of Mrs. Queen Ellis of Mt. Pleasant. A pleasant woman in her early forties, she sews baskets and sells them in the open-air market in Charleston. She has made baskets all of her life, like most of the other basket ladies, and like all the others, she learned the processes of coiling and stitching from her mother. These skills exist generally in the entire Sea Islands community, but the tradition is chiefly fostered by women. Men know how to sew baskets[21] but few do; the market is controlled by women.[22] Men and boys continue to be involved in the craft, however, as collectors of the basket materials. Mrs. Ellis pays between two to three dollars for a small supply of sweet-grass, pine needles, and palmetto. Thus, the special role of the basket sewer, her working techniques, and her choice of forms are the key traditional elements of this craft. The forms Mrs. Ellis makes occasionally resemble the older Sea Islands baskets, but by and large she creates baskets that will satisfy her own aesthetic sense and simultaneously appeal to her customers. The strength of her repertoire rests in purses, trays with holders for glasses, and bread baskets. Hence, we see the tradition undergoing a process of change and transformation. The basket sewers are fully capable of making the older types of baskets, but in general they would rather make something new and unique.

Mrs. Ellis' approach to her materials does not seem to be very different from the manner apparent in older examples (Figure 3). She gathers a handful of grass into a quarter-inch bundle and ties one end in a knot to form the center of the base. She then takes a quarter-inch strip of palmetto and wraps it tightly around the bundle. As she turns the coils clockwise in ever-growing circles, two stitches are used alternately: one cinches the grass into a tight bundle, the other ties each coil to the preceding one (Figure 4). The end of the palmetto strip is sharpened to a point with scissors and is fed through the coils with the aid of an awl-like tool called a "bone." The bone is usually a sharpened teaspoon handle

or a nail with a flattened end. New handfuls of grass are constantly added to the continuous coil, although dark brown pine needles may be used now and again to provide a contrasting decorative band. When the base is large enough the coil is pulled inward so that the side wall can be built up. The entire sewing process is done without measuring devices. A basket is measured by its appearance and its feel.

Traditional forms are discernible within Mrs. Ellis' modern baskets. Some of her small trays could be identified as old-time church baskets, but to her they are just trays. When asked about the similarity between her serving trays and rice fanners she was quick to point out that fanners were quite large. To illustrate just how important size is as a determinant of basket type, she later made a rice fanner for me. Visually, the impact of a two-foot diameter basket is much more impressive than one that measures only a foot across. But for the maker the difference is more than a matter of dimension. In the time it took to make a fanner, Mrs. Ellis could have sewn three smaller baskets or several hot pads. The negative economics involved in the making of rice fanners is not difficult to perceive. It is inevitable, therefore, that some of the traditional forms remain latent and submerged in Afro-American tradition so that the craft can continue to be financially feasible.

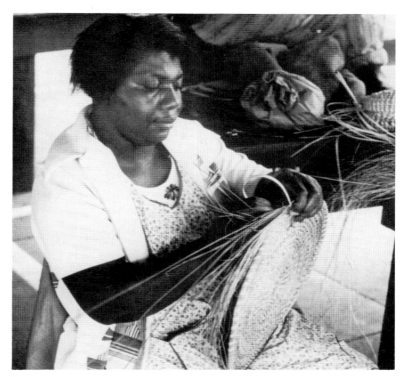

Figure 3. Mrs. Queen Ellis of Mount Pleasant, South Carolina, sewing a basket, June 1976.

Figure 4. Bottom of a coil basket showing stitching details.

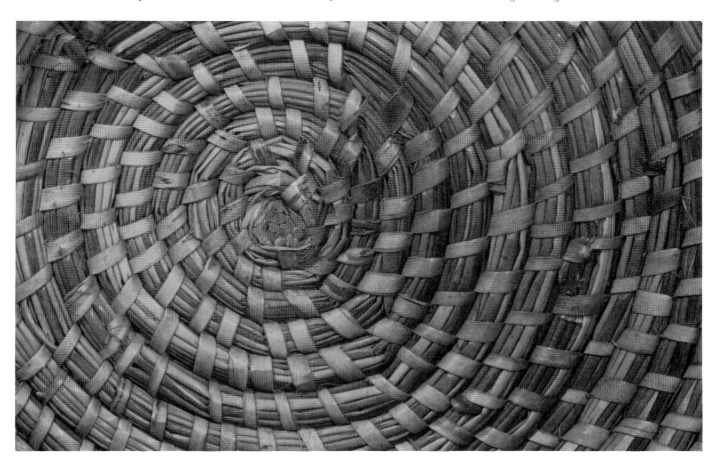

Native American Basketry: A Supportive Element

Early agricultural dominance and continued resourcefulness with basket forms are the major factors that account for an African-derived basketry tradition in the United States. There is, in addition, one other supportive element to be considered—the baskets made by Native Americans. John Lawson in 1714 noted of the Tuscaroras: "The Baskets our neighboring Indians make are all made of a very fine sort of Bulrushes, and some times of silk-grass which they work with figures of Beasts, Birds, Fishes, &c."[23] These grass baskets in some degree may have resembled those made by Africans. That slaves could have seen Indian basket work is suggested by Lawson when he reveals that rush mats which were used for slave bedding were made by Indians.[24] Coiled baskets were generally known to a wide range of Indian tribes, from the Seminoles in Florida to the Chippewa in Minnesota.[25] Today, coiled baskets made by the Coushata of southern Louisiana are sometimes mistaken for Sea Islands work. Close inspection, however, reveals that the stitching technique is very different, that some of the basket forms are unique to the Coushata, and that pine needles are used exclusively rather than in combination with grass.[26] Although Indians certainly did not have to teach slaves how to make coiled baskets, the fact that they too had this type of basket probably gave some measure of encouragement to the African version of that basket form. It has even been suggested that southeastern Indian tribes acquired the coiled-grass basket tradition from runaway slaves.[27] This certainly squares with the occurrence of African folktales among these same groups of Native Americans.[28]

Afro-American Traditions and Today's Baskets

Afro-American basketry was initially practiced exclusively in the coastal regions of South Carolina and Georgia. Today it largely survives in Mt. Pleasant, at the northern end of the Sea Islands chain. There is adequate proof, nevertheless, that coiled-grass and rush baskets were also made in St. Helena, Hilton Head, and Defuskie (all near the Georgia border), and just south of Savannah at Brownville [13].[29] Later, when Blacks moved inland, they carried their basket-making tradition with them. Nineteenth-century examples of coiled baskets made by Blacks have been recovered from Alabama, Tennessee, and Mississippi.[30] Indeed, in Mississippi's southwestern counties, Blacks still make "pine straw" baskets in many forms [14, 15]. What was at first only a coastal tradition thus became a southern tradition. Ishe Webb tells how her father came to Arkansas and continued "plaiting baskets and mats like he used to in Georgia"[31] (the term "plaiting" here may indicate the use of a coiling technique). Wherever it is found, the coiled-grass basket is a definitive example of an Afro-American artifact; in it we may recognize the historical impact of the Afro-American craftsman.

In Africa, coiled baskets are made all along the thousands of miles of coast line from Dakar to Mombassa. All of the peoples of this vast region were involved in the Atlantic slave trade. Most were familiar with the cultivation of rice. Senegambian and Angolan peoples were numerically dominant in South Carolina's slave cargoes, and hence Carolina basketry most resembles the baskets from these two areas.

At first the Carolina repertoire was restricted to agricultural baskets, as we have seen, but by the nineteenth century it was expanded to include a wider range of domestic items. Contem-

13 *Market Basket,* Georgia.

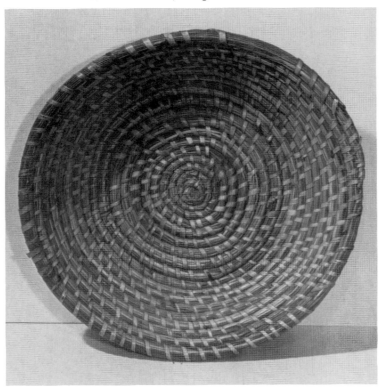

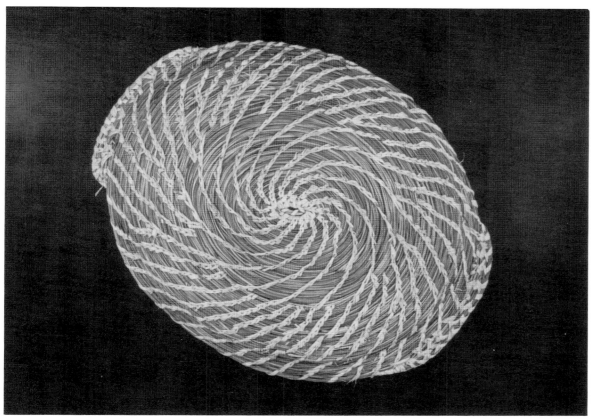

14 *Basket,* Dorothy McQuarter.

15 *Basket,* Dorothy McQuarter.

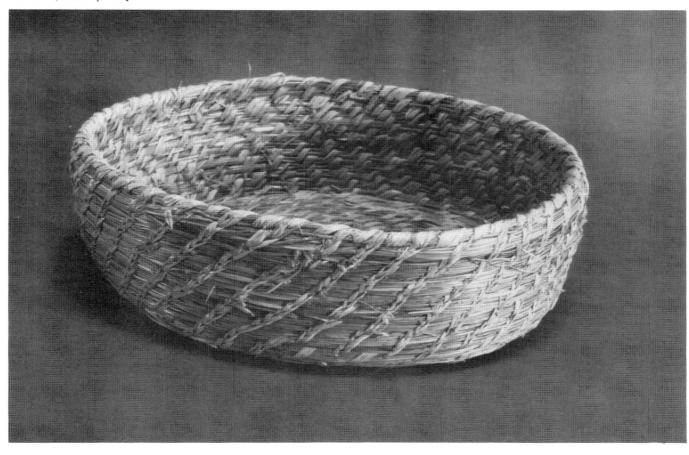

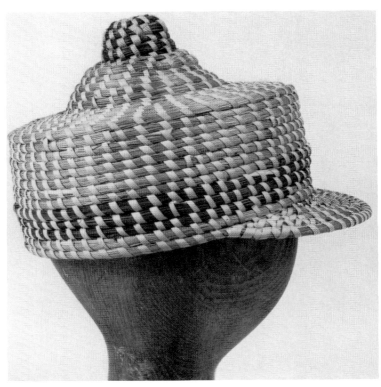

porary basketry was profoundly affected by the commercial resurgence in the craft that occurred in the 1930's, when attention was diverted away from a local market with traditional needs to the needs of tourists. This led to a further diversification of the basket sewer's repertoire. Today there are more than fifty basket types, and more are constantly being created.

Some of the innovations are modifications of older types. Recently a male basket sewer made himself a coiled hat styled like a baseball cap [16]. Although this is a new creation, coiled hats were made in the nineteenth century, and the traditional form is still made today [17, 18].[32] Contemporary basket sewers often attempt to make something other than old-fashioned items. Another example is Elizabeth Washington, who sometimes makes what can be called basket

16 *Cap*, South Carolina.

17 *Hat*, Benjamin Sheppard.

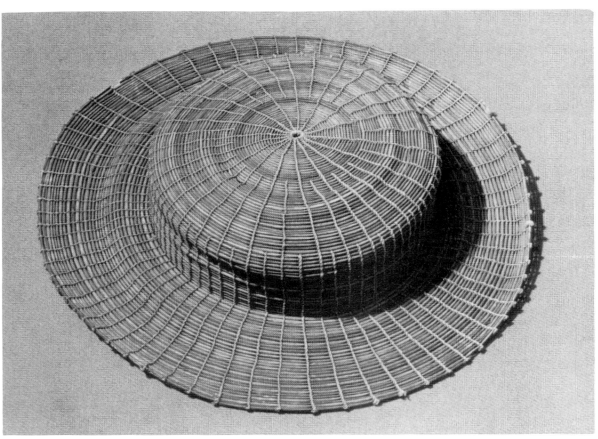

sculpture. Recently she made a pitcher basket complete with spout (no mean feat with coiled grass). It is intended solely to be viewed as an art work, for of course it will never be able to hold water. Some contemporary coiled mats, too, have become so fanciful in their open-work design that they no longer serve their stated function and instead become "wall mats," to be hung up and viewed from a distance [19]. Variations in creative patterns have become so important that many basket sewers make "own style" baskets (baskets of their own design that no one else makes).[33] An African craft that began with functional intentions thus has become an art medium with primarily aesthetic motivation. The blending of craft and art with the passage of time is a theme in Afro-American decorative arts which we will confront many times.

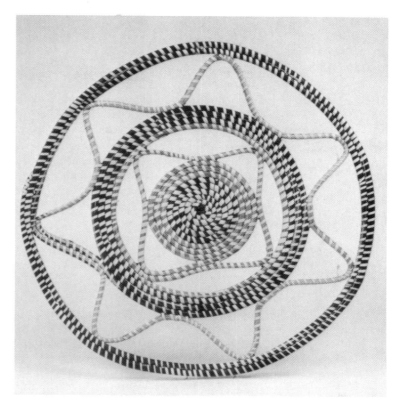

19 *Star Mat*, South Carolina.

18 *Hat*, Irene Foreman.

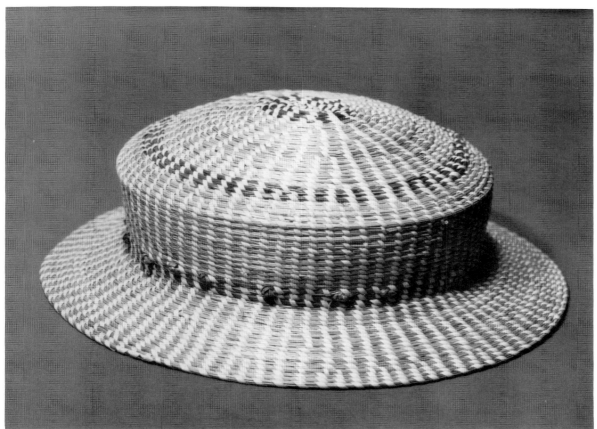

2. Musical Instruments

There is no doubt that black American music derives its identity from an African heritage. Every commentator on black people has at some point seen fit to describe their musical abilities. And whether speaking in awe or in criticism, no writer has ever failed to suggest that black songs represent an alternative musical tradition. Black music stands as a great cultural achievement, which becomes even more admirable when we consider the fact that this music was created and preserved largely with borrowed instruments. But not all African instruments were lost. Drums continued to play a central role in Afro-American music just as they had in Africa. The early drum forms were more like those of the ancestors, but these were eventually replaced by commercially manufactured trap sets. Cane fifes were a mainstay of some West African melodic compositions and are still made today in Mississippi. Single strand instruments are also found in Africa and Afro-America. The banjo, which contemporary America considers part of a white southern mountain heritage, owes its origins to Afro-American instrument makers and to African chordophone prototypes. These four musical instruments—drum, fife, one-strand, and banjo —demonstrate the diversity of instrument-making traditions. With these three kinds of instruments (percussion, woodwind, and stringed) we can illustrate both the longevity of black instrument-making traditions and the broad cultural impact of African influences on American music.

Percussion Instruments

Percussive sounds are a basic element in African and African-derived music. The common instrument for creating these sounds is not, as is commonly assumed, the drum, but the hands clapped together. African slaves were then obviously equipped to maintain a rhythmically oriented music even if drums were prohibited. Furthermore, many objects might function as drums. Benches and table tops, doors, inverted buckets, and wash tubs could all be used to pound out a rhythmic beat. A rice mortar is essentially the same as a hollowed-log drum body. It is possible that some mortars had skins temporarily stretched over them so that they could be played as drums [20]. The shaping of these drum-mortars is so exquisite that the extra care taken in their manufacture is readily appreciated. The shift from food preparation vessel to musical instrument is not extreme, for when hulling rice black women often established a song cadence with the thump of the pestle in the mortar. Herskovits described how an innovative response to a culturally repressive law in Surinam kept drumming alive:

> Adaptation to the legal ban is simple, employing objects of European manufacture never intended for such use. A metal wash basin is filled with water, and another caused to float in it upside down; the rhythms beaten on the bottom of this smaller basin give the sound of a hollow-log drum without the same carrying power. The curing rite [requiring drum playing] is thus carried out quietly and African medical practices continue despite the troublesome rule.[1]

Figure 5. *Slave Drum*. Wood, late 17th-early 18th century, H. 18 inches. Virginia. The British Museum, London.

Thus, the absence of drums does not necessarily prevent the survival of drumming. In this context, it is important to recognize that a stubborn persistence of rhythmic concepts in the African nature helped to foster the maintenance of drum-making traditions.

Drums made of hollowed logs with pegged heads were common to both the West Indies and the American South.[2] George Washington Cable described this type of drum in New Orleans in 1886: "The drums were very long, hollowed, often from a single piece of wood, open at one end and having a sheep or a goat skin stretched across the other."[3] The same kind of drum was also found in the Gullah-speaking communities of the Georgia coast. James Collier, a drum maker in Brownville, Georgia, made "old-time drums" in 1938: "He made one . . . out of a hollow log across the end of which he tightly stretched a goatskin. He fastened the skin to the log by means of a number of wooden pegs. Unlike modern drums, this one was taller than it was wide, measuring about eighteen inches in length and ten inches in diameter."[4] The strength of the Georgia tradition is further suggested by the fact that eleven reports of drum making were elicited from seven different communities. Another, rather recent, example of a peg-type log drum was found in western Alabama in 1950.[5] These widespread nineteenth- and twentieth-century reports of the hollow-log drum bespeak a heritage which probably dates back to the eighteenth century. Moreover, because of its presence in the West Indies, we can assume it also bespeaks a link between the South and the Caribbean.

The ties that unite African and Afro-American instrument making are illustrated by an early slave drum from Virginia (Figure 5), possibly made in the seventeenth century but certainly no later than 1753, when it was placed in The British Museum.[6] Like the other Afro-American drums described above, this drum is exquisitely sculptured into a bottle shape typical of Akan-Ashanti *apentemma* drums and decorated with incised patterns of lines. Ghanaian musicologist J. H. Kwabena Nketia notes that plain drums are rare among the Akan and lists among the motifs cut into the surfaces of drums: bands of saw-edged design, bands of vertical grooves, plain bands, and alternating patches of vertical grooves and plain squares.[7] All of these motifs appear on the Virginia drum. Furthermore, the drum head is secured to the tightening pegs in the same manner Akan drum heads are fixed.

20 *Rice Mortar,* South Carolina.

21 *Fife,* Othar Turner.

In form, decorative content, and technology this slave drum is identical to an Akan drum. It is conceivable that if this drum were today taken to Ghana and put into a drum orchestra, it would not be out of place. The only indication that this instrument is indeed not African is in the material from which it is made: American cedar and deerskin.[8]

That this early Afro-American drum should be so African and the others less so is readily apparent. Recently-arrived Africans and first generation slaves had a clearer memory of their African heritage. As they struggled to preserve their ethnicity and to recreate something of the world they had lost, they could draw upon recent memories of even the most intricate details. Later on in the nineteenth century the vision of the past became dim—although it was not forgotten—and consequently only the broad outlines of traditional forms were retained. The commitment of the first slaves to their African heritage was very strong. The Virginia drum is an example of their struggle to maintain an African identity: the patina or red clay which cakes the surface of the drum indicates that it had been buried, hidden away, perhaps, to keep some white master from taking it.

Blacks in the Gullah-speaking communities of Georgia, who in the 1930's continued to make and play drums, also had a sense of commitment. Their instruments may have been rude and simple when compared to those of their ancestors, but their struggle should account for the difference. Even the Djuka, an Afro-American group now in the jungles of Surinam, do not accurately maintain the traditions of their Akan ancestors even though they have been free from European cultural influences for more than two centuries.[9] Should we then expect more of American Blacks? Not only did they keep the tradition of the large hollow-log drum alive, but they also made tambourine drums,[10] square frame drums, gourd drums,[11] and barrel drums.[12] Drum making thus flourished through diversity; older styles were supplanted by newer forms bereft of extensive artistic embellishment. The art of drumming, then, surpassed the art of drum making.

Cane Fifes

It is within the context of folk drum playing that the making of cane fifes has survived. Several fife and drum groups in the Delta area of Mississippi still entertain at picnics, barbecues, and front porch parties. A three-drum ensemble provides an exciting musical framework for the melodic lead of a fife player.[13] The rhythmic pattern of a single drum is fairly simple, but when three are played together their thumping beats interlock into a complex polyrhythm which is clearly a carry-over of the drumming tradition of West Africa.

The cane fife is also found in West Africa, both in the savannah and the rain forest.[14] The techniques used both in Africa and Afro-America to make fifes appear to be identical. A short piece of bamboo cane, perhaps a foot long, is cut and hollowed out with a red hot iron rod. Next the holes for the mouth and fingers are marked and then bored. Often the fife maker will experiment with the position of the finger holes in an attempt to find a better sound.

The fife tradition appears to have entered the United States through Georgia. Ex-slave F. J. Jackson of Grimball Point remembered Saturday night parties where there was dancing to drum music accompanied by the sounds of a cut-reed cane fife.[15] In 1970 at Waverly Hall, Georgia, fifes were still being played.[16] Mississippi fife maker Othar Turner claims that the cane fife tradition came from Georgia to Mississippi,[17] where it survives today among several families: the Turners, the Youngs, and the Stricklands.

The instrument is a simple one, but its physical simplicity should not disguise its cultural complexity. The cane fife is the material manifestation of a deep musical memory. African slaves found in the sound of the fife an escape from oppression. Fife and drum music became, therefore, a firmly entrenched mode of southern black music. The fife changed only slightly as Afro-Americans moved westward out of Georgia. Othar Turner's cane fifes [21] have only five holes, while those made elsewhere in Mississippi and Georgia have as many as eight.[18] This is enough of a change to demonstrate the dynamics of folk culture while simultaneously illustrating the stability of the tradition.

Stringed Instruments

There are some stringed instruments in the United States which owe their origins to Afro-American instrument makers. One of these is called the "one-string" or "one-strand." As its name suggests, it consists of one string or wire which is stretched out over some surface, usually a board. It may have a tin can resonator, but often it is only the single string set up on two wooden block bridges. This minimal instrument is important for three reasons. First, it represents an Afro-American retention of African single-string instruments—the earth bow and the musical bow (Figure 6).[19] Second, it has a drone sound—one of the key features of the banjo. Eddie "One-String" Jones plays what he calls a "three-quarter banjo," which consists of a single wire stretched over a thin neck and a tin can resonator (Figure 7). With only one drone string, three-fourths of the strings required for a banjo are missing![20] Third, the one-string is played by plucking the string and running a slider along the strand to change its sound (Figure 8), a method that later gave rise to the use of intricate slide techniques in the Mississippi Delta style of "bottle neck" blues guitar playing.[21]

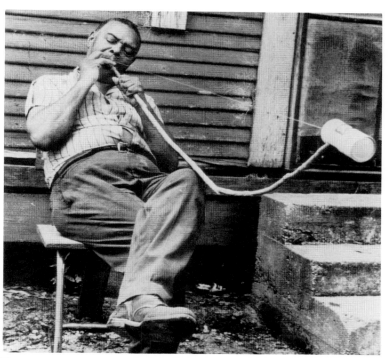

Figure 6. Eli Owens of Bogalusa, Louisiana, playing a mouth bow, 1973. Owens' great grandfather taught him how to make the mouth bow, an instrument that is well known throughout Africa. Note the substitution of a beer can for a gourd as resonator.

Figure 7. Drawing of Eddie "One-String" Jones's one-string instrument, consisting of a three-foot long "two-by-four," a steel wire, and a one-gallon paint can for a resonator. The wire was struck with a whittled stick and the tones were changed by sliding a small pill bottle along the string. Jones at one time lived in Los Angeles; his present whereabouts is unknown. It is known that he played this instrument in the 1950's.

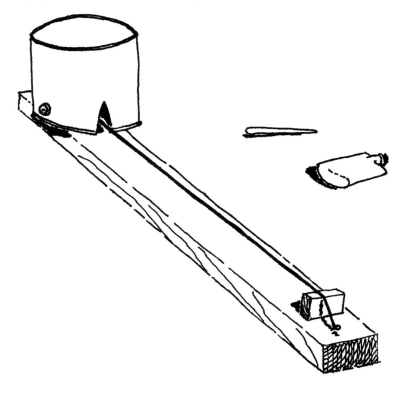

Figure 8. Compton Jones of Senatobia, Mississippi, playing a one-string or "diddley-bow" set up on the side of his house, 1971. The small bottle is used as a slider to change the sound of the string as it is plucked.

Figure 9. *The Old Plantation*. Water color, late 18th century, 11-3/4 x 18 inches. United States. Abby Aldrich Rockefeller Folk Art Center, Williamsburg, Virginia. 35.301.2. Note the banjo player and drummer at the right.

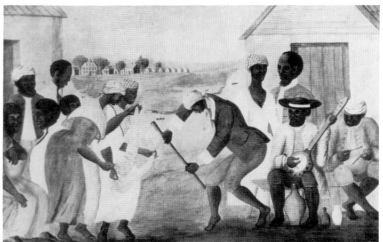

Because so little is required in the way of materials to make a one-string, it has taken on many forms. Commonly the string is run horizontally along the wall of a house or vertically on the front of a door, or it might be stretched between two chairs.[22] It would appear that such examples as these can never be given clear antecedents. Yet it has been noted that instruments consisting of a single string mounted on a board, which are laid on the ground and played with a slider, occur not only in Mississippi but also in black communities in Venezuela and in Zaïre.[23] We can thus identify this instrument as an African-derived musical instrument. Simplicity, of course, aids its retention. Recently, Lonnie Pitchford, a young black musician from Lexington, Mississippi, constructed a modern version of the one-string, complete with electric pickup. While his instrument is more like a minimal guitar, it is also a continuation of an older folk instrument.

Modern changes in the banjo have so radically altered the instrument that its African origins have become obscured and generally overlooked. Since 1852 there have been more than 360 patents filed in Washington for banjos or banjo-related devices.[24] The factory-made banjo with its metal frame, parchment head, fretted neck, steel strings, and screw-adjusted tuning pegs is difficult to associate with African instruments. Comparison becomes more productive when we consider folk banjos.

The banjo made in the southern mountains has a wooden frame, a fretless neck, a head of groundhog or squirrel skin, which is only six inches in diameter, and gut strings.[25] Were we to exchange the wooden frame for a calabash or a gourd, a material commonly used in early American banjos, we would then have an instrument that could be easily associated with African prototypes [22]. Litt Young, an ex-slave from Mississippi, remembered from his youth in 1860 that "Us have small dances Saturday nights and ring plays and fiddle playin' and knockin' bones. There was fiddles made from gourds and banjos from sheep hides."[26] A painting discovered in Columbia, South Carolina, from the late eighteenth century, shows a black musician playing a banjo with a gourd body (Figure 9).[27] Mariah Hines, who was 102 years old when interviewed in the 1930's, recalled from among her slavery experiences in Virginia that an evening's entertainment included tunes picked on the banjo.[28] It is evident that the banjo occurred widely in black communities and in a form very like an African instrument. Thomas Jefferson wrote in

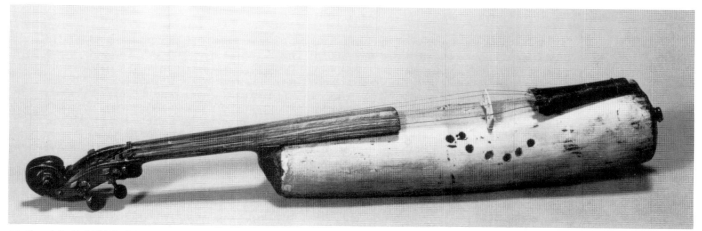

22 *Gourd-Bodied Fiddle*, Virginia.

23 *Chordophone*, Western Savannah Grasslands.

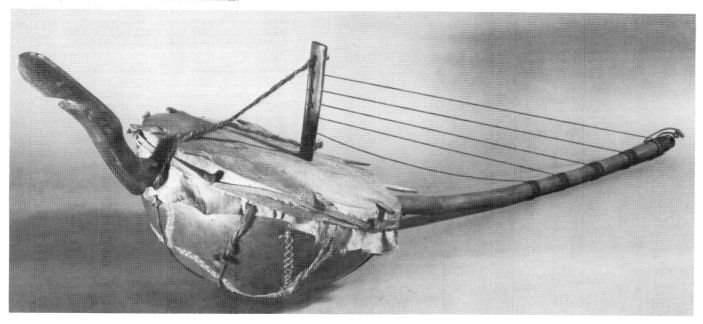

1781: "The Instrument proper to them [Blacks] is the Banjar, which they brought hither from Africa, and which is the origin of the guitar, its chords being precisely the four lower chords of the guitar."[29] When Jefferson gave this description, the presence of the banjo in the American colonies had already been noted by six previous writers, with the first mention coming in 1754.[30] As early as 1678 an instrument called the *banza* is reported from Martinique. It was probably the same instrument that Richard Jobson described in 1621 in the Gambia: "They have little varietie of instruments, that which is most common in use is made of a great gourd, and the necke thereunto fastn'd, resembling in some sort our Bandora; but they have no manner of fret, and the strings are either such as the place yeeldes."[31] It is clear that the banjo as it was first known in America was an African instrument [23]. It remained a black instrument until the 1840's when minstrel shows took it on as part of their black-face farces. Only then did the banjo become a badge of ridicule for Afro-Americans; they generally gave it up, allowing white southerners to claim it as their own invention.[32]

While the African origins of the banjo have gone largely unrecognized, there was one instance where African decorative influences were readily apparent. Architect Benjamin Latrobe made a trip to New Orleans in 1819 to work on the buildings around Jackson Square. In his spare moments he carefully observed the inhabitants, all of whom he considered exotic. One Sunday afternoon he was drawn to the area where slaves would gather for an afternoon's recreation—a place known as Congo Square. After critically evaluating the caliber of the music and dance he makes this startling observation: "The most curious instrument, however, was a stringed instrument which no doubt was imported from Africa. On the top of the finger board was the rude figure of a man in a sitting posture, and two pegs behind him to which strings were fastened. The body was a calabash. It was played upon by a very little old man, apparently 80 or 90 years old."[33] Whether this instrument was a type of banjo is not clear. It certainly was African in character. The rough sketches provided by Latrobe suggest Mande, possibly Bamana, origins for its maker (Figure 10). New Orleans received some of its slaves from Senegambian sources, which would have included Bamana people.[34]

If two strings were added to the instrument described by Latrobe and the decorative figure removed, the resulting product would be hard to separate from the banjo described by John Allen Wyeth almost a century later:

> The most primitive instrument was made from a large gourd with a long straight neck or handle, shaped like those of smaller growth, used commonly then for drinking dippers. The bowl of the gourd was cut away on a plane level with the surface of the neck, the seed and contents removed and over this, like a drum head, a freshly tanned coon-skin was stretched, fastened, and allowed to dry. The five strings of home-made materials passing from the apron behind over a small bridge near the middle of the drumhead were attached to the keys in proper position on the neck.[35]

It is important to note that Wyeth, the maker of this instrument, was white and that he was helped in this project by an older black man. In ways such as this African instrument traditions influenced the development of the American banjo.

There are many more associations to be made between the musical instruments of Africa and Afro-America. Harold Courlander points out that frying pans were used to produce the sound of African metal gongs, that washboards filled in for scrapers, that rattles with both internal and external strikers were used in the United States, and that even a form of the *"mbira"* (the African "thumb piano") occurred in the late nineteenth century in New Orleans.[36] These examples are enough to indicate that instrument making was able to survive the trials of slavery. Many changes occurred in the transmission of musical skills across the Atlantic, but the core of the tradition remained firm. If we plumb the depths of Afro-American musical expressions we find that the distance to Africa is not great. So may we also come to understand that Afro-American musical instruments are not so far removed from their African sources.

Figure 10. Drawing of an African instrument discovered by Benjamin Latrobe in New Orleans, Congo Square, 1819. From the papers of Benjamin Henry Latrobe, Vol. IV, February 16, 1819-February 26, 1819, p. 32. Collection of Maryland Historical Society, Baltimore.

3. Wood Carving

Georgia Wood Carving : The Coastal Area

The coast of Georgia is a logical place to begin a search for a sculptural tradition in Afro-American folk art. The demographics of the region tilt in favor of the black population, and the marshy geography provides isolation from the mainland—two basic factors that encourage the survival of black culture in this area. In 1939 there were thirteen known carvers here, mostly concentrated in shanty towns around Savannah. Farther down the coast at Wilmington Island there remained not only the memory of an old fisherman (recently deceased) who had carved canes but also the recollection of African ritual sculptures of the nineteenth century:

> "I remember the African men used to all the time make little clay images. Sometimes they like men sometimes they like animals. Once they put a spear in his hand and walk round him and he was the chief. . . . Sometimes they try to make the image out of wood. . . ."[1]

There were several classes of work in which a carver's talents might be displayed. Some made walking sticks, while others carved human figures or animal forms. Whittling skills could be used to fashion useful tools like forks and spoons, or whimsical objects—such as chains or balls-in-cages—from a single block of wood. In each instance African antecedents can be suggested.

Walking sticks represent perhaps the most sophisticated sculptural form in the Georgia tradition. James Cooper of Yamacraw, also known in the 1930's as "Stick Daddy" for his carving virtuosity, tended to keep his canes thin, almost lithe in feeling. He favored reptile motifs—snakes, lizards, turtles, alligators—as have most Afro-American cane carvers, and he rendered them usually with striking graphic designs (Figures 11b-d). Despite the thinness of the sticks, he incised deeply so that the snakes and alligators appear to stand out from the surface of the cane, even though they are carved in low relief. This effect is further enhanced by a contrast in finishes; figures are stained and polished, while the background of natural wood is left unfinished. In two instances Cooper's walking sticks included other media: a black and white die was used as a handle for one cane; another was topped by a flashlight handle with a small photo inserted in the end.

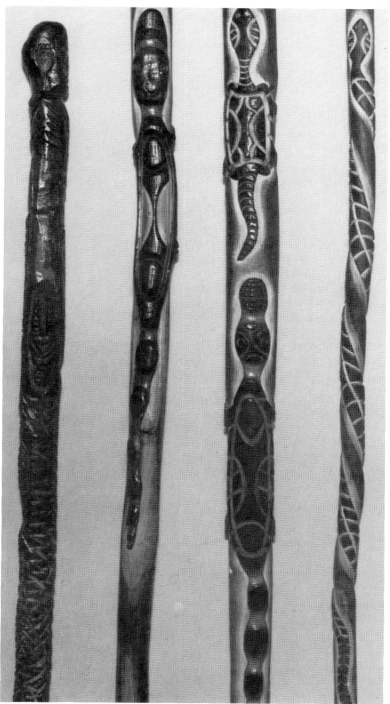

Figure 11. *Left:* (a) Detail of walking stick, Savannah, Georgia. Present whereabouts unknown. Note the mask with horns. *Right:* (b, c, d) Details of walking sticks carved ca. 1930 by James Cooper, also known as "Stick Daddy." Present whereabouts unknown.

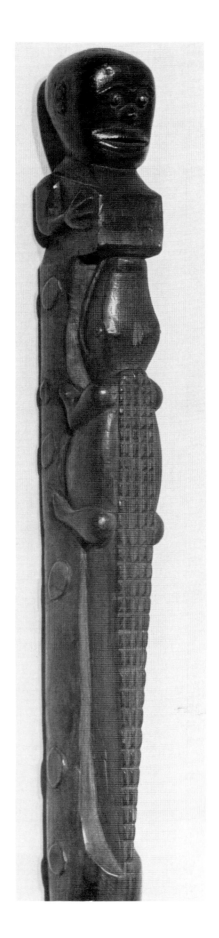

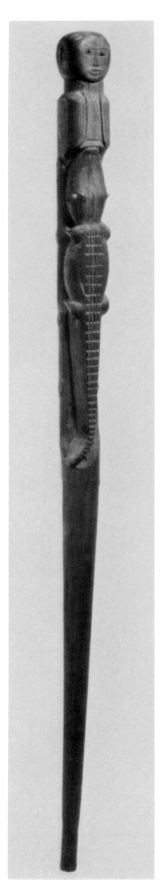

Another Afro-Georgian master of the walking stick was William Rogers of Darien, Georgia. His canes are heavy when compared with those of Stick Daddy. They are thick and rigid, massive at the top, tapering gradually and uniformly to a narrow base. One cane [24], which he made in 1938, is described by Mary Granger:

> This [cane] proved to be of stout cedar carved with a large alligator topped with the bust of a Negro man cut all in one with the body of the stick and painted black to signify his race. The smooth almost square protruding skull of the figure, its small, high-set ears, broad mouth, blue bead eyes driven by minute steel nail heads, and little short arms with four-fingered hands are all noteworthy points. The alligator's eyes are also blue beads driven in by nail heads.[2]

Another cane collected in 1939 by William Bascom must also be by the hand of Rogers [25]. It, too, has a large "gator," seemingly crawling up the chest of a man. The proportions of the two sticks are identical, and in both canes the figures are carved full and round. The alligators' backs are similarly marked by a grid of horizontal and vertical incisions, and beads are again used to mark the eyes. Both canes have six low-relief ovals on the side, underneath the alligator. The repetition of forms here is a signal of the impact of tradition. Rogers had perfected his vision of the walking stick and used it again. Like James Cooper, he used reptile and human motifs, plus mixed media techniques.

Two men from Brownville, a community just to the west of Savannah, carved canes decorated only with very realistic snakes. One of William Brown's walking sticks (Figure 12) has a curved piece of wood horizontally attached to the top as a somewhat T-shaped handle; it is decorated with a figure of a lizard. The snake that winds around the length of the shaft makes only one full turn, and its head is lifted up away from the cane altogether in what could be interpreted as an attack posture. This is an important variation from the common Georgian practice, since most snake figures closely hug the surface of the cane and are wound around the shaft many times. The other known Brownville carver, Crawford Smith, apparently only decorated his sticks with snake forms, and, like William Rogers, he uti-

24 Detail of *Walking Stick*, William Rogers.

25 *Walking Stick*, William Rogers.

lized a mixed media approach when he set flashing rhinestones into the serpent's head as eyes.[3]

One artisan from Wilmington Island, who was remembered simply as an old fisherman, used only a human form for the decoration of his cane.[4] The top third of his walking stick consists of a female form (Figure 13) standing stiff and erect, facing straight ahead, with her arms at her sides and hands pressed against her thighs.

Extremely African-looking designs are found in a cane abandoned in Savannah (Figure 11a); it is topped by a carved human head and decorated with numerous crosshatching marks. These features are generally found in Afro-Georgian work, but, in addition, along the side of the shaft is a mask form with long spiraling horns and eyes set on sharp, raking angles, strongly reminiscent of an Ogoni mask from Nigeria.[5] Unfortunately, the carver of this walking stick is unknown.

The walking sticks of coastal Georgia have several combinations of decorative motifs: repeated reptile forms (groups of alligators), multiple reptiles (snake, alligator, tortoise, and lizard in a series), single reptiles (one snake), human and reptile combinations (snake and man, alligator and man), and human figures alone. These five possibilities describe only the physical parameters of a cane-carving tradition in coastal Georgia. Stylistically, the smooth, lustrous surfaces, the use of diverse media, and the iconic rendering of figures characterize this carving tradition, traits of which also occur in other forms of Afro-Georgian wood sculpture.

The figural carvings of coastal Georgia are as remarkable as the walking sticks. One artist, William Rogers, sculptured animals [26] with the same flair he demonstrated in his canes. A frog he carved has been well described by Robert Farris Thompson:

> [The] frog . . . has a raised triangular head and beaded eyes, focusing upward, as if in search of an insect. The mouth is seamless. Powerful shoulders lift the brilliantly rounded body of the frog. Articulation of the solid mass is achieved in such a way that the shoulders and hind quarters are carved as matching accents of some elegance over the curve of the body.[6]

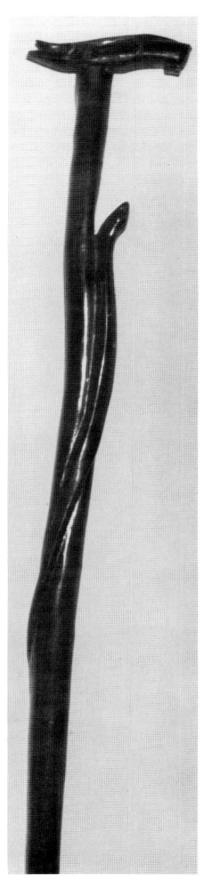

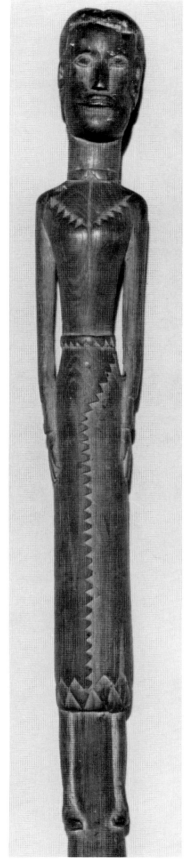

Right: Figure 12. Detail of walking stick, by William Brown of Brownville, Georgia, ca. 1930. Present whereabouts unknown.

Far right: Figure 13. Detail of walking stick, Wilmington Island, Georgia, by an unknown carver, ca. 1930. Present whereabouts unknown.

The extent of the figural repertoire in coastal Georgia is seen in the work of Allen Parker of Tatemville.[7] He carved a menagerie of animals including snakes, lizards, frogs, dogs, alligators, and rabbits. Jerome Carter of Frogtown, an aggregation of ramshackle dwellings on the western fringes of Savannah, also had a varied repertoire of carvings.[8] Some were full-length human figures, some were half-busts, and others were just heads set on square blocks. In addition to these,

he carved some mask-like forms, one of which had a snake across its brow. His human forms have some of the same qualities found in the Wilmington Island cane: frontality, symmetry, minimal detail, stiff posture.

Figural sculpture is still carried on today in Savannah by Ulysses Davis.[9] A barber by trade, he has carved religious scenes such as the crucifixion, and memorial busts of John F. Kennedy and Martin Luther King, Jr. Sometimes he

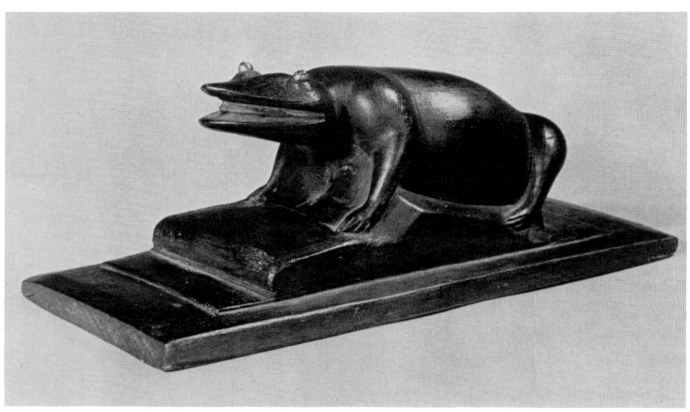

26 *Frog Carving*, William Rogers.

27 *Spoon*, William Rogers.

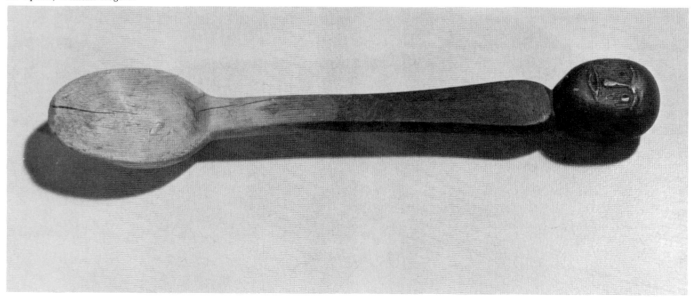

finishes his pieces with commercial paint, but what is most significant is that his treatment of form and his style of presentation recall the works of Jerome Carter in the 1930's. Traditions invariably survive in communities where ethnic identity is strongly tied to artistic expression.

Wood carving skills were often diverted from decorative to functional purposes. Allen Parker, for example, would occasionally make wooden forks and spoons rather than animal figures. In some cases the spoons made in the area were very sculptural; their handles, like the handles of walking sticks, could be carved with human figures. William Rogers, the master wood carver of Darien, made a spoon with a human head at the end [27]. The head is round with a flat face; the features are lightly incised (the nose barely stands out, although it may have been worn down by extensive use), and the eyes are marked by pin heads. This sculpted head closely resembles the head of the Bascom cane.

The making of useful items from wood by slaves was encouraged in the plantation context; in the process, these black artisans may have relied on models of performance brought from Africa. Tonie Houston remembered the skills which his ancestors brought to the environment of slavery: "They would make any thing they needed. They made spoons, trays, buckets. They made picket and mortar and pestle from a log of wood. They would make wooden cutters for meat and vegetable and would dress some of them with pretty figures."[10] This last comment may help to explain the origin of an elaborate knife box by an anonymous carver [28], which may be the kind of object that Tonie Houston had in mind.

From Savannah to Darien, men who were not artistic but nevertheless still skillful with wood created pieces of technical virtuosity that were neither decorative nor utilitarian but simply whimsical. Out of solid chunks of pine they whittled chains with each link free, movable, and solid [29]. They made cages in which a wooden ball rolled freely back and forth. The delight in these objects stems from the contradiction between the medium and the final object. Motion is created while preserving the fixed permanence of the material. A linked chain carved from one piece of wood is still one piece of wood even though it has many parts. Many whittlers, both white and black, have successfully used the chain and the ball-in-the-cage to demonstrate their skill and to entertain themselves in idle

28 *Knife Box*, American South (?).

29 *Chain*, Thomas Alvin Jarrett.

moments.[11] These whimsies or puzzles are a widespread genre of folk art, but in Georgia they can be seen as an element of an Afro-American tradition, for they also occur as decorative motifs in house posts made by the Yoruba of Nigeria and the Fang of Gabon.[12] The motivation to decorate wood most likely springs from the reputations of men like James Cooper and William Rogers. But when someone like Alfred Wilcher of Brownville, whose efforts were confined to utilitarian objects, attempted to be decorative, he turned to whimsical chains rather than to sculpture. He preferred to use a generally well-known form rather than to experiment with the complexities of the reptile or human form; in other words, he did not venture very far into the realm of the wood carving tradition.

Georgia Wood Carving : Inland Areas

The Georgia carving tradition was not confined to the coastal areas. As Blacks moved on to new regions their talents went with them. During the second half of the nineteenth century, people from the swampy marshlands first made their way to the outskirts of Savannah, then turned inland. Howard Miller of Dixie, Georgia, made an excellent cane in 1920 [30].[13] It has an L-shaped handle, and it is covered with intricately carved alligators, which are evenly spaced over the entire length of the stick. Each animal is sculptured in high relief with exacting care paid to anatomical detail. Horizontal and vertical lines mark the horny scales of the reptile, while the sides and legs have fine crosshatching marks. Another of Miller's canes has only one highly polished "gator" on a roughly finished staff [31]. We see, then, that the same type of cane common to coastal Georgia was also made 120 miles inland.

The movement of carving traditions is also indicated by the history which surrounds a cane made by the grandfather of Harve Brown of Raytown, a small settlement in the Georgia Piedmont. This thin cane is decorated by a simple wooden head, crosshatching, and a snake that coils two times around the bottom of the shaft [32]. The combination of human and reptile forms falls well within the coastal tradition. Harve Brown, in fact, came from the coast in 1893 to work on the farm belonging to the Gunn family. Since he claimed that the cane was carved by his grandfather, we can safely project the date of its creation to sometime between 1840 and 1880. Even if it was made in the latter portion of the nineteenth century, it is still the oldest cane by a black carver known in Georgia; if it was made before 1860, it is the oldest by a black carver known anywhere in the United States. Harve Brown carried this cane with him because it was an important memento belonging to an ancestor. Most probably this cane was not used to help an infirm person walk, for it is too thin to take much stress. Rather, it was more of a piece of costume, a prop to show off or to carry when a bit of pomp was called for. Brown thought the cane important enough to pass on to his employer, Paul Gunn. In this walking stick we have evidence of both the diffusion and sustained appreciation of artistic carvings—themes which are important for understanding wood carving as it appears elsewhere in Afro-America.

Mississippi Wood Carving

There is still little information about past traditions of wood carving in Mississippi. Yet contemporary achievement in carved walking sticks provides firm evidence of an aesthetic history there. The canes of Leon Rucker and Lester Willis did not suddenly spring up in the twentieth century from nothing. A close look at some of their work will reveal a strong affinity with the Georgia tradition. The black communities of Mississippi expanded westward between 1820 and 1850 as planters pursued the rich soil of the black belt across Alabama into the northeastern portion of Mississippi.[14] If this group included a cane carver, he would have been contemporary with Harve Brown's grandfather. Works such as those of the elder Mr. Brown provide a sensible background for the early twentieth-century efforts of Mississippian Leon Rucker.

Rucker was born in 1894 and was raised by his grandfather, Lewis Rucker, a man who had experienced the agonies of slave life and who had an African's knowledge of herbal cures. Young Leon mastered these secret formulas and probably also learned to whittle and carve from his grandfather. Yet he does not credit any specific ethnic heritage for his inspiration, despite the fact that he acknowledges receiving a personal vision in much the same manner that African carvers claim to dream their commissions:

"The idea came in the voice of the man. Now who was the man, I don't know but I say he must have been a god . . . I had a snake on it, I had a fish on it and I had another thing . . . something like a chicken . . . a rooster and I put about twelve or thirteen marbles . . . in that stick. I made a man . . . mustache and everything."[15]

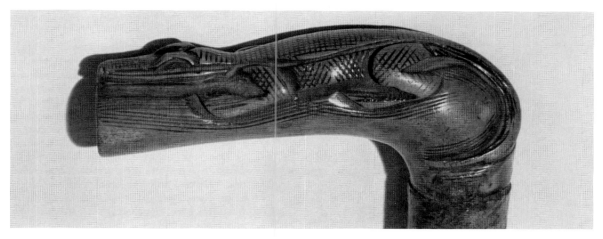

30 Details of *Walking Stick,* Howard Miller.

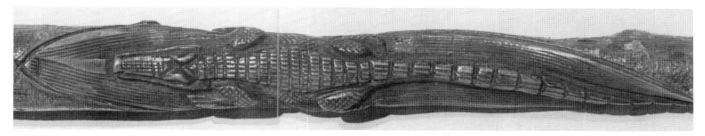

31 *Walking Stick* (and detail), Howard Miller.

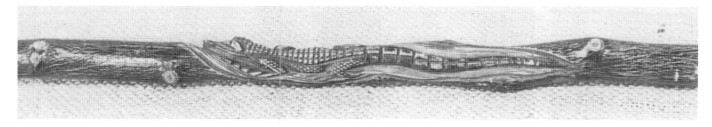

32 *Walking Stick,* Grandfather of Harve Brown.

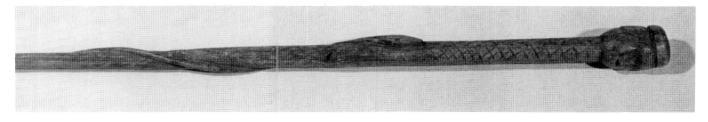

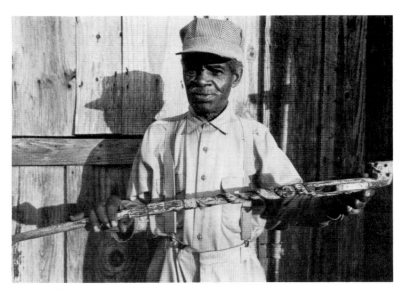

33 *Cane,* Leon Rucker.

34 and 35 Details of *Canes,* Lester Willis.

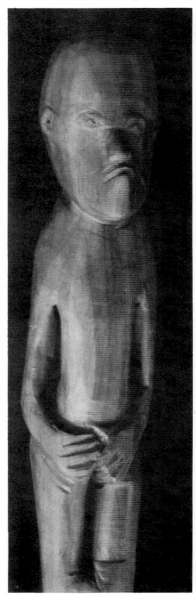 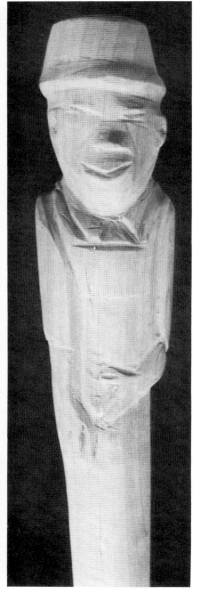

This cane was so striking that it caught the curiosity of all who saw it. The power of his sculpture is also sensed in another cane, which he claims is still unfinished [33]. This walking stick has a blunt L-shaped handle into which several holes were drilled. There are three faces carved along the upper portion of the shaft, each with a mask-like intensity strongly reminiscent of Dan *poro* masks from Liberia and the Ivory Coast.[16] There are also reptile forms—a snake and a lizard—and a rooster intermixed with the mask faces. Almost all the figures have nail-heads for eyes. A standing female figure fills the lower half of the cane. At one time four marbles were inserted into the handle, and as a final touch of decorative flash a small thermometer was glued near the top of the cane.

We see here a combination of the traits pointed out earlier in the works of James Cooper and William Rogers of Georgia. The content is the same: a combination of reptile and human forms. The sense of bricolage found in Cooper's cane with the flashlight handle is seen again in Mississippi in Rucker's addition of marbles and the dime-store thermometer. Stylistically, Rucker's work compares well with the canes by Rogers: the carving is bold and the eyes are marked by nails. The stiffly posed figure of a woman resembles the figure on the cane from Wilmington Island, Georgia. Were it not known that Rucker was from Mississippi, his canes might well be judged as a segment of the Georgia tradition. Certainly, the aesthetic sensitivites in the two areas are comparable.

Another black artist in southwestern Mississippi is Lester Willis of Crystal Springs. He is best known locally for his paintings and drawings, but during the 1930's he made it his personal mission to put a cane in the hand of every elderly person. He sold them generally for seventy-five cents, but some cost as much as six dollars. Often these canes were unadorned staffs with only the owner's name incised on them or a quotation from scripture. Willis became so skilled at cane making that it became his chief source of income: "In 1933 when the panic was on, most everybody in the community was on welfare, you know, and the bucket brigade; but I kept the wolf away from my door with walking sticks and that's the truth."[17] Some recent canes by Willis are topped with a single human figure [34, 35]. In these sculptures, extensive attention is paid to the details of costume; for example, one figure of a man is outfitted with a suit and top hat. Willis' canes, like Rucker's, can be tied to the Georgia tradition, for his sculpted cane

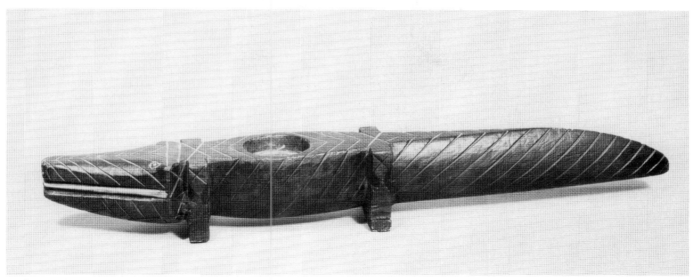

36 *Carved Alligator,* Mississippi.

37 *Walking Stick,* Henry Gudgell.

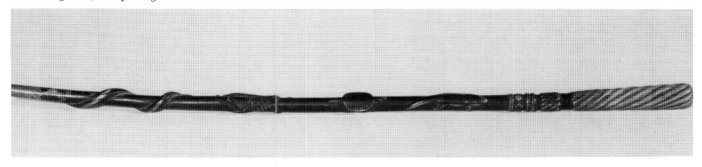

tops are not unlike the sculptures of Jerome Carter or Ulysses Davis. Canes with a solitary human figure are part of the Afro-Georgian repertoire.

David Evans recently discovered an interesting piece of utilitarian sculpture, an alligator, almost two and a half feet long, with a hole cut in the back for an ashtray [36], made by an Afro-American inmate at the Mississippi State Penitentiary at Parchman.[18] The size of the animal suggests that it was probably intended as an art work and was later modified to hold the glass cup. (Alligators also decorated the handles of canes carved by other Parchman prisoners.) The sculptural details compare well with Rogers' rendering of "gators." The nostrils, eyes, and tongue are painted red, and the teeth are painted yellow. This carving is a stylized study in ferocity for which there are several African analogs among the Bakuba and Ambo.[19] But what is most significant are the close relationships between the Mississippi and the Atlantic seaboard configurations.

Missouri Wood Carving

It is ironic, although not incomprehensible, that the greatest piece of Afro-American walking stick sculpture should have been made in north-central Missouri, in Livingston County, over a thousand miles from the geographic focus of a black carving tradition. It was here that Henry Gudgell, born a slave in Kentucky in 1826, made an extensively decorated cane [37] for John Bryan in 1867.[20] Gudgell was known as a blacksmith, wheelwright, coppersmith, and silversmith, and so it comes as no surprise that he was adept at sculpture as well. His walking stick can be separated into two sections by differences in the selection of motifs. The upper portion has serpentine fluting, raised bands, and diamond forms. These geometric motifs are followed by a series of naturalistic figures, which are expertly described by Thompson:

At the top appear a lizard and a tortoise, both carved as if seen from above. The figure of a man appears below. He is dressed in shirt,

Figure 14. *Afro-American Cigar Store Indian.* Wood, Polychromed and carved, early 1800's. H. 59 inches. Attributed to Job, American. New York State Historical Association, Cooperstown.

trousers, and shoes. His knees are bent and the arms are extended as if the figure was embracing the shaft of the cane. On the opposite side of the cane below the hands of the figure is a bent branch from which sprouts a single veined leaf. The fork of the branch mirrors the bending of the knees of the human figure. The lower register of the cane is embellished with an entwined serpent, an echo of the serpentine coil of the handle.[21]

The reptilian concentration here combined with a human figure is similar to the Afro-American sculpture already considered. The exceptional composition of geometric shapes recalls Stick Daddy's treatment of the backs of the tortoise and the alligator. Although it may be impossible to trace the historical sources of Gudgell's inspiration, links to Georgia and Mississippi traditions seem evident. That history will forever remain convoluted because even though Gudgell's work would appear to be the last development of a historical sequence, his one known cane is the oldest dated example of an Afro-American walking stick. Nevertheless, we cannot doubt the skill and expertise of Henry Gudgell. The whole composition shimmers with a metallic gleam due to the care and precision of his carving. Not long after he made this cane, he was sold twenty-two acres of land by his master and father, Spence Gudgell.[22] Was this transaction a recognition of talent? We can only wonder.

Northeastern Wood Carving

Most of the sculpture that we have analyzed to this point, particularly the walking sticks, is close to the center of a black wood carving tradition. There are, in addition to these works, three other pieces which are very special if not spectacular. Their uniqueness removes them from the realm of folk sculpture, but they still reflect to some extent a distinct Afro-American aesthetic. European and African values are extensively blended in these pieces, but this is expected. Sculpture made by Blacks in New Jersey and upstate New York would hardly be expected to conform to the same canons of creativity found in Georgia.

Sometime around 1825 a slave remembered only as Job is said to have carved a figure of a female Indian (Figure 14) for a tobacco shop in Freehold, New Jersey, a town forty miles south of New York City.[23] Perhaps it would be more correct to say that he built an Indian. The head is carved as one piece. The trunk of the body consists of another piece of wood. Each arm is composed of two parts. The skirt is constructed

36

of no less than thirteen tightly fitted sections. It would seem that the talents of carver and cabinetmaker have been happily united here. The figure is almost five feet tall and is set in a rather casual posture. This asymmetrical pose is quite common for the cigar store Indian genre, although it is out of character for Afro-American sculpture.[24] From the shoulders upward Job's statue is symmetrical and rigid. It is almost as if the head belonged to a different body. The head has an iconic intensity suggestive of a mask. Its powerful formality does not fit the casual gesture of the body and also does not conform to the general feeling of naturalism found in most cigar store Indians. The mixture of attitudes in this piece suggests a retention by the carver of alternative principles of design. Perhaps we have in this statue an example of the cultural equation that describes the merger of two ethnic groups: the product reflects both sources but is not exactly like either. It may also be significant that Job chose to make the head more like an African sculpture rather than like the body. In African sculpture the head is often judged more important than the body, and so may be greatly enlarged. The head is the seat of intelligence, will, self-identity, and existence itself.[25] It is possible that Job carried this belief to the task of making a trade sign for the local tobacconist of Freehold.

A figure of a black man holding a bucket, carved sometime about 1860 in Fayetteville, New York, has also been attributed to a black artisan (Figure 15). The oral history that followed this piece as it passed from hand to hand claims that a mill owner named Hiram Wood gave this statue as a birthday gift to his daughter Martha (born 1842), telling her that it had been made by one of his mill hands.[26] The identity of the carver remains as yet unknown; it is thought that he was black, for the subject is handled with a sensitivity and dignity uncommon in nineteenth-century portrayals of Blacks.[27] Although a European point of view is very strong in this statue, particularly with respect to anatomical proportion and details of costume, the posture of the figure suggests what has been called a "dim memory of traditional African sculpture."[28] This piece is a carefully carved figure of a black man calmly holding a large wooden container on his knees. As a figure there is much about this piece that is Western; as an icon there is much about it that suggests African cult sculpture. In African sculptures in which an object is held, the supporting figure has a passive, quiet face, a "seal of noble nonchalance."[29] This quality is

certainly present in this statue. Whether or not the maker was an Afro-American (and there *were* slaves in upstate New York), the mixture of European content and African aesthetic priorities in this piece follows very much the same pattern seen in Job's cigar store Indian. New ways can be adopted to save old ideas.

Figure 15. *Man with Bucket.* Wood (pine), ca. 1860, H. 8 inches. New York, Fayetteville. Abby Aldrich Rockefeller Folk Art Center, Williamsburg, Virginia. 61.701.2.

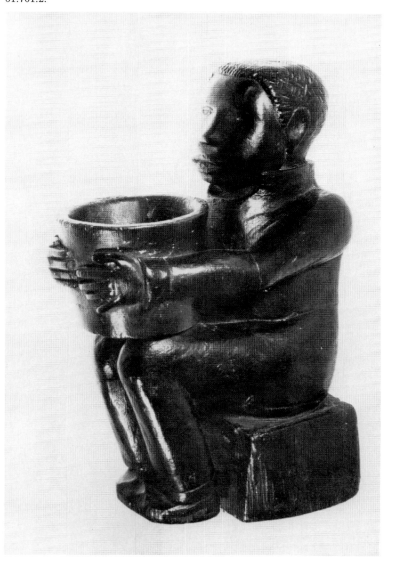

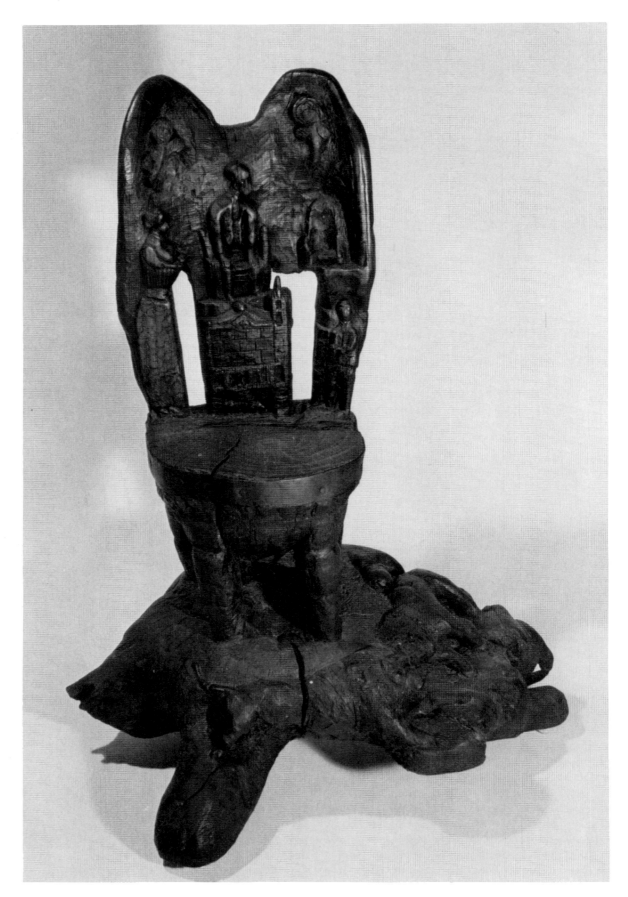

Texas Wood Carving

A very ornate wooden throne [38] has recently been discovered and linked to a black Presbyterian church in Victoria, Texas. What function this massive chair served is still uncertain, but it is clear that it is a "one-of-a-kind" item. Carved from one piece of wood, the sculpture consists of a four-legged slat-back chair resting on a ponderous turtle. Also riding on the back of this amphibian pedestal is a pair of full-maned lions rendered in profile and two bears carved as if seen from above. The legs of the chair have male and female figures incised in them, and the tops of the back chair posts are decorated with full rose blossoms. In the center of the chair's back a man is depicted as seated on the tortoise-borne throne. On the rear of the seat facing the back there is a small tableau of a courtroom judge perched on his podium. This wondrous assemblage of human, animal, and floral motifs stands almost four and a half feet tall and is very reminiscent of a mysterious Afro-American throne and altar made by James Hampton of Washington, D.C.[30] Hampton's work was apparently motivated by a particularly idiosyncratic theology; the Victoria throne seems to share the same sense of purpose. If nothing else, we can at least acknowledge a vivid imagination inspired by religious fervor. It would be far-fetched to attempt comparisons between this piece and the massive thrones of the Tikar of Cameroon or the highly figurated chairs of the Chokwe of Zaïre without knowing more about the aesthetic influences that affected the carver. Until more is known, we can only identify this throne as Afro-American by virtue of its use and some of its stylistic elements (synoptic vision; smooth, lustrous surfaces; equilibrated gesture[31]). It is clear that whoever made this chair was saying more about himself than about his people.

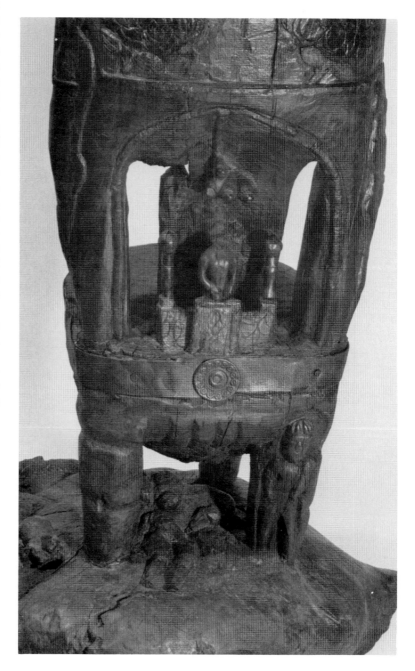

38 *Church Throne* (opposite) and detail, Texas.

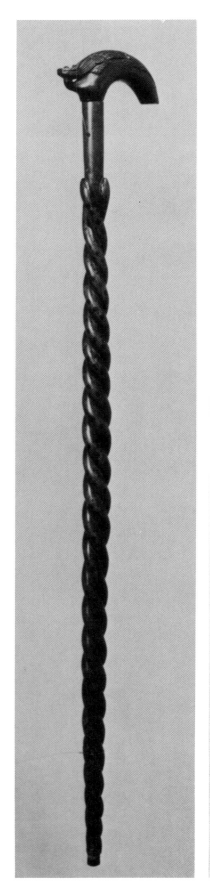

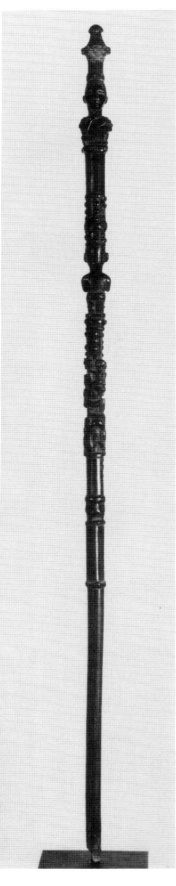

From African Antecedents to an Afro-American Tradition

It is evident that, despite the variety of forms found in black American wood carving, the walking stick is the primary expression. There are two reasons for this. First, decorated ceremonial staffs are common sculptural items throughout West and Central Africa, the source areas for America's black population. Secondly, figural canes with serpent decoration are also known in both Euro-American [39] and Native American folk art.[32] Indeed, there are numerous examples of figural shepherd canes from Holland, which have the same spirit as Afro-American carving.[33] It has been a commonplace idea in many cultures to surround a straight staff with a curving form (i.e., a snake). Thus, in large measure, Western and Indian cane forms provide reinforcement for an African-inspired sculptural form among Blacks. Hence, while the masks and ancestor figures of Africa fade into dim memories or are forgotten, the walking stick thrives as an important sculptural tradition.

The links which tie black American walking sticks to African origins are not all direct bonds across the Atlantic. Some elements in the Georgia area appear to be derived from Haitian sources. Canes topped with simply carved human heads and surrounded by incised snakes are found in the mountains in the southwestern part of the island.[34] Furthermore, Julian Linder of Brownville, Georgia, claimed that his grandfather had come to the United States from Santo Domingo and had given him a number of objects,[35] among these a carved stone amulet. The migration of this tiny sculptured object may indicate the movement of other sculptural ideas, if not sculptural items, from the West Indies to Georgia. Since Haitian walking sticks are minimally decorated, it is no wonder that some of the Georgia canes cannot be immediately tied to the intricate carved staffs of the Mende or Baule. Some of the African influences in the Georgia tradition had already been filtered out in their passage through the West Indies.

In attempting to describe the aesthetic origins of Afro-American wood carving, limited efforts have been made to isolate elements from the variety of all African art forms and relate them to walking sticks: Regenia Perry compares the

39 *Anglo-American Walking Stick*, Booth Caldwell (?).

41 *Chieftain's Staff*, Zaïre.

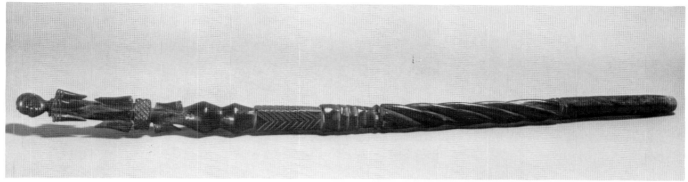

40 *Staff*, Liberia.

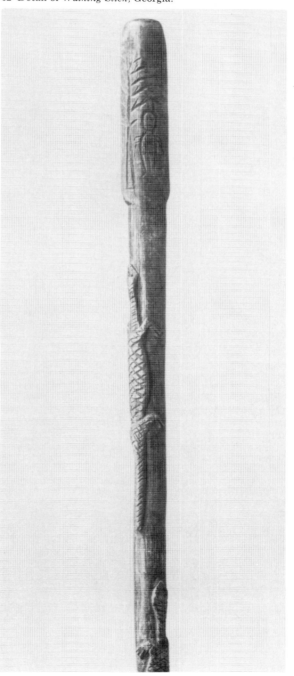

42 Detail of *Walking Stick*, Georgia.

Gudgell cane to a bronze tube from Benin which is decorated with a snake and an alligator;[36] Michael Kan attempts to tie the same cane to figural cups and pot lids.[37] Such forced explanations are not needed, for there are ample reasonable analogs to consider. The Mende in Sierra Leone and Bassa in Liberia make staffs topped with carved heads [40], decorated with relief banding, faceting, and serpentine fluting; occasionally, a snake will be entwined just below the head.[38] The Senufo of the Ivory Coast make "palaver" staffs with seated female figures on them.[39] Their neighbors to the south, the Baule, provide their spokesmen with authority staffs, which are extensively sculpted with human figures and studded with brass nails.[40] Chiefs' staffs from Zaïre are similar to those of West Africa. The common configuration among the Bakongo is a staff with a carved human finial [41]; the sides of the staff are sometimes decorated with geometric motifs or inlaid with ivory buttons and banded with strips of metal.[41] Similar authority staffs are found in Zaïre, within one hundred and fifty miles of the Atlantic Coast, among the Mbala and the Pende. These objects, like the staffs of the Senufo, have a plain shaft topped by a single human figure.[42]

While none of these staffs are walking sticks, morphologically they are of the same form, and those of the Mende are in the same size range, as an Afro-American cane. Stylistic similarities lead to immediate comparisons of the mixed media approach in Zaïre, Georgia, and Mississippi. The careful polishing of surfaces as well as the symmetrical postures of sculpted figures are also comparable elements of the African and Afro-American traditions. Transatlantic continuities also emerge in terms of content: human figure finials, geometric incisions, serpentine fluting, and coiled snakes. That a sculpted staff ceases to be a sign of political or religious authority and becomes instead a personal possession, an

41

Figure 16. Anthropomorphic newel post by Thomas Day (1801-1861) of Milton, North Carolina, located in Paschal House, Caswell County, North Carolina. Photograph, collection of North Carolina Museum of History, Division of Archives and History, Raleigh.

icon of self-identity, does not mean there is a severe break in the aesthetic ties between African and Afro-American carving traditions. Similarities in form, style, and content cannot be disregarded because of a different pattern of usage.

In one case the function of an Afro-Georgian carving may even have been quite similar to African custom. This staff is shorter than usual and very thin [42]. On the shaft there are three forms—a snake and two alligators—carved in high relief. The top of the staff has two flattened surfaces. On one side there is an incised rendering of a common sharecropper's house; on the opposite side, there is a depiction of a lynching victim hanging by his neck from a dead tree. The smallness of the staff coupled with the powerful image of death suggest a magical if not religious function for this piece. In South Carolina, canes carved with entwined serpents are referred to as "conjure sticks."[43] Because reptiles are often associated with illness in Afro-American folk belief,[44] we may be able to interpret this carving as an invocation of the supernatural powers associated with reptiles on the occasion of severe illness. The contrasting images on the handle—of home and death—perhaps indicate that such powers might be used in the domestic arena to prevent death. Wrought-iron healers' staffs among the Yoruba employ the same strategy of imagery. These staffs are topped with birds, the form of the witch. The healer defeats sickness caused by witches by brandishing the witches' image in an act of deliberate life-giving decorum.[45] As an object suggestive of power, this Georgian staff carries a sense of authority not unlike the standard of a Yoruba healer or even the scepter of a Bakongo chief.

Thus we have seen the widespread and continuous impact of African sculptural values in Afro-American wood carving. Blacks have worked with wood in one form or another as long as they have been in America. In the early eighteenth century they cleared the forests: "Many Negroes from this generation, usually working in pairs, spent most of their lives chopping and sawing timber, and very few slaves would not at some point have used a wedge to split fence rails, a froe to slice shingles, or an adze to square beams."[46] Blacks served throughout the eighteenth and nineteenth centuries as carpenters, coopers, shipwrights, wagonwrights, and cabinetmakers. One very exceptional black furniture maker, Thomas Day, of Milton, North Carolina, overwhelmed that state with the volume of his production.[47] Although his woodwork con-

Figure 17. *Church Chandelier.* Wood, ca. 1890, H. 39-1/2 inches, Diam. 39 inches. Luther Goines, American, Maryland, Clear Springs, ca. 1865-(?). The National Museum of History and Technology, Smithsonian Institution, Washington.

forms generally to period styles, several of his newel posts (Figure 16) hauntingly evoke the spirit of African sculpture. Even though Day had no apparent knowledge of African forms, he did implement an improvisational aesthetic system that has much in common with African art. A highly animated style is also encountered in a wooden chandelier (Figure 17) made around 1890 by Luther Goins, a black wheelwright and woodworker from Clear Springs, Maryland. His assembly of pine and poplar sticks achieves dramatic effect through its complex construction and meticulous details. In Winchester, Virginia, a slave named Cyrus was well known and respected for his wood-carving talents. A local newspaper reported on November 25, 1796:

> This is to acquaint the public, that all kinds of wooden TRAYS and LADLES are manufactured by CYRUS, a black man, who by indefatigable industry during his servitude, acquired a sum sufficient to liberate himself, by making and vending the above-mentioned articles. He served his later master, Rueben Triplet, near thirty years, to whom he paid fifty pounds for his discharge. His behavior and industry recommend him in a peculiar manner to the notice of the public, who no doubt will afford him every encouragement in the laudable profession he has adopted to procure a livelihood.[48]

Carving was in this latter case not only a medium for self-expression but also a means of finding freedom.

It is not, then, to be considered strange or exotic that some Blacks remained skilled at wood carving. Confronting wood—attacking it with tools—was a daily reality, and if the memory was strong and intense, it could guide the knife in the creation of African-inspired forms. That memory runs deep in Georgia and Mississippi and surfaces boldly, but briefly, in other areas. The important question to ask about Afro-American wood carving is not "What was forgotten?" but rather "What is remembered?"

43

4. Quilting

Many quilts made by Afro-Americans would seem to be examples of cultural surrender. The quilt is, after all, a European textile form, and quilted bed coverings are unknown and unnecessary in tropical Africa.[1] Blacks encountered the quilt as part of the plantation experience. Fannie Moore, an ex-slave from North Carolina, has this memory of her mother's quilt making:

> "My mammy she work in the field all day and piece and quilt all night. Then she has to spin enough thread to make four cuts for the white folks every night. Why sometime I never go to bed. Have to hold the light for her to see by. She have to piece quilts for the white folks too."[2]

When slaves stitched together quilts for their masters, it was perhaps more a task of drudgery than an opportunity for creative expression. Certainly in such circumstances there is not a very great possibility for a quilt to reflect anything more than the deliberate instructions of the slave owner. Yet Afro-American quilting is not simply an acquired craft, a set of skills borrowed from the dominant Euro-American culture. The creative act involves at least two choices: the selection of a technical means and the selection of a design. Africans came to this country without knowledge of quilting, although they had extensive expertise with textiles.[3] The techniques of quilt construction were largely derived from Euro-American sources. The choice of design for a quilt top, on the other hand, did not necessarily have European origins. Some of the geometric combinations of odd scraps of cloth that decorate American quilts have African analogs.[4] It is possible that some of the quilts made by slaves simultaneously served the requirements of their masters and preserved a cultural memory. The Afro-American quilt provides us with an example of how European artifacts may be modified by African canons of design and thus stand as statements of cultural survival rather than surrender.

Several types of quilt appear in America. They have been excellently described by Jonathan Holstein:

> Bed quilts are of three main types: the *plain quilt,* made of single pieces of material front and back, usually of a single color or printed cotton, and the two types which collectively are called "patch work"; [i.e.,] *appliqué quilts,* which have tops made of whole cloth to which have been applied—stitched down—forms cut from other cloth of contrasting color; and *pieced quilts,* which have tops made from pieces of material stitched together mosaic-fashion to form patterns and borders, usually of a geometric nature.[5] (Italics added.)

The appliqué and piece quilts are the two types in which patterns of decoration most strongly reflect African influences. Blacks have worked at all three forms, however, and have shown themselves competent with each type. What is most significant is not the degree to which Blacks have learned to replicate Euro-American quilts, but rather what African elements survive in their quilts and what unique Afro-American forms may have developed as a result of the effort to render remembered designs with borrowed techniques. Hence, emphasis in the following discussion is placed on quilt tops rather than on the selection of materials, types of stitching, amount of padding, paraphernalia such as quilting frames, or related social behaviors like quilting bees.

Appliqué Quilts

Not all appliqué quilts made by Blacks are necessarily tied to African sources. Jane Batson, a Virginia-born slave, sewed a quilt top in the 1850's which is decorated with twelve appliquéd couples.[6] The figures are all elaborately costumed, the men in hats and ties, the women in long dresses, kerchiefs, and large hats. Each panel is surrounded by a border of blocks consisting of concentric squares (a pattern known as "log cabin"). There is nothing African or Afro-American about this quilt except its maker. Although the piece is excellently done, it reflects a lesson well-learned rather than a heritage well-remembered.

The appliqué quilts of Harriet Powers of Athens, Georgia, on the other hand, are very special creations in which the memory of Africa is sometimes quite strong. Mrs. Powers is known to have sewn at least two pictorial quilts between 1886 and 1898. Both derive their content largely from Biblical sources. The older quilt, in fact, is devoted entirely to scenes from the Bible. The focus here on Christian themes does not necessarily negate the possibility of African inspiration; it reflects, rather, the historical truth that Afro-Americans acquired a Christian orientation

in their religious outlook. Converted Africans in Zaïre did not lose their native aesthetics when the Portuguese introduced them to Catholicism. They made brass crucifixes with African features (Figure 18). The face of the crucified Christ made by Bakongo artisans retains elements of the heart-shaped face common to the traditional sculpture of the rain forest area.[7] The same blend of Christian content and African aesthetics also occurred during the sixteenth and seventeenth centuries in Benin, where an ivory cup was decorated with figures of Christ and the Holy Spirit—but in the formal Benin court style.[8] Mrs. Powers' quilts, like the Bakongo crucifixes and the Benin cup, retain a stylistic affinity to African sources even though their content derives from Western sources.

The 1886 Bible quilt consists of eleven panels arranged in three horizontal bands (Figure 19). The top strip shows Adam and Eve in Paradise, a later moment in Paradise when Eve has given birth to a son, and an enigmatic depiction of Satan. The second band shows Cain killing Abel, Cain going into the land of Nod, Jacob dreaming about his struggle with the angel, and John baptizing Christ. The last set of panels, unlike the first two, reads chronologically from right to left, beginning with a portrait of the Holy Family, followed by scenes of the Last Supper, Judas and his thirty pieces of silver, and the Crucifixion. In addition to the primary human figures, the various panels are filled with animals, short-arm crosses, small flowers, and larger sunbursts. The panels are not the same size; hence, the overall arrangement of scenes appears quite random even though they follow a linear sequence.

The 1898 quilt [43], by contrast, is rigorously ordered. There are fifteen panels arranged horizontally in three rows of five. While there are variations in the width of some of the panels, those with the same dimensions have been carefully matched to provide a sense of vertical banding to reinforce the horizontal flow of the composition. Despite the visual sense of order in this quilt, the sequence of pictorial content is totally random. Ten of the scenes are Biblical, the other five concern events of local history. Three panels are repeated from the earlier quilt: Adam and Eve in the Garden, the baptism of Christ, and the Crucifixion. The new Biblical scenes include: Job praying for his enemies; Moses and the brazen serpent; Jonah being swallowed by a whale; the creation of two of every kind of animal (rendered in three panels); and a depiction of the angels of wrath with a seven-headed

Figure 18. *Crucifix*. Brass, 17th century, H. 8-1/8 inches. Africa, Zaïre, Bakongo tribe. Collection of Paul and Ruth Tishman, New York City.

monster, the seven vials, and the blood of fornications. Four of the local history panels concern memorable environmental phenomena: a dark day, May 19, 1790, when the sky was black at twelve noon, a meteor shower on November 13, 1833, the red light night of 1846, and a very cold day when people and animals froze to death where they stood (February 10, 1895). One final panel treats the subject of rich people who know nothing of God, and a sow named Betts who ran five hundred miles from Georgia to Virginia. The combined presentation of Biblical and local events in this quilt may reflect Harriet Powers' own sense of morality. The Bible may have seemed to her a distant and remote account of God's existence, while phenomena like dark days and extreme temperatures testified to His continued power. More than just a "Bible quilt," this second work is a personal statement of religious fervor.

The appliqué techniques used by Mrs. Powers are generally similar to methods known both in Europe and Africa. Textiles in Europe have been decorated with appliquéd designs since the medieval period and have been reported from Africa

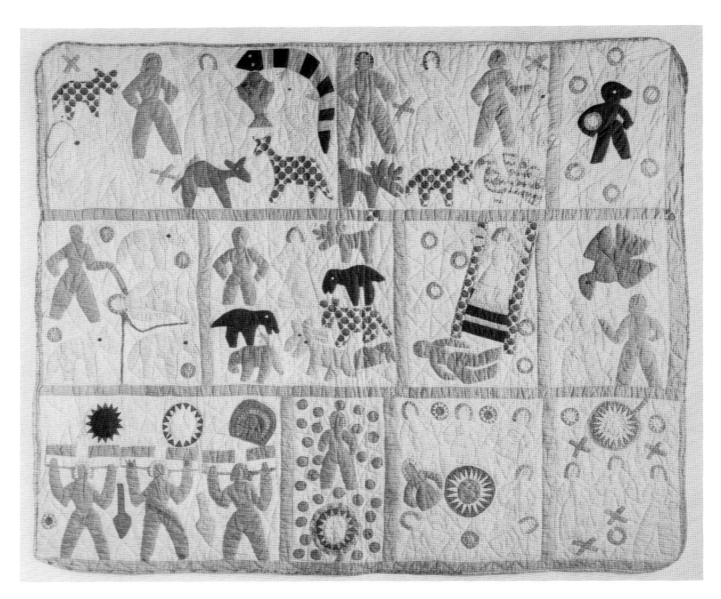

Figure 19. *Bible Quilt*. Cotton, ca. 1886, 88-1/2 x 73-3/4 inches. Harriet Powers, American, Georgia, Athens, 1837-1911. The National Museum of History and Technology, Smithsonian Institution, Washington.

Explanation, transcribed by Jennie Smith, of squares in the quilt (from top, left to right):

1. Represents Adam and Eve in the Garden of Eden, naming the animals, and listening to the subtle whisper of the "serpent which is beguiling Eve." It will be noticed that the only animal represented with feet is the only animal that has no feet. The elephant, camel, leviathon, and ostrich appear in this scene.

2. A continuation of Paradise, but this time Eve has "conceived and born a son," though he seems to have made his appearance in pantaloons, and has made a pet of the fowl. The bird of paradise in the right lower corner is resplendent in green and red calico.

3. "Satan amidst the seven stars," whatever that may mean, and is not as I first thought, a football player. I am sure I have never seen a jauntier devil.

4. Where Cain "is killing his brother Abel, and the stream of blood which flew over the earth" is plainly discernible. Abel, being a shepherd, is accompanied by sheep.

5. Cain goes into the land of Nod to get him a wife. There are bears, leopards, elks, and a "kangaroo hog," but the gem of the scene is an orange colored calico lion, in the center, who has a white tooth sticking prominently from his lower lip. This lion has a tiny neck and a very meek manner and coy expression, unlike the fierce manner of the original animal.

6. Jacob's dream when "he lay on the ground" with the angel ascending or descending the ladder. She has a rather stylish appearance.

7. The baptism of Christ. The bat-like creature swooping down is "the Holy Spirit extending in the likeness of a dove."

8. "Has reference to the Crucifixion." The globular objects attached to the crosses like balloons by a string represent the darkness over the earth and the moon turning into blood, and is stitched in red and black calico.

9. Judas Iscariot and the thirty pieces of silver. The silver is done in green calico. The large disc at his feet is, "star that appeared in 1886 for the first time in three hundred years."

10. The Last Supper, but the number of disciples is curtailed by five. They are all robed in white spotted cloth, but Judas is clothed in drab, being a little off-color in character.

11. "The next history is the Holy Family: Joseph, the Virgin, and the infant Jesus with the star of Bethlehem over his head. Those are the crosses he had to bear through his undergoing. Anything for wisement. We can't go back any further than the Bible."

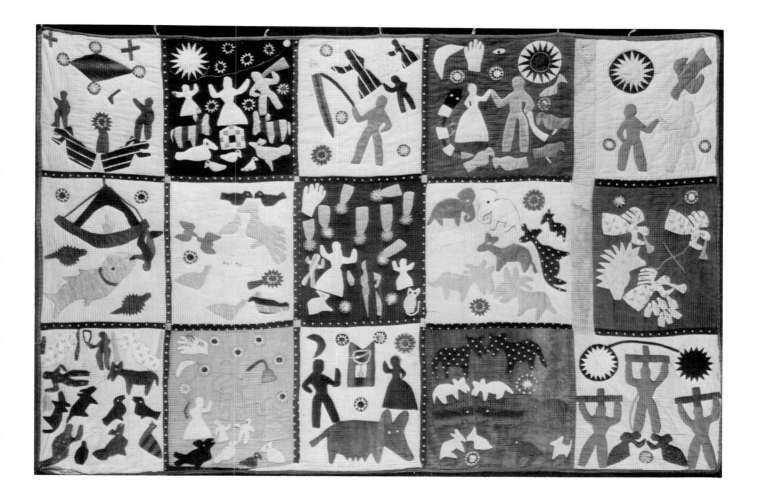

43 *Quilt,* Harriet Powers.

Mrs. Powers' explanation of squares (from top, left to right)

1. Job praying for his enemies. Job's crosses. Job's coffin.

2. The dark day of May 19, 1780. The seven stars were seen 12. N. in the day. The cattle all went to bed, chickens to roost, and the trumpet was blown. The sun went off to a small spot and then to darkness.

3. The serpent lifted up by Mosses and women bringing their children to look upon it to be healed.

4. Adam and Eve in the garden. Eve tempted by the serpent. Adam's rib by which Eve was made. The sun and moon. God's all seeing eye and God's merciful hand.

5. John baptising Christ and the spirit of God descending and rested upon his shoulder like a dove.

6. Jonah cast over board of the ship and swallowed by a whale. Turtles.

7. God created two of every kind, male and female.

8. The falling of the stars on Nov. 13, 1833. The people were frighten and thought that the end of time had come. God's hand staid the stars. The varmints rushed out of their beds.

9. Two of every kind of animals continued. Camels, elephants, "gheraffs," lions, etc.

10. The angels of wrath and the seven vials. The blood of fornications. Seven headed beast and 10 horns which arose out of the water.

11. Cold Thursday, 10. of Feb. 1895. A woman frozen while at prayer. A woman frozen at a gateway. A man with a sack of meal frozen. Isicles formed from the breath of a mule. All blue birds killed. A man frozen at his jug of liquor.

12. The red light night of 1846. A man tolling the bell to notify the people of the wonder. Women, children, and fowls frightened but God's merciful hand caused no harm to them.

13. Rich people who were taught nothing of God. Bob Johnson and Kate Bell of Virginia. They told their parents to stop the clock at one and tomorrow it would strike one and so it did. This was the signal that they had entered everlasting punishment. The independent hog which ran 500 miles from Ga. to Va. her name was Betts.

14. The creation of animals continues.

15. The crucifixtion of Christ between the two thieves. The sun went into darkness. Mary and Martha weeping at his feet. The blood and water run from his right side.

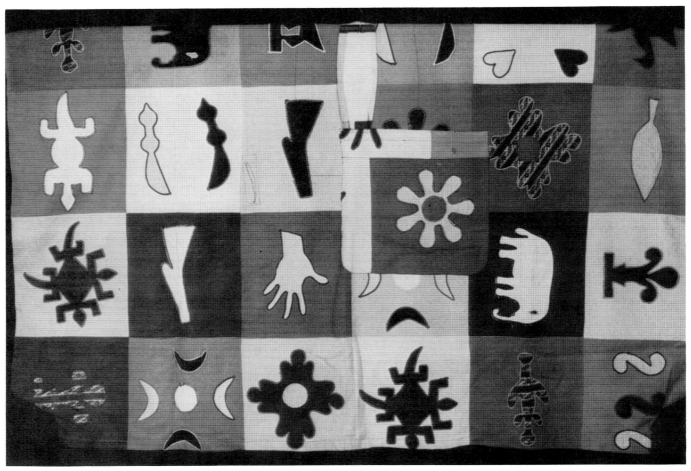

44. *Appliquéd Gown*, Ghana.

since the seventeenth century.[9] Hence, there are two simultaneous sources of support for Mrs. Powers' creative effort. Born in Georgia in 1837, Mrs. Powers would necessarily have received her heritage of Africa by example (the source of which is unknown) or by verbal description. Mrs. Powers' ancestors apparently arrived in Georgia late in the eighteenth or early in the nineteenth century. By that time most slaves were being imported from the Congo-Angola region, although a steady trickle were still entering from West Africa.[10] This is important because the African traditions for appliquéd textiles are practiced only by groups from that part of the continent. The presence of West African slaves in Georgia makes it possible, then, to link Mrs. Powers' quilts to African aesthetic systems. The Fon of Benin and the Ewe, Fanti, and Ashanti [44] of Ghana all use appliqué techniques in their textiles.[11] Although the overall approach of the Fon seems to correspond most closely to Mrs. Powers' work, her technique might repre-

sent more of an amalgam of African influences than a single ethnic legacy from old Dahomey.

The similarities encountered in the Bible quilts and the appliquéd "tapestries" of the Fon are very intriguing. In Dahomey, appliquéd items were part of the political paraphernalia of kings and chiefs, containing symbols of their identity (i.e., lion, buffalo, bird, shark) and depictions of the major events in their reigns. Large wall hangings, measuring as much as ten by fifteen feet, are displayed in the stool house at the palace at Abomey as part of the record of deceased rulers.[12] All of the cloths together might then be read sequentially as a history of the various dynasties.

Since some of the Fon appliquéd textiles [45, 46] represent ordinary moments in the lives of the persons for whom a cloth is sewn, they function in a manner not unlike the local event panels in Mrs. Powers' second quilt. In Ouidah there is a quilt-size hanging that relates the history of that ancient coastal city of Dahomey in fifteen

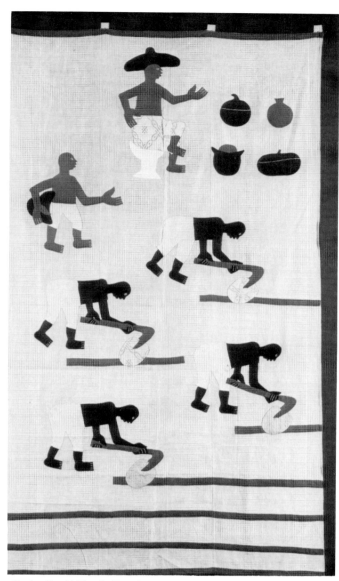

45 *Appliquéd Textile,* People's Republic of Benin (Dahomey).

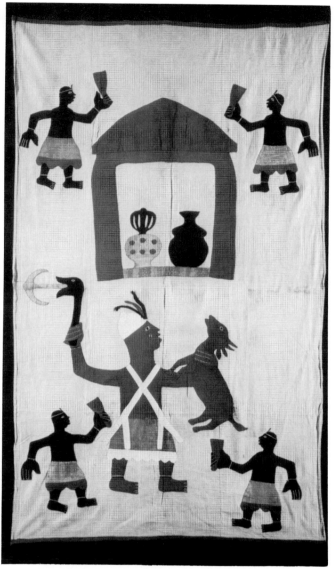

46 *Appliquéd Textile,* People's Republic of Benin (Dahomey).

panels (Figure 20). The scenes include domestic life, the royal court, enslavement, confrontation with European traders, warfare, and the coming of Christianity.[13]

The figures of Dahomean appliquéd textiles are based on patterns cut from cloth or paper which are "owned" by a sewing guild. These appliqué templates are standardized elements of the tradition and are repeated from generation to generation. The human figures are assembled from a pattern with five parts, which are manipulated like marionettes to achieve a number of

49

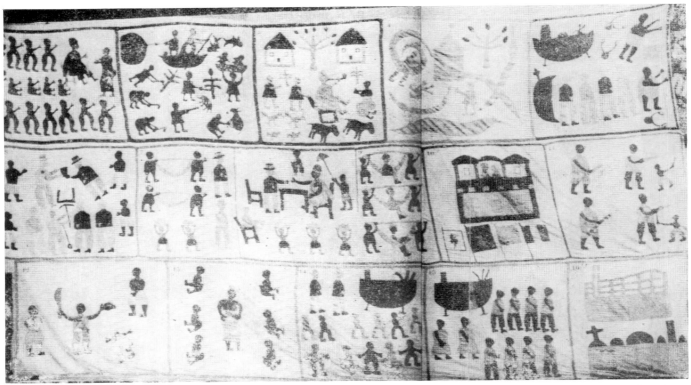

Figure 20. *Fon Appliquéd Wall Hanging.* Late 19th-early 20th century. (After Verger and Cruz.)

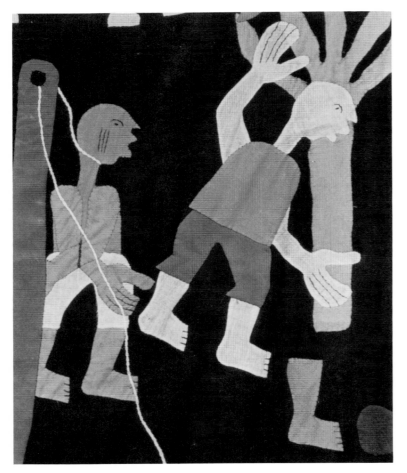

Figure 21. *Fon Appliquéd Textile* (detail). Cotton, collected 1969, 34 x 70 inches. Africa, People's Republic of Benin (Dahomey). Collection of John Michael Vlach, Austin, Texas. Note the similarity of the figure on the left, depicting a Yoruba warrior, to the figure on the right, depicting a Fon tribesman.

poses. Despite the possible variations, the figures are very much alike. For example, those appliqués which represent Yoruba victims of warfare look exactly like their Fon captors except for the fact that they are cut from red cloth (Figure 21).

Harriet Powers' figures also show little variation. In the first quilt the primary pattern is a standing figure with arms bent at the elbow and resting on the hips. This shape is used some eighteen times for both males and females. (Females are distinguished by their long dresses; for male figures, a V-shaped section is cut away from the skirt to make a pair of pants.) A variation of this form, used three times, has one arm extended from the elbow away from the body. Another pattern, used to depict Eve as well as three crucified bodies, is of a standing figure with its arms extending up from the elbows. The murdered Abel and the sleeping Jacob are represented by a single pattern. The arms of these figures hang at their sides and their legs are bent

slightly—the only difference is that Abel lies face up while Jacob dreams face down with his heavenly vision above him. The second quilt has some of the same forms as the first, although standing figures with one arm extended, of which there are thirty, are by far the most dominant. Just as the Fon appliqué sewers varied their patterns, sometimes placing one arm up and the other down, so too did Mrs. Powers manipulate her templates. A figure extending his right hand could just as easily be shown extending his left if the template were turned over. Two snips of a scissors could change a female figure to a male form. It is clear then that Harriet Powers approached the technical problems of appliqué design in the manner of the Fon makers of appliquéd textiles.

The similarities involve even the selection of specific motifs. Mrs. Powers' depiction of the whale that swallowed Jonah is very similar to the fish which the Fon use to represent Houegbadja, a seventeenth-century ruler (Figures 22a,b).[14] The placement of one ventral and two dorsal fins, plus the indication of gills are identical. The large standing birds that depict the kings Gangnihuesso and Kpengla resemble the birds in six panels of the second Bible quilt (compare Figures 23a and b).[15] Mrs. Powers' representations of horned animals also have their analogs on Fon cloths (compare Figures 24a and b). Though similarities in birds and animals may be due more to general accuracy in anatomical detail than to cultural memory,

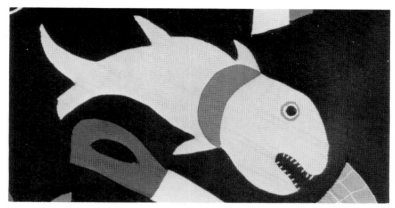

Figure 22a. Detail of Figure 21. Fon appliquéd symbol of Houegbadja (1654-1685), 17th-century king of Dahomey.

Figure 22b. Detail of Harriet Powers' *Quilt* [43].

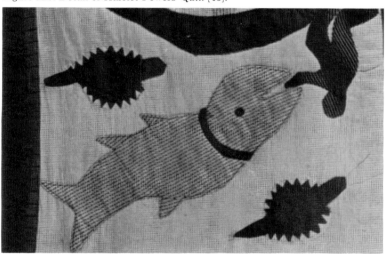

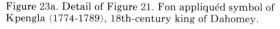

Figure 23a. Detail of Figure 21. Fon appliquéd symbol of Kpengla (1774-1789), 18th-century king of Dahomey.

Figure 23b. Detail of Harriet Powers' *Quilt* [43].

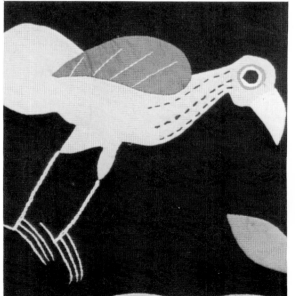

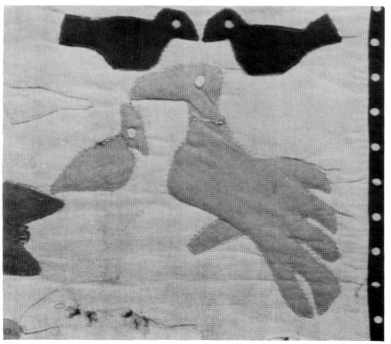

Figure 24a. Detail of Figure 21. Fon appliquéd symbol for Ghezo (1818-1858), 19th-century king of Dahomey.

Figure 24b. Detail of Figure 19.

nevertheless, there is ample precedent in Dahomey for the menagerie found in Harriet Powers' work. The background motifs in Fon appliquéd items include crescents, short-armed crosses, and rosettes [47, 48].[16] All of these designs appear in the Bible quilts—most notably the crosses and rosettes.

A stylistic affinity may also tie Mrs. Powers' work to African textiles. Her figures—whether of human, animal, boat, clock, or house—are very simple, direct, and minimal. They express the essence of a being or object; they are icons. With this quality of presentation her work differs markedly from Anglo-American appliquéd quilts. A bride's coverlet from Poughkeepsie, New York, for example, uses five colors of cloth to represent human figures.[17] Great care is paid to details of costume such as epaulets or puffed sleeves, and the rendering of form is marked by extensive naturalism. This is all in great contrast to Mrs. Powers' figures, which are all cut from a single piece of cloth without any color distinction for costume and without any indication of anatomical features. Indeed, her figures lack faces, feet, and hands (except for the crucified Christ, which has three fingers). The distinction between the two traditions in quilting is best seen in the way elephant figures are represented. The New York quilt (Figure 25) portrays a tusked pachyderm with a curving trunk, covered with a circus blanket bearing his name, "Hanible." Mrs. Powers' elephants (Figure 26) are but stiff silhouettes, rigidly posed, with only two legs visible; their tails are rendered as thick appendages almost the same size as a leg. In other words, the Anglo-American quilt shows a specific elephant, while Mrs. Powers presents an image which can be interpreted as any elephant. She creates a symbol while the other quilter shapes a literal representation. Euro-American folk artists were certainly capable of creating iconic statements, but they tended not to use the appliquéd quilt in such a manner. Fon, Ashanti, Fanti, and Ewe appliquéd textiles, however, trade heavily in symbolic presentation. Most figures embody power and authority. They are immediately identifiable; their meaning is unquestioned.

Opposite:

47 *Appliquéd Pillow Cover,*
People's Republic of Benin (Dahomey).

48 *Appliquéd Pillow Cover,*
People's Republic of Benin (Dahomey).

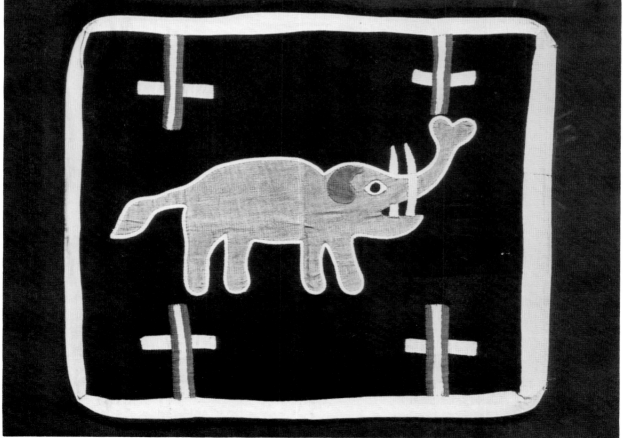

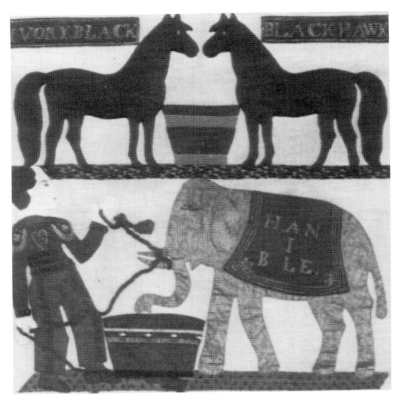

Figure 25. *Appliqué Quilt.* Cotton, silk, wool, and velvet on cotton muslin, 1858-1863, 87 x 71-1/2 inches. New York, Poughkeepsie. Collection of Mr. and Mrs. James Titelman, Hollidaysburg, Pennsylvania. (After Lipman and Winchester, no. 402 and cover illus.)

Figure 26. Detail of Harriet Powers' *Quilt* [43].

Since Harriet Powers' pictorial quilts compare closely with African appliquéd cloths in terms of function, technique, content, and style, the claims of African influence in her work are not without support. In fact, since her quilts are less like Euro-American appliquéd quilts and more like African prestige cloths, we might even postulate West African ancestry for her aesthetic sensibilities. All of the similarities between her work and that of Fon appliqué sewers cannot be explained by serendipitous accident. Since it seems doubtful that the ethnic identity of Mrs. Powers' ancestors will ever be discovered, we must depend on the visual evidence before us.

Another aspect of the Bible quilts bears mentioning: the apparent influence of emotions which we might call "ancestral reverie." Jennie Smith, a white school teacher in Athens, Georgia, tried to buy the first quilt in 1886. Mrs. Powers refused to sell until 1891, after which Miss Smith commented: "After giving me a full description of each scene with great earnestness she departed but has been back several times to visit the darling off-spring of her brain."[18] The quilt was obviously important to her. Her attachment to it may be interpreted as an awareness of a deep cultural heritage. At the very least, we can see that Harriet Powers created a very special quilt. If our comparisons are valid, her efforts were especially African.

Appliqué work strongly reminiscent of Harriet Powers' quilts and hauntingly like Dahomean wall hangings has been done in the last two decades by Clementine Hunter of Natchitoches, Louisiana. Known more for her painting, this elderly black woman has also stitched together some remarkable scenes [49],[19] usually involving the plantation on which she has lived for all of her eighty-four years (the same focus found in her paintings). Her subjects include the major buildings, and scenes of folks working in the fields, paddling canoes, driving wagons, and tending to their regular chores. While Mrs. Hunter claims to have figured out the pictorial appliqué format on her own, more research may uncover connections both to Afro-American appliquéd art works and to African textile sources. The similarities between her wall hangings and those of the Fon are too tempting to overlook.

Strip Quilts

The strip quilt, sometimes called a "string quilt," is a form of the pieced quilt that is particularly favored by Afro-American quilters. In this type of quilt the scraps of cloth are first sewn into strips, which are then assembled into various patterns. Usually the strip element runs the entire length of the quilt top so that it is a complete structural unit as well as a design element. Although black quilters have made all manner of pieced quilts, often using the same approaches as Euro-American quilt makers,[20] the strip technique is the method found most frequently in Afro-America. It has been observed in black communities in coastal South Carolina [50-52], southwestern Georgia [53], Alabama, Mississippi [54-58], Tennessee, southern Maryland, and in Washington, D.C., and Philadelphia. This wide distribution makes the strip quilt the most commonplace domestic example of black material culture in the United States. Why a single approach to the task of quilting should be so dominant among Afro-American quilt makers may be traced to the retention of design concepts found in African textiles.

Unlike the appliquéd quilts of Harriet Powers, whose ethnic analogs are limited to a small geographic area of Africa, the strip quilts may reflect a heritage of textile making which extends across all of western Africa. Throughout West Africa men weave cloth on small horizontal looms with very narrow warps, usually between four and ten inches in width. The long strips of cloth produced on these looms are cut into usable lengths and edge-sewn together to form a larger textile.[21] Hence, the strip is a basic structural unit in many West African textiles. It may also figure as a prominent design unit, since strips with uniformly decorated banding, when placed next to each other, may be manipulated to produce either checkerboard or horizontal stripe designs.[22] A broad vertical loom is used by the women of West Africa, and it is also found in Central Africa. The textiles produced on these looms may be quite wide. A stripe pattern is often introduced into the design of the cloth by using different colored threads in the composition of the warp.[23] Although it is only a simple concept, the strip pattern is a basic decorative motif for African textiles throughout the source areas for slaves. If we are to expect any survival of African influences on Afro-American textiles, it would most likely be in a basic motif rather than an esoteric one, and it would likely be a design familiar to Euro-Americans. The correla-

49 *Melrose Plantation*, Clementine Hunter.

tion between strip patterns in African textiles and Afro-American quilts may then reflect a transatlantic continuity of aesthetic preferences.

The deliberate retention of this pattern is seen in a wool blanket [59] made by Luiza Francis Combs of Hazard, Kentucky. An African-born black woman who died in 1943 at the age of ninety, she was totally in command in the making of this textile. She raised the sheep from which the wool was sheared. She carded the wool and spun it into thread. After dying the thread red-orange, orange, lavender, and blue, she wove it into a strip pattern. Both the color scheme and the strip design can be counted as African features. This strip blanket gives us an indication of the significance of strip quilts; both are based on African memories.

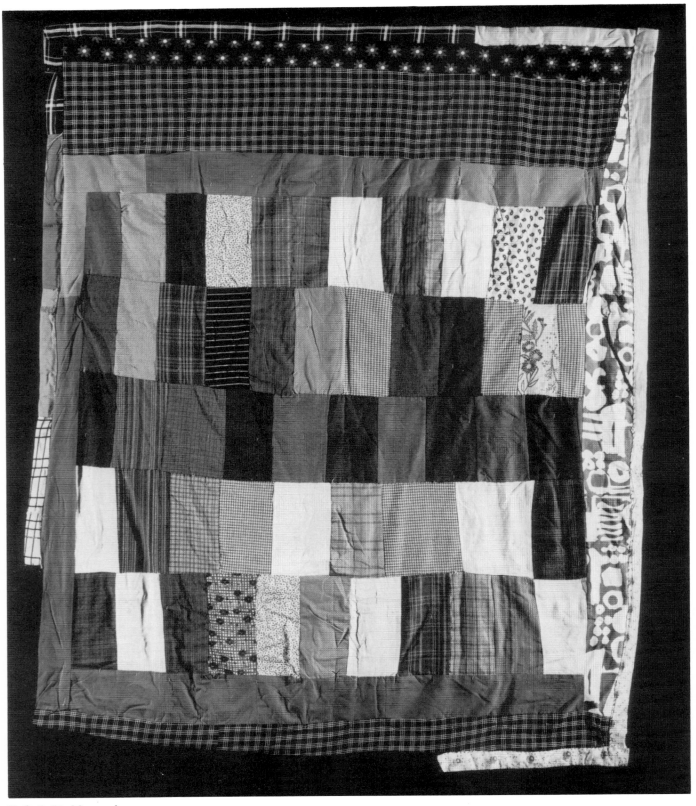

50 *Quilt,* Ida Magwood.

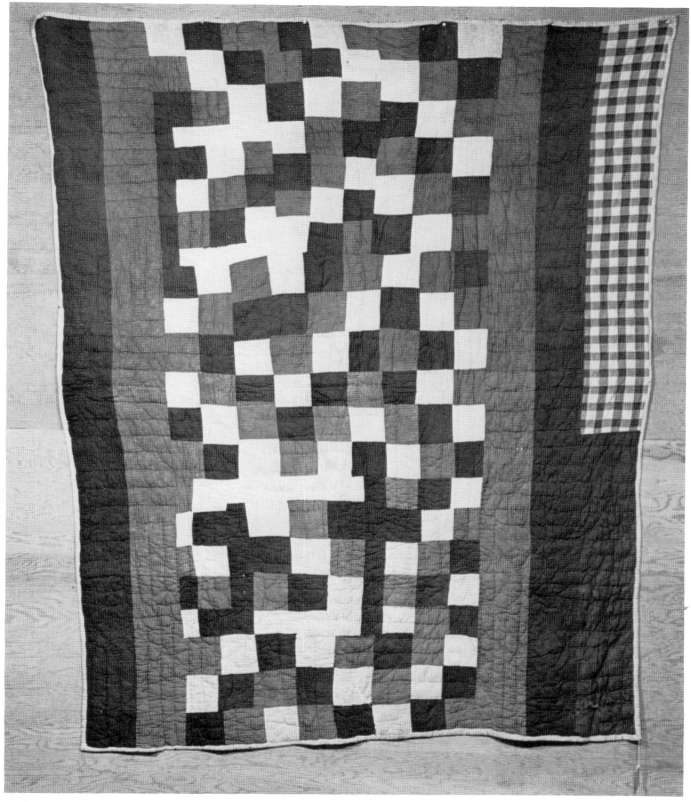

51 *Quilt,* South Carolina.

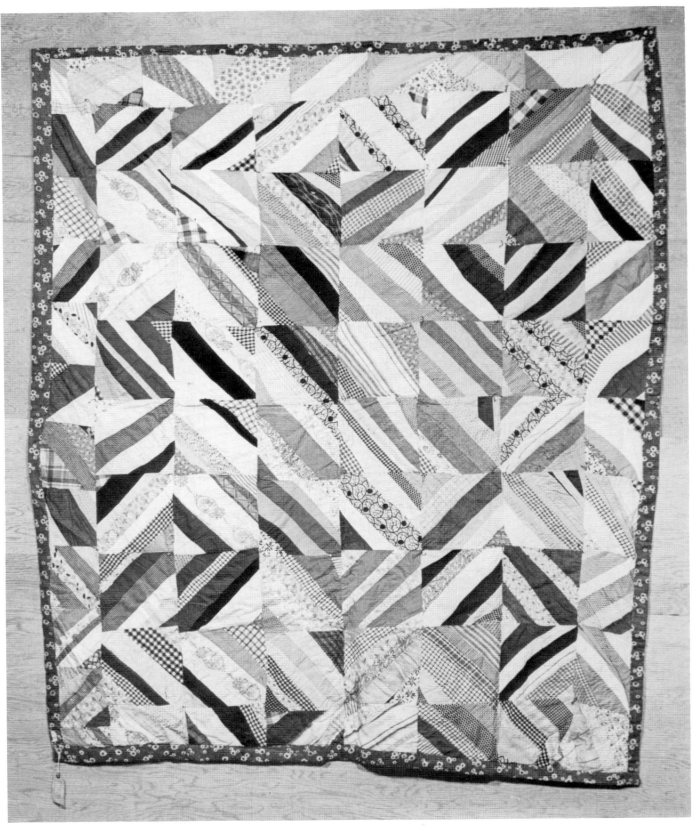

52 *Quilt*, South Carolina.

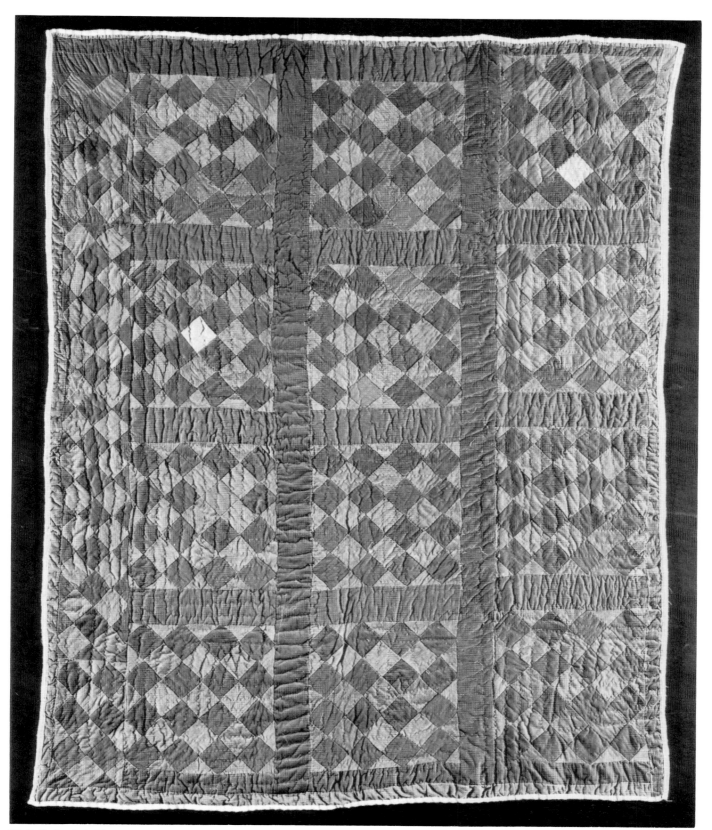

53 *Quilt*, Lucinda Toomer.

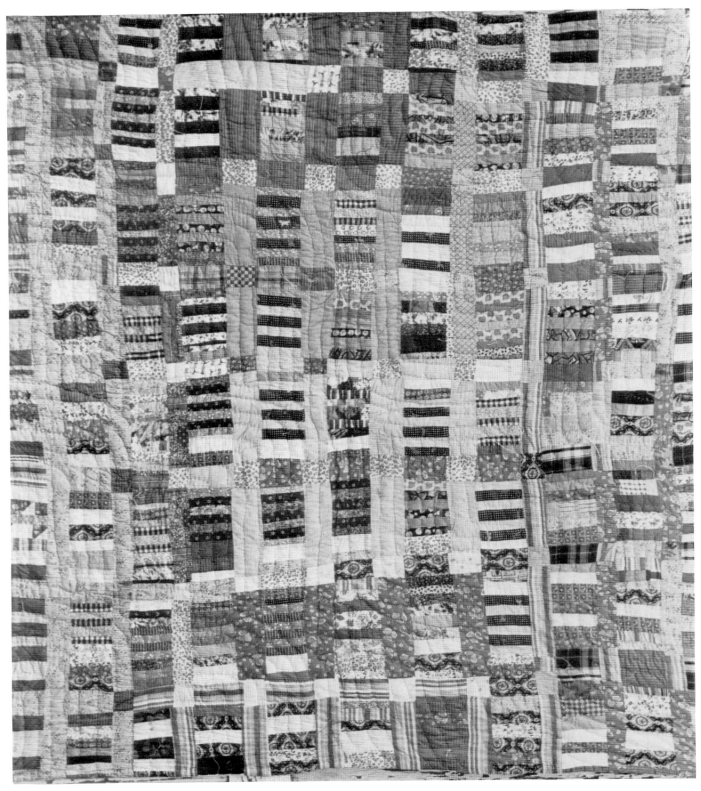

54 *Quilt,* Amanda Gordon.

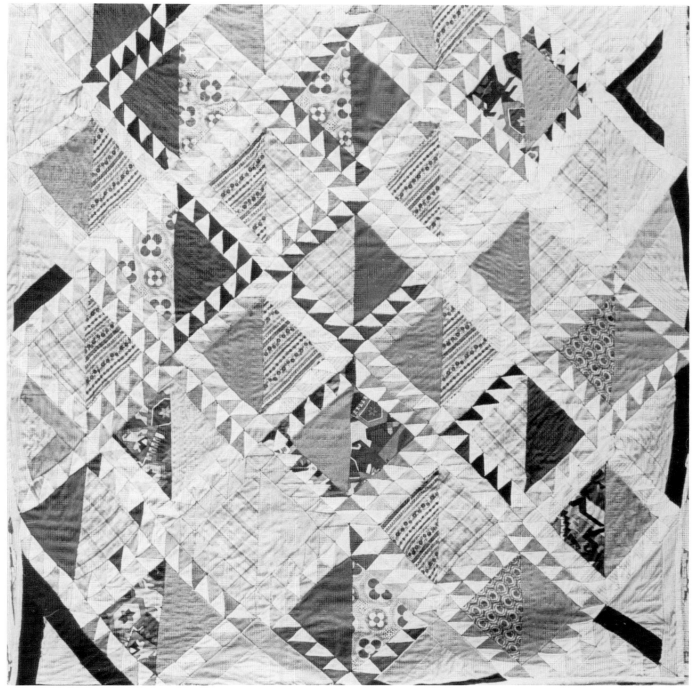

55 *Quilt*, Pecolia Warner.

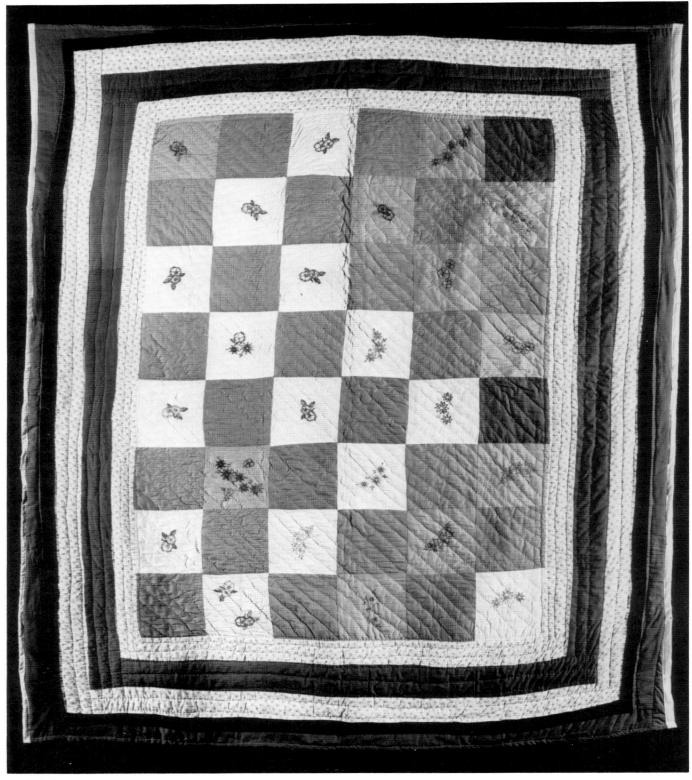

56 *Quilt,* Mrs. Ozzie Allen.

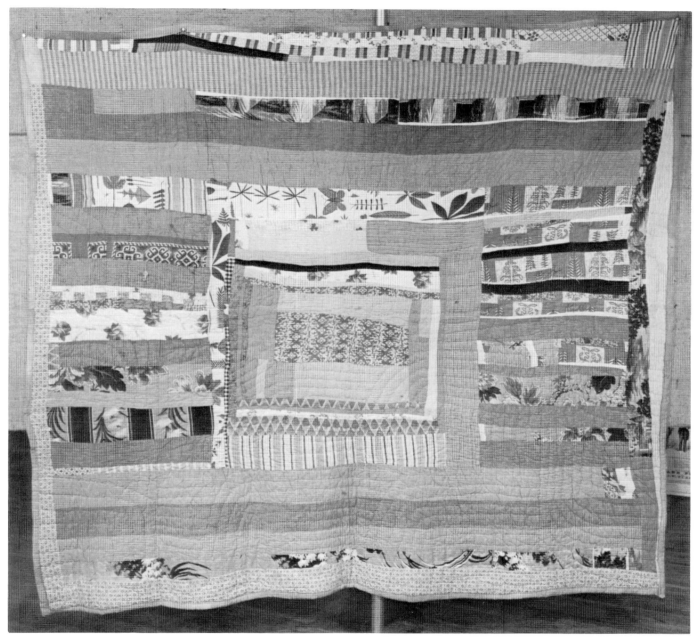

57 *Quilt,* Mrs. Floyd McIntosh.

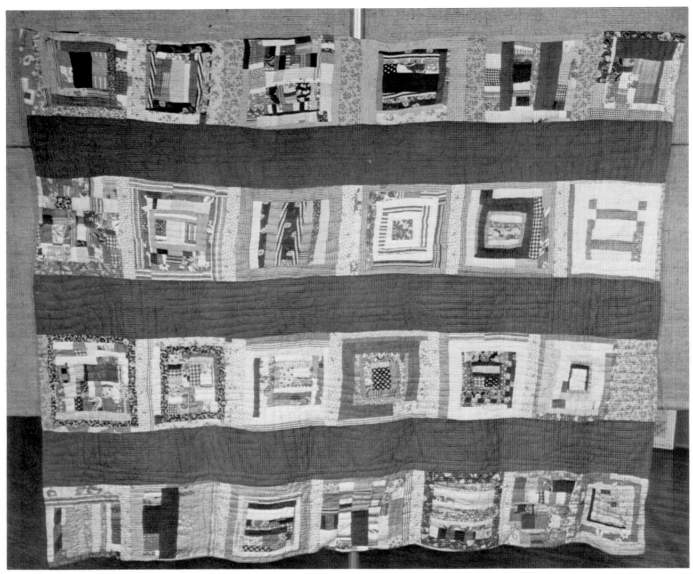

58 *Quilt,* Mrs. Pinkie Veal.

59 *Blanket*, Luiza Combs.

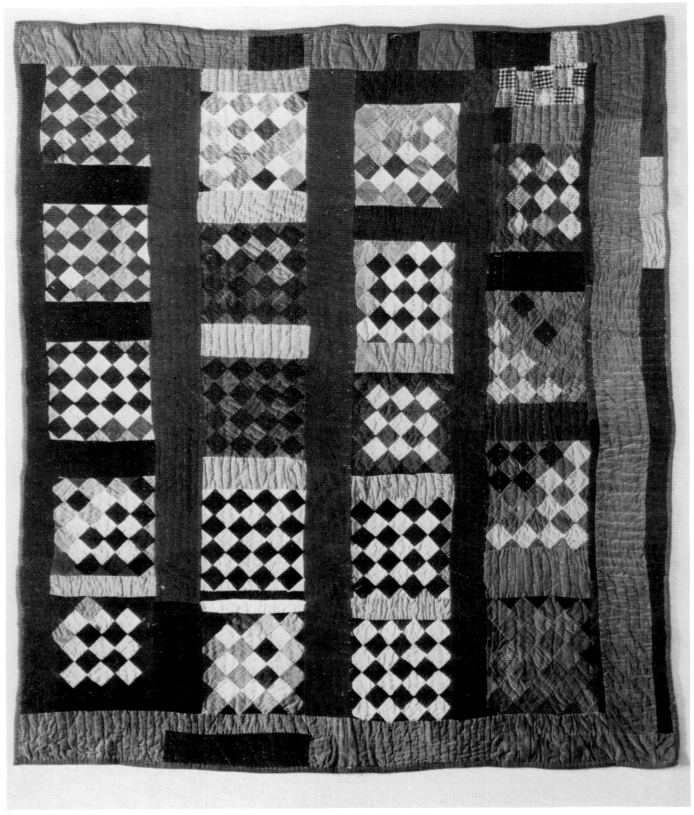

60 *Quilt*, Lucinda Toomer.

It should be pointed out that strip patterns are not the exclusive property of black peoples. They certainly occur in Euro-American quilts—for example, the quilts made by Pennsylvania Germans in the nineteenth century.[24] The quilts made by Blacks, however, would never be mistakenly identified as the work of Amish or Mennonite sewers. Euro-American quilters tend to draw their designs into a tight and ordered symmetry. When strip designs are used they are the same size and are pieced together in an orderly manner. Moreover, geometric motifs set in blocks constitute the core of the Euro-American quilt design tradition.[25] The strict formality of these works is only slightly relieved by a few instances of the "crazy" quilt. Rigid, uniform repetition and predictability are definite characteristics of Western folk art,[26] and the same is true of the Euro-American quilt.

By contrast, Afro-American strip quilts are random and wild, seemingly out of control. Even the subdued example of an Afro-American quilt by Lucinda Toomer of Dawson, Georgia, shows a distinct tendency toward improvisation [60]. She alternates thin solid strips of color with wide strips composed of blocks of diamonds. But then, her strips are not all exactly the same width, and the blocks of diamonds have as many as six colors scattered randomly about as a carefree counterpoint to the strict formality of the block motif. Furthermore, the strips which constitute the borders of the quilt are not all made of the same material but rather are pieced together from odd bits of corduroy. Mrs. Toomer thus strikes a visual balance between precision and random variation. Rigid block patterns have been worked into a free-flowing strip arrangement. The variation here in color and size of strip reflect an improvisational approach to design which is analogous to the instrumental break in a jazz composition. Having established a theme with diamond blocks and solid strips, Mrs. Toomer plays variations by changing a few colors and altering the dimensions of her motifs. Though her manipulations of the design do not change the basic motif, these slight changes do create a meandering pattern of random improvisation. It is this quality that sets this quilt apart from the European genre to which it belongs and allows us to make direct comparisons with African narrow strip weaving [61].

Within the narrow weave types of African cloths no less than fourteen means of introducing pattern have been noted.[27] Some techniques involve variations in the weft so that the cloth may vary in texture as well as color and design. Sections of a strip which have been double wefted are narrower than the rest of the strip. The edge of the cloth then becomes slightly curved, and stripes seemingly flair in and out. Sieber points out that, even though controlled geometric motifs are a standard element of African textiles, improvisational cloths are also part of the tradition: "Actually, the accidentals in such cloths are not unanticipated, but are allowed for if not calculated."[28] Decoration that is not woven into the cloth may be applied by a number of dyeing and painting techniques, often creating random, almost haphazard design [62, 63]. Even the tie-dye techniques, which introduce a measure of control into the resist dyeing process, result in motifs that are soft and fuzzy at the edges. Certainly they are not rigorous designs, but rather blend subtly into the texture of the cloth.

These African qualities are analogous to the spirit sensed in Afro-American strip quilts. In both cases there is a use of formal design motifs but not a submission to them. There is playful assertion of creativity and innovation over the redundancies of disciplined order. Thus, we come to realize the shared stylistic affinity between African textiles and Afro-American quilts. There is in both a commitment to a deeply imbedded sense of improvisation. When a Sea Islands woman mixes and matches thirteen assorted strips of cloth to make a quilt [64], she is inspired by the same creative muse that leads the Ashanti weaver to make a priest's robe out of fifteen different strips of kente cloth [65]. The African weaver continues to use the techniques of his ancestors, while the Afro-American quilter has had to learn new techniques. The ancestral ideals, however, remain the same.

Most quilters think of the strip pattern as being very old.[29] The achievement of the black strip quilter in this long tradition is based not simply on cultural memory but also, and more importantly, on the assertion of a new definition of Euro-American patterns. In the Sea Islands, quilts often strike the viewer as Pollack-like splatterings of color. There is a harsh enjambment of contrasting hues along with a subtle blending of complementary shades. Each quadrangular bit of fabric may have unique dimensions. All is seemingly chaotic and free-form. Yet if one stops to consider the positioning of the strip units, a familiar although new pattern emerges. Strips are sometimes arranged in decreasing concentric ranks, like the log cabin motif found so widely across the United States.[30] Rarely, however, does one log cabin fill up an entire quilt; a cabin usually measures only a few

61 *Men's Weave Textile*, Upper Volta.

62 *Resist-Print Textile*, Ivory Coast.

63 *Bambara Hunter's Cloth*, Mali.

64 *Quilt,* Ida Magwood.

65 *Men's Weave Textile,* Ghana.

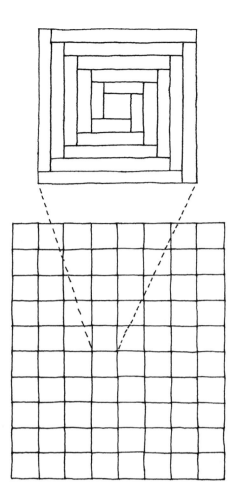

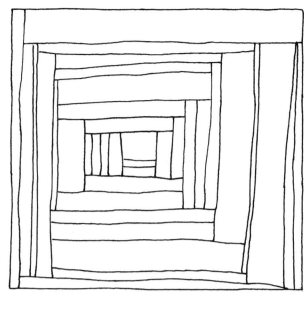

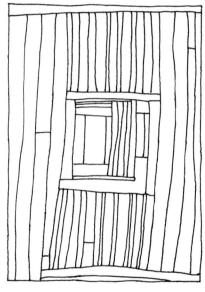

Figures 27a, b, c, d. Comparison of Anglo- and Afro-American interpretations of the log cabin motif. (a) Diagram of a typical, symmetrically composed, Anglo-American log cabin quilt. (b) Diagram of log cabin strip quilt made ca. 1970 by Mrs. Ida Magwood of Johns Island, South Carolina. Collection of Indiana University Museum. (c) Diagram of strip quilt with log cabin center [57], by Mrs. Floyd McIntosh. (d) Diagram of strip quilt from Johns Island, South Carolina, with large strips arranged asymmetrically in decreasing ranks. Collection of Mary Arnold Twining, Buffalo, New York.

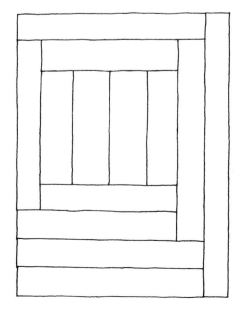

inches and is repeated as many as eighty times over the top of a single quilt. In one case, a twelve-patch square was used to fill up the vast area in the center of the quilt. Normally we would expect this motif to be repeated several times as a much smaller unit. This simple re-interpretation of standard Euro-American quilting motifs represents the implementation of a different aesthetic system by Afro-American quilters (Figures 27a-d). Their designs are familiar but novel—the result when two design systems confront each other.

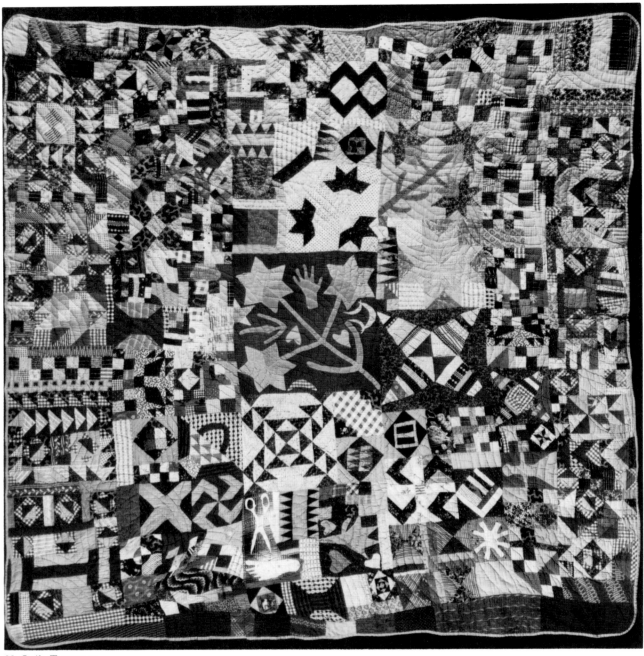

66 *Quilt,* Tennessee.

As we have seen, a primary characteristic of Euro-American quilts is a focus on geometric symmetry. Afro-American strip quilters recognize this design principle and often define what can be termed a mid-point for their own compositions. Their definition of center, however, may in fact not be precisely the center of a quilt. One extremely fine example of strip quilting from Tennessee [66] consists of six strips, all of different widths. Although the third strip is in the middle of the quilt and is highlighted by several

appliquéd motifs, it is not at the exact center. We might argue that the quilter in this case was aware of symmetry, for she established a visual center of attention, but then she went on to ignore the quality of precision we expect in symmetrical composition. Moreover, in jamming so many different motifs into each strip she created an electric excitement that almost disguises the floral cluster in the center block. A concept more important than order for this quilt is improvisation, the basis of Afro-American creativity. The

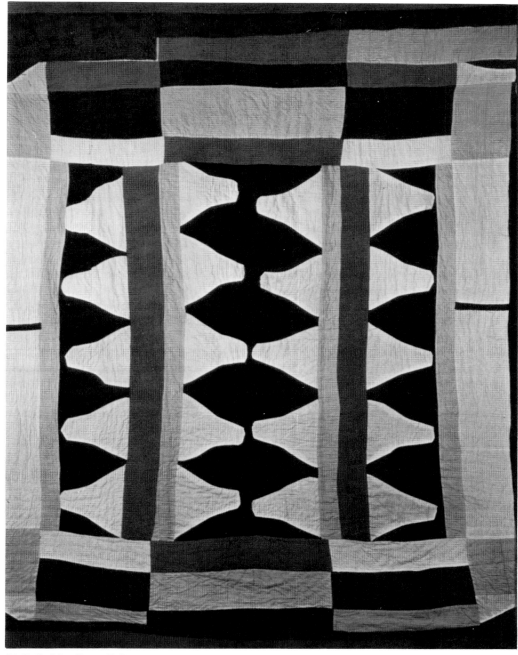

67 *Quilt,* Mrs. Betty Tolbert.

maker of this quilt, while acknowledging the familiar order of the central-medallion style of quilt, like the blues guitarist went off into improvisation, challenging the viewer to see as she sees, to be off-balance but still under control.

Although the appliqué and strip forms have been selected most often as a mode of African-inspired creation, even pieced quilts may suggest an African feeling [67]. Harriet Powers' achievement recalls a single ethnic source. The strip quilts, in form and particularly in style, reflect the widespread heritage of African textiles. What may in the end be regarded as the most important feature of Afro-American quilting is the apparent refusal to simply surrender an alternative aesthetic sense to the confines of mainstream expectations. Euro-American forms were converted so that African ideas would not be lost.

5. Pottery

Blacks have been involved in all major craft activities in the United States from the colonial period on up to present times. This is not surprising when we understand that black people constituted half, if not more, of the labor force for many southern states. A British traveler in 1759 remarked: "The number of Negroes in the southern colonies is upon the whole nearly equal, if not superior, to that of the white men."[1] In Louisa County in central Virginia the number of Blacks was just slightly above the white population in 1790, but by 1880 their margin of dominance increased to more than 4,000.[2] The daily chores which were essential to the maintenance of life in rural eighteenth- and nineteenth-century America included many tasks other than field labor. There were houses and barns to build, tools to make and repair, grain to mill and store, cloth to weave and tailor. Although most Blacks toiled their lives away under the sharp eye of the field foreman, some had to be placed in the workshop, forge, mill, and loom house. None of the historians of slavery ever fails to note the involvement of Blacks in skilled trades.[3] Carl Bridenbaugh notes that "in the Carolinas the overwhelming majority of artisans were Negro slaves."[4] Circumstances such as these gave rise to a black American tradition in pottery, a craft most often practiced in this country by Whites.

That Blacks did not dominate American ceramics is understandable, given the distinctly European technology and materials involved: treadle-operated wheels, wood-stoked kilns, decorative slips and glazes. Even if an African slave had known something of his own pottery traditions of hand-built, open field-fired earthenware, he still would have been inadequately prepared to "turn and burn" stoneware jugs and crocks. Furthermore, pottery as practiced throughout Africa is mainly a woman's craft.[5] Black men who became potters may thus have had to break sharply away from their past as they entered into their new trade.

The meager reports of black potters, when assembled, reveal a pattern of general isolation. Most were single individuals who had been brought up in shops belonging to white pottery-making families. Such was the case of Peter Oliver, who was trained in 1788 in North Carolina to make pottery like his owner, Br. Christ.[6] Bob Cantrell of Cleveland, Georgia, who worked in the shop of William Dorsey late in the nineteenth century, was at that time the only Black among 215 known potters in the state.[7] Other Blacks working in the ceramic craft in Alabama and Mississippi were, like Cantrell, trained by Whites and relatively rare. Only in Texas was this general trend reversed, when around 1900 a white man hired an ex-slave to teach his son to be a potter.[8]

The rift between a possible memory of an African aesthetic and the demands of the American experience could only be closed when black craftsmen worked in groups, a situation that is encountered in eastern Texas but is most prevalent in the Edgefield District of west-central South Carolina. This latter area was a primary center throughout the nineteenth century for the production of alkaline-glazed stoneware,[9] much of which was made by black labor. Lewis Miles of Edgefield, for example, owned forty slaves, many of whom were employed in his pottery works.[10] The Afro-American tradition in ceramics thus began in South Carolina, and it is here that we can expect to find a distinct black achievement.

Edgefield District Utilitarian Ware

The first pottery in the Edgefield District (see map, Figure 28), a former militia area comprising what today are Edgefield and Aiken counties, was established sometime between 1810 and 1820 by Abner Landrum at a site just outside of Edgefield, named, appropriately enough, Pottersville.[11] A contemporary account from 1826 by Robert Mills praises Landrum as "ingenious and scientific" and describes his operation: "The village is altogether supported by the manufacture of stoneware, carried on by this gentleman; and which by his own discovery is made much stronger, better, and cheaper than any European or American ware of the same kind. This manufacture of stoneware may be increased to almost any extent; in case of war, &c., its usefulness can hardly be estimated."[12] The vigorous tone used here is rich with optimism, but in 1827 the Pottersville manufactory passed out of Landrum's control and for the next sixteen years continuously changed owners. Seven different companies ran the pottery works until 1843 when it was sold. Other potteries sprang up in the same general period: Miles Mill opened around 1834; Collin Rhodes and Robert W. Mathis founded

Figure 28. Important pottery sites in South Carolina. Edgefield and Aiken Counties are roughly equal to what was known as the Edgefield District in the 19th century.

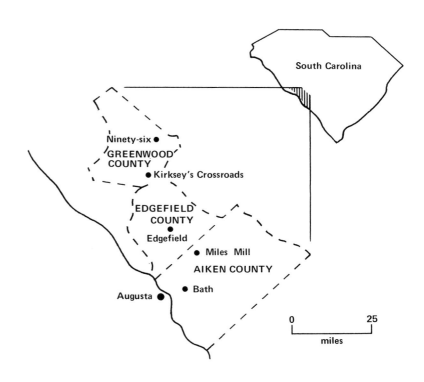

the Phoenix Factory in 1840; Thomas Chandler, a former potter at the Phoenix Factory, started his own business at Kirskey's Crossroads in 1850.[13] Stoneware did, as Mills had suggested, become a major product for the Edgefield area. Landrum started it all and had a major influence on subsequent developments. His brother Amos worked with Collin Rhodes; Lewis Miles, owner of the Miles Mill, was Landrum's son-in-law; and Landrum's slave Dave was to become the most accomplished Afro-American potter of the period.

Among Landrum's diverse interests was the publication of a newspaper, *The South Carolina Republican* (later called *The Hive*). Dave was taught to read and write by Landrum, perhaps as an example of his "scientific" attitude. Dave apparently was a fine student, for he was put to work on the newspaper. He filled the post of typesetter for the *Hive* until 1831 when the paper was disbanded and moved to Columbia, South Carolina's capital.[14] Dave was then given over to Lewis Miles to work as a potter. He has been variously remembered as "Dave Potter," "Dave Pottery," and "Dave of the Hive," the latter alluding to his newspaper apprenticeship. His verbal training was useful to him in his pottery career, for he often inscribed his works with rhymed couplets. These poetic pots are among the outstanding achievements of Afro-American folk craft [68-71] (Figure 29).

Dave's work is a delight to the ceramic historian, for not only did he sign his name with a distinctive script, but he also recorded the name or initials of his owner, Lewis Miles, the date of manufacture, and occasionally the name of the customer. A stoneware jug splashed with white kaolin slip [68] bears a typical inscription: "Lm/Oct 26 · 1853/Dave." This is minimal information, but it is enough. Dave's career in pottery was quite long, and consequently he must have made hundreds of clay objects. Almost fifty have been discovered so far (more are sure to turn up). Roughly one-fourth of Dave's known repertoire carries a verbal message, a sign of his education and verbal skills. His themes tend to describe the function of his large jars, but he could also venture into the realm of the metaphysical; one jug bears only one word, "Ponder-

Figure 29. *Jar.* Stoneware, ash glaze. Inscribed: Lm Aug 24 1857/Dave. On opposite side: Pretty little girl on the virge/volca[n]ic mountain how they burge. Dave the Potter, American, South Carolina, Miles Mill, 1780-1863. University Museum, University of South Carolina, Columbia.

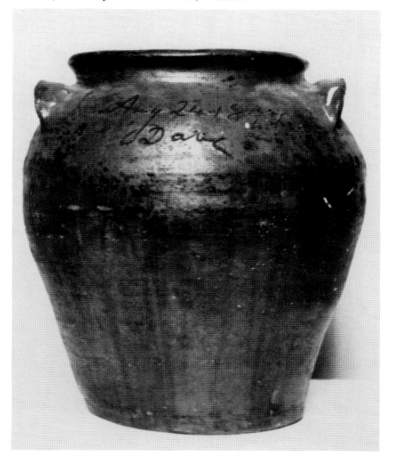

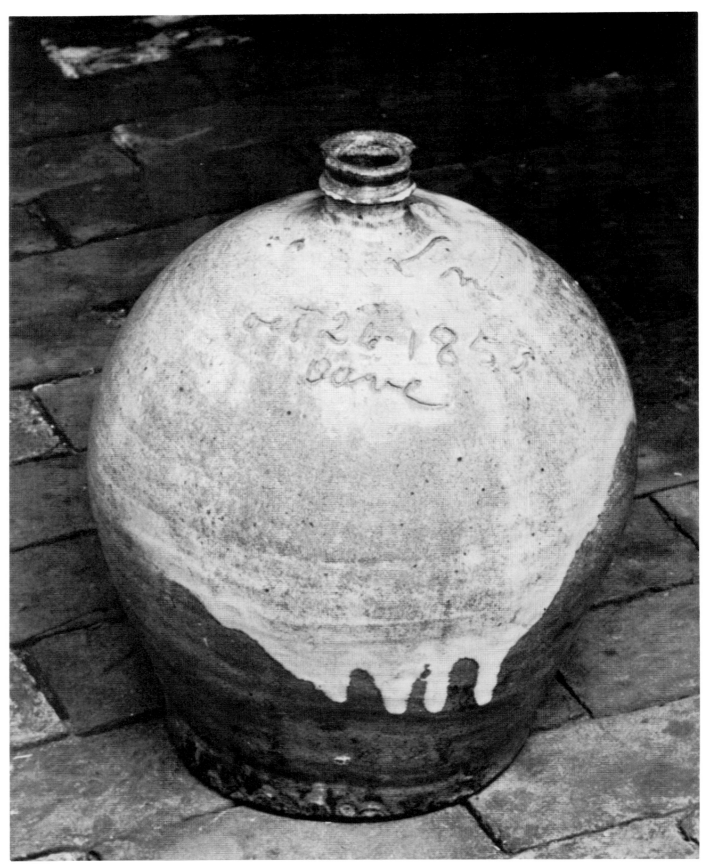

68 *Jug*, Dave the Potter.

osity."[15] Although most of his rhymes were unique compositions, the couplet, "Made at Stoney Bluff/ For making lard enuff," occurs on two pots.[16] Other verses which mention a storage function include: "Great & noble Jar/hold Sheep goat or bear" [69, detail]; "A very large jar which has four handles/ pack it full of fresh meat—then light candles";[17] "Put every bit between/ Surely this jar will hold fourteen [gallons];[18] and "Good for lard or holding/ fresh meat/ Blest we were when/ Peter saw the folded/ sheet" [70] (this last rhyme is an oblique reference to an edict allowing early Christians to eat pork). Dave's verbal skills were also directed toward monetary matters: "This noble jar will hold 20 [gallons]/ fill it with silver then you will have plenty";[19] females: "a pretty little girl on the virge/ volca[n]ic mountain how they burge" (Figure 29); patriotism: "The Fourth of July is surely come/ to sound the fife and beat the drum";[20] and even his own enslavement: "Dave belongs to Mr. Miles/ wher[e] the oven bakes & the pot biles" [71, detail]. A particularly poignant verse, "this jar is made all of cross/ if you don't repent you will be lost,"[21] may reflect Dave's combined feelings about slavery and religion. Though these verses are somewhat reminiscent of blues poetry, what can clearly be defined as the blues was still half a century away at the time of Dave's career. It is best to consider these verses as Dave's individual achievement. They are special flourishes of decoration, personal marks of the maker. They reflect Dave's history as typesetter turned potter, a blend of occupational lore that, in Edgefield, was Dave's alone.

Dave's work consists mostly of very large open-mouth storage jars, usually about two feet high, with slab handles around the rim. His largest piece stands twenty-nine inches high and is inscribed with his name and that of another slave, Baddler (Figure 30). This jar, which may hold more than forty gallons, is the largest piece of stoneware known in the South [69]. Made in sections, it was probably thrown by Dave while Baddler turned the wheel. Certainly, by the time Dave pulled the topmost coils of the vessel's walls he would not have been able to kick the treadle. This piece should be regarded as something of a ceramic monument; contemporary folk potters using the same technology are awestruck by Dave's ability.[22]

Another characteristic of Dave's work is the scale of his pieces; his pots tend to be very wide at the shoulder. Their bases conform to the usual dimensions (around twelve inches), but the walls

69 *Jar*, Dave the Potter; detail of inscription (above).

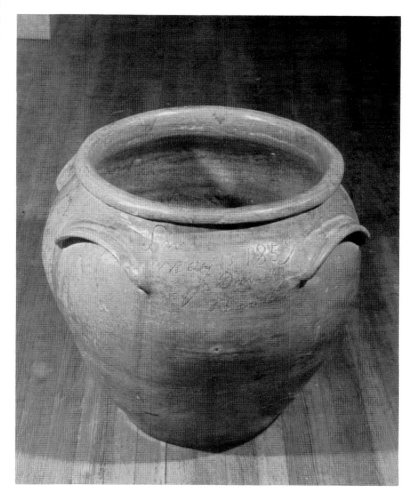

Figure 30. Detail of Dave the Potter's *Jar* [69].

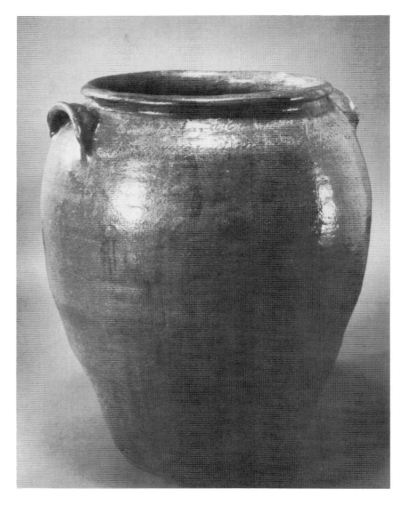

flair boldly to the shoulder, near the top of the vessel. Above the shoulder of the jar, the walls break sharply inward to the mouth, leaving a distinct ridge. Although these broad-shouldered pots are very much like other Edgefield wares—and all Edgefield potters made large storage crocks—the width of Dave's work is an important difference. Collin Rhodes, for example, also made bulbous storage jars, but the walls of his vessels are more curvaceous, with the widest portion coming at the middle of the vessel rather than the top.[23] These are subtle differences, but they are enough to identify the hand of the maker. Thomas Chandler, like Dave, placed four slab handles around the rim of his pots. Bulbous storage jars such as Chandler's are a genre of British folk pottery.

Dave's works are largely renderings of an Anglo-American form. It may be possible to think of Dave's pieces as modifications of the American norm, in the same manner that Afro-American quilts are renderings of Euro-American designs, but it is more appropriate to view his pottery as a heroic accomplishment. He threw larger and heavier ware than anyone else, sometimes requiring a mound of clay weighing more than forty pounds. Great strength and skill were required to turn such pots. He knew it and his owner knew it. Perhaps in this way he sought to throw off the shackles of bondage and gain a measure of respect. He was eighty-three years old when he died; it is evident that a powerful spirit had moved him through all those years.

Dave was, of course, not the only slave potter working in the Edgefield area. We have already mentioned Baddler. Another slave named Jack Thurman was remembered by a white potter, George Flesher, who had also worked at the Miles Mill in its last days.[24] He recalled that Thurman had been a strong and dignified man. Flesher died in 1908 at the age of eighty-four and hence would have worked with Dave for at least twenty years. Other Blacks owned by Miles can be named: from the Rev. John Landrum estate, in 1847, Miles acquired a slave named Phil for $785 and a boy named Frank for $685[25] —prices that may be considered an index of their skills. Others remain to be named, but it is clear from the impressive work of Dave that there existed ample motive in Edgefield to train slaves to make stoneware. If they did not actually throw pots, they certainly stoked kiln fires,

70 *Jar*, Dave the Potter.

stacked greenware, wedged clay, mixed glazes, and loaded wagons. Without their efforts Edgefield wares would not have become so well established.

That black labor was part of the commercial pottery industry in Edgefield has been clearly documented. A transaction in 1835 between Amos Landrum and the Gibbs and Drake pottery mentions a slave named Buster who is described as a turner.[26] A group of seven slaves—including Abram, Old Harry, and Young Harry—worked at the Phoenix Factory for Collin Rhodes.[27] Chandler's will, dated February 10, 1852, lists with the property of his pottery works four slaves: Simon, Easter, John, and Ned.[28] In 1862 a pottery was established at Bath, twenty-five miles south of Edgefield, by Colonel Thomas J. Davies, who hired one Anson Peeler from Bennington, Vermont (a noted pottery center), to direct the work of his slaves.[29] The four production works of Miles, Rhodes, Chandler, and Davies in a way constitute a larger community of artisans, since slaves were often exchanged for short periods between potteries.[30]

Edgefield Face Vessels

The circumstances in the Edgefield District that favored the production of utilitarian pottery by Blacks also fostered artistic attitudes that were to lead to the creation of ceramic sculpture. A number of vessels with sculptured faces were made at several of the Edgefield potteries. In the literature of folk art these vessels are variously called "grotesque jugs," "voodoo pots," and "monkey jugs." Rural Georgians today call them simply "ugly jugs."

There has been some speculation that this genre of artistic expression had its origins in South Carolina, but such views are without historical validity. Face vessels were made in every pottery region of the United States. Some of the oldest known examples are by an anonymous potter from Montgomery County, Pennsylvania (1805),[31a] by E. G. Grafts of Whatley, Massachusetts (1833),[31b] and by Henry Remmey of Philadelphia (1838).[31c] Even in Edgefield there is evidence of ceramic sculpture before 1840 (fragments of a portrait bust—not a vessel—have been recovered from the site of the Rhodes pottery; this piece, which may have depicted an Indian chief, stood perhaps sixteen inches

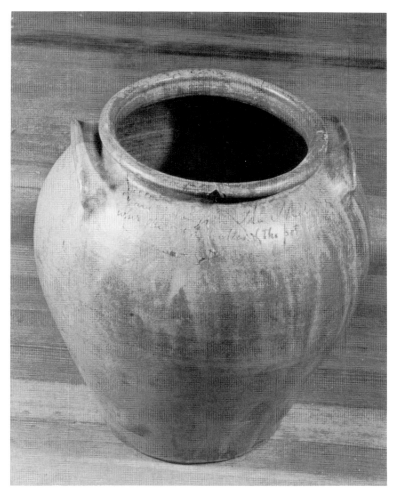

71 *Jar,* Dave the Potter; detail of inscription (above).

81

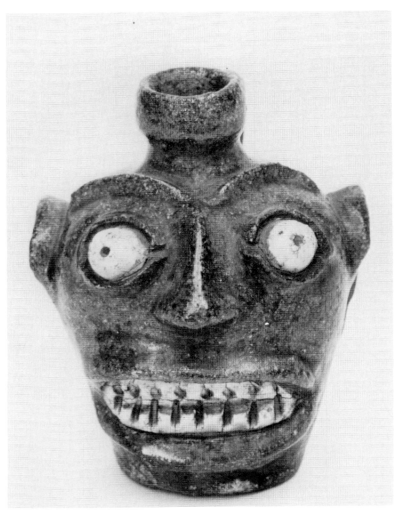

72 *Face Vessel*, South Carolina.

Figure 31. *Face Vessel*. Stoneware, kaolin, ca. 1860, H. 4 inches. South Carolina, Bath, Thomas Davies Pottery. Augusta-Richmond County Museum, Augusta, Georgia.

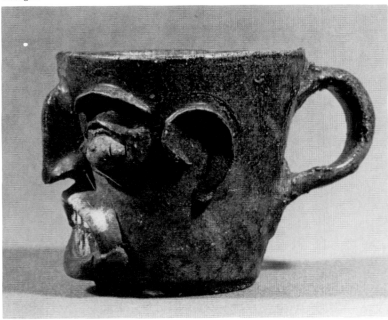

high).[32] Of course, the decoration of pottery with faces had been established much earlier in Europe.[33] Since English antecedents are most pertinent to southern ceramic forms, it is important to note that British face vessels date from the period of Roman domination. This mode of decoration, which became part of the British tradition of folk pottery around AD 200, emerges again in the fourteenth and fifteenth centuries. By the eighteenth century the face vessel form had matured into the comical Toby jug.[34] The face jugs made in Edgefield around 1850 are thus preceded by an extensive tradition in Euro-American pottery. Moreover, the making of pots with faces was so widespread by the late nineteenth century that it would be a mistake to consider all late nineteenth- and twentieth-century face vessels as necessarily tied to Edgefield tradition—obviously, other pertinent sources of inspiration were also available. Although Edgefield face vessels are neither the oldest nor the most influential expression of this type of ceramic sculpture in the United States, they are, nevertheless, stylistically distinct. Because of this, and because they were made by black potters, we may view them as an important achievement in Afro-American decorative art.

Some have questioned whether or not Blacks ever made face vessels at all. We have already seen that they were deeply involved in the making of utilitarian ware. To this perception we can add the comment of Thomas Davies, owner of the pottery at Bath, who informed ceramic historian Edwin Barber that his slaves made face vessels in 1862: ". . . they were accustomed to employ in making homely designs in coarse pottery. Among these were some weird-looking water jugs, roughly modeled in the front in the form of a grotesque human face evidently intended to portray the African features."[35] This was at a time when Davies' Palmetto Firebrick works was converted into a manufactory for jars, pitchers, and cups to supply Confederate hospitals, and when slaves apparently had some time to themselves. The "weird-looking water jugs" are small stoneware vessels (about four inches tall), glazed in colors ranging from buff to dark-olive, with white porcelain clay inserted for eyes and teeth [72]. Barber considered this last feature to be "ingenious," and he said the sculptural technique "reveals a trace of aboriginal art as formerly practiced by the ancestors of the makers in the Dark Continent."[36] All of this verbal testimony about Blacks making sculptural vessels with two kinds of clay was substantiated when a small cup with kaolin eyes

and teeth was discovered in the waster dump at the site of the now defunct Davies pottery.[37] Thus, we can be certain that Blacks made a specific type of ceramic sculpture in the 1860's—the archaeological remnant confirms the written history.

This type of pot was not confined solely to the Bath pottery. Two similar pieces in the Charleston Museum are attributed to Miles Mill (6448 and 1802a). The resemblance in the works of the two potteries may be due to an exchange of slaves. A design developed at one site could have been easily carried ten miles up the road to one of the other pottery works. It might even be suggested that the black style of shaping a face was practiced at all the potteries of the Edgefield District, for the basic ingredients—stoneware clay and kaolin—were readily available throughout the area.

There are some minor but nevertheless considerable variations in Edgefield face vessels. To begin with, faces were applied to a number of pot forms: jugs, cups (Figure 31), jars (Figure 32), pitchers [73], and bottles [74]. Although differences in form and size arise according to the

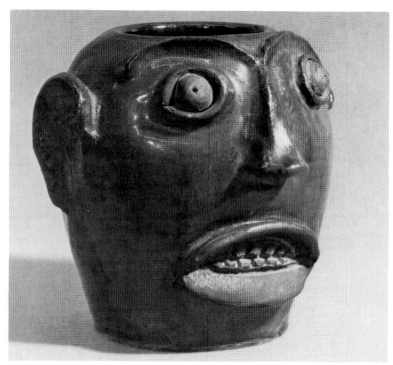

Figure 32. *Face Vessel.* Stoneware, kaolin, ca. 1860, H. 8-1/2 inches. South Carolina, Edgefield District. Augusta-Richmond County Museum, Augusta, Georgia. Another face vessel [75], very similar in style of modeling and pattern of glaze application, may have been made by the same potter.

73 *Face Vessel,* South Carolina.

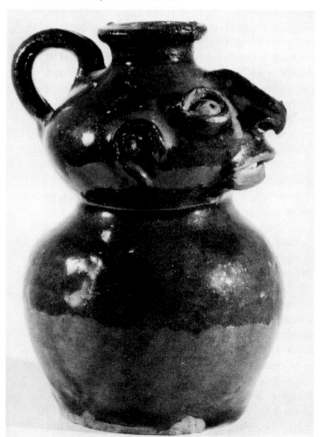

74 *Face Vessel,* South Carolina.

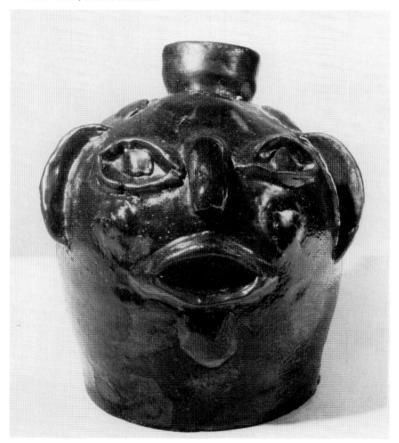

83

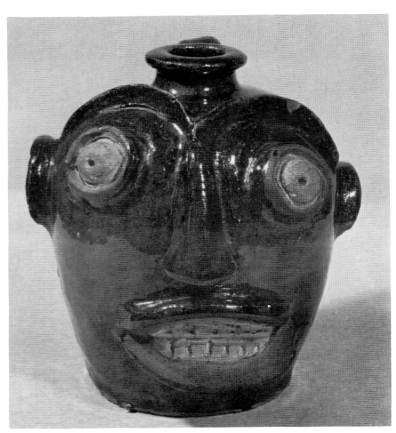

75 *Face Vessel,* South Carolina

76 *Face Cup,* South Carolina.

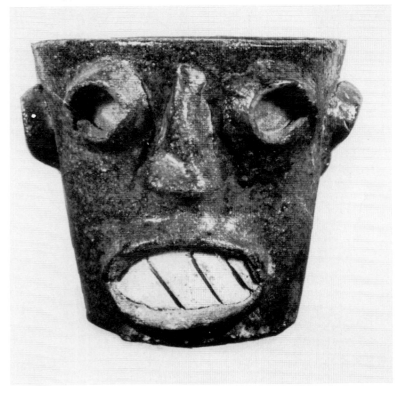

function of the object, faces are generally standardized, having curving eyebrows, bulging white eyeballs, long noses with flaring nostrils, and open mouths with white teeth. However, a feature or a group of features could be manipulated in ways that would best suit a single potter. Eyebrows, for example, might be made with sharp ridges and joined at the bridge of the nose, or be rounded and separated, or even omitted altogether. Eyes and teeth were either covered with glaze or left unglazed. In the latter case the potter painted wax (or some other type of resist) on the eyes and teeth and often on the eye rims and lips before dipping the jug into the glaze. Glaze would not adhere to those portions and wax would burn off by the time the kiln reached its 2300° firing temperature. The results were often dramatic, yielding a shiny face with a stark white stare and a grimacing mouth [75]. One sub-style of the genre has teeth incised with slanted rather than vertical strokes [76]. Thompson credits works with this feature to the "Master of the Diagonal Teeth."[38] Other "masters" might be recognized for their distinctive ears (one potter characteristically marked the center of the ear with a small lump of clay) or the rendering of chins with dimples or beards.[39] The shape of a face varies with the shape of vessel that supports it: jugs with rounded shoulders tend to have eyes and ears situated high on the vessel, while straight-sided pots tend to have faces with a frontal gaze. Some faces are stylized and others are more naturalistic. Because of the remarkable similarity in some groups of face jugs, it is evident that they were done by the same hand and may even have been included in the same kiln firing. The variety of formal possibilities, on the other hand, suggests that there were many different hands at work. Through experimentation, it seems, a potter would eventually satisfy himself with a particular arrangement of features.

The many variations and sub-types of the Edgefield face vessel did not all happen at once. The vessels themselves are very well-made examples of wheel-thrown hollow-ware. The makers of these pieces were competent in the intricate techniques of centering, opening, turning, forming, and trimming pottery. Because the knowledge required to make pottery on a wheel is only learned through a period of apprenticeship—a time of trial and error—we cannot simply accept the opening of the Davies pottery in 1862 as a starting point for the advanced production of face vessels. The skill required and the variety attained bespeak an older history. Thompson's

suggestion of late eighteenth-century origins is impossible, since there were no potteries in the region at the time. It is more likely that the tradition began after 1820, when the first pottery was underway. After this time, Blacks would have been fully trained in pottery and, having a good understanding of the complexities of glaze formulas, clay composition, and kiln behavior, could have begun to experiment with face vessels. A basic problem in the Edgefield format is encountered with the nature of the materials; stoneware clay and porcelain clay have different shrinkage rates. If an insert of kaolin is not bulky enough, it will shrink up and fall out of its socket. Perhaps by the 1830's this problem was understood and a solution discovered. Certainly, it is in that period that Edgefield pottery began to flourish and many more Blacks would have been brought into the trade. Twenty-five years seems enough lead time to account for the excellence of the vessels made at Bath in the 1860's.

Antecedents : African and Caribbean

Having established that some of the face vessels of South Carolina are Afro-American, a further issue to pursue is the relationship of these ceramic sculptures to African forms. The effigy pots of the Mangbetu of eastern Zaïre have been offered for comparison,[40] but it is highly unlikely that people from so far into the interior of Africa were ever pulled into the network of the Atlantic slave trade. A more appropriate comparison can be made with a recently discovered ceramic face vessel linked to Ghana [77]. A similarity of facial features is immediately apparent, although this pot bears some distinctive ethnic marks (keloid scars and fan-shaped beard) which may indicate either Akan or Ewe origins. There are also some cowrie shells stuck onto the outside of the pot with wax. In size, this vessel compares well with other jar sub-types of the Edgefield genre. The knobbed lid may be seen as the formal antecedent for the flared central spout encountered on most jug forms and thus may indicate a deeper level of Africanity in seemingly Euro-American ceramic forms. However, caution must be exercised, since it has not yet been determined how long vessels such as this one may have existed in Ghana. Pots decorated with faces in the manner and style of this piece may not have been known by the ancestors of South Carolina slaves.

Other possible correlations can be made on the basis of form rather than medium, but this strategy is very tricky and prone to error. Michael Kan, for example, on the basis of the bulg-ing eyes and clenched teeth found in Edgefield face vessels, sought a comparison with soapstone carvings from Sierra Leone.[41] While those features are indeed shared, Kan overlooks these critical facts: that peoples from the windward coast of Africa are the least numerous of all participants in the slave trade; and, more importantly, that the carvers of the soapstone figures are an extinct people, who preceded the current inhabitants of the land by several centuries. On the other hand, Thompson's attempts to link Afro-Carolinian face vessels to the Zaïre-Angola region are more in line with what is known about the ethnic origins of South Carolina's slaves. Placing an Edgefield jug next to a Bakongo statue [78], he notes: "The same pinpoint pupils within white eyes, the same long hooked nose, the same siting of the nose at a point relatively high above the lips, the same open mouth with bared teeth, the same widening of the mouth so that it extends across the width of the jaw...."[42] Most of the Edgefield works are iconic in nature, with simple, bold faces. These compare well with Bakongo sculptures, which also employ the force of direct symbolism. The flash of white eyes and

77 *Face Vessel,* Ghana.

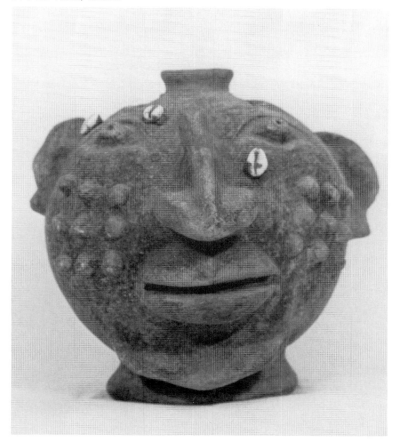

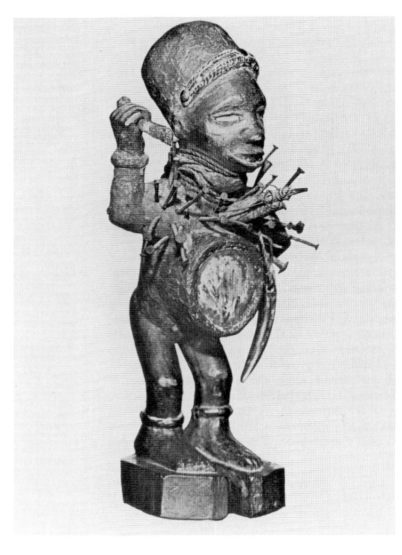

78 *Nkisi Figure*, Zaïre.

teeth against a shiny dark surface shared by Bakongo figures and Afro-American ceramic sculptures has been explained away by the availability of the necessary media in both areas of origin.[43] But considerations of environment should not cause us to overlook the similarity of presentation, no matter how accidental it might be. The fact that the sacred white chalk of Zaïre, *mpemba,* is not attainable in Edgefield does not mean that white kaolin cannot be used in its place. The face jugs with bulging white eyes [79] and the small wooden statues with eyes made from white shells are end points of a stylistic continuum stretching the breadth of the ocean.

The stylistic similarities that link Bakongo wood sculpture to Afro-American clay sculpture are reaffirmed by the presence of Kikongo words in the creole English spoken by nineteenth-century Blacks.[44] One of the last slave cargoes brought into the United States was landed from the *Wanderer* in 1858 on Jekyll Island, Georgia. Most of that group were Kikongo-speaking, and they ended up near Edgefield.[45] They were to be the last direct contribution of African heritage to the area, and their presence most likely provided a stimulus for sustained appreciation of face vessels by local Blacks. Even as late as 1940, face jugs were still kept in black households in Aiken County where they were regarded as objects of power and wonder.

Further evidence for African connections for Afro-Carolinian face vessels involves the nomenclature for these pots. Barber noted that face jugs were "generally known as 'monkey jugs' not on account of their resemblance to the head of an ape but because porous vessels which were made for holding water and cooling it by evaporation were called by that name."[46] In fact, the use of the word "monkey" in connection with water jugs appears in the Oxford English Dictionary as early as 1834. Even older is the 1797 phrase, "to suck the monkey," a slang expression used to describe someone who drinks directly from the bottle and therefore drinks too much. Some Blacks in South Carolina still use the word "monkey" to mean a strong thirst caused by physical exertion.[47] The antiquity of the term and the continued stability of its usage among American Blacks implies a long and intimate

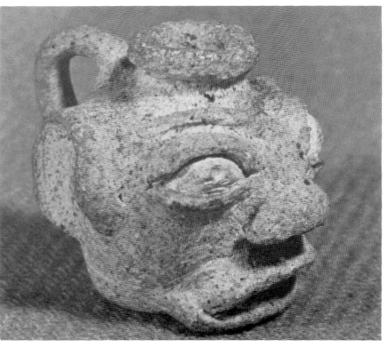

79 *Face Vessel*, South Carolina.

association of Afro-Americans with the pot form called a monkey.

Earthenware vessels called monkeys are known to have been made by slave potters from Barbados in the nineteenth century. F. Bayley, writing in the 1820's, noted that among the items for sale at the Bridgetown market were "gurglets for holding water."[48] A later traveler gives more detail:

> . . . although the ware is sold at a small price it is highly valued, and no Barbadian home, from the Governor's residence down to the poorest hut, is considered furnished without its assortment of "goglets" and "monkeys" as they are called. . . . The vase shaped vessels with narrow mouths and without handles are "goglets," those in shape much like a tea kettle and generally larger than the former are "monkeys."[49]

We can be fairly sure then that monkey jugs were known among Blacks in both the West Indies and the American South during the nineteenth century and possibly in the late eighteenth century as well. It is significant for our understanding of Afro-American pottery that South Carolina's first settlers came from Barbados and continued to maintain extensive economic ties with the Caribbean for many years.[50]

Another significant tie to Caribbean ceramics has recently been discovered in New England.[51] Earthenware jars formerly used as containers for tamarind, an African cultigen grown in the West Indies, have been excavated from three sites known to have been inhabited by Blacks in the early 1800's. These tamarind jars, although wheel-thrown, are, because of their form and function, outside the traditions of Euro-American pottery forms. Since pottery wheels were not used in Africa, these pit-fired pots could only have come from the Caribbean.

The origins of the Edgefield monkey jug tradition, in like manner, are to be found outside of South Carolina. While the Funk and Wagnalls dictionary intriguingly describes a monkey jug as "sometimes fashioned in imitation of a grotesque human head with moveable eyes and teeth," the common monkey jar of the West Indies is a plain and humble object. Those still made today generally resemble a large tea pot with a stubby spout, arching handle, and a lidded mouth [80]. They have, at the most, only a few bands of markings as decoration and, although a fine pot may be burnished, most are left with a rough finish. In fact, they serve their water-cooling function best if the surface is left coarse and porous.

80 *Monkey Jar*, Samuel Hylton.

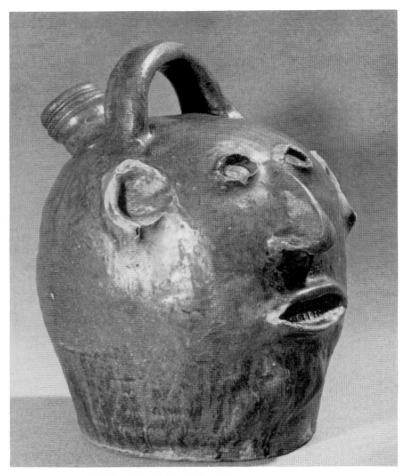

81 *Face Vessel*, South Carolina.

82 *Face Jug*, attributed to Lewis Miles Pottery.

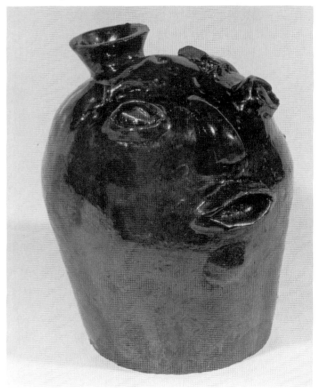

What relationship does the large unglazed earthenware vessel capable of holding five quarts have to the small glazed stoneware pots of Edgefield that can barely hold a pint? There are, in spite of their differences, a number of key similarities in form and possibly function. While most of the known Afro-Carolinian vessels are jug forms with spouts centered at the top and oval-section handles at the back, some were made with stirrup handles and had canted spouts, usually set at the rear [81]. This later form is essentially the same as a contemporary West Indian monkey jar except for the lidded mouth. Even though the usual Edgefield face vessel is not more than four or five inches tall, this particular variant is considerably larger and holds as much as a quart. Such vessels, then, are small monkeys made with stoneware and decorated with faces.

It is important to note that in the West Indies a miniature monkey jug, three or four inches high, is made as a child's toy.[52] This tiny jug form may have been the model from which Edgefield potters worked; like the Barbadians, South Carolina Blacks also may have intended their miniature monkey jugs for children. One report about the function of face vessels seems to confirm this speculation: it is told that a small face jug was used by black parents as a kind of bogey-man figure to scare their young children into behaving themselves.[53]

The Edgefield vessels are so elaborately decorated and sculpted that we tend to overlook the important cultural traditions their forms reveal. One of the oldest forms of ceramic ware known to Blacks was evidently a rough earthenware water cooler. Such vessels may have been carried into the fields to slake the thirst of the men and women who cultivated the cotton, tobacco, and rice. When Blacks made pottery they apparently used this familiar form as a model for a water jug while they learned the more conventional stoneware forms. Sculpted monkey jugs may have been the first form of Edgefield face vessel. Some of the surviving examples of this type are made with only one clay body [82, 83] and hence may precede the discovery of kaolin inserts [84, 85]. While face vessels similar to those made by Blacks are widely known, the mode of decoration that developed in Edgefield was essentially an independent ceramic invention based on a deep cultural preference for bold, iconic presentation. The combination of two different clay bodies was until then unknown anywhere in the world.

That the monkey jug form was also known in the Caribbean may indicate a remembered Afri-

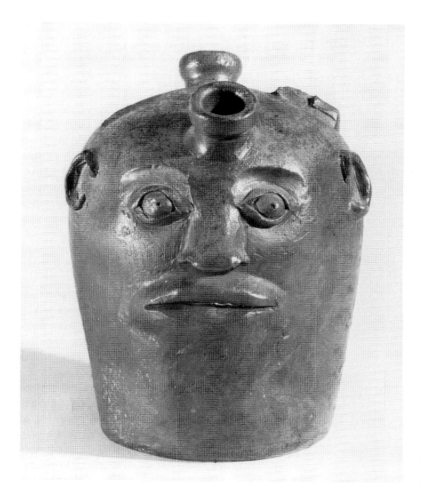

Left: 83 *Face Jug*, South Carolina (?).

Left below: 84 *Face Vessel*, South Carolina.

Below: 85 *Face Vessel*, South Carolina.

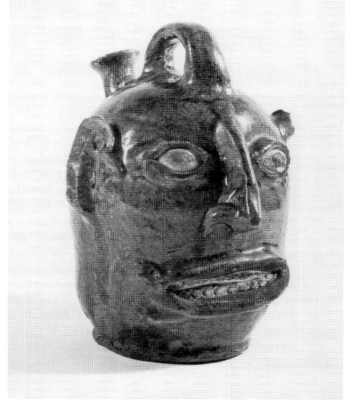

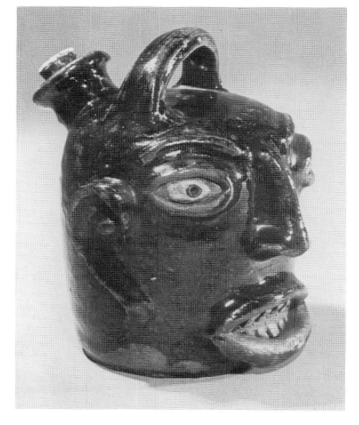

89

can pottery form. Bakongo potters made earthenware vessels called *m'vungu* [86] that closely resemble the water coolers known throughout the West Indies. These bulbous jars with canted spouts and stirrup handles may be the prototypes for the earthenware coolers known in Edgefield.[54] Slaves with Bakongo backgrounds may have expressed in the Afro-Carolinian vessel their memories of African sculpture and pottery. Incidentally, it is important to note that where *m'vungu* are made, men share with women the role of potter.[55]

We come, in the end, to see the Edgefield face vessel as a complex amalgam—a more-or-less direct retention of basic African decorative preferences and pottery traditions plus indirect influences from Afro-American ceramic forms and newly learned Euro-American pottery forms and techniques. Previous analyses of Afro-American ceramics have focused closely on the sculptural elements of face vessels. By looking at those works as pots as well as sculpture, we gain further insight into the matter of cultural survival, for we are made aware of levels of memory. In some instances we see a memory of decoration and in others a recollection of format. Both occasionally were combined [87] to create an example of Afro-American craftsmanship that is doubly representative of an African heritage and not just a potter's whimsy.

Figural Vessels

Another form of ceramic sculpture by Blacks in the vicinity of Edgefield was the figured bottle [88]. One piece is attributed to the slave potter Jim Lee, who worked at the Roundtree and Bodie pottery in Ninety-Six, South Carolina.[56] Made perhaps shortly before 1860, it has been called the "preacher burlesque"; it is possible that it was made to satirize Lee's owner, Baptist preacher Jesse Pitts Bodie. The figure depicts a pompous man seated in a casual, legs-crossed position. Despite his splendid attire, consisting of a frock coat with epaulets, piping, and large buttons, a bow tie, and a vest, his appearance is rather unkempt and shabby. The coat seems ill-fitting; the right shoulder of the garment is turned up. Even though the figure is posed casually in a moment of leisure—right hand on

87 *Face Vessel,* South Carolina.

the knee, left hand in the vest pocket—the face has a sour look. Its attitude is almost one of sulking, with tight lips and brooding eyes. The sculpture began as a wheel-thrown bottle. The features of human anatomy were then added by hand. The head was formed and attached so that the bottle opening runs directly through the top of the skull. Arms and legs were shaped from thin coils and attached to the body of the vessel; they are certainly spindly appendages and serve to emphasize the torso and head. Details of the costume were then added with care (the buttons, for example, are all the same size). These details as well as facial features were marked with iron oxide so that when fired they would show up as dark brown or black against the olive glaze.

This sculptured bottle has clear antecedents in British and American pottery. Molded bottles were made by Staffordshire potters in the late eighteenth century.[57] Since the founder of the South Carolina pottery industry, Abner Landrum, named one of his sons Wedgewood, it is probable that Staffordshire forms were known in the Edgefield District.[58] Lee's piece, however, is different from such prototypes in that it is not formed as a solid unit; the arms and legs stick out at odd angles. The bottle is not easy to grasp, and the thin clay legs may be easily broken (the piece has sustained just such damage).

Though it is in violation of the Staffordshire norm, it is, however, not without African sculptural precedent. The proportions are reminiscent of Kuba royal portraits, which, like Jim Lee's pieces, are roughly three-fourths trunk and head, with shrunken legs in a crossed configuration.[59] There is then a pronounced emphasis on head and torso. The focus on the upper body, particularly the head, is a feature that we have already encountered in African and Afro-American wood carving. Since aesthetic motivations are primarily mental constructs, it is understandable that the decorative influences used in the medium of wood might also be apparent when the medium is clay. Given the presence of ceramic forms in Edgefield that may be influenced by African aesthetics, it is then possible to consider the figure of the preacher as a variant form of a major theme of Afro-American ceramic art. Most black ceramic sculptors made face vessels; Jim Lee made the whole man. If the face vessels may be tied to Bakongo antecedents, it is not too difficult to connect Lee's figure to the Bakuba. Both Bantu groups are from Zaïre and are connected by the Congo River. The preacher bottle may thus be seen as related to but distinct from most Edgefield vessels because of its pos-

sible inspiration from the Kuba, whose artistic ideals are similar to but distinct from those of the Kongo. Moreover, Jim Lee was working on the fringes of the Edgefield tradition; the Roundtree and Bodie pottery, where he worked, was in Greenwood County, north of the Edgefield District. For this reason and for other possible cultural motives, his work represents a separate episode in the history of Afro-American pottery.

88 *Preacher,* Jim Lee.

Figure 33. Stoneware vessel sculpted into a human form, from the Odum and Turnlee Pottery of Knox Hill, Florida, 1860-1861. The glaze formula used in the Edgefield area was also used here. (After Ramsay.)

Apparently related to the preacher figure on the basis of form is a series of head and torso sculptures. One piece, from the Odum and Turnlee pottery of Knox Hill, Florida (1859-1860), is a pitcher form.[60] It has a double chamber configuration with two bulbous segments of almost equal size (Figure 33). The lower section, representing the shoulders and chest, is undecorated. The upper section, representing the head, has a spout centered at the top and an oval handle attached at an angle to the side. No specific information is as yet available about the maker of this piece, but there are some key characteristics found in this vessel which link it to the works of black potters in South Carolina. First, the double chamber form also occurs among Edgefield face vessels. Second, the same type of alkaline glaze is used in Edgefield. Furthermore, the treatment of eyes, mouth, chin, and ears strongly resembles the work of Jim Lee. There is, then, a good chance that the person who made this so-called voodoo jug was familiar with Edgefield ware. This sharing of features seems to be more than fortuitous.

Three other torso figures, attributed to Alabama origins, are rumored to have been used as cemetery decorations:

One is a double-chambered jug (Figure 34) very much like the Odum and Turnlee pitcher. The face on this vessel has been extensively damaged, and so it is difficult to make any stylistic judgment about the techniques of sculpture employed. It did at one time have two flimsy arms/handles, but both are now broken off.

A second piece has been dubbed the *Gospel Singer* [89]. It is a fairly straight-sided jug, about one foot tall, with sharply defined shoulders and a centered opening. The head is topped with a broad-brimmed conical hat, and small shards of china are used to mark the eyes and teeth. Costume is minimally detailed; a single raised coil suggests a coat by marking only its collar and lapel, and three buttons are used to indicate a

Figure 34. *Torso Figure*. Red ware with ash glaze, mid-19th century, H. 10-1/2 inches. United States, Alabama (?). Extensive damage to this piece makes it difficult to interpret, but surely it may be classed with the *Preacher Man* [90] and the *Gospel Singer* [89]. (After Driskell.)

shirt or vest. Two skinny arms end in hands, which are folded at the waist. This sculpted jug combines features of both white and black face vessel traditions. The use of china fragments is common in Anglo-American face jugs, while the construction of the arms recalls the techniques of Jim Lee. The origins of this piece remain cloudy. If made by a black person, it was an Afro-American with a broad knowledge of pottery possibilities.[61]

The best of this Alabama trio is called *Preacher Man* [90]. It is a bulky figure more than sixteen inches high. Lacking a spout or lid, it is not a functional vessel and consequently can be more easily interpreted as a graveyard decoration.

The torso section of the figure, in fact, has the same bell shape as ceramic supports for grave markers made in Alabama and Mississippi.[62] As in the previously described piece, the hands are folded at the waist. The head is also topped with a hat, but in this case it is an exquisitely styled skimmer. Colored with iron oxide, the hat is reddish-brown with a matt finish, in contrast to the shiny brown glaze of the rest of the figure. The face is impressively modeled with eye sockets that penetrate into the empty hollow center of the sculpture. The lips are wide and the nose broad in an apparent attempt to represent Negro facial features. The overall handling of mass and form in this piece is so impressive that it stands

89 *Gospel Singer*, Eastern Alabama (?).

90 *Preacher Man*, Eastern Alabama (?).

out as the masterwork among known ceramic torso figures. One scholar has remarked that this statue projects a kind of sympathy for a black subject.[63] If, indeed, the figure was meant to depict a black man or preacher, it is a competent and well-executed statement. Since the features of this piece tend to favor abstract presentation over naturalism, it might be classed as a black creation. It is not clear how one safely measures such an intangible as ethnicity in a mute work whose only history is rumor. More information here would be helpful, but it would not be surprising to discover Afro-American origins.

Texas Folk Pottery

The history of folk pottery in Texas is only just now beginning to be explored, but even the first probes have revealed a black involvement.[64] Slave labor was used extensively at several potteries in east Texas—most notably, the pottery opened in 1857 by John M. Wilson in Guadalupe County. After 1869 John Wilson sold his operation to black potter Hirum Wilson, who retained the black employees of the former owner. Two who are remembered were Wallace and James Wilson. (They were not related; they shared the same master.) When Hirum Wilson died in 1884, these two men teamed up with another black potter, John Chandler, and a white man, Alwerp A. Durham. The black potters made the ware and Durham would haul and sell it. It was in this manner that the Wilson-Chandler pottery made its stoneware available to the public until 1903. The works of the three potteries mentioned here are similar in form, consisting mainly of utilitarian wares such as jugs, churns, and jars.

The history of Texas pottery is marked, however, by a changing sequence of glaze usage. Alkaline glazes were used first [91] but gave way to salt and later to slip glazes [92].[65] We can see, then, that at the outset east Texas pots and Edgefield pots used the same glaze formulas, but then with the adoption of widespread influences the ware lost its specific regional characteristic.

The contribution of Blacks to the ceramic trade in Texas is clear; without their effort there would have been much less pottery available. Whether or not their achievement may be considered distinct in American folk pottery remains to be discovered. The known black wares from Texas are not as spectacular as the pottery of Edgefield, but the conditions of communal participation, technical competence, and a large measure of black control over the work suggest that greater discoveries lie ahead.

Opposite:

92 *Five-Gallon Storage Jar,* Hirum Wilson Pottery.

91 *Three-Gallon Jug,* attributed to John M. Wilson Pottery.

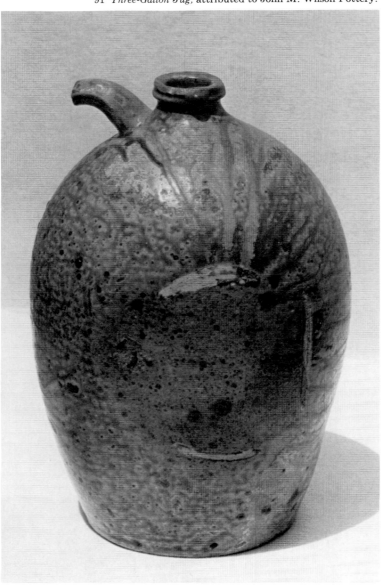

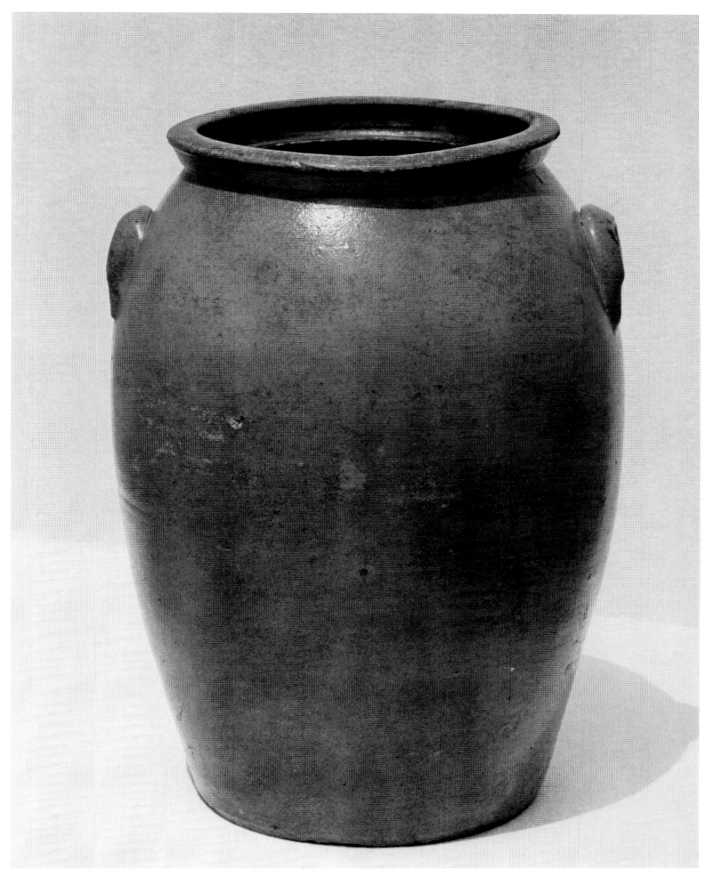

95

93 *Skull,* James "Son Ford" Thomas.

Contemporary Clay Sculpture

The artistic achievements of Afro-Americans in traditional pottery are largely a closed account. Folk pottery is now only a marginal craft pandering to the whims of occasional visitors to jugtowns and flea markets. Folk potters of any tradition are rare. But the aesthetic force that may emerge from clay is still very much alive. James "Son" Thomas, a blues musician/handyman from Leland, Mississippi, sculpts clay even today. His repertoire is extensive, including preachers in pulpits, corpses in coffins, different varieties of birds, and a vast array of representational busts.[66] At the core of his clay creation is the skull [93]. He describes the process for making this object: "You first shape it up like a regular man's head. Then you cuts it down to a skellepin [skeleton] head because you couldn't make a skellepin head straight out without cutting it down."[67] The end product of this effort is an image of death, a powerful iconic reminder of human fate that immediately recalls the face vessels of Edgefield—clay objects over one hundred years removed from Leland, Mississippi, and "Son" Thomas.

We must infer then that cultural influences have survived. Black folk religion has remained fairly stable throughout the South over the last century. Some philosophical concepts also made the journey from Africa and survived without much change: the African regard for the power of the head, for example, becomes the "strength of the haid" in conjuration.[68] It is not far-fetched to expect that aesthetic concepts might also remain fairly stable. A face vessel and a clay skull are both manifestations of a cultural sense that power is invested in the image of a head. But even more significantly, these Afro-American heads are invested with powerful eyes and glistening teeth. Whether the look is a painful grimace or a threatening snarl, the object commands attention and probably respect. A distinctly Afro-American pottery may today be only a historical subject, but the vision of black artists lives on and finds expression in the medium of clay.

6. Boatbuilding

Dugout canoes were at one time a very common water craft in America. Well known first among Native Americans, these hewn boats were quickly adopted by European settlers; they became an important means of transportation, particularly in the Chesapeake region and the tidewater areas of the South. But the links between Indians and Euro-Americans were not direct. Henry Glassie has written: "The New World dugout may have a debt to pay in history to Africa and to Ireland as well as to the Indian's America. It is suggestive that the idea of the canoe was not fully taken into Anglo-American culture until the population included its African and Irish element."[1]

The development of the dugout canoe in the United States is extremely complex. Not only must we contend with a three-way cultural interaction, but we must also sort out the influences of local developments as well as the widespread geographical diffusion of boat types. While black craftsmen may not have invented the New World dugout, their participation in its history cannot be overlooked. The log dugout was a common work boat even at the beginning of this century. J. F. Douty estimated that in 1900 there were between 4,000 and 7,000 of these humble craft on the Chesapeake Bay.[2] These large numbers compel us to recognize the dugout as important and the black involvement with it as a noteworthy craft achievement. Dugouts were obviously not rare and exotic items; for the Chesapeake region, at least, they were a vital part of everyday experience. Swepson Earle noted: "A sight common in the Bay Country, and one unequalled elsewhere on the coast, used to be that of a fleet of several hundred canoes hoisting sails and getting under way shortly before sunset."[3]

Of two basic forms of dugout, the simplest consisted of a single log which was hollowed out by controlled burning and subsequent scraping and chopping. Because the ends were left blunt, the craft was to the first European adventurers in the New World reminiscent of a hog trough.[4] These settlers, nevertheless, were impressed with the speed of the craft and soon induced the Indians to make log canoes for them (Figure 35).[5] Euro-Americans continued to use the single-log dugout for more than two centuries but with a minor, although significant, modification: the bow of the canoe was pointed so that it resembled

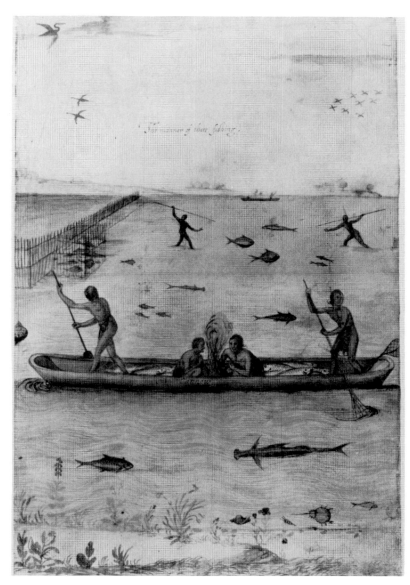

Figure 35. *Indians Fishing.* Water colors touched with white and gold, ca. 1585, 13-7/8 x 9-1/4 inches. Inscription: [at the top] The manner of their fishing; [on the canoe] A Cannow. John White, English, 1577-1593. The British Museum, London. Shown in this painting is a Native American log dugout, a single log with rounded ends and sides.

a European boat (Figure 36).[6] By the 1860's the dugout was further altered so that it was pointed at both ends; it was then a double-ender and fit nicely into the mainstream of European boat design. The native craft was thus modified by Western concepts of what a boat should look like.

The second dugout form consisted of several hewn logs joined together; three was the usual number, but eventually as many as nine were used. The multiple-log boat was larger than those made from only a single log, and because of its wider beam, it was more stable in the water. Often fitted with mast, sails, and centerboard, this form of the dugout became the preferred type (Figure 37). But more about this later.

Single-Log Dugout

It was not difficult for Euro-Americans to accept the single-log Indian dugout, because similar crafts had been known for centuries in Ireland.[7] After it was modified to look more like a proper double-ender, it seemed even more acceptable. But looking like a normal boat is not the same thing as acting like a normal boat. The single-log canoe was a tricky craft; it was unstable and difficult to manage. A traveler to Maryland in 1736 observed that a log dugout was "... a very small and dangerous sort of canoa, liable to be overturn'd by the least Motion of the Sitters in it. The Negroes manage them very dextrously, with a Paddle...."[8] Mention here of black boating skills is significant, for it points to an important influence in the maintenance and development of the dugout tradition.

The double-ended dugout form is also an African form known in fishing settlements from Senegal to Angola.[9] In 1705 William Bosman noted that fishing canoes were quite numerous in the Gold Coast (modern Ghana). It was not unusual for 500 to 600 canoes, each carrying three men, to put to sea each morning. The settlement at Anomabu had a daily fishing fleet of 800 two- or three-seater canoes.[10] It is not surprising, then, that Blacks should be competent at handling log dugouts. They were carrying on canoeing traditions not very different from those they had left behind. It is evident that slave owners consciously exploited this African skill. One black boatman in Virginia was described in the following manner: "he calls himself Bonna, and says he came from a Place of that name in the Ibo Country, in Africa, where he served in the capacity of a canoe man."[11] Indeed, during the period of the slave trade, the area of Nigeria around the city of Bonny was in Ibo territory, where canoe travel is quite common due to the riverine environment. When slaves were put to work hollowing out canoes, therefore, they did not find it an unfamiliar task. The talent of some African boatbuilders is described by James Hornell: "A notable exception to the general roughness of African canoe execution is seen in the small fishing canoes of the Krumen of West Africa. Here the canoe builder has dubbed out a canoe shell with bottom and sides so exceedingly thin that the small craft is as light as though it were built of birch bark."[12] Should one of the Kru tribe ever have fallen into the slavers' nets his skill would have been much appreciated. It is clear that African knowledge of boatbuilding was put to use by Whites. The *South Carolina Gazette* in the 1740's and '50's mentions cypress canoes of various dimensions, usually painted in bright colors, that were made on local plantations.[13] The single-log dugout was retained in the United States long after the demise of its Indian creators, not only because it was Europeanized but also because it was Africanized.

Multiple-Log Boats

The history of the single-log canoe evidently involves a syncretic blend of Indian, European, and African influences. The multiple-log dugout, on the other hand, seems to result from a sequential development rather than a confluence of cultural input. The only possible Old World antecedents for this boat type are found in India, Persia, and Arabia, but in those instances the vessels were more on the order of rafts and consisted simply of logs lashed together after some very minimal shaping.[14] The multiple-log canoe is, however, indigenous to the West Indies,[15] where the Carib Indians made canoes from several hewn pieces of wood. A 1667 description of the Carib boat form reads as follows: "Pirogues appear to be nothing more than two great planks joined to a base (which is the hollowed log), and these boats have a width across the gunwales of 6 or 7 feet. Where the planks join at each end of the boat, the opening is closed up with pieces of plank. This is especially true with the stern, which is almost always slightly higher than the bow."[16] Such vessels are without question canoe forms; more importantly, they were already present when Europeans arrived in the New World. Incidentally, the French word "pirogue" was taken directly from the Carib term for boat.

The multiple-log dugout, like the single-log

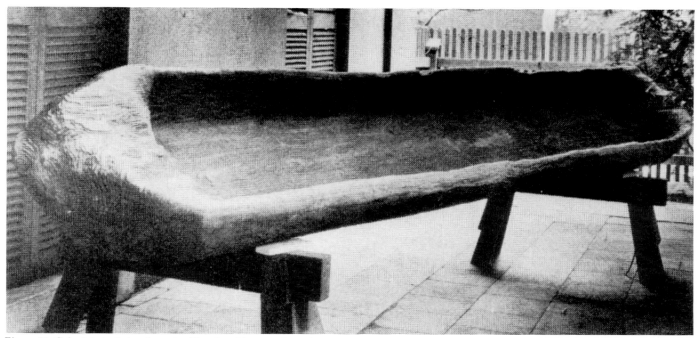

Figure 36. Colonial single-log dugout with pointed bow, early 18th century. The pointed bow was the first phase in the "Europeanizing" of a Native American artifact. (After Brewington, *Chesapeake Bay Log Canoes. . . .*)

Figure 37. *Queen of the Fleet.* Wood, 1880, 336 x 71 inches. William Hunt, American, active ca. 1880. Mariners Museum, Newport News, Virginia. This is a three-log canoe of the Poquoson type.

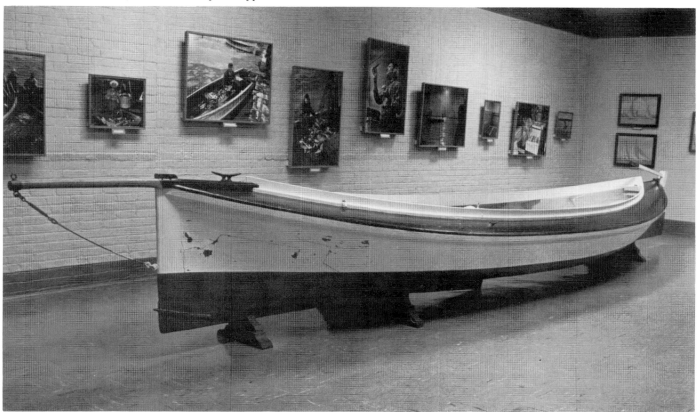

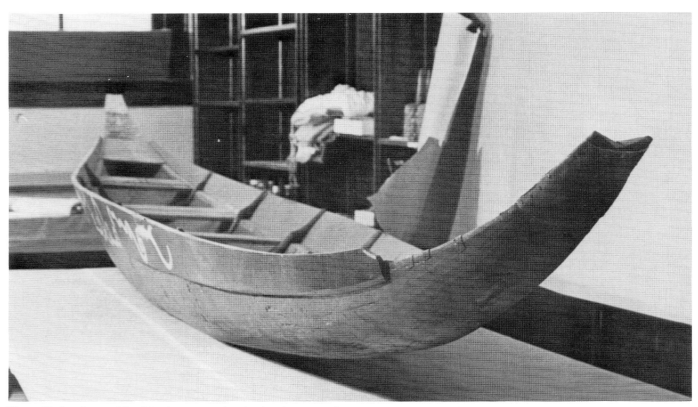

Figure 38. *Log Dugout*. Wood (mahogany), painted red and green, 20th century, L. 256 inches. South America, Guiana, Saramaka tribe. Indiana University Museum. Note the plank-raised sides.

94 *Plantation Barge "Bessie,"* South Carolina.

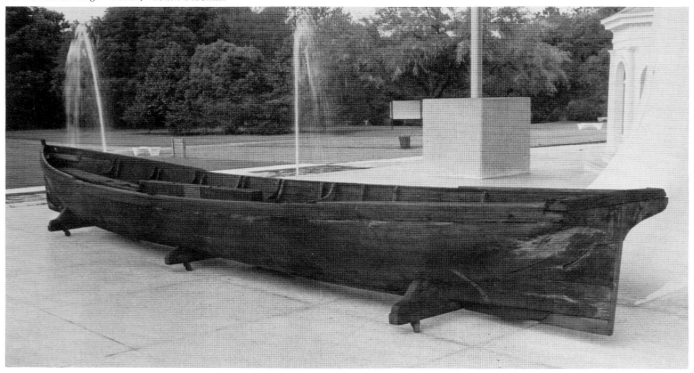

dugout, passed from the Indians to the newly arrived Europeans and Africans. The artifact, however, was transferred more easily to Blacks than to Whites. The first European colonists were notoriously inept at managing small craft on the open sea and in turbulent surf. R. P. Raymond Breton noted the difficulties of the French in adapting to canoe travel. He wrote in 1665:

> The French learned from the Savages to hollow out trees to make canoes; but they did not learn from them to row them, steer them, or jump overboard to right them when they overturned: the Savages are not afraid of overturning, wetting their clothes, losing anything, or drowning, but most French fear all of these things.[17]

Africans, being accustomed to steering canoes through crashing surf and paddling against stiff riptides, suffered no trauma when made to navigate a Carib pirogue. Richard Price has noted that African slaves in the West Indies quickly took on the role of plantation fishermen which had first been filled by Carib Indians.[18] Fishing was a well respected and prestigious task among slaves. It was also a desirable role because of the sense of freedom attainable while fishing on the open sea and because of the very real possibility of outright escape.

Blacks also took over the construction of the pirogues in the West Indies, for the Indians were slaughtered in short order and the Europeans were not at first very secure about small boats. An example of how the Indian artifact thrives in an Afro-American cultural setting is provided by the Maroon communities of Guiana. These groups of Blacks, descendants of seventeenth-century runaways, continue today to make canoes in the Carib manner (Figure 38). A large log is first hollowed out and then burned slightly to make the hull pliable. The log is then spread out and propped open with short branches until it hardens into a wider shape. Planks are then attached to the sides to increase the amount of freeboard by as much as three feet.[19] Africans acquired the Carib dugout with great ease, for in terms of form and structure boats made by Guianese Blacks are identical to the Carib vessels described in sixteenth- and seventeenth-century travel accounts. Perhaps the successful transfer is due in part to the similarities of a Carib and West African dugout. Both were generally long, slim, double-ended boats. The basic New World innovation of adding plank sides to the hewn hull is even anticipated to some degree in West Africa, for in coastal Benin, Ghana, and Senegal the sides of dugout canoes are raised with plank construction.[20]

Under the names "periagua," or "pettiauger" (Anglicized versions of the word "pirogue"), the multiple-log dugout spread from the West Indies to the coastal environs of the Carolinas and Virginia. Howard I. Chapelle reports that the term was known as early as 1785 in New York, and he confirms the suggestion made here of Carib origins: "The name seems to have been particularly used to indicate some kind of a large West Indian dugout, perhaps a log hull with plank raising strakes, that was long popular with freebooters there."[21] There are numerous early accounts which describe the colonial periagua. John Lawson described them in the Carolinas in 1709:

> Of these great Trees [cypress] the Pereaugers and Canoes are scooped and made; which sort of vessels are chiefly to pass over the Rivers, Creeks, and Bays and to transport Goods and lumber from one River to another. Some are so large as to carry thirty Barrels, tho' of one entire Piece of Timber. Others, that are split down the Bottom, and a piece added thereto, will carry eighty, or a hundred.[22]

These boats were generally manned by black oarsmen. In 1741, one slave owner advertised two Blacks as a pair "that is capable to go in a Pettiauger, and has practis'd going by Water above 10 Years and understand their Business as well as most of their colour."[23] Blacks also built multiple-log boats; an example built in 1855 in the Santee River area of South Carolina survives today [94]. It is an impressive plantation barge hewn from two large cypress logs. Although it is modeled after a naval ship's boat[24] rather than a canoe, there is no doubt that dugout technology has been employed. The rugged sturdiness of this boat more than a century after it was built is ample testimony to the boat-building expertise of slave craftsmen.

Since there were few roads in the South connecting tidewater settlements, most travel was done by small boat. Slaves who rowed the canoes often had to serve as guides as well as boatmen.[25] There are ample statistics from eighteenth-century Virginia to show that Blacks had strong control over the waterways. Of 359 runaways with listed occupations, fifty-five were watermen.[26] We find then that use of a West Indian type of craft had by the last quarter of the eighteenth century spread across much of the eastern seaboard, and that its care and conduct was given mostly to black oarsmen. A knowledge of

circumstances will help us understand boat-building developments in the Chesapeake Bay region.

An oral testimony collected by the late Dr. O. T. Amory of the Mariners Museum asserts that a slave named Aaron, who belonged to John Dennis of York County, Virginia, built the first two- and three-log canoes on Lamb's Creek sometime late in the eighteenth century.[27] While none of this information is as yet verified, the focus on specific information rather than vague generalities tempts us to regard this verbal testimony with some respect. The suggestion that multiple-log canoes were first produced in the Chesapeake region at the hands of a black craftsman squares well with information from the York County area which can be documented: i.e., a black shipwright named George was living in Poquoson in York County, perhaps near Aaron, before he ran away on August 3, 1795.[28] Furthermore, Joseph P. Goldenberg, in his recent study of colonial shipbuilding, noted that between 1742 and 1752 there were at least fifteen black shipwrights in Norfolk, Virginia; commenting on conditions in the late eighteenth century, he observed that: "... wills and inventories support the picture of extensive slave ownership by Virginia [ship] builders. For example, William Ashley left fourteen slaves to his family, John Widden left ten, and Thomas Herbert more than thirty."[29] When John Thompson of Yorktown disposed of his holdings in 1768, he listed "several valuable water Negroes, one of them an extraordinary good sail maker."[30] There were other Blacks employed as boatbuilders along the western shore of the Chesapeake in the same period. Robert Carter of Westmoreland County, Virginia, is reported to have hired Richard Oharrow in 1774 to build a pettiauger; to accomplish the task he was given the assistance of four slaves.[31] One John Gilliam of Prince Georges County, Maryland, reported that his runaway slave Billy Pompey was "an extraordinary good ship carpenter."[32] The following statement from the *Raleigh Star* on September 27, 1811, confirms both the participation and excellence of black shipwrights:

A brig is now at Alexandria which was launched from the estate of Col. John Tayloe, the beauty and workmanship of which are said by the Alexandria Gazette not to be exceeded by any vessel of that port. What is remarkable we learn that this brig was drafted by a coloured man belonging to Col. Tayloe, and under his superintendence built from her keel to her topmast.

(If a Black living on the Potomac could build a ship in 1811, it is not so unlikely that another black boatbuilder, named Aaron, could have hewn a canoe twenty or thirty years earlier, just two river inlets to the south.)

That the inspiration for the multiple-log dugout came from a West Indian source and is not an independent invention developed locally in Virginia is suggested by a 1795 description of a log vessel which was made with "remarkable stout timbers of West India wood."[33] M. V. Brewington verifies the dependence of colonial Maryland on maritime trade with the Caribbean; hence, it is fairly certain that West Indian boat types would have been known by Chesapeake watermen in the eighteenth century.[34] It may be mere coincidence, but the data available at this time indicate that a West Indian type of canoe was found in the Chesapeake region at the same time that slaves knowledgeable in handling this type of vessel are alleged to have first produced them.

Variations in construction techniques separate boatbuilding traditions at Chesapeake Bay (see map, Figure 40). On Virginia's western shore Poquoson log boats were hewn "by eye"; there was general disregard for plans or precision. Curved logs were often selected for the side planks so that the canoe would take shape naturally (Figure 39). The Poquoson canoe, as a result, often shows some variation in the two sides of the hull so that it sails faster on one tack than the other.[35] Two eastern shore canoe subtypes are both based on scaled half-models. In Maryland, on the other hand, logs are chosen for their straightness; cuts are measured precisely and chalked out on the squared timbers before any shaping takes place. The strict use of predetermined templates seems to set the Maryland practices apart from the techniques used in Virginia.

The rigorous procedures used on the eastern shore fall right in the center of a Euro-American tradition for remaking the environment; before working with a natural material (in this case a tree), these Maryland boatbuilders convert it into an artificial substance (a squared beam). Conceptually, the natural must be converted into the cultural in order to be accepted. Henry Glassie, in describing the folk housing of eighteenth-century Virginia, states: "The tree was chopped, drawn, hewn, sawed, chiseled, shaved, pierced with nails, and hidden by paint. Nature was made to submit utterly to the ideas of man."[36] The same attitude was also manifested with log dugouts in Maryland. Why a different

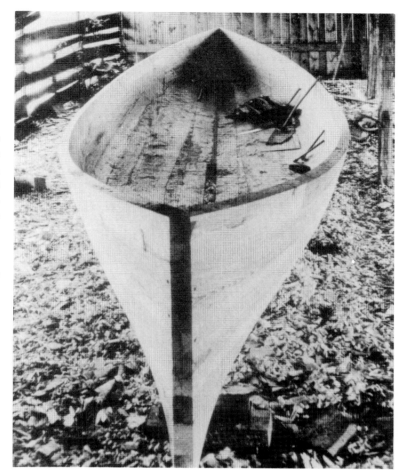

Figure 39. Hull of a five-log Poquoson canoe, ca. 1930. Several smaller pieces of wood have been added to finish the boat. (After Brewington, *Chesapeake Bay Log Canoes. . . .*)

approach was used just forty miles across the bay in Virginia may be explained by the presence there of an alternative culture. People of African descent are just as aggressive toward nature as Europeans, but they are less inclined to accept the value of technological complexity. House posts which retain the natural curve of the original branch are accepted in West African architecture but would be judged crude and unfinished by an Anglo-American builder. A similar acceptance of natural curvature may be seen in the Poquoson canoe. Shaping a canoe by eye rather than by plan indicates a different cultural bias, a different attitude about media, technics, and artifacts. The multiple-log canoes built on the western shore of the Chesapeake manifest a sensitivity to material and an acceptance of the natural irregularities judged abhorent by Anglo-American boatbuilders. What was called on the eastern shore the "winchum-squinchum method" was probably the retention of an African inclination in the making of boats. Since the Poquoson canoe was probably the first multiple-log boat built on the Chesapeake, the Maryland craft forms would seem to have developed only after white craftsmen had worked out a complex technology for the Virginia dugout.

Although African prototypes may have exerted only a very minor influence on Chesapeake log boats, it is worth noting that the dugouts of coastal Ghana have some of the same characteristics of shape and form found in Poquoson canoes. Both are pointed at the ends and have rounded hulls. In the Ghanaian boat the hull curves in slightly at the top; in the Chesapeake canoe, plank wash strakes attached to the top of the side logs tilt toward the center of the boat. The added planking carries the edge of the hull toward the center of the vessel, enclosing the passenger in a manner similar to the African craft. Both types of craft sometimes carried a single mast near the bow, which was rigged with a single leg-of-mutton sail. When built to the

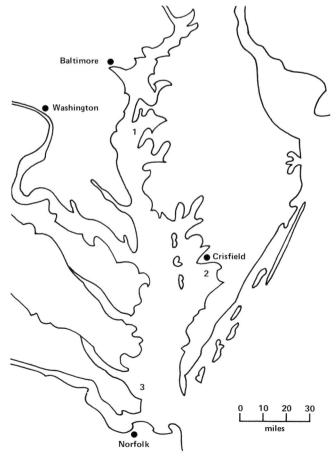

Figure 40. Centers for the production of Chesapeake Bay log canoes: 1. Tilghman Island; 2. Pocomoke Sound; 3. Poquoson. The tradition for building multiple-log craft seems to have originated on the western shore of the Bay in Virginia and then diffused to Maryland's eastern shore.

103

same dimensions a Fanti fishing canoe and a Poquoson multiple-log dugout definitely have the same look and feel about them (Figures 41a,b).

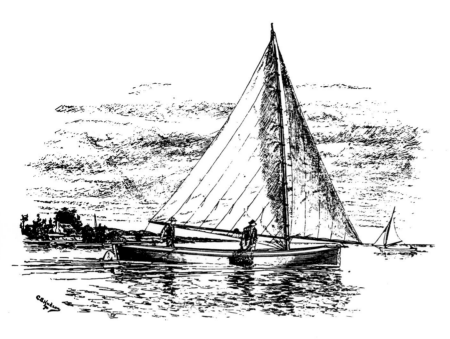

Figure 41a. Dredging crabs in a Poquoson log canoe, 1890. (After Brewington, *Chesapeake Bay Log Canoes.* . . .)

Figure 41b. Fanti fishing canoe, ca. 1945. (After Glassie, "The Nature of the New World Artifact. . . .")

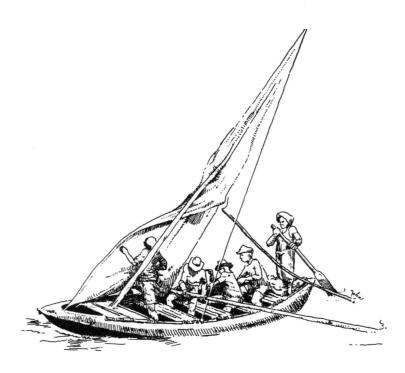

The total impact of the multiple-log canoe is difficult to gauge. Not only did Chesapeake dugout types develop as work boats, but by 1885 a special breed of dugout racing canoe with as many as six sails also had evolved on the eastern shore (Figure 42).[37] The log canoe also gave rise to a larger boat called a "bugeye." Averaging more than fifty feet in length and carrying two masts, these post-Civil War oyster boats at first had hulls which were hewn from logs. Later planking was substituted, thus disguising the relationship of the bugeye to the log canoe. The plank-hulled bugeye was next altered to create the sail-powered skipjack, which still criss-crosses the Chesapeake Bay dredging oysters. According to Glassie, the skipjack deck plan "amount[s] precisely to the forward two-thirds of the old bugeye."[38] The skipjack must, then, ultimately be considered a descendant of the log canoe. Although the development of nineteenth-century water craft might have occurred without the multiple-log dugout, the historical sequence began with that vessel. The importance of a slave named Aaron and his contribution to American small water craft design cannot be slighted. His effort and the work of other, as yet unnamed, black boatbuilders gave rise to a vital and still vibrant tradition in American craftsmanship.

The multiple-log dugout, once so common along the eastern seaboard, is no longer built. The days of sail work boats are over. Some of the larger log canoes have been modified by the addition of forward cuddies and gasoline engines (Figure 43) so that, to the untrained eye, they appear no different from any other oyster-tonging craft. That these old boats can survive such modifications is not surprising, for a rugged log hull will outlast four decks.[39]

At the present time, another boat form that may have evolved from log dugout construction is being built by black watermen in South Carolina (Figure 44). Its connection to the older log pirogue is suggested by its contemporary name: Sea Islands fishermen call this craft a "bateau" [95]. It has a flat bottom made of boards, which curve upward slightly at the ends and sides and form the bow. Although the bottom may be made up of several boards, the boat has basically only three major pieces: keel section and two sides. A short stern piece squares off the back of the boat. Now that marine plywood is available, the bateau may in fact still be fashioned mainly from three large pieces of wood as in former times when three logs were used. The shift in construc-

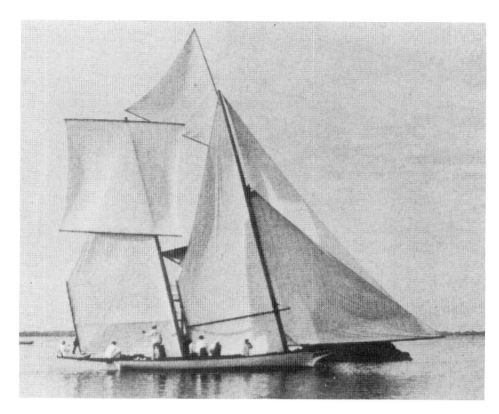

Left: Figure 42. Racing canoe *Flying Cloud.* Note the elaborate arrangement of sails. (After Brewington, *Chesapeake Bay Log Canoes. . . .*)

Below: Figure 43. Contemporary multiple-log dugout modified by addition of forward cuddy and inboard engine, from Crisfield, Maryland. (After Walter Escher, *et. al.,* eds., *Festchrift fur Robert Wildhaber* [Basel: G. Krebs, 1972].)

Bottom: Figure 44. Sea Islands "Batoe" from near Beaufort, South Carolina. Photograph (ca. 1910), collection of Penn Community Services, Inc., St. Helena, South Carolina.

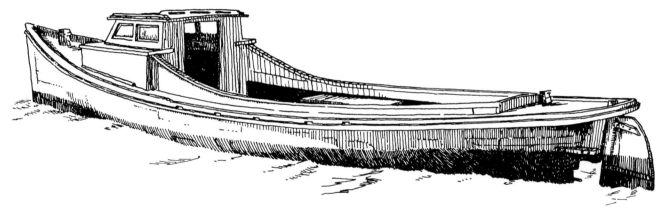

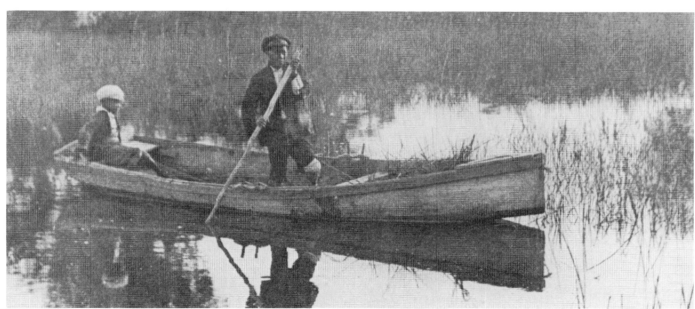

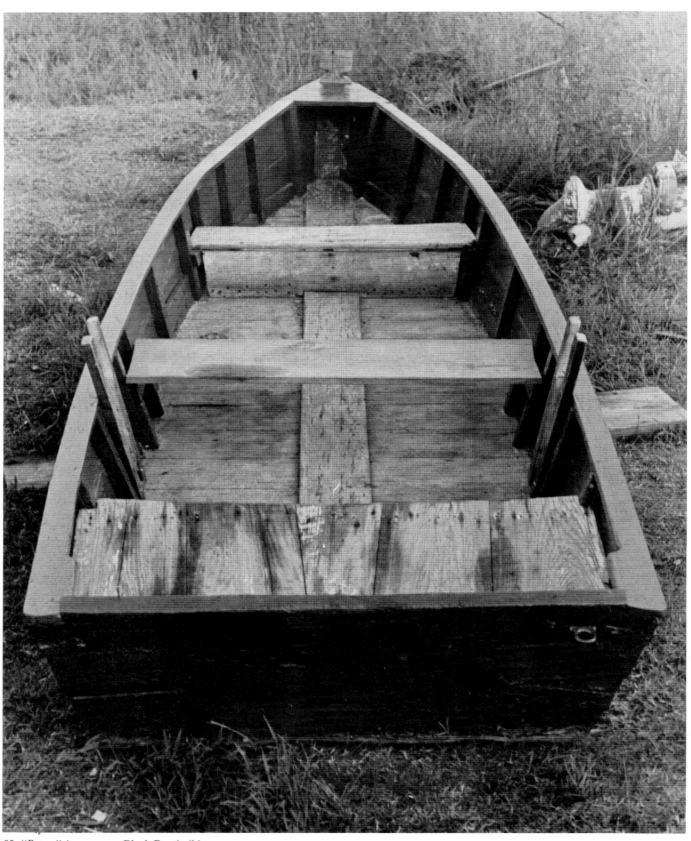

95 *"Batoe,"* Anonymous Black Boatbuilder.

tion technique does not, then, necessarily disrupt the traditions of boatbuilding. The replacement of hewn logs with milled planks occurred also among Louisiana Cajuns, but the concept of the older boat remained strong; there was ". . . remarkable similarity between the dugout and plank pirogues in form, size, use and associated equipment. . . ."[40] The same may be said of the Afro-American plank-built boat; it may be a modern version of an older artifact.

Afro-American Marine Traditions

Boatbuilding is a centuries-old tradition among Blacks on the American continent, beginning in the West Indies and continuing on into North America. Blacks, as we have seen, have been responsible for the construction of several types of small boats (even ships), particularly the multiple-log canoe. While this boat is not a particularly African artifact, it did derive from extensive Afro-American participation in water-oriented occupations. Just as coiled baskets demonstrate the impact of African agricultural technology on colonial farming in South Carolina, so may the proliferation of the multiple-log canoe be regarded as a sign of Afro-American influence on American water-borne customs. Known as prodigious fishermen in Africa, Blacks in South Carolina also were known for similar talents. Sometime in the 1730's a colonial officer remarked, "I've known two Negroes take between 14 & 1500 Trouts above 3 feet long, w^ch make an excellent dry fish."[41] The techniques used by Blacks involved both hand lines and cast nets, techniques with ample African precedents.[42] The black boatbuilding tradition in the United States should, then, be regarded as only one part of an African marine complex.

Blacks were brought to America with many well-developed skills and talents that could be put to use all along the coastal waterways. They knew how to navigate shallow streams and marshes (Figures 45, 46), to ferry canoes through the surf, to fish with line and net, and to make boats. To this day, they continue to be deck hands on oyster dredging and clamming boats in the Menhaden fishing fleet of Virginia, and they carry on traditions as independent watermen, masters of sailing boats, sail sewers, and boatbuilders.[43] But whether he hewed a log dugout or built a plank bateau, the black boatbuilder was fashioning a vessel that would enable him to carry out a life's work that is deeply rooted in an African past.

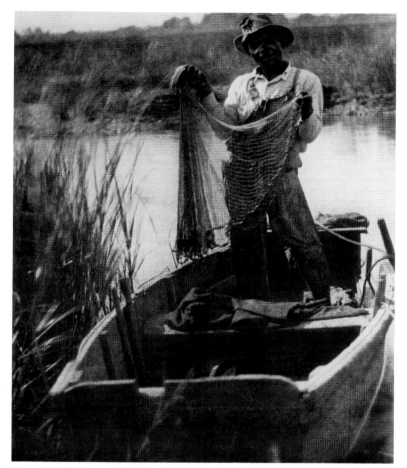

Figure 45. Fisherman, Sea Islands, Georgia, in plank bateau, 1933. Photograph, collection of the Library of Congress, Washington.

Figure 46. Detail of *Will Schuster and Blackman Going Shooting for Rail*. Oil on canvas, 1876, 22-1/8 x 30-1/4 inches. Thomas Eakins, American, 1844-1916. Yale University Art Gallery, Bequest of Stephan Carlton Clark, BA 1903.

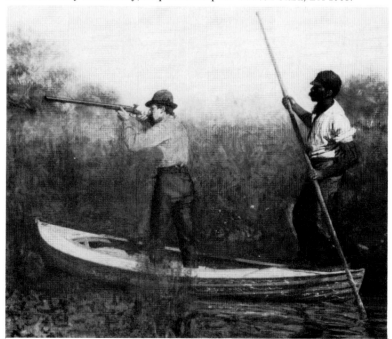

7. Blacksmithing

Except for carpentry there is no other trade in which Afro-American talent was expressed more often than in blacksmithing. Wherever records are available to assess the participation of Blacks in skilled occupations there are always abundant references to the tasks of the blacksmith: a slave named Dick from Potomac River, Virginia, was described in 1759 as a wheelwright; Stephen Butler of Charles County, Maryland, was a blacksmith in 1772; Harry of Prince George's County, Maryland, was recorded as a wheelwright in 1775; James is listed in 1791 as a maker of axes from Jones County, North Carolina; in 1794 Thomas Bailey, a blacksmith and fiddle player, ran away from Germana, Virginia; John Roman of Charleston, South Carolina, was known as a blacksmith and gunsmith in 1808.[1] It is too soon to say just how many black ironworkers there have been, but it is apparent that there were a great many of them and that an important subject of study awaits intensive investigation. Once we understand that Blacks were commonly employed in the metal trades— that in some places they dominated the smithing craft—we can recognize that the potential existed for an Afro-American tradition in blacksmithing. This potential was seized upon, and a rich record of achievement was written in iron. These ironworks are today the pride of several southern cities; they are also the pride of Afro-American blacksmiths.

The small sample of early slave blacksmiths given above only begins to suggest a pattern of dependence on black labor. When Bernard Moore of Todd's Warehouse, Virginia, sold his holdings in 1769 he had seventeen skilled slave workmen. While he may have praised their ability in order to inflate their sales value, we can at least derive a sense of the wide variety of tasks performed by the slaves from Moore's own account:

> Billy, aged twenty-two, is an exceeding trusty good forgeman as well at the finery as under the hammer, and understands putting up his fire; Mungo, twenty-four, is a good firer and hammer man; Sam, twenty-six, a capable good chafery hand; Abraham, twenty-six, a reliable forge carpenter; while Bob, twenty-seven, thoroughly understands the duties of a master collier.[2]

It is clear from this that Blacks were expected to work in many aspects of the iron trade, from watching forge fires to hammering out tools. Because many slave smiths and forgemen were available, Afro-American blacksmiths seem to have been employed in groups rather than as isolated craftsmen. The sense of group participation presented above was not unique in Virginia. In 1770, at the Providence Forge in New Kent County, ten slaves banged out hoes and axes for local farmers. It is important to realize that under circumstances where Afro-American blacksmiths labored with co-racial workmates, it was possible for an ethnic craft tradition to develop. Among the black potters of South Carolina an African-influenced form of ceramic sculpture was created. Among black craftsmen in Virginia the communal contexts of blacksmithing may have served as a similar creative stimulus. The Oxford Iron Works owned 220 Blacks; the Tredegar Iron Company of Richmond by 1861 had employed more than 450 slaves.[3] Afro-American blacksmiths were clearly capable artisans, who were well trained in the techniques of the craft. Placed in work situations with other Blacks, they may have been inclined to dwell upon objects of their own creation rather than on assigned tasks. In one case, which we shall examine here, a slave blacksmith conjured up a form which is definitely an example of African-inspired art.

Iron Sculpture

This piece of wrought-iron sculpture (Figure 47) was discovered during the excavation of the site of a blacksmith shop and slave quarters in Alexandria, Virginia. It is a figure of a man, symmetrically posed, with legs spread apart, and arms bent and reaching forward. The head has been worked so that it includes all the appropriate features, but the eyebrows and beard are particularly noticeable. The hands and feet of the figure are rendered with a full complement of fingers and toes. The trunk retains the square shape of the original iron bar from which the statue was forged. Although the figure presents only a minimal image, it is a powerful work. Its direct frontal presentation, together with a rough hammering technique clearly visible on all surfaces, combine to suggest the primal essence of human form. The date of origin for this statue has been set at sometime in the late eighteenth century.

The circumstances of discovery alone are adequate proof that this piece of sculpture was created by a black artisan. Stylistic evidence may also be added to provide further confirmation of black origins. Malcolm Watkins has called it a "remarkable example of African artistic expression in ironwork."[4] Another commentator refers to this piece as "one of the rare objects which link American Negro Art to Africa."[5] Indeed, comparisons with the wrought-iron sculpture of the Bamana [96] immediately set off sparks of recognition. If the forms made by Mande-speaking blacksmiths do not correspond exactly with the iron statue from Virginia, there can be no question that the handling of mass and medium is very similar. It is in the gray area of attitude that the strongest resemblances emerge.[6] Since the records of the slave trade for colonial Virginia reveal that one-seventh of all

96 *Statue*, Mali.

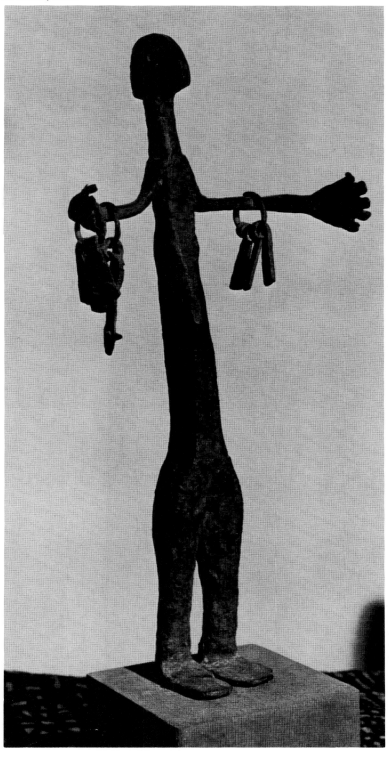

Figure 47. *Wrought-Iron Figure*. Late 18th century, H. 11 inches. Virginia, Alexandria. Collection of Adele Earnest, Stony Point, New York.

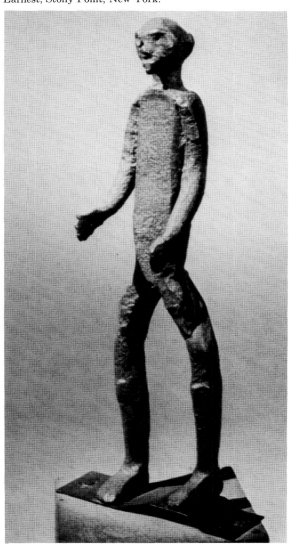

the Africans imported between 1710 and 1769 were from the Senegambian area and thus very likely Mande-speakers, it is not difficult to explain why this iron statue possesses such strong affinities to the wrought-iron sculpture of the Western Sudan.[7] Africans of Mandinka origins are mentioned several times in accounts of runaways from the 1770's.[8] Since this figure was made sometime during the late eighteenth century, it is very likely that its creator was either African-born or a first generation slave whose memory of his African heritage was still very strong. Watkins' assessment of this object as African rather than Afro-American is appropriate; the statue is a remarkable survival rather than an innovative adaptation. The value that was placed upon it is indicated by the fact that it was hidden from common view, buried in the dirt floor of the smithy. Apparently it had to be abandoned, and it only emerged again with the careful probes of the archaeologist's trowel.

While no other pieces of early Afro-American wrought-iron sculpture have been discovered, there is no question that slave blacksmiths were considered valuable artisans. A visitor to Natchez in 1835 remarked that "... slaves are trained to every kind of manual labor. The blacksmith, cabinet-maker, carpenter, builder, wheelwright—all have one or more slaves laboring at their trades. The negro is a third arm to every working man, who can possibly save enough money to purchase one. He is the 'right-hand man' of every man."[9] Earlier, in South Carolina, eighty Blacks were employed at the Aera and Aetna Iron Foundry in York County. According to James Porter, "... they engaged in every important task in the production of both plain and ornamental iron."[10] The work of slave blacksmiths and ironworkers was crucial for the financial success of this enterprise.

Ironwork and Insurrection

Although slave ironworkers were valuable artisans, they were also potentially dangerous. In 1792 a group of nine hundred Virginia slaves, armed with three hundred spears that had been forged by a blacksmith in their group, rebelled and put up a stiff resistance before their uprising was crushed.[11] The famous rebellion led by Gabriel Prosser of Richmond, Virginia, in 1800 included the material support of a slave blacksmith whose task was to make swords.[12] Denmark Vesey's insurrection in Charleston in 1822 was also supplied with abundant weapons made by two slave blacksmiths, Mingo Hearth and Tom Russell. They made pikes and swords which

were hidden at strategic locations in and around Charleston. By June 16, 1822, these rebel smiths had provided as many as three hundred pike heads and bayonets and around four hundred daggers.[13] It is clear, then, that the skills which served the masters well for financial gain could also destroy them. Blacksmithing was thus seen as a means to freedom, perhaps a way to get back to Africa. It certainly would be interesting to know more about the weapons forged by slave blacksmiths so that comparisons might be made with various African swords, knives, and spears.

Before the paranoia of revolts became widespread, it was very common for masters to allow their most talented slaves to be trained as iron craftsmen. Blacksmithing, being an essential craft for daily existence, was favored. In the 1760's in Charleston, slave artisans were hired out by the day to various clients. In some cases slaves were set up in their own shops, and they merely paid a percentage of their earnings to their master. This practice cut deeply into the potential business of white craftsmen, and it prevailed despite the passage of a law in 1756 which imposed a fine of five pounds a day for allowing a slave to work alone. Slaves could, however, continue to work if the master employed one White for every two slaves.[14] These legal restrictions explain the circumstances under which Christopher Werner, a famous German ironworker in Charleston from 1828 to 1870, came to employ three Whites and five slaves.[15] A balance between black and white blacksmiths was still in force in 1848, when a census of Charleston craftsmen recorded eighty-nine blacksmiths: forty-five were white, forty were slaves, and four were listed as "free colored."[16]

It is evident that the early preference for black workmanship fostered later patterns of patronage. The people of Charleston, at least, depended heavily on Afro-American artisans. As late as 1889, Philip A. Bruce noted that throughout South Carolina ironwork needs were still being satisfied by Blacks:

The negroes who now attend to the mechanical needs of the different plantations are men who have established themselves near a country store or at the crossing of two public roads, or wherever there is a site that is convenient to travellers or to the people of large communities. . . . The principle [sic] customers of the blacksmiths are the planters in their vicinity whose horses and mules they shoe or iron or whose wagon bodies and wheels they mend, but they are also patronized by strange team-

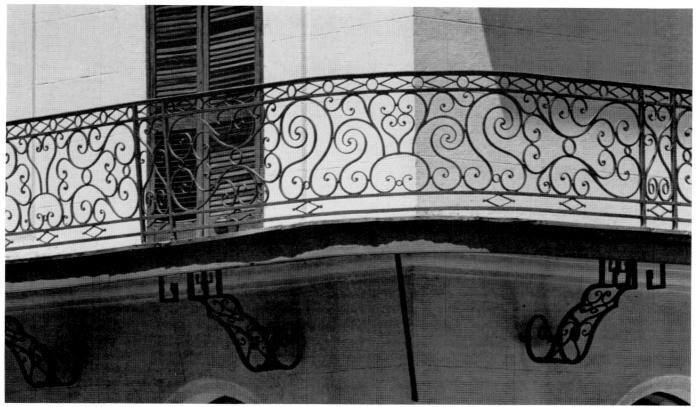

Figure 48. Detail of wrought-iron balcony, New Orleans, Royal Antiques, Royal Street, early 19th century.

sters who pass along the public roads or stop to rest at the country stores.[17]

Ornamental Ironwork

In addition to the pragmatic tasks commonly performed by rural blacksmiths, the urban smith was often asked to do decorative work. Ornamental iron was produced in great quantities throughout the eighteenth and nineteenth centuries in Charleston, Savannah, Mobile, and New Orleans, where it was often the product of Afro-American labor. In New Orleans in 1802 the following advertisement appeared in the *Moniteur de la Louisiane:*

> If any inhabitant desires to have a slave of 16 to 22 years learn what concerns the forge & edge-tool making, the Sieurs Henrico & Lafite will take charge of it, & will make reasonable conditions with the owner; they will only take docile & peaceful Negroes, & they will neglect nothing, either for making the said Negroes learn the trade promptly, or for watching out that the said apprentices do not misconduct themselves.[18]

It became commonplace for Blacks to fill out the staffs of New Orleans' smithies. As Henry Castellanos remarked, ". . . in the city forges of blacksmith shops, the master smith only would

be white, while all the other hands were either black or colored [mulattoes]."[19] The decorated balconies, window grills, and gates produced by such firms as Leeds, Geddes and Shakespeare, Baumiller & Goodwin, Malus, or Urtubise can be viewed as Afro-American work, for all of these ironmongers owned slaves or employed free Blacks. Although the designs used were apparently based on French and Spanish models, there have been suggestions that the New Orleans style is marked by local improvisation—that European wrought-iron prototypes were not strictly followed (Figures 48-52). That variance may be due to Afro-American involvement.[20]

The decorative wrought iron of Charleston was produced under conditions similar to those found in New Orleans. Ornamental ironwork was made in Charleston during the colonial period but only flourished there from the 1820's into the 1860's.[21] We have already seen that in the middle of this period there were forty-four Afro-American blacksmiths at work in the city. During the first half of the nineteenth century, Christopher Werner set up shop and probably turned out more work than anyone else. The quality of his designs has often been praised, but local legend preserves the memory of Werner's five slave workmen. One in particular, "Uncle

111

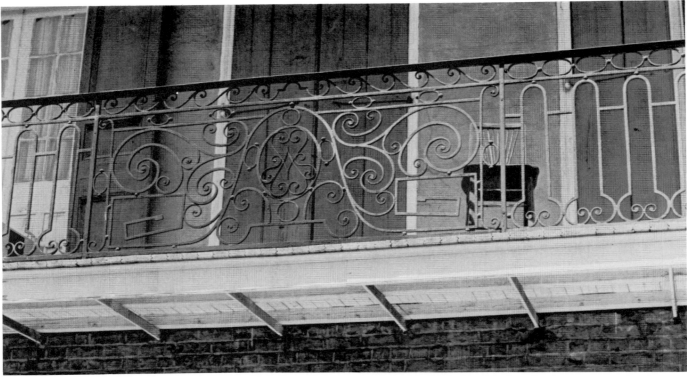

Figure 49. Detail of decorative wrought iron, New Orleans, Governor Nicholls Street, early 19th century.

Figure 50. Wrought-iron balcony, New Orleans, corner of Royal and Saint Peter Streets, 19th century.

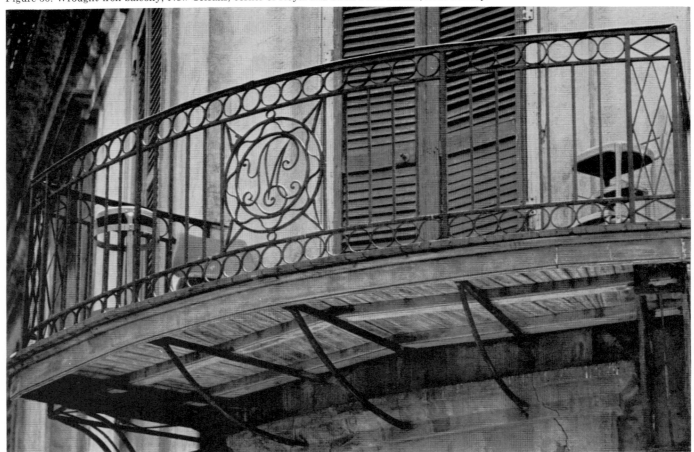

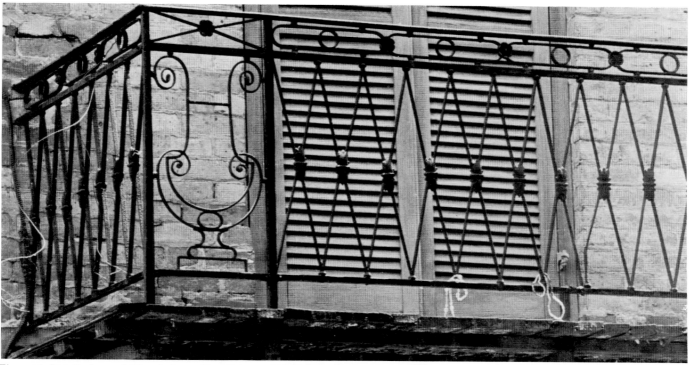

Figure 51. Detail of wrought-iron balcony, New Orleans, Old Absinthe Houses, 19th century.

Figure 52. Detail of a wrought-iron balcony support, New Orleans, Old Absinthe Houses, 19th century.

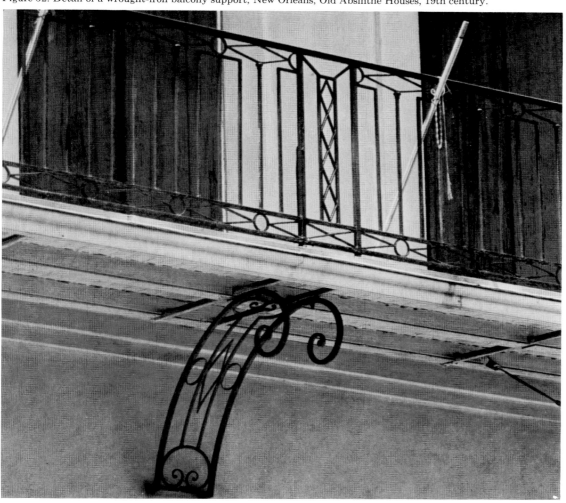

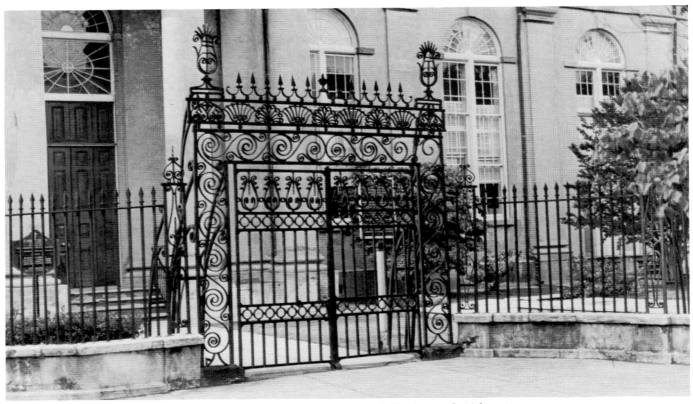

Figure 53. Wrought-iron gate and fence of St. Philip's Church, Charleston, South Carolina, early 19th century.

Figure 54. Wrought-iron gate of Hibernian Hall, Charleston, South Carolina, designed by Christopher Werner and perhaps executed by his slave workmen. Werner, an immigrant from Germany, worked in Charleston from 1828 to 1878.

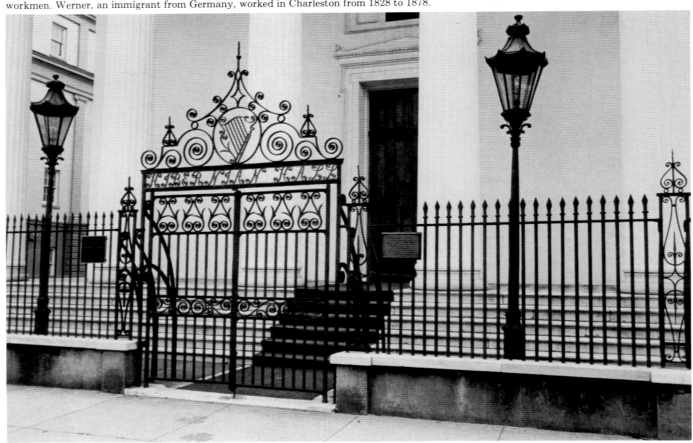

Toby" Richardson, is remembered as a "top rank artist in iron."[22] J. Francis Brenner records that Richardson was illiterate but an excellent artisan: "[he] couldn't read a foot rule, [but] was extremely skillful in executing work laid out for him by his master."[23] The elaborate gates and fences at St. Philip's Church (Figure 53), the gates at Hibernian Hall (Figure 54) and the Aiken House, and the famous sword gate (Figure 55) may have been actually made by Richardson and his fellow black workers. As in the New Orleans foundries, Werner may only have given instructions and allowed his slaves to do the rest. We can only wonder what modifications a skilled craftsman like Toby Richardson may have introduced into the pieces he forged on the anvil. A richly textured gate (Figure 56) could certainly disguise any flourishes of personal expression, so we are left with lingering questions about the possibility of the existence of an Afro-American style within a Euro-American artifact—a black tradition hidden at the center of a white art form.

Figure 55. The Sword Gate of Charleston, South Carolina, designed by Christopher Werner and possibly executed by his five slave artisans, mid-19th century.

Figure 56. Detail of wrought-iron overthrow in Park at City Hall, Charleston, South Carolina, 19th century.

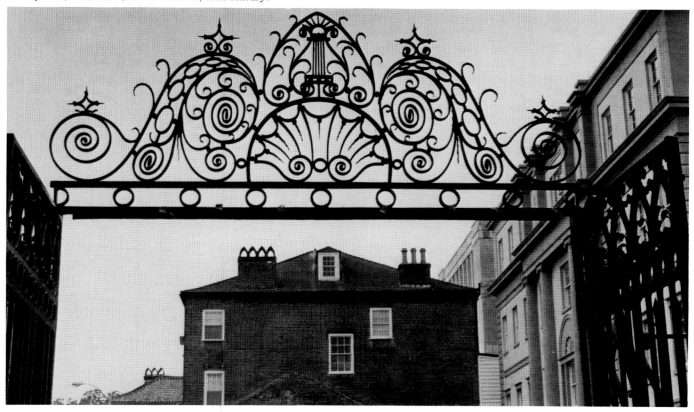

115

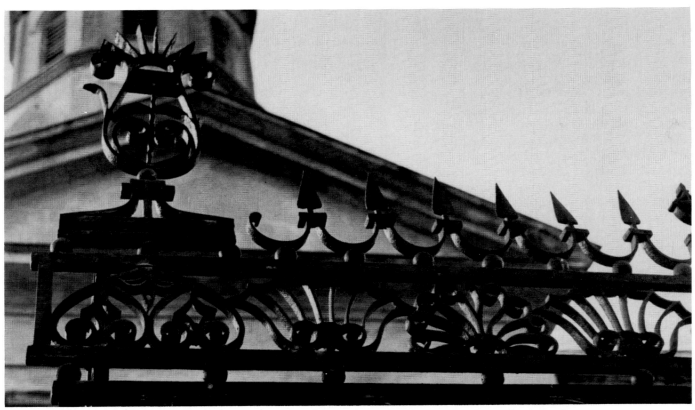

Figure 57. Detail of Figure 53. Spear points, fence at St. Philip's Church, Charleston, South Carolina.

There is less of a question about the relationship between ornamental ironwork and rebellion. One need only look at the top of any fence to see rows of spear points (Figure 57). The blacksmiths who made pike heads for Vesey's revolt were possibly given ample practice by their unwitting masters. If the blacksmithing craft could serve an alternative sense of politics, it could also foster an alternative aesthetic.

Modern Ornamental Ironwork: Philip Simmons

The existence of a distinct Afro-American style of nineteenth-century decorative wrought iron is made plausible by observations of current black ornamental ironwork. Today, Philip Simmons and his two journeymen, Silas Sessions and Ronnie Pringle, continue the Charleston tradition of decorative blacksmithing. Simmons, now sixty-five years old, has worked in the craft since 1924, more than half a century. He found early inspiration in the works [97, 98] of his teacher, Peter Simmons (no relation), an ex-slave whose father, Guy Simmons, had also been a blacksmith. The tradition carried on by Philip Simmons has its genesis some time around 1825. The impact of this more than 150 years of ironworking is seen not only in Simmons' techniques

and tools (some of which once belonged to Guy Simmons) but also in his style of work.

Recently I carefully observed Simmons' methods of manufacture and was able to document the very intricate and complex steps that are followed in making pieces of decorative wrought iron.[24] What is most important in the creative process is the formation of an ideal vision. Simmons says: "I have a tremendous vision, every so often it comes over me. I never dream about it. I get a tremendous vision. Every so often I'll visualize something. I never forget about it."[25] This vision is a mental concept, it is the final idea upon which a material form is based. It must be developed before any work is started. As clay sculptor James Thomas says, "If you ain't got it in your head, you can't do it in your hand. . . . If you can't hold it in your head, you can't shape it."[26] So Simmons starts to make a piece of ornamental ironwork by first fixing it in his mind. Next he trains his eyes and hands to reproduce this mental vision. He sketches out his idea on paper, laboring over each pencil line, tracing each curve and angle over and over. Then he draws the piece full size with chalk on the floor of his shop. If the shapes are not suitable they may be changed, but modifications are only made after a close study of the original pencil

sketch. As the various metal parts are forged, they are placed over the corresponding chalk templates. Again the option for change is available. The pieces may be shifted about to achieve the right balance between what Simmons calls "open-ness" and "closed-ness." He first bunches up the scroll work and then spreads the pieces out; then he draws them in again. Only after he inspects the full range of possibilities several times and consults the original plan does he decide what looks best. What we see here is an interaction of craftsman and medium in which certain insights about design are acquired through a tactile sensitivity, the "feel" of the object. As Simmons makes a piece of decorative iron his mental vision is constantly modified. As he changes design elements, he says out loud "That's got it; that's the one, that's the one," encouraging himself that the particular alteration is appropriate and that his mental template has not been seriously disrupted. Working within the fixed dimensions of a piece, he is able to experiment with various motifs: half-"C" scrolls, "S" scrolls, bars, leaves. The decorative components are only partially determined by the limits of space. There are many possible variations: curves can be tight or open, they can be rounded or straightened. Each leaf is intentionally made to be slightly different, each one is a variation. The final product is drawn in by Simmons to his own sense of visual balance and to the conventional symmetry of Charleston ironwork.

The key concept needed to understand Simmons' creative process is improvisation. His works are molded and shaped with a distinct focus on allowable change. Pieces are assembled in a loose, open-ended, experimental way. He is ever ready to improvise, to try out a possible variation. He will at times stretch, twist, and bend his original concept so that ideas which occur to him during the fabrication process may be included. Because his basic orientation to ornamental iron is flexible, these last-minute changes work well in the overall design. This ability to improvise is hidden in the final objects —to all who view them, they seem to be solidly centered in the local traditions of Charleston ornamental iron. Indeed, on formal grounds his work has British antecedents.[27] But if we consider his ironwork from the perspective of performance, we confront a black mode of creativity —the aesthetic of innovation, which we must evaluate as an African heritage.

Philip Simmons' works are a blend of cultural influences. His forms repeat motifs of Anglo-

97 and 98 *Decorative Panels,* Peter Simmons.

117

German origin, which are the mainstay of the Charleston tradition for ornamental ironwork (Figures 58-61). His techniques, although they may be similar to those of white blacksmiths, have been passed on to him by a series of black forebears. His creative process is strongly associated with the improvisatory approach typical of black music, rhetoric, and craft objects like quilts and walking sticks. What is most Afro-American about Simmons' art is the element which is least visible but most crucial. He has an animated approach to artifacts; he struggles in his mind to make his vision clear. This struggle lends a degree of vitality to pieces like his snake gate (Figure 62), about which he says:

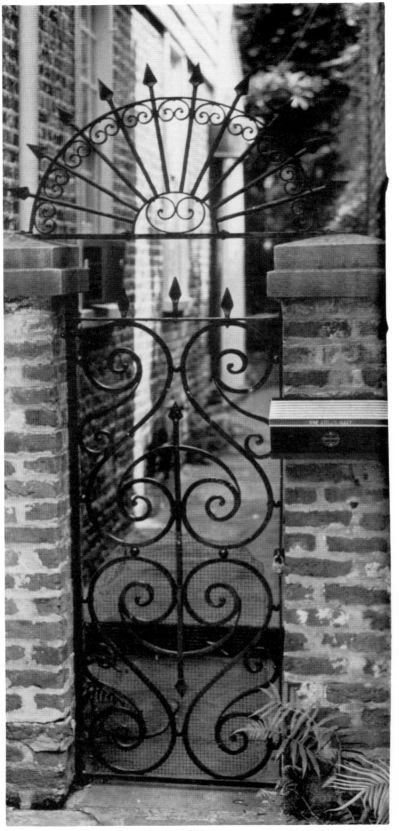

Figure 58. Wrought-iron gate by Philip Simmons, ca. 1945, Stolls Alley, Charleston, South Carolina.

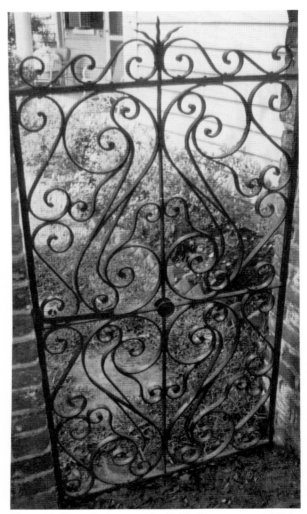

Figure 59. Wrought-iron gate by Philip Simmons, ca. 1945, Stolls Alley, Charleston, South Carolina.

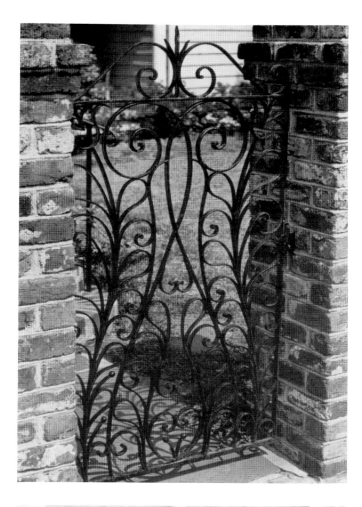

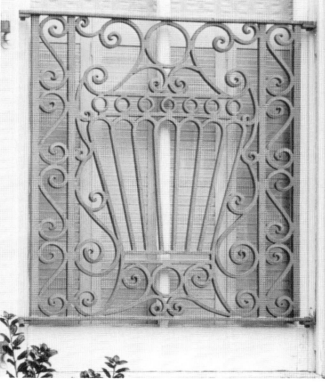

Left: Figure 60. Wrought-iron gate by Philip Simmons, ca. 1945, Stolls Alley, Charleston, South Carolina.

Left below: Figure 61. Wrought-iron window grill by Philip Simmons, ca. 1960, 45 Meeting Street, Charleston, South Carolina.

Below: Figure 62. The Snake Gate by Philip Simmons, ca. 1960, Gadsden House, East Bay Street, Charleston, South Carolina.

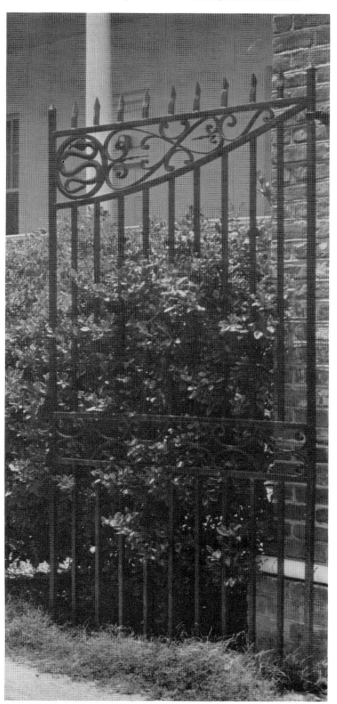

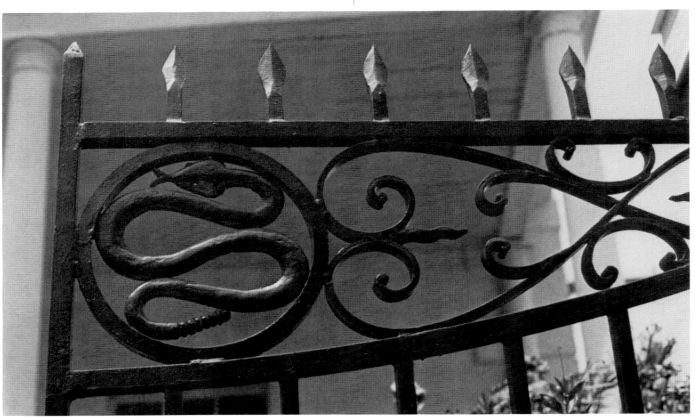

Figure 63. Detail of Figure 62. Note the snake.

". . . on the first sight I made the snake—the body. But the eye, I had to make several changes. Like the first, second, third, fourth time I placed the eye in the head of the snake, it look at me. That *was* the snake. . . . The eye was complicated. You put the eye in it and you just see something that look like a dead snake. He look dead. You know that's true. You got to get that eye set that he look live. You look at it now sitting up there in the gate. Now you see it looking after you anywhere you are. Any side you looking on, its looking dead at you. That's the important thing about the snake—to look alive."[28]

The snake gate is one of the most unusual pieces of decorative wrought iron in Charleston because it includes a sculptured figure (Figure 63). Though other gates may include figural representations, the urn, the sword, the flower, and the lyre are the expected motifs. They are part of the scroll and straight-bar patterns of English ornamental ironwork. There are no animal forms on Charleston gates except those that Simmons has made. In addition to his snake, he has hammered out an elegant egret and a spot-tail bass [99]. These are all recent creations, done within the last fifteen years of his career. They represent a departure from the mainstream of the Charleston tradition but a predictable adven-

ture for an innovative artist like Simmons. Perhaps his animals will be the stimulus to further Afro-American creativity in wrought iron by his two helpers. Blacksmithing is generally considered a "lost" art, but in Charleston new chapters in a black tradition for ironwork are still being written.

Afro-American blacksmiths served their masters well. Their works which survive today also earn our praise. We see in them the memory of Africa, the struggle to gain freedom and as much as possible to regain Africa and the heritage of African culture. Some have attempted to draw straight-line connections between the ironwork of Africa and the United States, pointing to the widespread knowledge of the smith's craft in Africa and the early and continuous participation of slaves in the iron trade here in America.[29] Only in a few instances are such direct connections possible. The important lesson of Afro-American blacksmithing is that we must be prepared to look for subtle stylistic nuances. We need to focus our critical skills more on processes of creativity and less on the question of ultimate ethnic origins. When we do this, a broad vista of cultural continuity opens up before us and we can understand more readily the significance of Afro-American decorative art.

8. Architecture

Too often our view of architecture is focused solely on the unique monumental structures designed in large part to display the wealth and power of the elite. Grand mansions, churches, and government buildings together with other public structures attract the scholar's attention, while the greatest portion of the built environment—the houses that most people live in—goes unnoticed. Dwellings are usually not even considered as architecture and are merely lumped together improperly as "vernacular housing." But should we be concerned with the largest and most comprehensive patterns in architectural thought, we must give due consideration to the humble dwelling house. Architectural accomplishments are not plucked whole and complete from the air; rather they are monuments inextricably tied to centuries of precedent both in form and technique. Traditional building practices provide a context for the development of

more grandiose designs and consequently cannot be ignored except at the price of accuracy. While black builders have made their contribution to elite architecture since the first years of America's existence,[1] the greatest contribution of Blacks to American building custom and precedent has been in the realm of the common dwelling house. When studies of architecture are expanded to embrace the totality of the built environment—all buildings great and small— the impact of an Afro-American tradition in architecture becomes evident.

The essence of architecture is the form it gives to space, the order it imposes on humans and their surroundings. A house thus serves as a cradle for cultural acquisition by providing a specific volumetric context in which most aspects of culture are learned. The powerful influence of space cannot be doubted. Edward T. Hall has shown that "space speaks" through the silent

Figure 64. Shotgun house, Pritchard, Alabama, 1977.

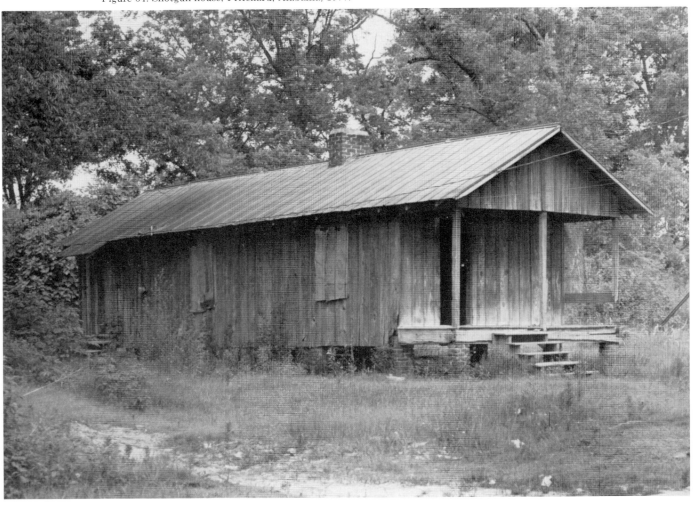

language of proxemic expression: "People take very strong cues from the space around them, space can crowd or overawe. It can irritate and it can be designed to serve a job, a personality, a state of mind."[2] The cultural identity of a house thus lies deeply within it; changes of exterior materials and additions cannot dislodge the primary spatial statement.

African Influences: The Shotgun House

A house known as a "shotgun" is found commonly throughout the United States in black neighborhoods (Figure 64). In terms of form it breaks a major convention of American folk housing; its gable side, rather than its long side, faces the road. This ninety-degree shift in alignment is a formal index of an alternative architectural tradition. Whether built with wood or bricks, roofed with shingles or tin, or sided with clapboards or board-and-batten weatherboard, it expresses a specific spatial context. Because a house as a spatial phenomenon is an important expression of the individual and his group, and because the values upon which culture depends are in many ways derived from house form, the shotgun may represent the continuation of an African lifestyle. The sense of proxemics which is inherent in architecture may make the shotgun house the most significant expression of Afro-American material culture.

In plan, the usual shotgun house has three or more small rooms all connected directly to each other (Figures 65a,b). This arrangement forces inhabitants in one of two directions: either into prolonged, immediate interaction with one another or out onto the porch or street. In a neighborhood of shotgun houses the level of curbside or street corner banter is quite high (Figure 66). I once asked a group of black women to define a shotgun house. After a few moments of deliberation their collective reply was: "A shotgun house is a house without privacy." Expressed positively, it is a building with a decided communal focus—either the community of the family or the community of the sidewalk. Circulating in and around shotgun houses, one has a certain expectation of confrontation, out of which has developed a protocol of interaction. The behavior manifested includes many gestures of touching: hands on shoulders, slapping knees, long ritualized handshakes. This is an etiquette of involvement, and it arises to some extent from the context of the shotgun house, which as a building form is the end product of a long evolution of an architecture of intimacy among black people.[3]

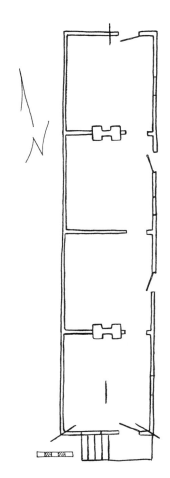

Figure 65a. Plan of a shotgun house, frame construction, New Orleans.

Figure 65b. Cross section of shotgun house. (From John Michael Vlach, "Shotgun Houses," *Natural History*, LXXXVI [1977].)

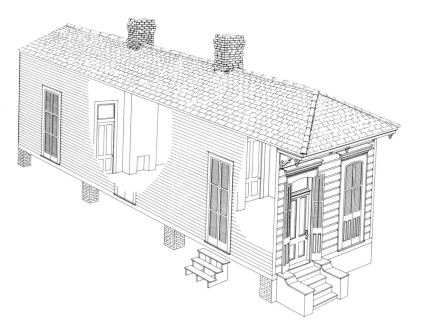

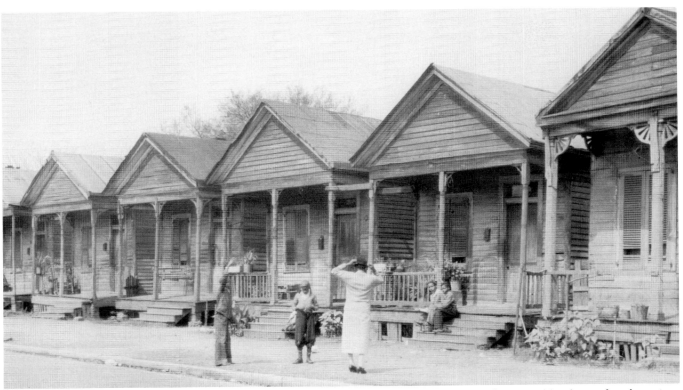

Figure 66. A row of shotgun houses in Mobile, Alabama, 1937. Each house on the street has a front porch—a transitional space from house to street. Photograph, collection of the Library of Congress, Washington.

From Senegal all along the Guinea Coast and down the western coast of Central Africa there stretches a zone with remarkable consistencies. Along this more than 4,000 miles of coast line and a considerable distance inland the same rain forest environment is encountered. The similarity of ecology is matched by the presence of root crop agriculture, generally concentrated on yams and cassava.[4] Alan P. Merriam has demonstrated that musical systems are also consistent in this region.[5] It is not surprising, then, that the architecture of this far-flung zone should possess basic similarities, too. The "rectangular, gable-roofed hut" (Figure 67) is constantly identified with the rain forest environment.[6] This common habitat encourages similarity in building techniques, so we find that wattle-and-daub construction also occurs roughly in the same area. Other regular architectural features within this African concept of the rectangular house include: the compound concept, the two-room basic building module, and specific room volumes.

In so large an area as the western half of Africa it might be expected that room dimensions would vary greatly, yet there appears to be a strict repetition of what African farmer-architects might consider optimum spaces. In the Bight of Benin region, 9 x 9 foot units are con-

tinually used; these figures compare well with the 10 x 10 foot and 8 x 8 foot units encountered in Angola. A sketchy survey of floor plans of West African houses revealed a 10 x 10 foot average room size.[7] West African architecture thus shares features at general and specific levels. Not only are straight walls with sharp corners desired to define living space, but a particular sense of dimension dictates that rooms shall be of a consistently fixed size. Western Africa is more than a region of rectangular houses; it is an area in which man has developed a constant proxemic dimension. Buildings here provide for intimate spatial encounters. Can it be otherwise in a room with less than one hundred square feet of floor space?

Though the people of Afro-America were drawn from the entire continent of Africa, they did not lack certain shared cultural perceptions. One of these (and a perception more crucial than we have previously understood) was a preference for a specific kind of spatial arrangement both in form and dimension. African slaves—whether from the Bight of Benin or the mouth of the Congo River—shared these attitudes about architecture and were able to unite their ideas when they were brought together in the West Indies.

124

The architecture which developed in Haiti provides a clear example of the contribution of African building concepts in the New World. Haitian slaves were, in the first half of the eighteenth century, largely from two sources. In any given decade between 1760 and 1790, from twenty-eight to forty-two per cent came from areas dominated culturally by the Yoruba; slaves of Angola-Zaïre origins, the next largest group, made up between thirty-two and thirty-seven per cent of the total imports.[8] Since the Yorubas arrived first and in the greatest numbers, it would appear that the cultural amalgam that produced Haiti's architecture is primarily Yoruba in nature, with supportive influences provided by later arriving Central Africans. The Yoruba architectural repertoire is quite extensive, with structures ranging from common houses to palaces.[9] But despite the variety, all of the buildings are based on a two-room module which measures 10 x 20 feet (Figure 68). Often a series of these small houses will be strung end to end (Figure 69) or gathered around an open courtyard (Figure 70) or a series of small impluvia (Figure 71). This latter compound arrangement can be quite extensive, but the houses are still clearly the same single dwelling unit. The compound is called in Yoruba, *agboile,* "flock of houses." They are an urban or village assembly of the same kinds of volumes that family members build when farming on their own plots in the countryside (Figure 72). This two-room house is essential to the Yoruba architectural system and consequently was not easily forgotten even under the rigors of slavery. The common slave house in Haiti was also a rectangular gable-roofed house made with wattle-and-daub walls and roofed with thatch. More importantly, it was built to the same dimensions found in Yorubaland. The similarity of materials used in the West Indies and Africa may be explained by the similarity in tropical environments, but the repetition of the 10 x 20 foot dimensions represents the impact of a West African architectural concept.

The importance of African proxemic tendencies is also encountered in a building type that developed in Haiti as the result of a three-way interaction among Arawak Indians, French colonials, and African slaves. This house is the prototype of the American shotgun. It contains the gable door and porch of the Arawak *bohio* (Figure 73), the construction techniques of French peasant cottages, and the spatial volume of a Yoruba two-room house. This building, called a *caille* (Figure 74), is found primarily in

Figure 67. Two-room Yoruba house in Ilefunfun, Nigeria, 1974. This structure illustrates the basic, minimal design unit of the Yoruba architectural tradition.

Figure 68. Plan of a two-room Yoruba House, mud-wall construction, Ilefunfun, Nigeria.

125

Figure 69. Double-module Yoruba house, Aroko, Nigeria, 1974.

Figure 71. Plan of a Yoruba compound house, mud-wall construction, Ile-Ife, Nigeria.

Figure 70. Plan of a Yoruba compound house, mud-wall construction, Edunabon, Nigeria.

Figure 72. Plan of rural compounds in Aroko, Nigeria.

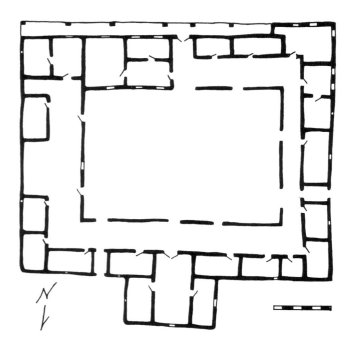

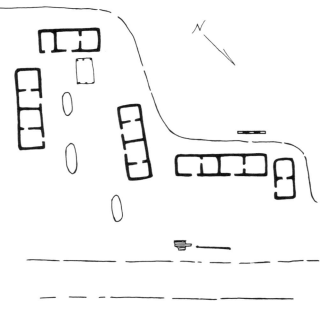

126

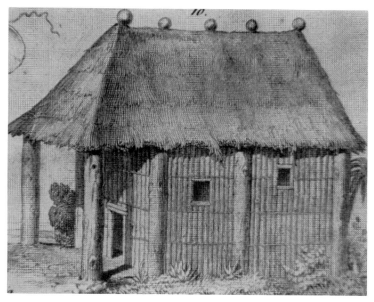

Left: Figure 73. Arawak *bohio*, 16th century. (After Gonzolo Fernandez de Oviedo y Valdez, *Historia General y Natural de las Indias, y las Tierra-Firma de Mar Oceane* [1535; reprint ed., Madrid: Imprenta de la Real Academia de la Historia, 1851].)

Below: Figure 74. Rural Haitian *caille,* north of Port-au-Prince, 1973.

Bottom left: Figure 75a. Plans of Haitian *cailles,* wattle-and-daub construction, Mais Gate.

Bottom right: Figure 75b. Cross section of Haitian *caille.* (From Vlach, "Shotgun Houses.")

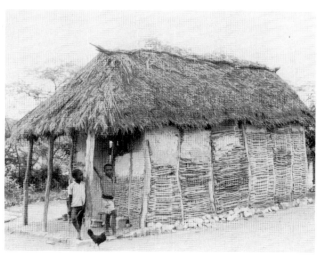

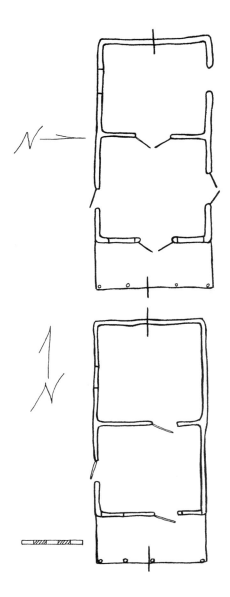

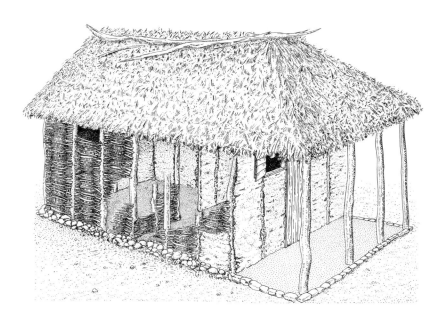

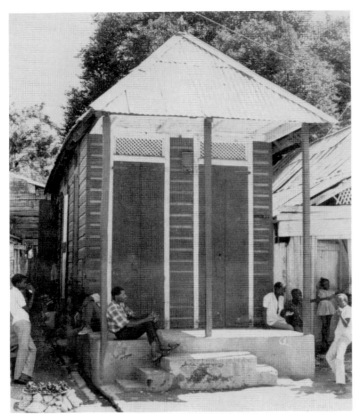

Figure 76. Urban Haitian house in Port-au-Prince, 1973.

southern Haiti. It was apparently firmly established as a common dwelling form by the late seventeenth century, and its dimensions have not varied appreciably from the mid-eighteenth century to the present.[10] The contemporary *caille* contains two rooms and a porch. The entire house measures on the average 10 x 21 feet with each room close to 10 x 8 feet, and the porch between four and five feet deep (Figures 75a,b). The eighty square feet of floor space in each room of the Haitian *caille* is significant because the interior dimensions of Yoruba rooms come close to 9 x 9 feet, or eighty-one square feet of space—a difference of only one square foot.[11] Hence, we see that despite slavery and the significant adjustment of building technique and secondary modifications (moving the doorway to the gable side), the *caille* remains proxemically African.

The continuity of spatial context provides us with a key clue to the survival of this house form in the urban areas of southern Haiti, particularly Port-au-Prince (Figure 76). In this city there are many buildings which are one room wide and three or four rooms deep, and whose gable end

Figure 77a. Plan of urban Haitian house, *maison basse*, half-timber construction, Port-au-Prince.

Figure 77b. Cross section of urban Haitian house. (From Vlach, "Shotgun Houses.")

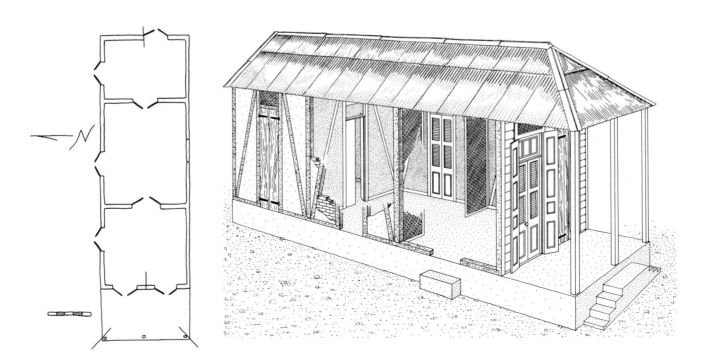

128

faces the street (Figures 77a,b). Constructed with a heavy timber frame and fitted with double-shuttered doors, these urban houses possess a distinct air of sophistication. The ceilings are often quite high (as much as fourteen feet), the roofs steeply pitched, and the house may sit on a three-foot-tall clay platform. The building can then measure almost twenty feet from ground to ridgepole. Hence, there is no mistaking this dwelling for a humble cottage. Yet for all its grandeur, it is nothing more than an oversized version of a rural *caille*. It served as a major architectural form for Haiti's *gens du couleur,* the class of free Blacks. With this fancy house they could perhaps participate simultaneously in the culture of France and still retain the African heritage of their slave ancestors. The exterior demonstrates a familiarity with French Creole carpentry, while the interior is arranged just like a rural Haitian house, with all rooms connected directly to each other. Room sizes increased significantly from 10 x 8 feet to 12 x 12 feet, and the porch became much deeper. Thus the interior sense of closeness declined, but the exterior sign of hospitality grew. The porch can be seen as a piece of the house that is part of the street—or a piece of the street incorporated into the house. From either perspective it is certainly a zone of transition, which draws the resident and the passer-by together. The impact of African communal architecture may thus have been felt beyond the slave society and may have made its mark on the houses of free Blacks.

The urban Haitian shotgun was transported quite directly to New Orleans during the first decades of the nineteenth century. Although New Orleans already had a large community of free Blacks, their numbers were markedly increased in 1809 by the arrival of 2,060 free people of color.[12] By 1810, in New Orleans, Blacks outnumbered Whites two to one, and there were almost as many free Blacks as Whites. It is easy then to understand how Haitian architecture was incorporated into the cityscape of New Orleans. The shotgun houses built in Louisiana after 1810 were not very different from those of Port-au-Prince. They were, after all, built by the same people for the same reasons. The New Orleans shotgun (Figure 78) is identical to its Port-au-Prince antecedent in ceiling height, floor space, mode of construction, arrangement of room partitions, door and window placement, hardware, and even mode of decoration. In the diffusion of the house form from the West Indies into the United States, it did not change very much.

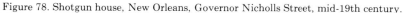

Figure 78. Shotgun house, New Orleans, Governor Nicholls Street, mid-19th century.

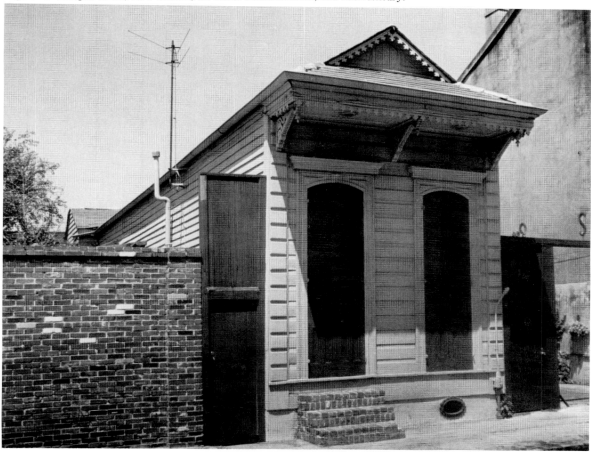

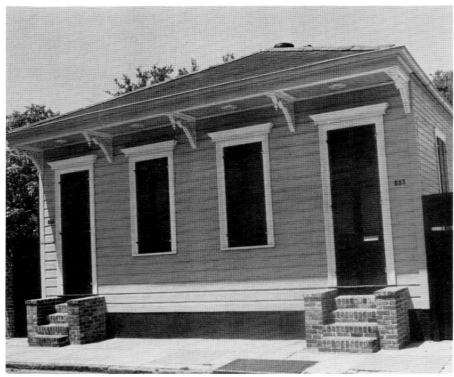

Figure 79a. Double shotgun house, New Orleans, Governor Nicholls Street, ca. 1880.

Figure 80. "Camelback" version of a double shotgun house, New Orleans, Bourbon Street, ca. 1880.

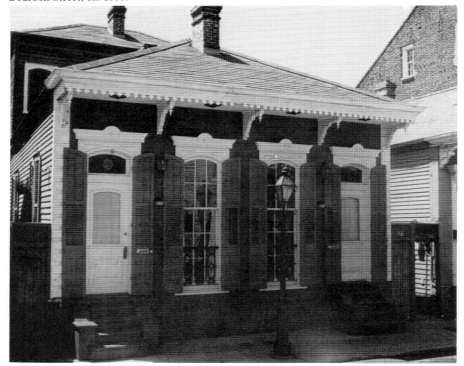

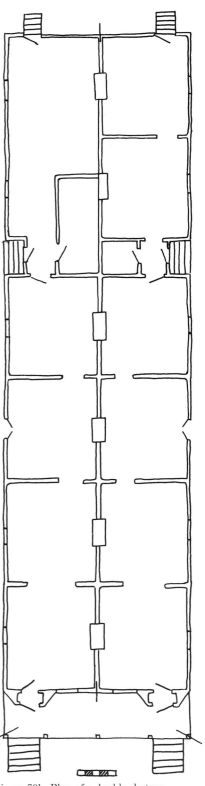

Figure 79b. Plan of a double shotgun house, frame construction, New Orleans.

Shotgun Variations

By the middle of the nineteenth century the shotgun proved very popular for economic reasons, and by the 1870's it was commonly built as a cheap rental house. A number of modified versions of the basic house form had also developed: most notably, a double shotgun (Figures 79a,b), which is two single shotguns built side-by-side under one roof; and a "camelback" house (Figure 80), which is a shotgun with a two-story rear section.[13] At this point two important changes occurred in the New Orleans shotgun. The exterior was draped with elaborate jigsaw-cut "gingerbread" decoration. The house was then referred to as a "Victorian cottage," and its alternative ethnic identity became obscured. Inside, a hallway was run down the side of the house so that rooms were no longer connected directly (Figure 81). Each room then became a place of privacy and isolation, and the ideal of intimacy which had been part of the house's design for more than two centuries was finally subverted. The house could, however, be more successfully lived in by people reared in a culture where individual privacy was highly prized. The addition of hallways to shotgun houses apparently came at a point when Whites adopted them as suitable dwelling forms. Only when the shotgun house moved across cultural boundaries were its African spatial priorities ignored.

Yet most shotgun houses built in the late nineteenth and on into the twentieth centuries conform to the earlier hall-less plan. The majority of the shotguns encountered in cottonfields in Mississippi and Arkansas, in oil fields in Texas, in coal fields in West Virginia, in mill towns in the Carolinas, in black neighborhoods throughout the country are very much like their Haitian antecedents. There must be well over a million shotgun houses in the United States. This building, then, cannot be dismissed as a simple, humdrum, little shack. Too many have been built and too many have been lived in to ignore them. The shotgun is an alternative house form within America's folk architectural repertoire. It represents the contribution of Afro-Americans to America's architectural traditions. With its gable facing the road even in the wide-open countryside, the shotgun stands as a kind of signpost of African-derived culture. The name shotgun may even be derived from the Yoruba *to-gun,* a word applied to houses meaning "place of assembly."

That the American shotgun is tied to the West Indies, that it represents the final product of a set of developments that ultimately can be traced to African architecture, and that for almost 170 years the shotgun house has been an important influence in American architecture cannot be denied. However, the ubiquitous shotgun is not the only Africanism in American architecture, as we shall see. The possibility that subtle African influences are manifested in other forms of buildings has been the subject of recent scholarship.

Figure 81. Shotgun house with hallway added to side, New Orleans, Bell Street, late 19th century.

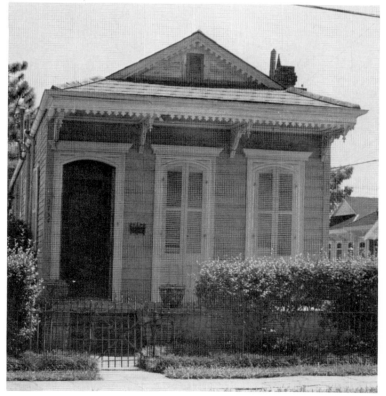

Figure 82. Single-pen log slave cabin, Rock Hall, Maryland. Photograph (1936), collection of the Library of Congress, Washington.

Figure 83. Single-pen houses, Beaufort, South Carolina. Photograph (ca. 1910), collection of Penn Community Services, Inc., St. Helena, South Carolina.

African and British Influences

Carl Anthony has written a provocative essay investigating the African contribution to New World architecture.[14] He suggests that small, rural outbuildings on southern plantations are related to African buildings. About these structures there is much confusion, for architectural history is as yet very hazy concerning dwelling houses, let alone functional buildings like smokehouses and granaries. It is, thus, premature to take up African buildings as models for the outbuildings of Williamsburg. The more the study of British vernacular building progresses, the more we come to understand the debt traditional American architecture owes to England. To suggest a relationship between a Virginia dairy house and an African granary is far-fetched—even though their shapes are similar—when we learn that the same structure with lathed and

plastered eaves is common to the British countryside.[15] The architecture of the New World is undoubtedly a creolized phenomenon, the result of mixed influences. A complete assessment of Old World architectural patterns, both European and African, is needed before a complete understanding of the specific contributions of Blacks and Whites to American building practices is possible. It would appear that in the case of the Virginia dairy and other outbuildings the structures are of British design, although they may well have been built with slave labor. The importance of Afro-American toil and sweat should not be slighted; but because the efforts of Blacks were directed toward the rendering of English forms, the chance that the final result helped to foster a strong alternative self-image appears to be lessened.

The mixing of African and European influences, however, could simultaneously serve both cultural ideals. This syncretic process is encountered in many of the common slave quarters which today are largely interpreted as signs of shame and dishonor. We have already seen that the rectangular gable-roofed house is a common house form throughout western Africa. The same house form is also typical of northern Europe, particularly England and Ireland.[16] More specifically, the common house of the British Isles was often a two-room dwelling, called in the literature a "hall-and-parlor house." This building was the mainstay of the folk architectural repertoire of the United States, and it eventually served as the model for the frontier cabin of the Appalachian Mountains.[17] Euro-Americans shared with Afro-Americans both a familiarity with the concept of two-room modules and rectangular building forms and a knowledge of techniques for thatching and wattle-and-daub construction. There is, then, a basic congruence between the architectural expectations of Blacks and Whites. The key difference was an attitude toward dimension. Rooms in Anglo-American buildings average between 16 x 16 feet and 18 x 18 feet, considerably larger than the 10 x 10 foot African norm. An interesting possibility emerges: the single-pen house form of the British tradition, one of the basic building forms of the Euro-American architectural design system, conceptually equals half of a common two-room African house (Figures 82-84).[18] It was built often as an appendage to a larger house or as a slave dwelling. This Euro-American house, when built smaller than normal, provides the proxemic environment of an African house. All that is strikingly different is the material

used. Thus, the tiny cabins described by Frederick Law Olmstead in 1859 as "not more than twelve feet interiorly" are perhaps a New World restatement of African architectural values.[19] The 144 square feet of floor space is certainly a more intimate area than the 324 square feet found in an 18 x 18 foot cabin.

Figure 84. Single-pen cabin near Jackson, Mississippi. Photograph (1937), collection of the Library of Congress, Washington.

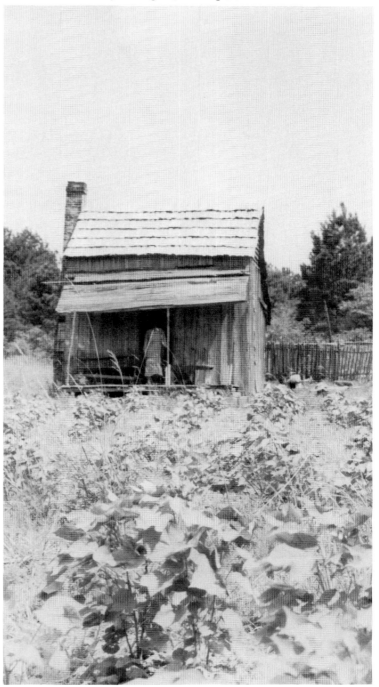

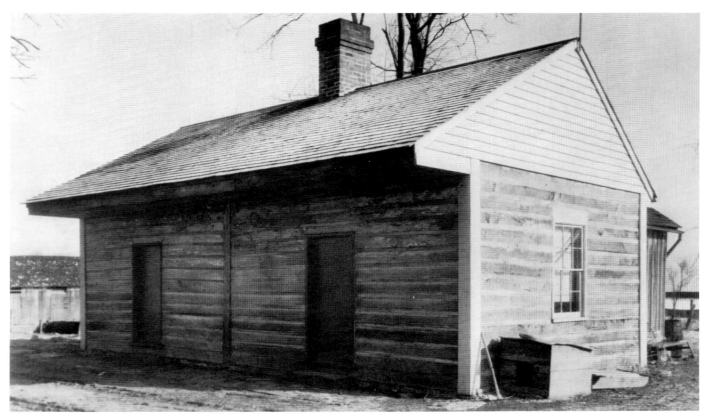

Figure 85. Double-pen (two-family) log slave quarters, Mount Lebanon, Kentucky. Photograph (1934), collection of the Library of Congress, Washington.

Figure 86. Black farmstead near Newport News, Virginia, early 20th century. Photograph, collection of the Library of Congress, Washington.

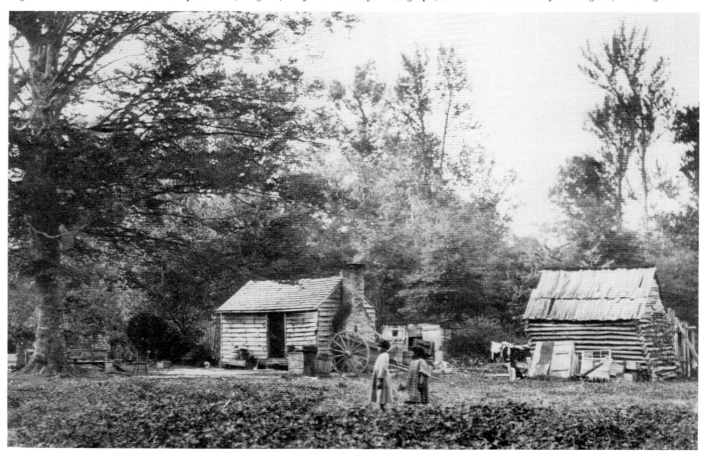

Afro-American Buildings

Slave narratives abound with descriptions of one-room cabins. Andrew Boone of Wake County, North Carolina, reports: "Our houses were built of logs and covered with slabs. They was rived out of blocks of trees about eight feet in length. The chimleys was built of sticks and mud, then a coat of clay mud daubed over 'em."[20] John Finnely described his Alabama cabin this way: "Us have cabins of logs with one room and one door and one window hole and bunks for sleepin'. But no cookin' done here."[21] Morris Sheppard remembered: "Us slaves lived in log cabins that only had one room and no windows, so we kept the doors open most of the time."[22] These descriptions compare well with an eighteenth-century account from the Congo: "The houses, with respect to their dimensions, may be compared to the tiny cells of monks. Their height is such that when you stand up your head reaches the roof, so to speak. The doors are very low. . . . The houses receive no other light than that which comes in through the door. There are no windows."[23] *De Bow's Review,* a journal commonly read by slave owners, encouraged the building of small slave quarters with statements like this: "One sixteen or eighteen feet square is not too large for a man and woman and three or four small children."[24] Since these dimensions are the top range suggested, it is understandable why slave houses in South Carolina and Georgia were often not more than twelve feet square.

Another common slave quarters was a double-pen structure, twice as large as the single-unit cabin (Figure 85). It is important to note, however, that such a building provided shelter for two slave families, and thus in terms of use it was no different from the single-pen cabin; it provided only one room as the total living space.

It is important to realize that many of these quarters were built by Blacks and that the size of the house may have been a deliberate choice (Figure 86). In 1727 a group of Virginia slaves escaped from their owners and attempted to reform a familiar corporate living arrangement. In so doing, they built houses like those used as plantation cabins.[25] These so-called outlandish Negroes apparently found some sense of satisfaction in the one-room slave cabin.

These same small spaces were also preferred by other free Blacks. In Plymouth, Massachusetts, around 1792, four black veterans of the Revolutionary War were granted a tract of land encompassing ninety-four acres.[26] They built

houses on this barren and gravelly piece of turf called "Parting Ways," and one of the houses was lived in by a lineal descendant until 1895. Recent archaeological investigation of the site of the house built by Plato Turner shows that a two-room structure, which stood there until a fire in 1908, was constructed in two stages. The first part was built by Turner; the second part may have been built by his grandson, James Burr. Both sections were twelve feet square. The remains of a cellar nearby the Turner-Burr house also measured 12 x 12 feet. The sections of a fourth set of foundations in this cluster of Afro-American structures measure 12 x 9 feet. It is evident that consistent dimensions were used in all the buildings constructed at Parting Ways, and these were closer to an African rather than a European norm.

We must, then, be ready to acknowledge the strength of African sensibilities in American architecture. Despite the imposition of strict limits on Afro-American building in terms of materials and techniques used and the designs allowed, important sensitivities to space, the essence of architectural traditions, remained relatively undisrupted. Other secondary features also could be inspired by African reminiscences. In South Carolina thatch roofs were still found in the Sea Islands in the early twentieth century, although riven cypress shingles were more common. Susan Snow, raised as a slave in Alabama, said of the slave quarters: "Every nigger had a house o' his own. My ma never would have no board floor like the rest of 'em, on 'count she was a African—only dirt."[27] The earthen floor, like the thatched roof, can be tallied up as an African feature and in this case a preferred alternative. In the James River Valley of Virginia there are two known plantation sites which had mud-walled slave quarters.[28] In plan and proportion these buildings were European, but the material and type of construction, while labeled *pisé,* were similar to those of West Africa. Robert Carter may have given testimony to the need for African construction techniques when he asked John Ballendine, a slave dealer, for a Black who "underst[ood] building mud walls"; a man who was "an Artist, not a Common Labourer."[29]

Given the pattern of continuity—which was possibly perceived by Blacks—between slave quarters and African houses, it is not surprising that African houses were sometimes built in America. Near St. Simons, Georgia, one Afro-American remembered:

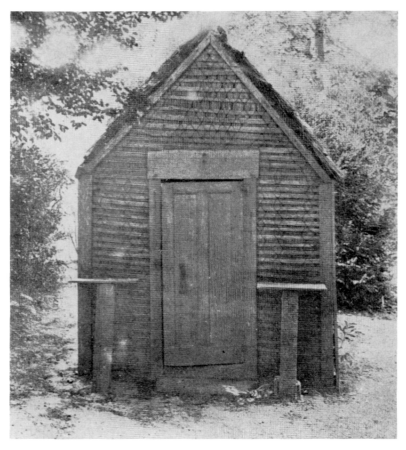

Figures 87a and b. House built by Tahro, Edgefield, South Carolina. Tahro, whose slave name was Romeo, was brought from the central Congo to Edgefield, where he built this house which, he said, was African. (After Montgomery, pls. 42-43.)

"Ole man Okra he say want a place like he have in Africa so he built 'im a hut. I 'member it well. It was 'bout twelve by fo'teen feet an' it have dirt floor and he built the side like basket weave with clay plaster on it. It have a flat roof what he make from bush and palmetto and it have one door and no windows. But Massa make 'im pull it down. He say he ain' want no African hut on he place."[30]

In size, form, and materials this house was not much different from the usual slave cabin. The wattle-and-daub walls were perhaps unusual for the mid-nineteenth century when the house must have been built, but that construction technique was in continuous use for building chimneys and fireplaces well into the twentieth century throughout the South. Another African house, which survived longer, was built by Tahro, a Bakongo slave captured in 1858 and transported eventually to Edgefield, South Carolina.[31] In 1907 his one-room rectangular dwelling, measuring approximately 7 x 10 feet, was still standing (Figures 87a,b). It had a timber frame with lath walls held in place by a system of twine netting. Bundles of straw were hung vertically inside to fill in the open spaces, and the roof was covered with straw thatch. Significantly, Tahro claimed that this structure was like the one he had built for himself in Africa.

African architecture was also learned in one case by Native Americans when a runaway slave taught a band of Tuscarora how to fortify their encampment. Colonel John Barnwell reported in 1712 that the Indian camp had been surrounded with impressive trenches and earthworks as well as a palisade of reeds and canes,[32] defenses that recall the fortified villages of the Vai of Liberia.[33] These military structures were not part of the Tuscarora building tradition, and certainly the British did not teach the Indians how to effectively resist attacks. Thus Barnwell's claim that Harry was "a runaway negro [who] taught them to fortify thus" must be taken as correct. We have seen already that Indians acquired basket sewing techniques and folk tales from fugitive Africans. Earthen fortifications such as this one comprise another element of the African cultural bequest to Native Americans.

African Influences: The Front Porch

The impact of African architectural concepts has ironically been disguised because their influence has been so widespread; they have been invisible because they are so obvious. This unfortunate circumstance is demonstrated by the history of that common extension of the house—

Figure 88. Log "dog-trot" house (two single-pen with open hallway between), near Forkland, Alabama, 1936. Photograph, collection of the Library of Congress, Washington.

the front porch (Figure 88). It is now widely acknowledged that European houses do not have structures equivalent to the broad, open front porches of American houses. British houses have small enclosures around their front doors which act like antechambers to the house. The porch, as commonly encountered, is an appropriate modifier of the hot, humid, summer climate. It shades the house and provides a sheltered place to sit and catch the faint afternoon breezes. Some have guessed that the innate genius of the European builder led him to invent the wide galleries so frequently found on the front of southern houses. If this is so, it took a long time for him to recognize the problem and understand the solution. Pierce Lewis writes: ". . . gallons of eighteenth century Virginian sweat were spilled before there was grudging admission that the doors and windows of Georgian London provided inadequate ventilation for a Tidewater summer. . . . It was a long time before southerners could bring themselves even to attach porches to their Georgian townhouse."[34] Not until the nineteenth century did large, adequate porches extend across the entire façade commonly appended to Virginia houses.[35] Glassie observed that they looked "for all the world like a veranda in Yorubaland," but that by the twentieth century they were no longer constructed in Virginia.

It seems that after acquiring an alien architectural feature the Tidewater Virginian went back to his Anglo ways.[36]

That extensive porches were outside of the Anglo-American repertoire of architectural forms is seen clearly in Charleston houses. The typical dwelling there is a Georgian "I" house built with its gable facing the street and having a two-story open gallery along one side. There is an impressive door that leads from the street to a side porch and another door off the porch that leads to the interior of the house. The porch—or "piazza," as it is locally called—is, therefore, an integral part of the house. Albert Simmons has indicated that these side porches did not become common until after 1790, when refugees from Haiti arrived in Charleston.[37] Another possible source for these additions may have been the elaborate porticos of such dwellings as the Miles Brewton house (ca. 1769), the John Edwards house (ca. 1770), or the Josiah Smith house (ca. 1788).[38] Yet the functional and formal differences between these symbols of grandeur and the side galleries that provided much needed relief from the semitropical summer suggest that the piazza can best be analyzed as a South Carolinian adaptation of a West Indian architectural feature.

Caribbean origins have also been cited for the verandas found on French buildings in the Mississippi Valley from New Orleans to Kahokia, Illinois.[39] To draw linkages to the West Indies is also to suggest Afro-American and African involvement. The veranda is a feature of architecture in tropical environments and certainly is well known to Blacks in both Africa and the Caribbean. Anthony is correct when he says "it is not unreasonable to suppose that millions of African slaves upon whom Europeans depended taught them more about tropical architecture than they cared to remember."[40] Of the black and white immigrants who faced the American South, the African was the better prepared. For him the hot, humid, semitropical climate of the Virginia Tidewater and the South Carolina Low Country was normal and preferable.

We have already seen that many agricultural skills were successfully transplanted from Africa to the United States. The front porch may be another manifestation of the common wisdom of black folk. Slaves might have added porches to their cabins as a matter of traditional architectural practice, but this was apparently a strange innovation to "Ole Massa," who was slow to see the advantage of it. He was, however, eventually forced to either build a front porch or swelter through the summer. Eventually a wide veranda became the height of architectural elegance, but this was only after almost two centuries of experimentation during which its origins were apparently forgotten.[41] When we rightfully credit the front porch to African genius, we must acknowledge that millions have benefited from the impact of African custom.

Most studies of black American architecture have concentrated on spectacular and unique structures that immediately assault the eye. The round slave quarters at Keswick Plantation at Midlothian, Virginia, and the two-story hipped-roof structure called "African House" at Natchitoches, Louisiana (Figure 89), are two buildings that have received abundant attention.[42] But it is important to remember that these are only isolated examples. They stand alone without the support of a tradition. Built with black labor after eccentric (possibly African) designs, they demonstrate a rather individualistic concept of architecture. Strong traditions are continuous and are preserved by groups of people. African House should not be overlooked; but if attention is focused solely on exceptional examples, the persistent and subtle survival of black architecture may be missed altogether. If we accept only those buildings which absolutely look African as examples of black architecture, we will remain ignorant of how successfully African architecture has been incorporated into the mainstream of American building. There are both direct and indirect recollections of Africa in black architecture. The purer survivals are spectacular and uncommon. The indirect retentions of African building traditions are subtle and pervasive. Those examples which are less obvious are more exciting because the struggle for cultural assertion is clearly present. In these instances the aesthetic principle of improvisation is unquestionably tapped as a creative source. Black builders constantly responded to changes in climate, both natural and social, as well as to changes in technology and design. They found ways to maintain their own ideals while simultaneously making a contribution to American architectural traditions.

Figure 89. "African House," Natchitoches, Louisiana, Melrose Plantation, early 19th century.

9. Graveyard Decoration

Across rural Afro-America the cemetery is very special. Not only is it the realm of the deceased, but it is also where we find the strongest material demonstration of African-inspired memories. Herskovits and Bastide have amply documented a complex set of Afro-American behaviors and beliefs regarding funerals that might be called a "cult of the dead."[1] The attitudes and practices manifested in this cult derive from the belief that the deceased can continue to affect the lives of their families and friends. Thus it is important, if not crucial, that elaborate care is taken in the planning and preparation of a funeral. Strong feelings about one's last rites have led to the formation of communal burial societies. The significance of such organizations has been duly noted: "Burial insurance is usually the first to be taken out and the last to be relinquished when times grow hard. It is considered more important by the very poor than sickness or accident insurance. . . . No Negro in Cottonville can live content unless he is assured of a fine funeral when he dies."[2] A proper funeral must be conducted with decorum and respect. The deceased must be honored and his remains treated with dignity and reverence. A "settin' up" or wake was held, when all the mourners bade farewell to the deceased, and some kind of procession brought the body to the grave.[3] Finally the grave was decorated, a tradition which, as we shall see, is directly linked to African mortuary practice. To encounter Afro-American graveyard decoration is to witness a physical manifestation of strong religious belief. The cemetery gives us a glimpse of the spiritual force which has ever been the source of hope and inspiration for black America.

The mode of decoration used in Afro-American graveyards is so different from what is commonly expected of a cemetery that the graveyard may not even be recognized for what it is. A recent report on the work of the Institute of Archaeology and Anthropology of the University of South Carolina included the following evaluation:

> A man was dispatched to check out the area [Charlestowne Landing] and he returned reporting that there didn't appear to be anything there other than some late nineteenth century and twentieth century junk scattered throughout the area. [Stanley] South and the writer [John D. Combes] both remembered

the area and had written the location off as being late period garbage of no interest. . . . That turned out to be an unwise decision.[4]

The tone of lament taken here is appropriate, for the "late period garbage" turned out to be a black graveyard. The common expectation for a cemetery is neat rows of stones and markers on a well-mowed green lawn. Afro-American graves in rural areas do not conform to this norm. William Faulkner made some appropriate remarks about Afro-American graveyards in *Go Down Moses*:

> . . . the grave, save for its rawness, resembled any other marked off without order about the barren plot by shards of pottery and broken bottles and old brick and other objects insignificant to sight but actually of a profound meaning and fatal to touch, which no white man could have read.[5]

It is interesting that a novelist's perceptions should be so close to reality, while archaeologists miss the mark completely.

Black graves are made distinct by the placement of a wide variety of offerings on the top of the burial mound (Figure 90). Most of these items are pottery or pressed-glass containers, but many different objects are encountered, including cups, saucers, bowls, clocks, salt and pepper shakers, medicine bottles, spoons, pitchers, oyster shells, conch shells, white pebbles, toys, dolls' heads, bric-a-brac statues, light bulbs, tureens, flashlights, soap dishes, false teeth, syrup jugs, spectacles, cigar boxes, piggy banks, gun locks, razors, knives, tomato cans, flower pots, marbles, bits of plaster, toilet tanks.[6] These objects, when arranged on a group of graves, constitute a visual environment which in Afro-American tradition is seen as the world of the spirits, often the spirits of ancestors. Graveyard goods are a statement of homage; their function is to keep a tempestuous soul at rest. Far from being heaps of junk, funeral offerings are sanctified testimonies; material messages of the living intended to placate the potential fury of the deceased.

Given the strong belief in the potential return of ancestors, it is no wonder that graveyards would be treated in a special manner. Sarah Washington of Eulonia, Georgia, commented: "I don't guess you be bother much by the spirits if you give 'em a good funeral and put the things

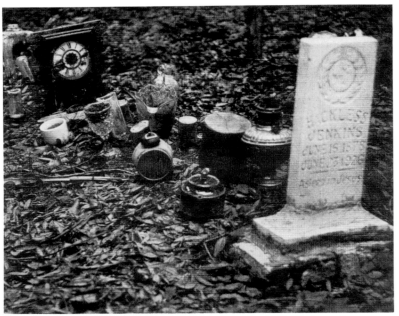

Figure 90. Graveyard decoration, Sea Islands, Georgia, 1933. Photograph, collection of the Library of Congress, Washington.

what belong to 'em on top of the grave''; and her husband Ben seconded her opinion: ''You puts all the things what they use last like the dishes and the medicine bottle. The spirits need these same as the man. Then the spirit rest and don't wander about.''[7] Similar statements have also been collected in Mississippi, where it was reported that the cup and saucer used in the last illness, if placed on the grave, would keep the deceased from coming back.[8] An Alabama resident is recorded as saying: ''Unless you bury a person's things with him, he will come back after them.''[9] The ability to return was also clear to Jane Lewis of Darien, Georgia: ''. . . we take what victuals left and put it in a dish by the chimley and that's for the spirit to have a last good meal. We cover up the dish and there's many a time I hear the spirit lift 'em.''[10] More recently, in South Carolina, a black woman said that several sleepless nights after her daughter's funeral the girl appeared in a dream and told her that she needed her hand lotion, whereupon the woman hurriedly placed the item on the grave, thus solving the problem and ending the in-

Figure 91. Black graveyard, Hale County, Alabama, ca. 1938. Photograph, collection of the Library of Congress, Washington.

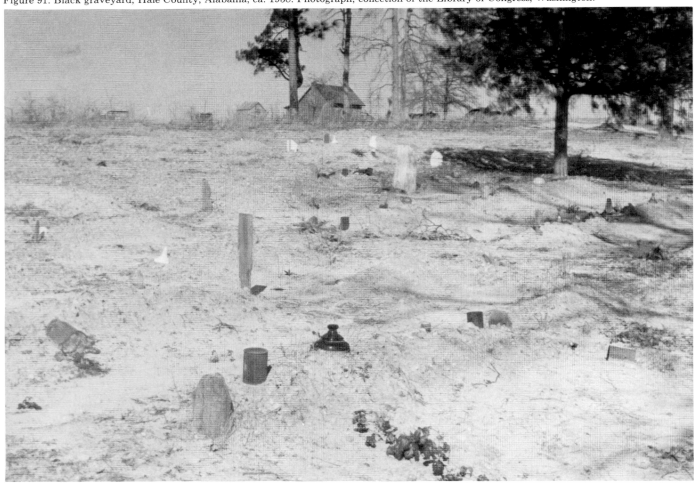

somnia.[11] The demands of the dead thus lead the living to follow a distinctive mode of grave decoration.

There is a discernible pattern in the types of objects left on graves. Most are containers, and most can be broken in such a way that they still retain their form (Figures 91, 92). For example, a pitcher may have the bottom broken out, but when set in the cemetery it will still look like a perfectly good pitcher. Rosa Sallins of Harris Neck, Georgia, provides the rationale for this treatment of grave goods: "You break the dishes so that the chain will be broke. You see, the person is dead and if you don't break the things, then the others in the family will die too. They will follow right along."[12] Some commentators have suggested a poetic image for the ritual shattering of grave decorations, citing proverbs ("The pitcher that goes often to the well shall at last be broken") and other suggestive lines ("the golden bowl shall be broken").[13] These notions, however, ignore deeper cultural motivation. The theory that breaking objects prevents their theft is also short of the mark, for there is a complex set of malevolent moral forces which prevent such deeds. Jane Lewis said of stealing from a grave: "Sure it's bad luck. Them dishes and bottles what put on the grave is for the spirit and it ain't for nobody to touch 'em."[14] In his literary ethnography of the Sea Islands, Du Bose Heyward describes how the mysterious "Plate-eye" attacks a white man who takes a half-pint flask from a grave.[15] Combes observes a similar situation in contemporary South Carolina: "Within the present city limits of Charleston exists a black cemetery located in a black community in which all of the discussed traits [placement of grave goods] are still being observed. Grave offerings not excluding coins remain undisturbed by the community *including* the children!"[16] It would thus appear that objects do not have to be rendered useless in order to be protected from larceny. Rather they are broken because of customs remembered from African ancestors. Slaves clung to this ritual when it seemed that all else was hopeless. Death was to them an escape forever from the bonds of servitude and a return to the ancestral spirit home.[17]

Figure 92. Black graveyard, Hale County, Alabama, ca. 1938. Photograph, collection of the Library of Congress, Washington.

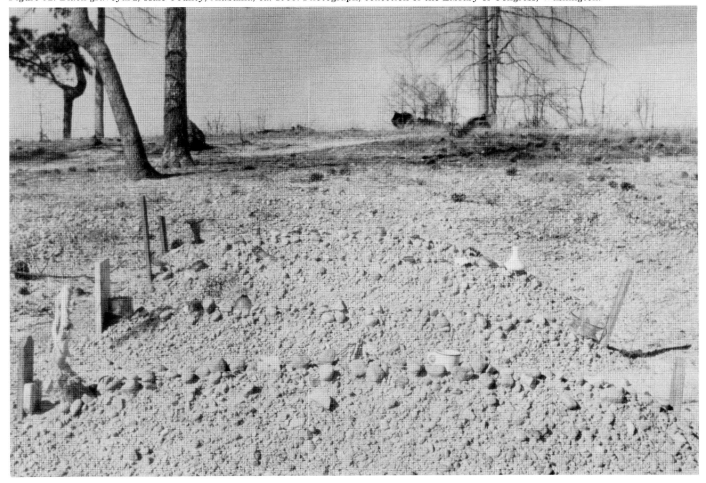

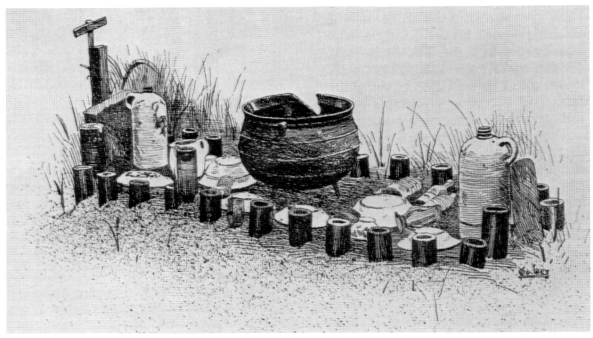

Figure 93. Congo chieftain's grave. (After Glave, p. 827.)

African Antecedents

The antecedents for Afro-American mortuary decoration are found all across West and Central Africa. E. J. Glave who traveled through Zaïre in 1884 wrote in 1891: ". . . natives mark the final resting-places of their friends by ornamenting their graves with crockery, empty bottles, old cooking pots, etc., etc., all of which articles are rendered useless by being cracked or penetrated with holes."[18] His illustration (Figure 93) of a Kongo chief's grave would not be out of place in Central Alabama. In Gabon the same funeral custom occurs. In 1904 missionary Robert Hamill Nassau wrote:

> Over or near the graves of the rich are built little huts, where are laid the common articles used by them in their life—pieces of crockery, knives, sometimes a table, mirrors, and other goods obtained in foreign trade. Once, in ascending the Ogowe, I observed tied to the branches of a large tree extending over the stream from the top of the bank, a wooden trade-chest, five pitchers and mugs, and several fathoms of calico prints. I was informed that the grave of a lately deceased chief was near.[19]

He also noted that "however great a thief a man may be, he will not steal from a grave. The coveted mirror will lie there and waste in the rain, and the valuable garment will flap itself to rags in the wind but human hands will not touch them."[20] Recent anthropological studies in the same region show a remarkable, but expected, continuity of these same funerary practices.[21] Graves are covered with diverse objects for the dead which will help them in the other world. Encountered on a chief's grave were ten baskets, an iron pot, a large cloth, and ceramic figurines of an elephant, a tiger, and a crocodile. Pottery objects are still broken, and people are afraid to touch any object set on a grave. Among the Ekoi of southeastern Nigeria, devotees of the goddess Nimm were buried under a stick framework from which were suspended the belongings of the deceased: cloths, dishes, pans, and gourds. In other burial sites elaborate graves are constructed:

> These usually take the form of a low divan made of mud, 8 to 10 feet long, 3 feet wide, and about 1-1/2 feet high. All along the edge plates and dishes have been pressed into the mud when soft. These were first broken, as is always done with the property of the dead, but the hardening mud acts as cement to hold them together.[22]

The Akan groups of Ghana and the Ivory Coast also honored their dead with ceramic ornaments, usually idealized terra-cotta portraits. But these masterpieces of the potter's art were but one element in an elaborate program of grave goods. Roy Sieber notes: "After dark on the last day of the [funeral] ceremonies, the hearth, the pottery and wooden cooking vessels and utensils, the shelter, and the terracottas were all taken to the

royal cemetery and placed on the grave."[23] Among the Yoruba of Nigeria today the deceased are often interred in the floor of the house; the site is marked on the adjacent wall by an embedded china plate.[24] The pattern and practice of burial customs across West and Central Africa is roughly equivalent. Graves are marked by common material possessions; they are often broken and must not be disturbed because they are the property of the deceased. These basic concepts match up directly with the explanations given by Afro-Americans for their burial customs. The close agreement among African cultures concerning mortuary traditions provides a stable basis for their continued practice on this side of the Atlantic.

The selection of decorative motifs in Afro-America can be largely explained by reference to African belief systems, particularly to the theology of the Kongo religion. It is believed in lower Zaïre that deceased ancestors become white creatures called *bakulu,* who inhabit villages of the dead located under river beds or lake bottoms; they may return from this underworld to mingle with the living without being seen and can then direct the course of the living.[25] Stone figures set as guardians for graves *(mintadi)* are carved from a soft dense rock (chlorite schist), which is white.[26]

The grave goods in Afro-American cemeteries are also usually white, whether they are china, porcelain, enamel ware, bleached sea shells, bits of plaster, or light bulbs. Furthermore, many of the objects are associated with water or can be interpreted as water symbols. Most of the pottery and glass objects are pitchers, tumblers, cups, or bottles; all can hold water. In one case a pitcher was placed on a woman's grave because it was "the pitcher she made ice water in. . . ."[27] Sea shells have obvious water associations. When placed on top of the grave they create an image of a river bottom, the environment in African belief under which the realm of the dead is located. Mirrors also may be considered as water symbols. Their smooth, reflective surfaces have some of the characteristics of a river or lake. At Sunbury, Georgia, a grave at the First Baptist Church had a large mirror (approximately 2 x 3 feet) set into a concrete slab that covered the top of the burial mound.[28] This was apparently a dramatic representation of the watery transition between life and death.

Several patterns of arrangement are common: a few large conch shells are set near the headstone or in a line from the head to the foot of the grave; small oyster and clam shells can frame

the outside edge of the burial plot, or they may completely cover the entire mound (Figure 94). Afro-American graves may thus be read as a kind of cosmogram: the world of the living above; the dividing line of shells; the realm of the spirits, which is not only under ground but also under water. The tradition for shell ornamentation is so strong that even in areas far from the ocean, like Kentucky, shells are sought for decorative purposes. Sometimes shells and water containers are combined into one symbol of transition. In Conway, South Carolina, I encountered a grave with a glass pitcher on it. The bottom of the pitcher had been knocked out, and

Figure 94. Shell-covered grave in Mount Pleasant, South Carolina, 1976.

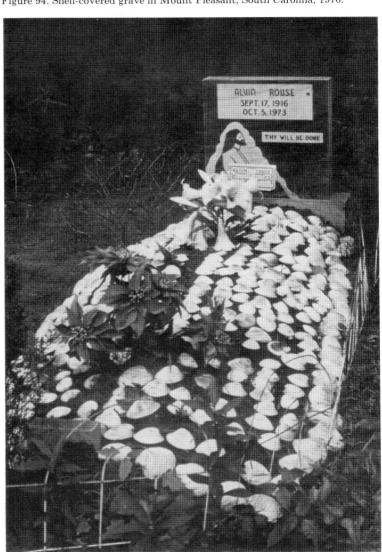

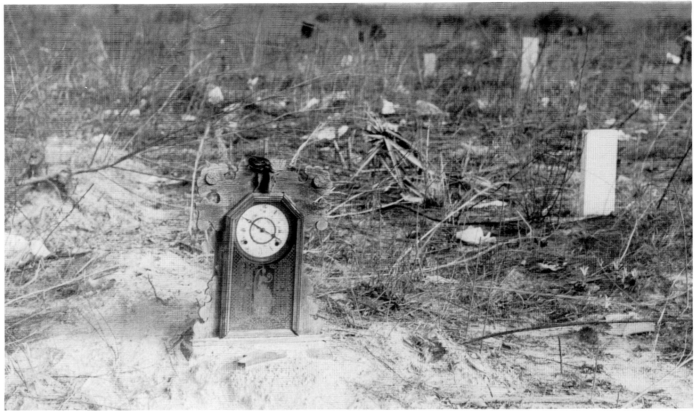

Figure 95. Black graveyard on abandoned land in Santee-Cooper Basin, near Moncks Corner, South Carolina, ca. 1938. Photograph, collection of the Library of Congress, Washington.

the vessel had been set down over a conch shell. The layering of emblems is but another instance of an African sculptural aesthetic we have already encountered in wooden canes.

Another funeral custom traceable to Africa involves the sacrifice of a live animal or fowl—often a chicken—to the spirit of the deceased. This ritual was carried on in many black communities in the South but is particularly well remembered in Georgia. According to Shad Hall of Sapelo Island: "They kill a white chicken when they have set-ups to keep the spirits away. She [his grandmother] say a white chicken is the only thing that will keep the spirits away and she always keep white chicken for that in yard."[29] We find that chicken symbols also carry over into grave decoration. In 1924 Homer Eaton Keyes found a black graveyard in Camden, South Carolina, which "fairly bristled with glass chickens." His photographs record pressed-glass hens set amidst oyster shells in front of a tombstone marked 1912. It is possible that these vitreous fowl were cognate forms of the chicken sacrifice. At some moments in the day translucent glass may even appear white under the glare of the sun's rays.

Modern and Traditional Practices: A Comparison

New behaviors consistent with the tradition but reflecting new orientations in theology have entered Afro-American burial practice in the twentieth century. Clocks are now a very common grave offering. Large pendulum clocks (Figure 95) were apparently used in the 1920's, but in later years small, spring-wound alarm clocks have become more common. Most recently professional morticians have provided styrofoam and floral constructions with clock faces on them.[30] There are two general reasons for the presence of clocks on graves: they are set at twelve to wake the dead on Judgment Day, or they are set to mark the hour when the deceased passed away. The first is decidedly Christian in orientation, while the latter demonstrates the relationship between the object and the deceased person. Hence, we can see that clocks, even of styrofoam, are part of older grave decoration customs.

Monuments and markers are another element of grave decoration. It is now common for "commercial" stones—granite or limestone—to be

144

Figure 96. Ceramic vessel, possibly used for grave decoration, late 19th century. Collection of the Pottersville Museum, Edgefield, South Carolina.

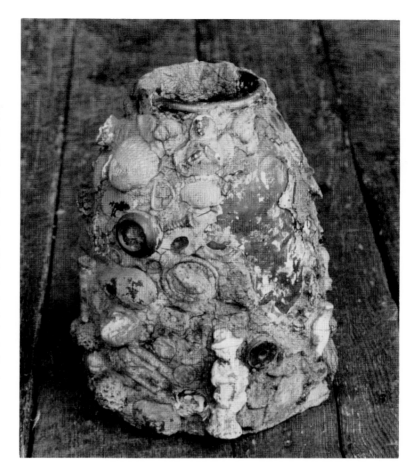

used, but numerous homemade concrete and wooden markers can still be found. One vase (Figure 96), dated to the 1880's, is covered with the kinds of objects that are usually scattered on the surface of a grave. Shells, bits of glass, coins, a pill bottle, a ceramic statue, and other odds and ends have been stuck with plaster onto a brownware jar. It is a three-dimensional rendering of what is usually encountered as a two-dimensional environment. Set on a grave, this decorated jug could be read as either a superior grave offering or a tasteful monument. The concrete grave markers form a neat intersection between commercial headstones and scattered clusters of burial offerings. They are usually tablet forms inscribed with the pertinent information, often in a rough, uneven hand (Figure 97). For example, the tombstone of Colin Baken in the Palmyra Baptist Church at Sunbury, Georgia, reads:

COLI
ИBAK
EИ

Designs also may be inscribed on these concrete markers while the cement is still wet. Sunbury graveyards have many tombstones with decorative motifs. At the First Baptist Church cemetery Chaney Bowens' stone has a dove on it; Rachel Bowens' marker has a hand imprinted in it with a mirror set in the palm; Aaron Bowens' headstone carries an automobile headlight. Over at the Palmyra Baptist Church many concrete markers have broken pieces of glass imbedded in them, often with pieces of white paper behind them. Thus we see aspects of the grave offering included in tombstones. Concrete grave markers are obviously a twentieth-century development, but, as we have seen before, novelty does not always override tradition—rather novelty provides a new format for the expression of tradition.

Wooden markers do not last long. The weather and termites eventually reduce them to splinters, but the surviving remnants give some indication

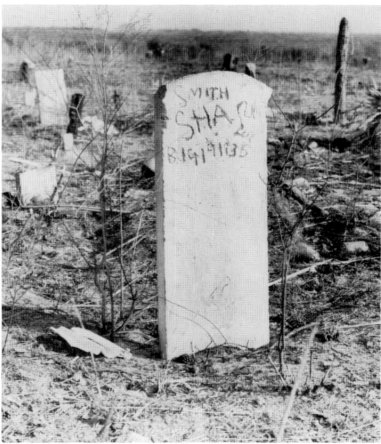

Figure 97. Black graveyard on abandoned land in Santee-Cooper Basin, South Carolina, 1941. Photograph, collection of the Library of Congress, Washington.

of sculptural concepts. Ideally, each grave has two markers (see Figure 92); a larger, more elaborate one for the head, and a stake with a notch in the end at the foot.[31] The head marker is a slab of wood, one-half to one inch thick, which is shaped into a human form. The head, neck, shoulders, and torso are minimally represented. These markers are appropriate icons of lost human life. They indicate the outlines of the body but give no details. When bleached by the sun these markers appear almost cadaverous. Simple wooden markers such as these, however, constitute a traditional basis for other more elaborate grave sculptures.

Cyrus Bowens of Sunbury created not only concrete markers in his family plot but also a group of large wooden sculptures (Figure 98), which are the artistic focus of his mortuary environment. The central piece in this group is a rudimentary human form not unlike the commonplace wooden head boards. Standing almost five feet high, it consists of a round head on a cylindrical post. The head has oval eyes, and the mouth is indicated by a thin line. It is a three-dimensional treatment of the flat marker. The relationship of this unique sculpture to the common head board is similar to the relationship between the previously described funeral vase and the arrangement of grave goods. Both the sculpture and the vase have their origins in communal custom. Even in the round this monument is still a minimalistic sculpture. Of central importance are the bold capital letters spelling BOWENS across the front of the post. The two flanking pieces, now lost, were both serpent-like forms. In making these sculptures Bowens took advantage of the natural shapes of the branches he found in the woods. In the piece to the right, a forked limb served as a pedestal for a curved branch which was pointed at one end and had a knob at the other. The knobby end when set on the pedestal is easily interpreted as a head of a snake; the slim end thus becomes the tail. The other assemblage was primarily a vertical expression, reaching twelve or thirteen feet into the air. The main element of this sculpture was an oddly formed piece of wood (perhaps the trunk of a sapling that got bent around a larger tree somewhere out in the thicket that is the natural environment of the Sea Islands). It starts at the bottom as a thick shaft, then turns abruptly into a horseshoe curve, and then tapers for the last seven or eight feet into a thin rod. Several short pieces were nailed on to this large branch, some within the curve and others at the top. The exact intentions of this tall sculpture

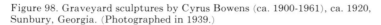
Figure 98. Graveyard sculptures by Cyrus Bowens (ca. 1900-1961), ca. 1920, Sunbury, Georgia. (Photographed in 1939.)

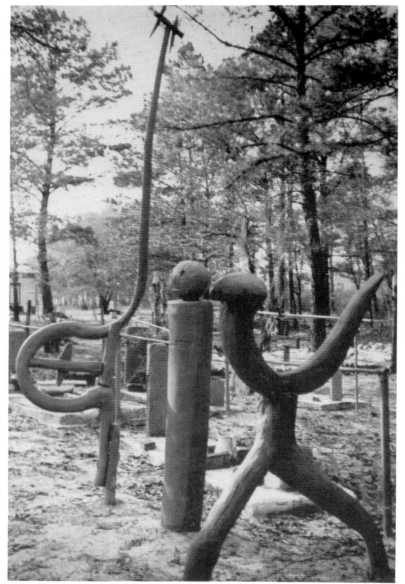

146

are still a mystery; but because the curvature found in the snake sculpture is repeated here, there was probably some continuity between the two art works. One final assemblage, set a little distance from this trio of sculptures, served as a bracket, from which was hung a sign bearing the names of the deceased members of the Bowens family. A bold curve encountered in this standard tempts us to recall the dominance of reptile motifs in Afro-American wood carving. (Another possible manifestation of the snake motif is found in an iron grave marker from Alabama [Figure 99], which has a rod twisted into a snake-like form in an apparent attempt to spell out the name of the deceased.) However, Bowens died in 1966 before anyone could ask him about his designs, so it is perhaps safer to analyze his work against the background of the usual grave sculpture, the wooden head board. We see then in Bowens' central figure a close approximation of the commonplace traditional form. It would seem that once he finished this name-bearing title piece, he abandoned the somber, restrictive convention that controlled the making of grave markers. All of the other pieces have expressive exponential curves. Perhaps once the tradition was honored, the creative adrenalin flowed more wildly. All of this is, of course, conjecture, for we do not know in what order the Sunbury sculptures were created. Only the simple pole and head statue remains as a hint of Cyrus Bowens' exciting vision for the cemetery, the world of the dead.

We have surveyed a wide range of decorative expression in black cemeteries and have seen how intimately those expressions are associated with an African heritage. In brief, we can say that Afro-American graves are often indistinguishable from African graves. This is because the religious systems which shape the attitude toward death, and therefore the way death is treated, are not very different. Nassau reports that in Central Africa "the coffin is laid with the face of the dead looking eastward."[32] Parsons says of coastal Blacks in South Carolina that their graves are "invariably dug east to west, the head to the west," i.e., facing to the east.[33] The continuity here is obvious, and it results from a shared concept of the cosmos—that the world is oriented east to west following the sun. In black cemeteries throughout the South (that is, from the Atlantic seaboard to eastern Texas, and from the Gulf Coast to Kentucky), a very African religious and aesthetic perspective is maintained. A comparison of the graves documented by Farm Security Administration photo-

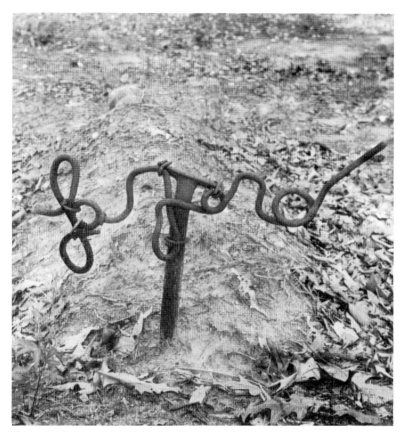

Figure 99. Grave marker, Taladega Forest, Alabama, ca. 1959.

graphers in the 1930's with graves decorated today shows how stable the tradition has been in recent decades. Graves are decorated the same way now as they were forty years ago, sixty years ago, even a hundred years ago.[34] More importantly, the custom is not confined to the South alone, for grave goods appear also in the cemetery at Sandy Ground, a black settlement in Staten Island.[35] The northward urban migration of Blacks in the twentieth century has caused many Afro-American traditions to change. But values and behaviors associated with death are so strongly felt that they manage to survive the pressures of social crises and perhaps serve as a source of ethnic identity and strength. The realm of the dead does truly have an impact on the living.

Conclusion

Every survey of art unavoidably must look in two directions, back over what has been covered and forward to future scholarship which one hopes will complement the earlier findings. So it is with this survey of Afro-American decorative arts. We have considered only nine facets of the subject, largely from the perspective of cultural history. There are many more elements to scrutinize and other strategies of analysis to employ. Yet it seems that the further study of black art and craft must rely on the kind of foundation that has been laid in this survey. We have basically located Afro-American decorative art in space and time, the two coordinates necessary to plot its evolution and chart its impact.

Beyond these essentials certain assumptions about art have been made and, I think, to a great extent verified. These premises can be summarized as follows:

1. Art is as much concept as object.
2. The concepts of art are effectively the concepts of culture.
3. Art can be a specific source of ethnic strength.

Henry Glassie in elaborating upon a definition of folk art sought to distinguish between art that was culture and culture that was art,[1] but what seems to be most significant is the broad and encompassing relationship between the two. Creativity reinforces identity; a sense of community is manifested between the maker and his artifact and other, like-minded, individuals. This dynamic interaction of perceptions allows us to liken patterns in people to patterns in art. In the study of Afro-American art this is crucial. Little has been written about Afro-American artistic achievements, while hundreds of volumes have been devoted to the political and social history of black America. Now these histories can be our key to understanding the achievements of black people in the decorative arts. Art moves within people, and wherever there have been Afro-Americans, there has been Afro-American art.

The history of black population patterns from 1790 to 1860[2] tells us much about the objects we looked at here. We have considered different kinds of artifacts from different places and periods. So far we have developed a sense of the competence of black artisans, but all remains fragmentary and disjointed until we understand how Afro-Americans moved across the land (Figure 100).

In 1790 the heaviest concentrations of Blacks were found in the tidewater areas of Maryland, Virginia, and North Carolina, and in coastal South Carolina. These are precisely the areas where we encounter an Afro-American tradition for boatbuilding and basketry. The oldest objects that we have considered—those that were perceivably the most African—have been from this same region. Tidewater Virginia, having one of the largest early concentrations of African slaves, experienced the direct implantation of African-derived culture. The slave drum, the wrought-iron statue, the multiple-log dugout, and mud-walled houses are surviving evidence of the black textures interwoven in the fabric of everyday life in Virginia. The observation also applies for coastal South Carolina during the same period. Our evidence is, however, more utilitarian in nature, consisting of the tools for rice harvesting and fishing.

By 1860, as the frontier receded before the onslaught of the general westward movement of the American populace, Blacks had moved a considerable distance inland. Black populations were massed solidly through the tidewater and piedmont areas of the southeastern United States, from the coast right up to the Appalachian mountains. A long arc of black settlement also stretched from South Carolina through central Georgia, Alabama, and Mississippi, almost to Tennessee. Finally, throughout the Mississippi River Valley, from Louisiana on up to northern Kentucky and central Missouri, the dispersement of slaves followed the meandering courses of America's mightiest rivers—the Mississippi, the Ohio, and the Missouri. Just prior to the Civil War, Blacks ranged over the entire South and were in positions from which they would eventually move further to the North and West. If we look closely at this population pattern we soon observe a connection that ties together all of Afro-America. And it is a connection that confirms our speculations about the history of black American decorative art.

We have noted that a distinctive quilting form, the strip or string quilt, is found in black communities from Maryland down the eastern seaboard to Georgia and inland from the coast to Mississippi. Within this sweeping curve, from the South Carolina Low Country all the way to

Louisiana, we also observe the existence of a coiled basket tradition, and from Georgia to Mississippi, there is a complementary dispersion of fife making artisans. The close match-up between the patterns of migration and settlement and the diffusion of black arts and crafts gives us the key to understanding the similarities in Afro-American carvings found in both Georgia and Missouri. Not only was there a flow of people from Georgia well into the Midwest, but there was a flow of ideas as well. Hence, there is ample aesthetic connective tissue between the coast of Georgia and north-central Missouri to explain the provenance of Henry Gudgell's work. The east to west migration of artistic ideas was complemented by the south to north movement from the Gulf Coast inland along the Mississippi. The distribution of black population along this route matches the eventual distribution of the shotgun house. It, too, followed the rivers as far north and west as St. Joseph, Missouri, and as far north and east as Cincinnati. Overlaying these two movements is the pattern of grave decoration; graveyard offerings occur wherever black churches are found. We might be able some day to argue that this extremely African set of practices entered the United States at several points—Annapolis, Jamestown, Wilmington, Charleston, Savannah, Mobile, New Orleans—and was perpetuated wherever possible as Blacks radiated out from these points of initial entry.

Since 1865 black folk art and craft have either become entrenched in their source areas in the South, usually in out-of-the-way corners of civilization, or they have followed the movement of black people north to urban centers, where objects like quilts relieve the monotony of city life. Wherever these arts and crafts are practiced, contemporary developments depend on a sense of communal history which developed in the South, "down home."

If we can perceive linkages among the various decorative arts in this country, this unity should not cause us to overlook the bonds which tie black Americans to other New World black communities. In many instances we have seen that black creations in the United States were an extension of decorative, expressive, and pragmatic concepts initiated in the West Indies. We can point to boatbuilding as a prime example of this connection. In like manner, an important American folk house type, the shotgun house, has its origin in Haiti, and some southern monkey jugs may be traced to Barbadian and Jamaican pottery sources. Caribbean musical instru-

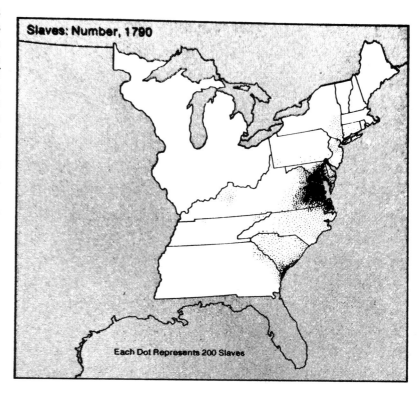

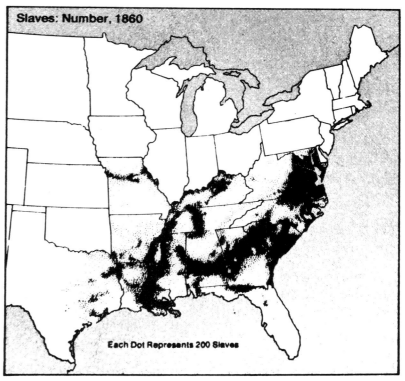

Figure 100. Distribution of slave population in 1790 and 1860. (After Fogel and Engerman.)

ments, like fifes, drums, and banjos, have their obvious North American counterparts. Even in walking sticks continuities can be observed between the work of Haitian wood carvers and Afro-Georgian sculptors. The intensity of the cultural relationship between the Caribbean and North America varies with each example, but the sense of carry-over is obvious. Herskovits spoke of New World African peoples as belonging to "cultures lying within a given historic stream."[3] He also charted the African retentions for all Afro-American communities and demonstrated how this stream flowed not only from Africa to the New World but from South America to the urban United States.[4] While he rated the "Africanness" of African-derived art and technology in black American communities from "somewhat African" to "absent," we have seen that his estimates should be revised to show stronger African retentions, for the historic flow of Afro-American culture surges boldly in the South and is not a mere trickle at the end of the stream.

The objects at which we have looked have been basically of two types: pure African retentions and New World hybrids. Those artifacts which are culturally distinct tend to be either the objects produced in a social context where African concepts were dominant (such as the coiled grass baskets of South Carolina) or the objects made by African-born people (such as the Virginia slave drum, the wrought-iron statue from Alexandria, or Luiza Combs' blanket). With the exception of grave decorations, uninterrupted cultural survivals are rare. There has been too much intervening history between 1619 and now to allow the unaltered retention of cultural concepts, let alone the absolute stability of decorative and pragmatic expressions. Most features of an African artistic heritage survive in a residual manner, balanced against the social role imposed by a dominant white culture. Yet, through the implementation of a different style, white forms and techniques become conduits for black ideals. Each of the genres of expressive endeavor that we have considered involve the blending of Euro-American and Afro-American cultures. Consider the quilts, the walking sticks, the ironwork, the jugs and crocks, the banjo, the shotgun house, the multiple-log dugout, concrete grave markers, modern coiled baskets—all are what they are because two cultures have intermingled. The blending of two cultural perspectives is a basic theme in the black experience. Ralph Ellison in summarizing that experience speaks of a "complex double vision, a fluid, am-

bivalent response to men and events which represents at its finest a profoundly civilized adjustment to the cost of being human in this modern world."[5] The development of hybrid expressions in decorative art is thus essential to the growth and enrichment of black American culture.

Improvisation has often been noted as a key definitive characteristic of black music, dance, and rhetoric, and we have often noted here that whether the object is a house, a quilt, or a basket, an improvisational aesthetic is at work. If we think of improvisation as a spontaneous experiment, with creative possibilities, we can easily appreciate that the presence of cultural alternatives stimulates this mode of performance. Improvisation is an additive process, a trying of new ideas. This mind set is the most important contribution of Africa to the New World. Robert Plant Armstrong calls it "syndesis," creation through the addition of parts.[6] Afro-American hybrid objects, while they occur as documents of New World history, derive their creative effect from their close connection to the wellspring of African aesthetics. Even in their "impurity" they, too, are African.

Many issues concerning Afro-American art still require consideration. The broad history sketched here needs refinement. For example, black creative achievement might be divided into shorter periods and each studied in more depth. Exhaustive studies of each genre (basketry, blacksmithing, quilting, etc.) are sorely needed. New details concerning the conduct of slavery, plantation life, black entrepreneurship, and sharecropping are constantly coming to light. These data can only further develop our understanding of Afro-American decorative art. To such historical analyses must be added studies of contemporary traditional artisans. Older practitioners of blacksmithing and wood carving represent living archives, vital links to the past, that may soon be lost. Their role in shaping the current status of folk art and craft must be recorded now or we will face a future without full knowledge of their confidence and stabilizing influences. Key concerns in the black experience are necessarily key themes in black artistic expression. Thematic studies concerning, for example, the struggle for freedom, the importance of religion, or the quest for ethnic identity should be pursued. Now that the Afro-American tradition in the decorative arts has been identified and its wide scope revealed, we may look forward to an even fuller understanding and appreciation of black traditions and their impact on the world.

Notes

Introduction

1. Pp. 16-18.
2. Pp. 13-28.
3. See Fine, *The Afro-American Artist;* Driskell, *Two Centuries of Black American Art.*
4. *Nineteenth-Century Afro-American Art,* p. 2.
5. Quoted in Thompson, "African Influence," p. 173.
6. Driskell, *Two Centuries of Black American Art,* p. 14.
7. Porter, "Four Problems in the History of Negro Art," p. 11.
8. *Negro Past,* p. 32.
9. P. 17.
10. Bohannon, "A Project for Current Anthropologists," pp. 361-362.
11. Herskovits, *Negro Past,* pp. 136-137.
12. *The Souls of Black Folk,* p. 17.
13. Indian influences might also be mentioned, for there was some interchange between Blacks and Native Americans. See Willis, "Red, White, and Black in the Southeast," pp. 157-176. The impact of this contact was slight, however, when compared to the social exchange with Whites. Indeed, it seems that Blacks had more impact on Indians than the Indians had on Blacks.
14. Wood, *Black Majority,* p. 132.
15. Wood, "'It was a Negro Taught Them,'" pp. 159-179.
16. Finnegan, *Limba Stories,* p. 64 *et passim.*
17. Scheub, "The Art of Nongenile Mazithatha Zenai," pp. 115-142.
18. See Rattray, *Akan-Ashanti Folktales,* for examples of spider stories.
19. See Lomax, *Folksong Style and Culture.* Compare cantometric profiles for African and European music.
20. See Sieber, *African Textiles and Decorative Arts.*
21. Vlach, "Affecting Architecture of the Yoruba," pp. 48-53.
22. Bidney, *Theoretical Anthropology,* p. xxxix.
23. "African Influence," pp. 136-150. Let me hasten to add that Thompson's article was preliminary in nature. I'm quite sure that no one in the field of art history is more aware of the broad, encompassing contexts of Afro-American creativity than he is.
24. See Dorson, *Negro Folktales in Michigan.*
25. "African Influence," p. 172.
26. *The European Vision of America,* p. 14.

For the full form of abbreviated references, please see the Bibliography.

1. Basketry

1. See Turner, *Africanisms in the Gullah Dialect.*
2. Davis, "Afro-American Coil Basketry," p. 153.
3. See Twining, "Afro-American Baskets from the Sea Islands."
4. *The Baskets of Rural America,* p. 71.
5. "'A Negro Taught Them,'" p. 162.
6. *Ibid.,* p. 163.
7. Heywood, *Seed From Madagascar,* p. 35. (Heywood ran a Sea Islands rice plantation until 1910.)
8. Glenn, *A Description of South Carolina,* p. 171.
9. See Day, *South Carolina Low Country Baskets.*
10. Glassie, *Folk Culture of the Eastern United States,* p.116, gives a number of European and Native American analogs for the mortar and pestle.
11. Barber, *A History of the Amistad Captives,* pp. 9-15.
12. Murdock, *Africa: Its Peoples and Their Culture History,* p. 45.
13. Wood, "'A Negro Taught Them,'" p. 172.
14. Chase, *Afro-American Art and Craft,* p. 60.
15. Davis, "Afro-American Coil Basketry," p. 159. The Charleston Museum has a basket made of rush and oak from 1865 (no. 18292).
16. Gregory Day, personal communication, January 1977. Rush baskets were made in Georgia in the late 1930's by Isaac Basden of Harris Neck and John Haynes of Old Fort. See Georgia Writers' Project, *Drums and Shadows,* pp. 8, 121-122.
17. Gregory Day, personal communication, July 1977.
18. This list is compiled from a field report by Gregory Day and Kay Young Day on file with the Division of Cultural History, Museum of History and Technology, Smithsonian Institution, Washington.
19. Herskovits, *Negro Past,* p. 146.
20. Teleki, *The Baskets of Rural America,* p. 174.
21. Davis, "Afro-American Coil Basketry," pp. 154-155, gives the example of Peter Alston, a male basket sewer. Male basket sewers are also mentioned by Parsons, *Folk-Lore of the Sea Islands, South Carolina,* p. 208. Alfred Graham, an African-born basket maker, is pictured in Dabbs, *Face of an Island,* n.p.
22. "Basket Weavers of Charleston," p. 26, interview with Mrs. Comie German.
23. *Lawson's History of North Carolina,* p. 199.
24. *Ibid.*
25. Teleki, *The Baskets of Rural America,* p. 51; Densmore, *Chippewa Customs,* p. 162, pl. 72-b.; James, *Indian Basketry,* pp. 162-164.
26. See Sylestine, "Coushatta Pine Needle Basketry."
27. Perdue, "'African' Baskets in South Carolina," p. 292.
28. Dundes, "African Tales among North American Indians," pp. 207-219.
29. Cooley, *Homes of the Freed,* p. 144; Parsons, *Folk-Lore,* p. 208; Georgia Writers, *Drums and Shadows,* p. 52.

30. On display at the Museum of History and Technology, Smithsonian Institution, Washington, in an exhibition entitled *A Nation of Nations*.

31. Quoted in Botkin, *Lay My Burden Down*, p. 244.

32. A coiled rush hat is in the collection of the Old Slave Mart Museum, Charleston, S.C.

33. Gregory Day, personal communication, February 1977. See also Day, *South Carolina Low Country Baskets*.

2. Musical Instruments

1. *Negro Past,* p. 142.

2. Courlander, *The Drum and the Hoe*, pl. 41; Courlander, *Negro Folk Music: U.S.A.*, p. 212.

3. "The Dance in Place Congo," p. 191.

4. Georgia Writers, *Drums and Shadows*, p. 62.

5. Courlander, *Negro Folk Music*, p. 212.

6. Watkins, "A Plantation of Differences," p. 74.

7. *Drumming in Akan Communities of Ghana*, pp. 8-9.

8. Watkins, "A Plantation of Differences," p. 75.

9. Kahn, *Djuka: The Bush Negroes of Dutch Guiana*, p. 60, shows a drum made by a Djuka artisan. The shape is vaguely reminiscent of Akan bottle drums, but the decoration has no Akan antecedents (at least not for drums).

10. Georgia Writers, *Drums and Shadows*, p. 187.

11. Latrobe, *Impressions Respecting New Orleans*, pp. 50-51.

12. Puckett, *The Magic and Folk Beliefs of the Southern Negro*, p. 59.

13. The best documentation of this tradition is a short film by Ferris, *Gravel Springs Fife and Drum*.

14. Oliver, *Savannah Syncopators: African Retentions in the Blues*, pp. 109-110, cites the appearance of fifes and flutes in Mali, Upper Volta, Niger, and Ghana and provides a comparison of African and Afro-American fifes on pp. 78-79. Caribbean fife and drum ensembles are illustrated in Messenger, "African Retentions in Montseratt," pp. 54-57.

15. Georgia Writers, *Drums and Shadows*, p. 101.

16. Evans, *Traveling Through the Jungle: Negro Fife and Drum Band Music*, Testament Records, gives examples from Georgia and Mississippi. Other examples of fife and drum music can be found on Ferris, *Mississippi Folk Voices*, Southern Folklore Records; and Lomax, *The Roots of the Blues*, Atlantic.

17. Ferris, *Gravel Springs Fife and Drum*. See also Mitchell, *Blow My Blues Away*, pp. 19-47, for a short biographical interview with Othar Turner.

18. Mitchell, *Blow My Blues Away*, p. 33.

19. Courlander, *Negro Folk Music*, pp. 206-207.

20. Evans, "Afro-American One Stringed Instruments," p. 230. Selections of one-string music may be heard on *One String Blues*, Takoma Records.

21. Pearson, "The Late Great Elmore James," pp. 163-164, and 165, points out how bottle neck technique took hold in Mississippi and was carried north to flourish in the urban Chicago style of blues.

22. Evans, "Afro-American One Stringed Instruments," figs. 2-3.

23. *Ibid.*, p. 237.

24. Adler, "The Physical Development of the Banjo," pp. 187-208.

25. Glassie, *Folk Culture of the Eastern United States*, pp. 22-23.

26. Quoted in Yetman, *Life Under the "Peculiar Institution": Selections from the Slave Narrative Collection*, p. 167.

27. This painting, *The Old Plantation*, is in the Abby Aldrich Rockefeller Collection of Folk Art at Colonial Williamsburg.

28. Yetman, *Life Under the "Peculiar Institution,"* p. 167.

29. Koch and Peden, eds., *The Life and Selected Writings of Thomas Jefferson*, p. 258.

30. Epstein, "The Folk Banjo: A Documentary History," pp. 359-360.

31. *The Golden Trade; or A discovery of the river Gambia, and the golden trade of the Aethiopians set downe as they were collected in travelling part of the yeares 1620 and 1621*, quoted in Epstein, "The Folk Banjo," p. 350.

32. Bluestein, "America's Folk Instrument: Notes on the Five-String Banjo," pp. 241-248, comments on the theory that Joel Sweeny, a white minstrel from Appomattox, Virginia, invented the five-string banjo. Odell, "Folk Instruments," p. 32, refutes this theory. See also Odell's article on the banjo in *Grove's Dictionary of Music* (forthcoming).

33. Latrobe, *Impressions Respecting New Orleans*, p. 50.

34. Curtin, *The Atlantic Slave Trade: A Census*, p. 83.

35. *With Sabre and Scalpel: The Autobiography of a Soldier and a Surgeon* (1914), quoted in Epstein, "The Folk Banjo," p. 358. For a good comparison in methodology of construction see Lornell and Moore, "Clarence Tross: Hardy County Banjoist," p. 8. Tross, a black banjoist, describes how he made his first banjo.

36. *Negro Folk Music*, pp. 204-220.

3. Wood Carving

1. Georgia Writers, *Drums and Shadows*, p. 106.

2. *Ibid.*, p. 152.

3. *Ibid.*, p. 53.

4. *Ibid.*, p. 103.

5. Compare with Thompson, *African Art in Motion: Icon and Act in the Collection of Katherine Coryton White*, p. 136, pl. G-1.

6. "African Influence," p. 153.

7. Georgia Writers, *Drums and Shadows*, p. 70.

8. *Ibid.*, p. 33.

9. Wadsworth, ed., *Missing Pieces: Georgia Folk Art 1770-1976*, pp. 64-65.

10. Quoted in Georgia Writers, *Drums and Shadows*, p. 67.

11. Wiggins, "The Wooden Chains that Bind: A Look at One Shared Creation of Two Diaspora Carvers," pp. 29-32, describes chain carving by Thomas Alvin Jarret of Rockvale, Tennessee; and Henry Williams of Africa Town, Alabama (just outside of Mobile), recalls chain carving by Blacks in his area. Chains and balls-in-cages by white carvers are presented by Klamkin and Klamkin in *Wood Carvings: North American Folk Sculptures*, pp. 180-181.

12. The ball-in-the-cage motif appears in house posts in the palace at Ilesha, Nigeria (personal field work, February 1974). A Fang carving with an open-work motif appears in Schadler, *African Art in Private German Collections*, p. 224. See also Fernandez, *Fang Architectonics*, pp. 31-32.

13. Wadsworth, *Missing Pieces*, p. 61.

14. Mier and Rudwick, *From Plantation to Ghetto*, pp. 53-55.

15. Long, "Leon Rucker: Woodcarver," p. 34.

16. Thompson, *African Art in Motion*, pp. 159-163.

17. Ferris, *Made in Mississippi*.

18. "Afro-American Folk Sculpture from Parchman Penitentiary," pp. 141-152.

19. *Ibid.*, p. 152.

20. Thompson, "African Influence," p. 134.

21. *Ibid.*, p. 135.

22. *Ibid.*, p. 136.

23. Lipman and Winchester, *The Flowering of American Folk Art: 1776-1876*, p. 154.

24. See Klamkin and Klamkin, *Wood Carvings*, pp. 34-35, for several examples of cigar store Indians. Each has one foot ahead of the other; and one arm is extended, while the other is at the side.

25. Jahn, *Muntu: The New African Culture*, pp. 161-162.

26. Thompson, "African Influence," p. 162. See also *Folk Art in America: A Living Tradition*, p. 79.

27. See Klamkin and Klamkin, *Wood Carvings*, pp. 76-79, for typical examples of three-dimensional portrayals of Afro-Americans.

28. *Folk Art in America*, p. 8.

29. Thompson, *African Art in Motion*, p. 84.

30. Horowitz, *Contemporary American Folk Artists*, pp. 127-132; Roscoe, "James Hampton's Throne," pp. 12-19.

31. Thompson, "African Influence," pp. 164-166, identifies these characteristics as Afro-American and cites African analogs.

32. Klamkin and Klamkin, *Wood Carvings*, p. 82, illustrate snake canes carved by Civil War prisoners. Kan, "American Folk Sculpture: Some Consideration of its Ethnic Heritage," p. 63, illustrates a serpent-decorated stick made by Sioux Indians.

33. Hansen, *European Folk Art in Europe and the Americas*, p. 266.

34. Courlander, *The Drum and the Hoe*, pl. 60.

35. Georgia Writers, *Drums and Shadows*, pp. 53-54.

36. *Nineteenth-Century Afro-American Art*, p. 4.

37. "American Folk Sculpture," p. 60.

38. Art of the Mende exhibition at the Museum of African Art, Washington, 1976.

39. Schadler, *African Art in Private German Collections*, p. 8.

40. Thompson, *African Art in Motion*, p. 95.

41. Cornet, *Art From Zaire: One Hundred Masterworks from the National Collection*, pp. 36, 44.

42. *Ibid.*, p. 63. See also *African Art: Nature, Man, and Vital Force*, p. 38.

43. Chase, *Afro-American Art and Craft*, p. 61.

44. Puckett, *Magic and Folk Beliefs*, p. 301.

45. Thompson, *Black Gods and Kings: Yoruba Art at UCLA*, Chap. 11, pp. 1-3.

46. Wood, *Black Majority*, p. 109.

47. Barfield, *Thomas Day, Cabinetmaker*, p. 9.

48. *Bowen's Virginia Gazette and the Winchester Sentinel*, 25 November 1796, p. 4, col. 4.

4. Quilting

1. Holstein, *The Pieced Quilt: An American Design Tradition*, pp. 13-14.

2. Yetman, *Life Under the "Peculiar Institution,"* p. 227.

3. See Sieber, *African Textiles and Decorative Arts*.

4. Compare Williams, *African Designs from Traditional Sources*, pp. 63-65, with Hall and Kretsinger, *The Romance of the Patch Work Quilt in America*, p. 52.

5. *The Pieced Quilt*, p. 10.

6. *Quilter's Newsletter Magazine*, p. 5.

7. Sieber and Rubin, *Sculpture of Black Africa: The Paul Tishman Collection*, p. 122.

8. Herskovits, *Cultural Anthropology*, p. 255, pl. 12.

9. Kent, "Appliqué," p. 58.

10. Curtin, *The Atlantic Slave Trade*, p. 225.

11. Sieber, *African Textiles and Decorative Arts*, pp. 29, 41, 206; *African Arts*, VIII, no. 3 (1975), front end-paper; Herskovits, *Dahomey: An Ancient West African Kingdom*, I, frontispiece, pls. 7, 15, 33, 34, 39; Vol. II, 328-343, pls. 51, 52, 54, 67, 69, 84, 86-89; Lamb, *West African Weaving*, pp. 14-15.

12. Personal field work in Abomey, Benin, October 1969, March 1970.

13. Verger and da Cruz, "Musée historique de Ouidah," pp. 18-19.

14. Kent, "Appliqué," p. 59.

15. *Ibid.*, pp. 59-60.

16. Herskovits, *Dahomey*, II, pl. 54.

17. Lipman and Winchester, *The Flowering of American Folk Art*, p. 275, fig. 402.

18. Fry, "Harriet Powers: Portrait of a Black Quilter," p. 19.

19. Horowitz, *Contemporary American Folk Artists*, pp. 43-48.

20. Mrs. Susan Hembrook, an ex-slave from Dinwiddie County, Virginia, sometime before 1881 made a quilt using the log-cabin motif; she arranged the colors in the squares so that a diagonal pattern of light and dark bands, called straight furrow, sweeps across the quilt (personal communication, Mrs. Robert Madison, November 1976). This pattern is also found in Penn-

sylvania at the same time (see Holstein, *The Pieced Quilt*, pl. 49). Other Euro-American quilt types made by Blacks are illustrated in Chase, *Afro-American Art and Craft*, pp. 85-89.

21. Sieber, *African Textiles and Decorative Arts*, p. 155. See also Lamb, *West African Weaving*.

22. Sieber, *African Textiles and Decorative Arts*, pp. 184-185.

23. *Ibid.*, pp. 160, 172-173, 178, 182.

24. Holstein, *The Pieced Quilt*, p. 55, pls. 9, 20, 21, 38.

25. *Ibid.*, pp. 50-54.

26. Glassie, "Folk Art," p. 280.

27. Lamb and Lamb, *West African Narrow Strip Weaving*, pp. 9-16.

28. *African Textiles and Decorative Arts*, pp. 181, 191-192. For other examples see Lamb, *West African Weaving*, p. 112.

29. Mary Arnold Twining, personal communication, February 1977.

30. Glassie, *Folk Culture of the Eastern United States*, p. 222.

5. Pottery

1. Burnaby, *Travels Through the Middle Settlements in North America*, p. 111.

2. Glassie, *Folk Housing in Middle Virginia: A Structural Analysis of Historic Artifacts*, p. 6.

3. See for an example Stavisky, "Negro Craftsmanship in Early America," pp. 315-325.

4. *The Colonial Craftsman*, pp. 15-16, and 139-141.

5. Newman, *Contemporary African Arts and Crafts*, pp. 26-52; Thompson, "Abatan: A Master Potter of the Egbado Yoruba," pp. 120-182.

6. Craig, *The Arts and Crafts in North Carolina*, 1699-1840, p. 89.

7. Burrison, "Prolegomena to a Study of Afro-American Folk Pottery in the South."

8. Georgeanna H. Greer, personal communication, March 1976.

9. Burrison, "Alkaline-Glazed Stoneware: A Deep South Pottery Tradition," p. 391, fig. 2.

10. Franklin Fenenga, personal communication, January 1977.

11. Ferrell and Ferrell, *Early Decorated Stoneware of the Edgefield District, South Carolina*, n.p.

12. Robert Mills, *Statistics of South Carolina, 1826*, quoted in Ferrell and Ferrell, *Early Decorated Stoneware*, n.p.

13. Ferrell and Ferrell, *Early Decorated Stoneware*, n.p.

14. Burrison, "Afro-American Folk Pottery."

15. T. M. Ferrell, personal communication, June 1976.

16. Charleston Museum, and private collection.

17. Collection Georgia State University Folklore Museum, Atlanta.

18. T. M. Ferrell, personal communication, June 1976.

19. Private collection, Seagrove, North Carolina. See Ferrell and Ferrell, *Early Decorated Stoneware*, n.p.

20. Collection Georgia State University Folklore Museum, Atlanta.

21. Private collection. See Ferrell and Ferrell, *Early Decorated Stoneware*, n.p.

22. John A. Burrison, personal communication, July 1976, told me of the reaction of Lanier Meaders, last of the traditional potters in the Mossy Creek area of Georgia (see Burrison, *The Meaders Family of Mossy Creek: Eighty Years of North Georgia Folk Pottery*). Meaders, a man not given to outright praise, studied an example of Dave's work for some time and pronounced him a great potter.

23. Ferrell and Ferrell, *Early Decorated Stoneware*, no. 46.

24. Thompson, "African Influence," p. 140.

25. T. M. Ferrell, personal communication, March 1977.

26. *Ibid.*

27. *Ibid.*

28. *Ibid.*

29. Barber, *The Pottery and Porcelain of the United States: A Historical Review of American Ceramic Art from the Earliest Times to the Present*, pp. 248-249.

30. Thompson, "African Influence," p. 140.

31a. Cox, *The Book of Pottery and Porcelain*, p. 986.

31b. Stow, "A Strange Face from Whately," p. 77.

31c. Smithsonian Institution, National Museum of History and Technology, display of Mid-Atlantic and Southern pottery.

32. Collection of Stephen and Terrence Ferrell.

33. See Hansen, *European Folk Art*, p. 154, figs. c, f, h, for examples from Switzerland, France, and Italy.

34. Taggart, *The Burnap Collection of English Pottery*, pp. 17, 142.

35. Barber, *Pottery and Porcelain*, p. 466.

36. *Ibid.*

37. This piece is now in the collection of the Augusta-Richmond County Museum, Augusta, Georgia.

38. "African Influence," p. 139.

39. See Hornung, *Treasury of American Design*, II, p. 359.

40. Chase, *Afro-American Art and Craft*, p. 45.

41. "American Folk Sculpture," p. 58.

42. "African Influence," pp. 145-146.

43. Burrison, "Afro-American Folk Pottery."

44. Dillard, *Black English: Its History and Usage in the United States*, p. 118.

45. Montgomery, "Survivors from the Cargo of the Slave Yacht *Wanderer*," p. 613.

46. Barber, *Pottery and Porcelain*, p. 466.

47. Personal field work, Charleston, South Carolina, June 1976. Chase, *Afro-American Art and Craft*, p. 57, quotes Alice Davis, a black woman from Augusta, Georgia, who remembered the cry of old-time field hands, "I see the monkey," when they were dizzy from exhaustion.

48. *Four Year Residence in the West Indies* (1830), quoted in Handler, "A Historical Sketch of Pottery Manufacture in Barbados," p. 152, n. 65.

49. Reverend J. H. Sutton Moxley, *A West Indies Sanatorium and Guide Book to Barbados* (1886), quoted in Handler, "Pottery Manufacture in Barbados," p. 146.

50. Wood, *Black Majority,* p. 55.

51. Deetz, "In Small Things Forgotten."

52. Handler, "Pottery Making in Rural Barbados," p. 322.

53. Franklin Fenenga, personal communication, January 1977.

54. MacGaffey, "Two Kongo Potters," pp. 28-31. John A. Burrison, personal communication, July 1976, suggested that pots with stirrup handles and canted spouts were alien to British folk pottery.

55. Janet MacGaffey, personal communication, April 1977.

56. *Bulletin of the Charleston Museum,* p. 52.

57. Polley, *America's Folk Art,* p. 133.

58. Ferrell and Ferrell, *Early Decorated Stoneware,* n.p.

59. See Leuzinger, *Africa: The Art of Negro Peoples,* p. 179, for an example of a Kuba royal portrait.

60. Ramsay, *American Potters and Pottery,* pl. 81.

61. The Gordys, a white pottery family from Georgia, have a tradition for torso figures similar to the *Gospel Singer.* See Wadsworth, *Missing Pieces,* pp. 8, 99, for an example.

62. Burrison, "Clay I Am and Clay You Must Become: The Tradition of Southern Grave Pots."

63. Franklin Fenenga, personal communication, January 1977.

64. Georgeanna H. Greer, personal communication, March 1977.

65. See Greer, "Preliminary Information on the use of the Alkaline Glaze for Stoneware in the South: 1800-1920," v, 155-170.

66. Ferris, "Vision in Afro-American Folk Art: The Sculpture of James Thomas," pp. 115-131.

67. *Ibid.,* p. 125.

68. Puckett, *Magic and Folk Beliefs,* p. 189.

6. Boatbuilding

1. "The Nature of the New World Artifact: The Instance of the Dugout Canoe," p. 158.

2. "History of Chesapeake Sailing Vessels."

3. *The Chesapeake Bay Country,* p. 267.

4. Ebeneezer Cook, "The Sot-Weed Factor: Or a Voyage to Maryland," quoted in Glassie, "New World Artifact," p. 156.

5. Seemes, *Captains and Mariners of Early Maryland,* p. 82.

6. Brewington, *Chesapeake Bay Log Canoes and Bugeyes,* p. 3, fig. 4.

7. Rogers, "The Navigation of Lough Erne," pp. 97-103.

8. Quoted in Brewington, *Log Canoes and Bugeyes,* p. 4.

9. For an example from the Kru people of Liberia, see James Hornell, *Water Transport: Origins and Early Evolution,* pl. 26b.

10. Dickson, *A Historical Geography of Ghana,* p. 83.

11. *Virginia Gazette,* December 24, 1772, quoted in Wood, *Black Majority,* p. 203.

12. *Water Transport,* p. 191.

13. Quoted in Wood, *Black Majority,* pp. 202-203.

14. Hornell, *Water Transport,* pls. 11 A-B, 12.

15. McCusick, *Aboriginal Canoes in the West Indies,* p. 7.

16. Quoted in McCusick, *Aboriginal Canoes,* p. 6.

17. *Dictionnaire Caraibe-Français* (1665), quoted in Wood, *Black Majority,* p. 123, n. 107.

18. "Caribbean Fishing and Fishermen: A Historical Sketch," pp. 1363-1383.

19. Hurault, *Africains de Guyanne: La vie matérielle e l'art de Noirs Refugies de Guyanne,* pp. 61-79.

20. Larsen and Larsen, *Boy of Dahomey,* p. 5; Nunoo, "Canoe Decoration in Ghana," pp. 32-35; Coulon, "Niominka Pirogue Ornamentation," pp. 26-31.

21. *American Small Sailing Craft: Their Design, Development, and Construction,* p. 19.

22. Lawson, *A Voyage to Carolina,* pp. 96-97.

23. Quoted in Wood, *Black Majority,* p. 202.

24. Chapelle, *American Small Water Craft,* pp. 22, 23, fig. 4.

25. Clontes, "Travel and Transportation in Colonial North Carolina," p. 17.

26. Mullin, *Flight and Rebellion: Slave Resistance in Eighteenth-Century Virginia,* pp. 95, 118.

27. Brewington, *Log Canoes and Bugeyes,* p. 31, n. 21.

28. *Herald and Norfolk & Portsmouth Advertiser,* 5 August 1795, p. 3, col. 4.

29. *Shipbuilding in Colonial America,* p. 65.

30. Hatch, *The Ballard House and Family,* p. 10.

31. Mullin, *Flight and Rebellion,* p. 86.

32. *Richmond and Manchester Advertiser,* 27 April 1796, p. 4, col. 4.

33. Quoted in Brewington, *Log Canoes and Bugeyes,* p. 18.

34. "Shipbuilding in Maryland," p. 241.

35. Brewington, *Log Canoes and Bugeyes,* pp. 7-8.

36. *Folk Housing in Middle Virginia,* p. 130.

37. Brewington, *Log Canoes and Bugeyes,* p. 28; Chapelle, *American Small Water Craft,* pp. 300-301.

38. "New World Artifact," p. 162.

39. Brewington, *Log Canoes and Bugeyes,* p. 30.

40. Knipmeyer, "Folk Boats of Eastern French Louisiana," p. 127.

41. Quoted in Wood, *Black Majority,* p. 201.

42. Price, "Caribbean Fishing and Fishermen," p. 1376.

43. Glassie, "New World Artifact," p. 158.

7. Blacksmithing

1. All of these craftsmen are but a partial sampling of Afro-American artisans listed in the archives of the Museum of Early Southern Decorative Arts, Winston-Salem, North Carolina.

2. Quoted in Bridenbaugh, *The Colonial Craftsman,* p. 18.

3. Starobin, *Industrial Slavery in the Old South,* p. 15.

4. "A Plantation of Differences," p. 77.

5. *Made of Iron,* p. 107.

6. See Goldwater, *Bambara Sculpture from the Western Sudan,* p. 52, pl. 88.

7. Curtin, *The Atlantic Slave Trade,* p. 157.

8. Mullin, *Flight and Rebellion,* pp. 44-45, and 173.

9. Joseph H. Ingraham, *The South-West,* quoted in Stampp, *The Peculiar Institution,* p. 63.

10. *Modern Negro Art,* p. 22.

11. Apthecker, *American Negro Slave Revolts,* pp. 192-195.

12. Carroll, *Slave Insurrections in the United States, 1800-1865,* p. 49.

13. *Ibid.,* p. 93.

14. Bridenbaugh, *The Colonial Craftsman,* pp. 139-141.

15. Brenner, "Master Ironworkers Came to Practice Art in City," n.p.

16. Phillips, "The Slave Labor Problem in the Charleston District," p. 435.

17. *The Plantation Negro as a Freeman,* p. 231.

18. Quoted in Christian, *Negro Ironworkers of Louisiana, 1718-1900,* p. 17.

19. Quoted in Christian, *Negro Ironworkers,* pp. 26-27.

20. Porter, *Modern Negro Art,* p. 25.

21. Deas, *The Early Ironwork of Charleston,* p. 27; Deas, "Charleston Ornamental Ironwork," p. 748.

22. Shuey, "Charleston *Signed* Ironwork," p. 5.

23. Brenner, "Master Ironworkers."

24. Vlach, "Philip Simmons: Afro-American Blacksmith," pp. 35-57.

25. Interview with Philip Simmons, June 30, 1976.

26. Ferris, "'If You Ain't Got It in Your Head,'" p. 96.

27. See Lister, *Decorative Wrought Ironwork in Great Britain,* p. 67 *et passim.*

28. Interview with Philip Simmons, June 30, 1976.

29. For a good survey of the blacksmithing craft in Africa, see Cline, *African Mining and Metallurgy.*

8. Architecture

1. Driskell, *Two Centuries of Black American Art,* p. 19; Porter, *Modern Negro Art,* pp. 18-19; Dover, *American Negro Art,* p. 17.

2. "The Language of Space," p. 45.

3. Although the principle of architectural intimacy has been thoroughly demonstrated in the history of the shotgun house, current investigations suggest that contemporary residents desire a more elaborate kind of house, generally one which provides more privacy, more space for one's self (Walter Farrell, remarks made at the meetings of the Organization of American Historians, Atlanta, April 1977).

4. Murdock, *Africa,* pp. 5, 18.

5. "African Music," p. 78.

6. Gluck, "African Architecture," pp. 228-229.

7. Vlach, "Sources of the Shotgun House: African and Caribbean Antecedents for Afro-American Architecture," p. 153.

8. Curtin, *The Atlantic Slave Trade,* pp. 192-197.

9. See Vlach, "Architecture of the Yoruba," pp. 50-57.

10. Vaissiere, *Sainte Domingue (1629-1789): La societe et la vie Creoles sous L'ancien Regime,* pp. 169-170.

11. Vlach, "The Shotgun House: An African Architectural Legacy," pt. II, pp. 68-69.

12. McConnell, *Negro Troops of Ante-Bellum Louisiana: A History of the Free Men of Color,* p. 47.

13. Vlach, "The Shotgun House," pt. I, pp. 52-53.

14. "The Big House and the Slave Quarters," pt. I, pp. 8-19; pt. II, pp. 9-15.

15. Henry Glassie, personal communication, October 1976.

16. Evans, *Irish Heritage: The Landscape, the People, and Their Work,* chap. 7; Addy, *The Evolution of the English House,* pp. 38-41.

17. Glassie, "Types of the Southern Mountain Cabin," pp. 338-370.

18. Glassie, *Folk Housing in Middle Virginia,* p. 37.

19. Quoted in Anthony, "The Big House and the Slave Quarters," pt. II, p. 10.

20. Yetman, *Life Under the "Peculiar Institution,"* p. 35.

21. *Ibid.,* p. 270.

22. *Ibid.,* p. 124.

23. Jean Cuvelier, *Relations sur le Congo du père Laurent de Lucques (1700-1717),* quoted in Balandier, *Daily Life in the Kingdom of Kongo from the Sixteenth to the Eighteenth Century,* p. 141.

24. Vol. III (1847), quoted in Stampp, *The Peculiar Institution,* p. 293.

25. Mullin, *Flight and Rebellion,* p. 43.

26. Deetz, "In Small Things Forgotten," chap. 7.

27. Yetman, *Life under the "Peculiar Institution,"* p. 291.

28. The two sites are the plantation at Bremo Bluff in Fluvanna County and Four-Mile Tree Plantation in Surry County. Both sites have been recorded and are on file with the Historic American Building Survey in the Library of Congress.

29. Mullin, *Flight and Rebellion,* p. 86.

30. Quoted in Georgia Writers, *Drums and Shadows,* p. 179.

31. Montgomery, "Slave Yacht *Wanderer,*" pls. 42-43.

32. Wood, "'A Negro Taught Them,'" p. 160.

33. Zetterstrom, *House and Settlement in Liberia,* pp. 11-12, fig. 2.

34. "Common Houses, Cultural Spoor," p. 2.

35. Dell Upton, personal communication, June 1977.

36. Glassie, *Folk Housing in Middle Virginia,* pp. 137-138.

37. "Architectural Trends in Charleston," p. 550.

38. Stoney, *This Is Charleston: A Survey of the Architectural Heritage of a Unique American City,* pp. 61, 71.

39. Charles E. Peterson, "The Houses of French St. Louis," pl. 3-D.

40. "The Big House and the Slave Quarters," pt. II, p. 13.

41. West, "The Rise and Fall of the American Porch," p. 44.

42. Driskell, *Two Centuries of Black American Art,* pp. 31-33.

9. Graveyard Decoration

1. *Negro Past,* pp. 197-206; Bastide, *African Civilisations in the New World,* pp. 162-168.

2. Hortense Powdermaker, *After Freedom* (1939), quoted in Herskovits, *Negro Past,* p. 200. Please note that "Cottonville" is a pseudonym for the town where Powdermaker did her research.

3. See the account of the burial given by ex-slave Lucinda Davis of Tulsa, Oklahoma, in Yetman, *Life Under the "Peculiar Institution,"* p. 84.

4. Combes, "Ethnography, Archaeology, and Burial Practices Among Coastal South Carolina Blacks," p. 52.

5. P. 135.

6. Bolton, "Decoration of Graves of Negroes in South Carolina," p. 214; Ingersoll, "Decoration of Negro Graves," pp. 68-69; Davis, "Negro Folklore in South Carolina," p. 248; Parsons, *Folk-Lore,* p. 214; Parrish, *Slave Songs of the Georgia Sea Islands,* p. 31; Cate, *Early Days of Coastal Georgia,* pp. 207-215; Brewster, "Beliefs and Customs," I, p. 260.

7. Georgia Writers, *Drums and Shadows,* p. 136.

8. Puckett, *Magic and Folk Beliefs,* p. 104.

9. *Ibid.,* p. 103.

10. Georgia Writers, *Drums and Shadows,* p. 147.

11. Combes, "Burial Practices," p. 58.

12. Georgia Writers, *Drums and Shadows,* pp. 130-131.

13. Ingersoll, "Decoration of Negro Graves," p. 69.

14. Georgia Writers, *Drums and Shadows,* p. 147.

15. See *The Half-Pint Flask.*

16. Combes, "Burial Practices," p. 59.

17. Blasingame, *The Slave Community: Plantation Life in the Ante-Bellum South,* pp. 25, 37.

18. "Fetishism in Congo Land," p. 825.

19. *Fetishism in West Africa,* p. 232.

20. *Ibid.*

21. Raponde-Walker and Sillens, *Rites et Croyances des Peuples du Gabon,* p. 107.

22. Talbot, *In the Shadow of the Bush,* pp. 94, 215, illus. opp. p. 94.

23. "Kwahu Terracottas, Oral Traditions and Ghanaian History," pp. 178-179.

24. Personal field work, 1974, in the vicinity of Ile-Ife, Nigeria.

25. Balandier, *Daily Life in the Kingdom of Kongo,* pp. 251-252. See also MacGaffey, "The West in Congolese Experience," pp. 52-56.

26. Balandier, *Daily Life in the Kingdom of Kongo,* p. 234.

27. Georgia Writers, *Drums and Shadows,* p. 87. See also Peterkin, *Roll, Jordan, Roll,* p. 282; and Agee and Evans, *Let Us Now Praise Famous Men,* pp. 395-399.

28. Thompson, "Cyrus Bowens of Sunbury: Portrait of an Afro-American Artist."

29. Georgia Writers, *Drums and Shadows,* p. 167.

30. Combes, "Burial Practices," p. 59.

31. Crum, *Gullah: Negro Life in the Carolina Sea Islands,* p. 97. Arthur P. Bourgeois (personal communication, April 1977) observed that among the Yaka of lower Zaïre stakes with notches were used to mark the foot of the graves of several people who had been struck by lightning.

32. *Fetishism,* p. 218.

33. *Folk-Lore,* p. 215.

34. Torian, "Ante-Bellum and War Memories of Mrs. Telfair Hodgson," p. 352.

35. Thompson, "From Africa," p. 19.

Conclusion

1. Glassie, "Folk Art," pp. 258-276.

2. See Fogel and Engerman, *Time on the Cross: The Economics of American Negro Slavery,* pp. 44-52.

3. Herskovits, "On Some Modes of Ethnographic Comparison," p. 81.

4. Herskovits, "Problem, Method and Theory in Afroamerican Studies," p. 53.

5. *Shadow and Act,* pp. 131-132.

6. Armstrong, *Wellspring: On the Myth and Source of Culture,* p. 128. The African mode of creativity contrasts with the Western mode which Armstrong describes as "synthesis," a resolution of contradictions.

Catalog

Yacina Diof, contemporary
African, Senegal, Thiès, Wolof tribe

1 FOOD STORAGE BASKET

Grass, palm leaves, 1972. H. 6-1/2 inches, Diam. of base 10-1/2 inches, Diam of top 15-1/2 inches.
Collection: Indiana University Museum.

Africa, Senegal, Thiès, Wolof tribe

2 RICE FANNER BASKET

Grass, palm leaves, 1972. H. 2 inches, Diam. of base 13-1/2 inches, Diam. of top 17-1/4 inches.
Collection: Indiana University Museum.

Rice fanner baskets are to be found throughout the continent of Africa. They are particularly common among the peoples of Angola, the ancestors of many black Americans.

South Carolina, Midway Plantation,
Waccamaw River

3 RICE MORTAR AND PESTLE

Wood, ca. 1850. *Mortar:* H. 20-5/16 inches, Diam. 10-1/2 inches. *Pestle* (not illustrated): L. 45-3/4 inches, Diam. of base 4 inches.
Collection: The Charleston Museum, Charleston, South Carolina.

South Carolina, Low Country,
between Charleston and Georgetown

4 RICE FANNER BASKET

Rush, split oak, ca. 1850. H. 2 inches, Diam. 20-3/4 inches.
Collection: The Charleston Museum, Charleston, South Carolina.

South Carolina, Sea Islands, Mount Pleasant

5 CHURCH COLLECTION BASKET

Grass, palmetto, pine needles, 1970. H. 2-1/4 inches, Diam. of base 7-1/2 inches, Diam. of top 17-1/4 inches.
Collection: Indiana University Museum.

NOTE

Where more than one collector is cited, the last named is the present owner. Dealers' names appear in brackets.
Names of exhibitions with a published catalog of the same name are cited in italics under References.
For the full form of abbreviated references, please see the Bibliography.

South Carolina, Sea Islands, Mount Pleasant

6 SEWING BASKET

Grass, palmetto, pine needles, 1971. H. 16 inches, Diam. at base 13-1/2 inches.
Collection: The National Museum of History and Technology, Smithsonian Institution, Washington, D. C.

South Carolina, Sea Islands, Mount Pleasant

7 CAKE BASKET

Grass, palmetto, pine needles, 1971. H. 6-1/2 inches, Diam. 9-1/4 inches.
Collection: The National Museum of History and Technology, Smithsonian Institution, Washington, D. C.

Mary Manigault, ca. 1910-
American, South Carolina, Sea Islands,
Mount Pleasant

8 CLOTHES BASKET

Grass, palmetto, ca. 1970. H. 30 inches, Diam. 14 inches.
Collection: Mary Arnold Twining, Buffalo, New York.

South Carolina, Sea Islands, Mount Pleasant

9 SPITTOON BASKET

Grass, palmetto, pine needles, 1970. H. 5 inches, Diam. of base 7-1/2 inches, Diam. of top 10 inches.
Collection: Indiana University Museum.

South Carolina, Sea Islands, Mount Pleasant

10 IN-AND-OUT BASKET

Grass, palmetto, pine straw, 1971. H. 18-1/2 inches, Diam. of base 6-1/2 inches.
Collection: The National Museum of History and Technology, Smithsonian Institution, Washington D. C.

Baskets like this are new designs, but the technology is basically the same as that used in the older rice fanners.

South Carolina, Sea Islands, Mount Pleasant

11 FRUIT BASKET

Grass, marsh grass, palmetto, 1970. H. 15 inches, Diam. of base 5 inches, Diam. of top 11 inches.
Collection: Indiana University Museum.

South Carolina, Sea Islands, Mount Pleasant

12 FLOWER VASE BASKET

Grass, marsh grass, palmetto, 1970. H. 11-1/2 inches, Diam. of base 7 inches.
Collection: Indiana University Museum.

Georgia, Savannah

13 MARKET BASKET

Bullrush, 1930's. H. 4-1/2 inches, Diam. 17-3/8 inches.
Collection: Muriel and Malcolm Bell, Jr., Savannah, Georgia.
Reference: Wadsworth, *Missing Pieces,* no. 52.

Dorothy McQuarter, ca. 1925-
American, Mississippi, Wilkinson County, Woodville

14 BASKET

Pine needles, 1976. L. 13-3/4 inches.
Collection: The Roland L. Freeman Collection of the Mississippi Folklife Project, Jackson, Mississippi.
Exhibition: Folkroots: Images of Mississippi Black Folklife (1974-1976), State Historical Museum, Jackson, Mississippi, September-October 1977.

Dorothy McQuarter

15 BASKET

Pine needles, 1976. Diam. 9-3/4 inches.
Collection: The Roland L. Freeman Collection of the Mississippi Folklife Project, Jackson, Mississippi.
Exhibition: Folkroots: Images of Mississippi Black Folklife (1974-1976), State Historical Museum, Jackson, Mississippi, September-October 1977.

South Carolina, Sea Islands, Mount Pleasant

16 CAP

Grass, palmetto, pine needles, plastic cord, 1971. H. 5-1/2 inches, Diam. 7-1/2 inches.
Collection: The National Museum of History and Technology, Smithsonian Institution, Washington, D. C.

Benjamin Sheppard, active ca. 1860
American, South Carolina, James Island

17 HAT

Rush and cotton string, ca. 1860. H. 2-1/2 inches, W. 12 inches.
Collection: Old Slave Mart Museum, Miriam B. Wilson Collection, Charleston, South Carolina.
Reference: *Catalog of the Old Slave Mart Museum and Library* (Boston: G. K. Hall, 1977), no. 463.

Irene Foreman, contemporary
American, South Carolina, Sea Islands, Mount Pleasant

18 HAT

Grass, palmetto, pine needles, 1973. H. 3 inches, Diam. 8 inches.
Collection: Mary Arnold Twining, Buffalo, New York.

South Carolina, Sea Islands, Mount Pleasant

19 STAR MAT

Grass, palmetto, pine straw, 1971. Diam. 19 inches.
Collection: The National Museum of History and Technology, Smithsonian Institution, Washington, D. C.

This mat demonstrates the vast artistic potential in the craft of coil basketry.

South Carolina

20 RICE MORTAR

Carved from live oak, before 1860. H. 32 inches, Diam. 14-1/2 inches.
Collections: [V. C. Schwerin, Charleston, South Carolina, 1976]. Greg Day, Charleston, South Carolina.

This mortar may have doubled as a drum. The groove halfway down the side could have held a thong or cord that allowed a skin head to be stretched over the top. Certainly the care taken in the making of the mortar indicates that this was not just an ordinary device for husking rice.

Othar Turner, 1908-
American, Mississippi, Senatobia

21 FIFE

Bamboo cane, 1977. L. 14 inches.
Collection: Center for Southern Folklore, Memphis, Tennessee.
References: Evans, David, "Black Fife and Drum Music in Mississippi," *Mississippi Folklore Register,* VI, no. 3 (1972), 94-107; *Southern Folklore Reports,* no. 2 (Memphis: Center for Southern Folklore, 1978).

Fife and drum ensembles are part of a little-known musical tradition in Georgia and Mississippi. The combination of woodwind and percussion instruments has antecedents in both West and Central Africa.

Virginia, Upper Shenandoah Valley

22 GOURD-BODIED FIDDLE

Gourd, wood (maple?), metal, early 20th century. L. 24 inches.
 Collection: Roderick and Betsy Moore, Ferrum, Virginia.

Afro-American stringed instruments—especially the banjo and the fiddle—were made with gourds. In form and acoustic property these New World instruments repeated aspects of the African past.

Africa, Western Savannah Grasslands

23 CHORDOPHONE

Calabash, wood, string, goat(?) skin, before 1918. L. 44 inches, W. 12-3/4 inches.
 Collections: Charles G. King, Jr. Collection, Cleveland, 1918. The Cleveland Museum of Art, The Charles G. King, Jr. Collection, Gift of Ralph King in memory of Charles G. King, Jr. 18.352

William Rogers, 1865-1952
American, Georgia, Darien

24 WALKING STICK

Cedar, black paint, blue bead eyes attached by steel nail heads, 1938. L. 34-1/2 inches.
 Collections: Mary Granger, Savannah, Georgia, 1971. Mr. and Mrs. Harvey Granger, Jr., Savannah, Georgia.
 Reference: Wadsworth, *Missing Pieces,* no. 40.

William Rogers

25 WALKING STICK

Wood, 1939. L. 33-1/4 inches.
 Collection: Dr. and Mrs. William Bascom, Berkeley, California.
 Exhibitions: La Jolla Museum of Art, La Jolla, California, 1970; Afro-American Cultural Arts Center, Minneapolis, Minnesota, 1975.
 Reference: Driskell, *Two Centuries of Black American Art,* no. 15.

William Rogers

26 FROG CARVING

Wood, brass nail heads for eyes, before 1938. L. 8-1/8 inches.
 Collections: Mary Granger, Savannah, Georgia, 1971. Mrs. George M. Saunders III, Joanna, South Carolina.
 Reference: Wadsworth, *Missing Pieces,* no. 39.

William Rogers

27 SPOON

Cedar, nail heads for eyes, before 1938. L. 13-1/2 inches.
 Collections: Mary Granger, Savannah, Georgia, 1971. Mr. and Mrs. Harvey Granger, Jr., Savannah, Georgia.
 Reference: Wadsworth, *Missing Pieces,* no. 38.

American South (?)

28 KNIFE BOX

Wood, painted red, with black and gilt decoration, last quarter 19th century. H. 15 inches.
 Collections: June and Howard Lipman, New York City, ca. 1950; Stephen C. Clark, Sr., Cooperstown, New York, 1961. New York State Historical Association, Cooperstown, New York.
 Exhibitions: American Folk Sculpture, The Personal and the Eccentric, Cranbrook Academy of Art, Bloomfield Hills, Michigan, 1972; Early American Folk Art, Rensselaer County Historical Society, Troy, New York, 1967.
 References: Hemphill, Herbert W., Jr., ed., *Folk Sculpture U.S.A.* (exh. cat.; New York: Brooklyn Museum, 1976), p. 78; Teilhet, Jehanne, ed., *Dimensions of Black* (exh. cat.; La Jolla, California: La Jolla Museum of Art, 1970), no. 162, p. 51, illus.

Thomas Alvin Jarrett, 1904-
American, Tennessee, Rockvale

29 CHAIN

Cedar, 1975. L. 44 inches. Inscription: 11.00 [on end link]; Rockvale, Tenn. [and] TAJ. 1975 [on opposite link].
 Collection: Dr. and Mrs. William H. Wiggins, Jr., Bloomington, Indiana.
 Reference: Wiggins, "The Wooden Chains That Bind," pp. 29-32, illus. p. 31.

Howard Miller, active first quarter 20th century
American, Georgia, Brooks County

30 WALKING STICK

Magnolia, ca. 1920. L. 34-1/2 inches.
 Collection: The John Wesley Stipe Family, Dixie, Georgia.
 Reference: Wadsworth, *Missing Pieces,* no. 36.

Howard Miller

31 WALKING STICK

Wood (hickory?), ca. 1916. L. 34-1/2 inches.
 Collections: Mr. and Mrs. Thomas Baker, Jr., Charleston, South Carolina, ca. 1916; Mr. Donald Baker, Mt. Pleasant, South Carolina, 1973. Old Slave Mart Museum, The Chase-Graves Collection, Charleston, South Carolina.
 Reference: *Catalog of the Old Slave Mart Museum and Library* (Boston: G. K. Hall, 1977), no. 302.

Grandfather of Harve Brown, active 1850-1860
American, Georgia, Taliaferro County, Raytown

32 WALKING STICK

Wood, ca. 1850-1860. L. 34-1/2 inches.
 Collections: Mr. and Mrs. Paul Gunn, Crawfordville, Georgia. Dr. James T. Bryson, Washington, Georgia.
 Reference: Wadsworth, *Missing Pieces,* no. 35.

The oral history of this piece suggests that it is the oldest known Afro-American carved cane.

Leon Rucker, 1896–
American, Mississippi, Alcorn

33 CANE

Oak, nails, thermometer, 1962. L. 35 inches.
 Collection: The Roland L. Freeman Collection of the Mississippi Folklife Project, Jackson, Mississippi.
 Exhibition: Folkroots: Images of Mississippi Black Folklife (1974-1976), State Historical Museum, Jackson, Mississippi, September-October 1977.
 Reference: Shapiro, *Black People and Their Culture,* pp. 33-34.

This Mississippi-made cane is similar to the works of Georgian carvers and the work of Henry Gudgel in Missouri. It is evidence of a wide geographic diffusion of an Afro-American walking stick tradition.

Lester Willis, 1913-
American, Mississippi, Crystal Springs

34 CANE

Wood (aromatic red cedar), varnished, 1977. L. 43 inches.
 Collection: Center for Southern Folklore, Memphis, Tennessee.
 Reference: *Southern Folklore Reports,* no. 2 (Memphis: Center for Southern Folklore, 1978).

Lester Willis

35 CANE

Wood (aromatic red cedar), 1977. L. 38 inches.
 Collection: Center for Southern Folklore, Memphis, Tennessee.
 Reference: *Southern Folklore Reports,* no. 2 (Memphis: Center for Southern Folklore, 1978).

Mississippi, Parchman State Penitentiary

36 CARVED ALLIGATOR

Wood, paint, early 1940's. L. 28-1/2 inches.
 Collections: John McKee, Hazelhurst, Mississippi, 1970. David and Cheryl Evans, Yorba Linda, California.
 Reference: Evans, David, "Afro-American Folk Sculpture," pp. 141-152.

This carving was apparently converted into a holder for an ashtray some time after it was made. Though it was probably conceived as a sculpture, we see it now as a functional object.

Henry Gudgell, 1826-1895
American, Missouri, Livingston County

37 WALKING STICK

Wood, ca. 1863. L. 36-1/4 inches.
 Collections: John Bryan, grandson of original owner. Yale University Art Gallery, Director's Fund, New Haven, Connecticut.
 Exhibition: African and Afro-American Art: The Trans-Atlantic Tradition, The Museum of Primitive Art, New York, September 1968-March 1969.
 Reference: Perry, *Nineteenth-Century Afro-American Art,* no. 2.

This is without question the finest Afro-American carved walking stick extant. What is most surprising is that it was carved so far from the source area of the black tradition in wood carving.

Texas, Victoria

38 CHURCH THRONE

Wood, first quarter of 20th century. H. 36-1/2 inches.
 Collection: Jim Aldridge, San Antonio, Texas.

The function of this spectacular chair, as well as the meaning of the symbols that adorn it, remains a mystery. Nevertheless, there is no question about the bold, creative ability of the carver. The suggested, but tenuous, connection with a black Presbyterian church holds some promise for further research into the questions of use and aesthetic content.

Booth Caldwell (?), 1803-1872
American, Pennsylvania, North East

39 ANGLO-AMERICAN WALKING STICK

Wood, ca. 1850-1860. L. 35 inches.
 Collections: Jane Caldwell Parker, North East, Pennsylvania, 1916; Emma Parker, North East, Pennsylvania, 1952. Mr. and Mrs. Richard C. Farver, Corry, Pennsylvania.

Africa, Liberia, Bassa tribe

40 STAFF

Wood. L. 34 inches.
 Collection: Museum of African Art, Gift of Benjamin Weiss, Washington, D. C.

Africa, Zaïre

41 CHIEFTAIN'S STAFF

Wood, nails. L. 47 inches.
 Collection: Indiana University Art Museum.

Georgia

42 WALKING STICK

Wood, ca. 1900. L. 33 inches.
 Collection: Dr. John A. Burrison, Atlanta, Georgia.
 Reference: Wadsworth, *Missing Pieces,* no. 34.

Harriet Powers, 1837-1911
American, Georgia, Athens

43 QUILT

Cotton, pieced and appliquéd with details, embroidered with cotton and metallic yarns, ca. 1895-1898. 69 x 105 inches.
 Collections: Gift of faculty ladies of Atlanta University to Charles Cuthbert Hall, Westport, Massachusetts, ca. 1898; Reverend Basil Douglas Hall, Westerly, Rhode Island; M. and M. Karolik Collection, Newport, Rhode Island, 1964. Museum of Fine Arts, Boston, M. and M. Karolik Collection.
 Exhibition: American Bed Furnishings, Museum of Fine Arts, Boston, April-July 1975.
 References: Perry, *Nineteenth-Century Afro-American Art,* no. 1; Wadsworth, *Missing Pieces,* no. 59, pp. 17-23, pl. p. 16.

Mrs. Powers' quilts are exceptional statements of black artistry. In this quilt she has blended American and African forms, Biblical and local history, beauty and utility.

Africa, Ghana, Akan people

44 APPLIQUÉD GOWN

Felt, 20th century. L. 75 inches.
 Collections: Chief Kofi Kamami of Jamasi. The Katherine White Collection, Los Angeles, California.
 Reference: Sieber, *African Textiles and Decorative Arts,* p. 206.

Africa, People's Republic of Benin (Dahomey), Fon tribe

45 APPLIQUÉD TEXTILE

Cotton fabrics and brocade, collected 1931. 70 x 38-1/2 inches.
 Collection: The Herskovits Collection, Chicago, Illinois.
 Reference: Herskovits, *Dahomey,* Vol. 1, pl. 15.

Africa, People's Republic of Benin (Dahomey), Fon tribe

46 APPLIQUÉD TEXTILE

Cotton fabrics and brocade, collected 1931. 68-1/2 x 39-1/2 inches.
 Collection: The Herskovits Collection, Chicago, Illinois.
 Reference: Herskovits, *Dahomey,* Vol. 2, pl. 67.

Africa, People's Republic of Benin (Dahomey), Fon tribe

47 APPLIQUÉD PILLOW COVER

Cotton fabrics, collected 1931. 22 x 19-1/2 inches.
 Collection: The Herskovits Collection, Chicago, Illinois.
 Reference: Herskovits, *Dahomey,* Vol. 2, pl. 15.

Africa, People's Republic of Benin (Dahomey), Fon tribe

48 APPLIQUÉD PILLOW COVER

Cotton fabrics, collected 1931. 18 x 21 inches.
 Collection: The Herskovits Collection, Chicago, Illinois.
 Reference: Herskovits, *Dahomey,* Vol. 2, pl. 54.

Clementine Hunter, ca. 1885-
American, Louisiana, Natchitoches,
Melrose Plantation

49 MELROSE PLANTATION

Fabric sewn on heavy paper, signed lower right corner in black oil paint, 1940. 76 x 59-1/2 inches.
 Collections: François Mignon, Melrose Plantation, Louisiana, 1973. Dr. Mildred Hart Bailey, Natchitoches, Louisiana.

Ida Magwood, ca. 1912-1972
American, South Carolina, Sea Islands,
Johns Island

50 QUILT

Cotton or cotton blends, 1969. 119 x 75 inches.
 Collection: Mary Arnold Twining, Buffalo, New York.

South Carolina, Johns Island

51 QUILT

Cotton or cotton blends, 1970. 61 x 83 inches.
Collection: Indiana University Museum.

South Carolina, Johns Island

52 QUILT

Cotton or cotton blends, 1970. 73 x 59 inches.
Collection: Indiana University Museum.

By taking a standard quilting unit, which usually is only a small element of a quilt top, and reinterpreting it as the entire quilt design, the black quilter effects an alternative notion of design—her own tradition for quilting.

Lucinda Toomer, 1890-
American, Georgia, Dawson

53 QUILT

Cotton materials (flannel, corduroy), 1977. 76 x 61 inches.
Collection: The Links of Cleveland, Inc.

Amanda Gordon, ca. 1892-
American, Mississippi, Rose Hill

54 QUILT

Cotton, 1968. 68 x 74 inches.
Collection: Center for Southern Folklore, Memphis, Tennessee.

Pecolia Warner, 1901-
American, Mississippi, Yazoo City

55 QUILT

Cotton, 1971. 76 x 66 inches.
Collection: Center for Southern Folklore, Memphis, Tennessee.
Reference: *Southern Folklore Reports,* no. 2 (Memphis: Center for Southern Folklore, 1978).

Mrs. Ozzie Allen, 1913-
American, Mississippi, Columbia

56 QUILT

Cotton fabrics, 1977. 85 x 74 inches.
Collections: Miss Sarah Ball, Harrisville, Mississippi, 1977. James A. Birch, Cleveland.

In this quilt we see a merger of design notions. The borders are composed of the Afro-American "string" elements, while the center has a Euro-American grid of blocks. A mixture of odd-colored squares makes up the center grid, an improvisation that may be credited to black creativity, while embroidered flowers profess the presence of an Anglo-American influence.

Mrs. Floyd McIntosh, ca. 1925-
American, Mississippi, Simpson County, Pinola

57 QUILT

Cotton, 1934. 79 x 72 inches.
Collections: Miss Sarah Ball, Harrisville, Mississippi. Mississippi State Historical Museum, Jackson.

Mrs. Pinkie Veal, ca. 1925-
American, Mississippi, Simpson County, D'Lo

58 QUILT

Cotton, 1935. 84-1/2 x 72 inches.
Collections: Miss Sarah Ball, Harrisville, Mississippi. Mississippi State Historical Museum, Jackson.

Luiza Combs, 1853(?)-1943
American (born in Africa), Kentucky, Hazard

59 BLANKET

Wool, ca. 1890. 79-1/2 x 61 inches.
Collection: Kenneth Combs, Cleveland.

Luiza Combs, a native of the Guinea Coast of Africa, was in charge of every aspect in the making of this blanket—from raising the sheep, shearing, spinning, and dyeing the wool, to the eventual weaving. The blanket is therefore a very important demonstration of the maintenance of an African-based aesthetic.

Lucinda Toomer, 1890-
American, Georgia, Dawson

60 QUILT

Cotton (corduroy), 1975. 80-3/4 x 68 inches.
Collection: William Arnett, Atlanta, Georgia.
Reference: Wadsworth, *Missing Pieces,* no. 63.

Africa, Upper Volta, Ouagadougou

61 MEN'S WEAVE TEXTILE

Cotton, 20th century. 87 x 56 inches.
Collection: The Katherine White Collection, Los Angeles, California.
References: Sieber, *African Textiles and Decorative Arts,* p. 191; Thompson, *African Art in Motion,* p. 12, pl. 14.

Africa, Ivory Coast

62 RESIST-PRINT TEXTILE

Cotton, 20th century. 67 x 47 inches.
Collection: The Katherine White Collection, Los Angeles, California.
Reference: Sieber, *African Textiles and Decorative Arts,* p. 221.

Africa, Mali, Beledugu region, Kolokani, Bamana tribe

63 BAMBARA HUNTER'S CLOTH

Cotton with paint, early 20th century. 67 x 43 inches.
 Collection: Charles and Joan Bird, Bloomington, Indiana.
 Reference: Sieber, *African Textiles and Decorative Arts,* p. 209.

Ida Magwood, ca. 1912-1972
American, South Carolina, Johns Island

64 QUILT

Cotton or cotton blends, 1970. 97 x 60-1/2 inches.
 Collection: Indiana University Museum.

This quilt is an example of the continuity of African design concepts in the United States. Compare with the Akan strip textile [65].

Africa, Ghana, Akan people, Ashanti tribe

65 MEN'S WEAVE TEXTILE

Cotton. 72 x 60 inches.
 Collection: Museum of Cultural History, University of California, Los Angeles.

Tennessee, Triune

66 QUILT

Cotton, ca. 1910. 81 x 80 inches.
 Collection: Richard H. and Kathleen L. Hulan, Austin, Texas.

Quilt blocks, the traditional basis of Euro-American quilt design, in this quilt have been assembled into strips of varying sizes and then edge-sewn together. The effect at first appears to be quite random, but after some deliberate viewing the linear order emerges. This quilt clearly demonstrates the union of Euro-American and Afro-American concepts of quilting.

Mrs. Betty Tolbert, 1897-
American, Mississippi, Franklin County, Roxie

67 QUILT

Cotton, 1972. 75 x 67 inches.
 Collection: The Roland L. Freeman Collection of the Mississippi Folklife Project, Jackson, Mississippi.
 Exhibition: Folkroots: Images of Mississippi Black Folklife (1974-1976), State Historical Museum, Jackson, Mississippi, September-October 1977.

Dave the Potter, 1780-1863
American, South Carolina, Miles Mill

68 JUG

Stoneware, ash glaze, signed and dated October 26, 1853. H. 16 inches, Diam. 12 inches. Inscribed near rim: Lm/Oct 26·1853/Dave.
 Collection: Dr. James T. Bryson, Washington, Georgia.
 Exhibition: Washington-Wilkes Historical Museum, Washington, Georgia.

Dave the Potter

69 JAR

Stoneware, ash glaze, signed and dated May 13, 1859. H. 29 inches, Diam. 26 inches. Inscribed near rim: Lm/May 13·1859/Dave &/Baddler. On opposite side of jar: Great & noble Jar/hold Sheep goat or bear.
 Collections: Major Z. W. Carwile, South Carolina, 1870; W. E. Carwile and R. E. Carwile, South Carolina, ca. 1900. The Charleston Museum, Charleston, South Carolina.

This is thought to be the largest stoneware jar ever made in the South. Its capacity is estimated at forty-four gallons.

Dave the Potter

70 JAR

Stoneware, ash glaze, signed and dated May 3, 1859. H. 26-1/2 inches. Inscribed near rim: Lm May 3d 1859 Dave/Good for lard or holding/fresh meat/Blest we were when/Peter saw the folded/sheet.
 Collections: Nicholson estate, Cedar Grove Plantation, Edgefield, South Carolina. Franklin Fenenga, Long Beach, California.
 Reference: Driskell, *Two Centuries of Black American Art,* no. 4.

Dave the Potter

71 JAR

Stoneware, ash glaze, signed and dated July 31, 1840. H. 15 inches, Diam. 13 inches. Inscribed near rim: Lm/Dave belongs to Mr. Miles/wher[e] the oven bakes & the pot biles/31st July 1840.
 Collection: The Charleston Museum, Charleston, South Carolina.

South Carolina, Bath

72 FACE VESSEL

Stoneware, kaolin, ash glaze, ca. 1850. H. 4 inches.
 Collection: National Museum of History and Technology, Smithsonian Institution, Washington, D. C.

We see here the combination of two different kinds of clay bodies—an achievement that marks the importance of Edgefield pottery in the annals of ceramic history. Note also the African sculptural style.

South Carolina, Edgefield District

73 FACE VESSEL

Stoneware, kaolin, ash glaze, mid-19th century. H. 5-1/2 inches.
Collection: John Gordon Gallery, New York City.
Reference: Perry, *Nineteenth-Century Afro-American Art,* no. 10.

South Carolina, Bath

74 FACE VESSEL

Red ware, ash glaze, mid-19th century. H. 5 inches.
Collection: John Gordon Gallery, New York City.
Reference: Perry, *Nineteenth-Century Afro-American Art,* no. 12.

South Carolina, Bath

75 FACE VESSEL

Stoneware, kaolin, ash glaze, ca. 1860. H. 5 inches.
Collection: National Museum of History and Technology, Smithsonian Institution, Washington, D. C.

South Carolina, Bath

76 FACE CUP

Stoneware, kaolin, ash glaze, ca. 1850. H. 4 inches, Diam. at top 5-1/2 inches.
Collection: John Gordon Gallery, New York City.
Reference: Perry, *Nineteenth-Century Afro-American Art,* no. 9.

A cup similar to this was recovered from the water dump at the site of the Thomas Davies pottery, leading to the speculation that this vessel also may have been made at that manufactory.

Africa, Ghana, Akan people, Ashanti tribe(?)

77 FACE VESSEL

Earthenware, cowries. H. 9 inches.
Collection: Museum of African Art, Gift of Eliot Elisofon, Washington, D. C.

Africa, Zaïre, Yumbe

78 NKISI FIGURE

Wood, knives, nails, mirror, bone, leopard tooth, late 19th or early 20th century. H. 12 inches.
Collections: [Harvey Menist, Amsterdam]. Dr. and Mrs. Ernst Anspach, New York City.
Reference: Preston, George N., *African Sculpture, Rare and Familiar Forms from the Anspach Collection* (exh. cat.; Brainerd Hall Art Gallery, State University College at Potsdam, New York [Ogdensburg, New York: Ryan Press, 1974]), no. 16.

South Carolina, Edgefield District

79 FACE VESSEL

White clay, collected first quarter 20th century. H. 1-3/16 inches.
Collections: B. H. Teague Collection, Aiken, South Carolina, 1902. The Charleston Museum, Charleston, South Carolina.

The smallness of this jug strongly suggests a function that was symbolic—maybe even ritualistic. No firm information is yet available about the function of face vessels, but it is clear that they were sometimes made for more than amusement.

Samuel Hylton, 1919-
Jamaican, Kingston

80 MONKEY JAR

Earthenware, 1976. H. 16 inches.
Collection: John Michael Vlach, Austin, Texas.

South Carolina, Bath

81 FACE VESSEL

Stoneware, ash glaze, mid-19th century. H. 8-3/8 inches, Diam. at base 7-1/8 inches.
Collections: Mrs. R. L. Steinek, Augusta, Georgia. Augusta-Richmond County Museum, Augusta, Georgia.
Reference: Ferrell and Ferrell, *Early Decorated Stoneware of the Edgefield District,* no. 28.

This jug should be compared to the Jamaican *Monkey Jar* [80] for indications of its alternative origins with respect to form.

Attributed to Lewis Miles Pottery, active ca. 1830-1890
South Carolina, Edgefield District

82 FACE JUG

Stoneware, slip glaze, ca. 1840-1860. H. 7 inches, Diam. at base 5 inches.
Collection: The Ferrell Collection, Easley, South Carolina.

South Carolina (?), Edgefield District (?)

83 FACE JUG

Red ware, ash glaze (?), ca. 1850-1875. H. 9-1/2 inches.
 Collections: Clara D. Brown, Nashville, Tennessee, 1935. Abby Aldrich Rockefeller Folk Art Center, Williamsburg, Virginia.
 Exhibition: American Folk Art from the Abby Aldrich Rockefeller Folk Art Collection, Abby Aldrich Rockefeller Folk Art Collection, Williamsburg, Virginia, June-September 1962.
 References: Hornung, *Treasury of American Design*, Vol. I, 359, pl. 1254 A; Little, Nina Fletcher, *The Abby Aldrich Rockefeller Folk Art Collection: A Descriptive Catalogue* (Williamsburg, Virginia: Colonial Williamsburg Foundation; and Boston: Little, Brown & Co., 1957), no. 163, illus. p. 341; "19th-Century Americana," *Newsweek* (February 25, 1957), p. 110.

Note that the stirrup handle has been broken off.

South Carolina, Edgefield District

84 FACE VESSEL

Red ware, kaolin, ash glaze, mid-19th century. H. 6 inches.
 Collection: John Gordon Gallery, New York City.
 Reference: Perry, *Nineteenth-Century Afro-American Art*, no. 13.

South Carolina, Edgefield District

85 FACE VESSEL

Red ware, ash glaze, ca. 1850. H. 5-3/4 inches.
 Collections: Rhea Mansfield Knittle, Milan, Ohio, ca. 1958. George O. Bird, Taylor, Michigan.
 Reference: Bishop, Robert, *American Folk Sculpture* (New York: E. P. Dutton, 1974), p. 221, fig. 413.

Mayivangwa Therese, contemporary
African, Zaïre

86 KONGO STIRRUP-HANDLED WATER PITCHER (Kikongo name: *mvungu*)

Terra cotta, 1960's. H. 8-1/2 inches.
 Collection: Janet and Wyatt MacGaffey, Haverford, Pennsylvania.
 Reference: MacGaffey, Janet, "Two Kongo Potters," p. 31, pl. 13.

South Carolina, Edgefield District

87 FACE VESSEL

Stoneware, kaolin, ash glaze, mid-19th century. H. 5-1/2 inches.
 Collection: John Gordon Gallery, New York City.
 Reference: Perry, *Nineteenth-Century Afro-American Art*, no. 11.

Jim Lee, active ca. 1860
American, South Carolina, Ninety-Six,
Pottery of Roundtree and Bodie

88 PREACHER

Stoneware, iron oxide, ash glaze, ca. 1860. H. 12 inches.
 Collection: The Charleston Museum, Charleston, South Carolina.
 References: *Bulletin of The Charleston Museum* (October-November 1920); Ferrell and Ferrell, *Early Decorated Stoneware of the Edgefield District*, n.p.

Although this bottle form is very much in an Anglo-American tradition, the proportions of the figure—large upper torso, minimal legs—suggest some affinity with Bakuba portrait figures.

Eastern Alabama (?)

89 GOSPEL SINGER

Red ware, china fragments, slip glaze, late 19th century. H. 13 inches.
 Collection: John Gordon Gallery, New York City.
 Reference: Perry, *Nineteenth-Century Afro-American Art*, no. 18.

Eastern Alabama (?)

90 PREACHER MAN

Red ware, iron oxide, slip glaze, late 19th century. H. 16-1/2 inches.
 Collection: John Gordon Gallery, New York City.
 References, *Discoveries in American Folk Art* (New York: John Gordon Gallery, 1973), p. 19, no. 16; *Masterpieces of American Folk Art* (exh. cat.; Lincroft, New Jersey: Monmouth Museum, 1975), p. 96; Perry, *Nineteenth-Century Afro-American Art*, no. 16.

Attributed to John M. Wilson Pottery,
active 1857-1869
Texas, Guadalupe County

91 THREE-GALLON JUG

Stoneware, alkaline glaze with secondary drops of salt glaze. H. 14-1/2 inches, Diam. at base 9-1/2 inches.
 Collection: Georgeanna H. Greer, San Antonio, Texas.
 References: Greer, Georgeanna H., "Alkaline Glazes and Groundhog Kilns," *Antiques* (April 1977), p. 770, pl. 3; Steinfeldt, Cecelia, and Stover, Donald L., *Early Texas Furniture and Decorative Arts* (exh. cat.; San Antonio: San Antonio Museum Association and Trinity Press, 1973), no. 263.

The use of alkaline glazes in Texas pottery is a material link to the traditions of the Edgefield District. In both areas ceramic ware was made largely by black artisans.

Hirum Wilson Pottery, active 1870's-1884
Texas, Guadalupe County

92 FIVE-GALLON STORAGE JAR

Stoneware, salt glaze, ca. 1875. H. 16-1/2 inches, Diam. at base 11-1/2 inches.
 Collection: Georgeanna H. Greer, San Antonio, Texas.
 Exhibition: Institute of Texas Cultures, Negro Division, University of Texas, San Antonio, 1968-1971.

James "Son Ford" Thomas, 1926-
American, Mississippi, Leland

93 SKULL

"Delta gumbo clay," April 1977. H. 8 inches.
 Collection: Center for Southern Folklore, Memphis, Tennessee.
 References: Ferris, "The Sculpture of James Thomas," pp. 115-132; *Southern Folklore Reports,* no. 2 (Memphis: Center for Southern Folklore, 1978).

South Carolina, White Oak Plantation, Santee River

94 PLANTATION BARGE, "BESSIE"

Cypress, ca. 1855; centerboard added ca. 1890. L. 29-1/2 feet.
 Collection: The Charleston Museum, Charleston, South Carolina.
 Exhibition: Charles Towne Landing, Charleston, South Carolina, 1970-1977.

Anonymous Black Boatbuilder
South Carolina, Charleston County, James Island

95 "BATOE"

Wood, ca. 1935-1955. L. 178 inches.
 Acquired for this exhibition by Greg Day, Charleston, South Carolina.

This craft has been a part of the water-oriented traditions of Sea Islands Blacks for almost forty years. A number of black fishermen have owned this boat, each one making his own contribution to its preservation and eventual form. For the last six years the boat has belonged to members of the Manigault family. Arthur Manigault, Jr., modified the craft extensively—replacing several ribs and some of the decking, rebuilding the bow, and installing new oar pins. Folk boats are organic objects; they change with changes in tradition.

Africa, Mali, Beleduga region, Kolokani, Bamana tribe

96 STATUE

Iron, early 20th century. H. 9-1/2 inches.
 Collection: Charles and Joan Bird, Bloomington, Indiana.
 Reference: *The West African Blacksmith* (exh. cat.; Lafayette, Indiana: Purdue University, 1975).

Peter Simmons, 1853-1955
American, South Carolina, Charleston

97 DECORATIVE PANEL

Iron, last quarter of 19th century. 78-1/2 x 6-1/2 x 1 inches.
 Collections: Philip Simmons, Charleston, South Carolina, 1969. Old Slave Mart Museum, The Chase-Graves Collection, Charleston, South Carolina.
 References: *Catalog of the Old Slave Mart Museum and Library* (Boston: G. K. Hall, 1977), no. 663; Chase, *Afro-American Art and Craft,* p. 132, illus. p. 71.

Peter Simmons

98 DECORATIVE PANEL

Iron, last quarter of 19th century. 65-1/2 x 9-1/2 x 1-1/4 inches.
 Collections: Philip Simmons, Charleston, South Carolina, 1969. Old Slave Mart Museum, The Chase-Graves Collection, Charleston, South Carolina.
 References: *Catalog of the Old Slave Mart Museum and Library* (Boston: G. K. Hall, 1977), no. 662; Chase, *Afro-American Art and Craft,* p. 132, illus. p. 71.

Philip Simmons, 1912-
American, South Carolina, Charleston

99 STAR AND FISH GATE

Wrought iron, August 1976. 61-1/2 x 33 inches.
 Collection: Philip Simmons, Charleston, South Carolina.

Bibliography

Addy, Sidney O. *The Evolution of the English House.* London: Swann Sonneschein, 1898.

Adler, Thomas. "The Physical Development of the Banjo." *New York Folklore Quarterly,* XXVIII (1972), 187-208.

African Art: Nature, Man, and Vital Force (exhibition catalog). West Palm Beach, Fla.: Art Museum of the Palm Beaches, 1975.

"Afro-American Craftsmen" (file). Museum of Early Southern Decorative Arts, Winston-Salem, North Carolina.

Agee, James, and Evans, Walker. *Let Us Now Praise Famous Men.* 1941; reprint ed., New York: Ballentine Books, 1966.

Anthony, Carl. "The Big House and the Slave Quarters." Pt. I, *Landscape,* XX, no. 3 (1976), 8-19; Pt. II, *Landscape,* XXI, no. 1 (1976), 9-15.

Apthecker, Herbert. *American Negro Slave Revolts.* New York: Columbia University Press, 1943.

Armstrong, Robert Plant. *Wellspring: On the Myth and Source of Culture.* Berkeley: University of California Press, 1975.

Balandier, Georges. *Daily Life in the Kingdom of Kongo from the Sixteenth to the Eighteenth Century.* New York: Pantheon Books, 1965.

Barber, Edwin Atlee. *The Pottery and Porcelain of the United States: A Historical Review of American Ceramic Art from the Earliest Times to the Present.* 1893; reprint ed., New York: Feingold and Lewis, 1976.

Barber, John W. *A History of the Amistad Captives.* 1840. Reprinted in Jules Chanetzky and Sidney Kaplan, eds., *Black and White in American Culture,* pp. 291-330. New York: Viking Press, 1971.

Barfield, Rodney. *Thomas Day, Cabinetmaker.* Raleigh: North Carolina Museum of History, 1975.

Bascom, William R., and Herskovits, Melville J., eds. *Continuity and Change in African Cultures.* 1959; reprint ed., Chicago: University of Chicago Press, 1970.

"Basket Weavers of Charleston." *Southern Living* (October 1970), pp. 22, 26.

Bastide, Roger. *African Civilisations in the New World.* 1967; translation, New York: Harper & Row, 1971.

Bidney, David. *Theoretical Anthropology.* New York: Shocken Books, 1953.

Blasingame, John W. *The Slave Community: Plantation Life in the Ante-Bellum South.* New York: Oxford University Press, 1972.

Bluestein, Gene. "America's Folk Instrument: Notes on the Five-String Banjo." *Western Folklore,* XXIII (1964), 241-248.

Bohannon, Paul. "Rethinking Culture: A Project for Current Anthropologists." *Current Anthropology.* XIV (1973), 357-372.

Bolton, H. Carrington. "Decoration of Negro Graves in South Carolina." *Journal of American Folklore.* IV (1891), 214.

Botkin, B. A. *Lay My Burden Down: A Folk History of Slavery.* 1945; reprint ed., Chicago: University of Chicago Press, 1969.

Brenner, J. Francis. "Master Ironworkers Came to Practice Art in City." *Charleston Courier,* 21 August 1932, n. p.

Brewington, M. V. *Chesapeake Bay Log Canoes and Bugeyes,* Cambridge, Md.: Cornell Maritime Press, 1963.

——. "Shipbuilding in Maryland." In Morris L. Radoff, ed., *The Old Line State: A History of Maryland,* pp. 238-246. Baltimore: Maryland Historical Association, 1956.

Brewster, Paul G., ed. "Beliefs and Customs." In *The Frank C. Brown Collection of North Carolina Folklore,* I, 223-282. Durham, N. C.: Duke University Press, 1964.

Bridenbaugh, Carl. *The Colonial Craftsman.* 1950; reprint ed., Chicago: University of Chicago Press, 1974.

Bruce, Philip A. *The Plantation Negro as a Freeman.* New York: G. P. Putnam's Sons, 1889.

Bulletin of The Charleston Museum, XVI, nos. 6-7 (1920).

Burnaby, Reverend Andrew. *Travels Through the Middle Settlements of North America.* 1775; reprint ed., Ithaca: Cornell University Press, 1960.

Burrison, John A. "Alkaline-Glazed Stoneware: A Deep South Pottery Tradition." *Southern Folklore Quarterly,* XXXIX (1975), 377-403.

——. "Clay I am and Clay You Must Become: The Tradition of Southern Grave Pots." Paper given at the meetings of the American Folklore Society, Philadelphia, November 1976.

——. *The Meaders Family of Mossy Creek: Eighty Years of North Georgia Folk Pottery.* Atlanta: Georgia State University Art Gallery, 1976.

——. "Prolegomena to a Study of Afro-American Folk Pottery in the South." 1975. (Manuscript.)

Cable, George Washington. "The Dance in Place Congo." *Century Magazine,* XXXI (February 1886); reprinted in Bruce Jackson, ed., *The Negro and His Folklore in Nineteenth-Century Periodicals,* pp. 189-242. Austin: University of Texas Press, 1967.

Carroll, Joseph Cephas. *Slave Insurrections in the United States, 1800-1865.* Boston: Chapman & Grimes, 1938.

Cate, Margaret Davis. *Early Days of Coastal Georgia.* St. Simons Island, Ga.: Fort Frederica Association, 1955.

Chapelle, Howard I. *American Small Sailing Craft: Their Design, Development, and Construction.* New York: W. W. North, 1951.

Chase, Judith Wragg. *Afro-American Art and Craft.* New York: Van Nostrand Reinhold, 1971.

Christian, Marcus. *Negro Ironworkers of Louisiana, 1718-1900.* Gretna, La.: Pelican Publishing, 1972.

Cline, Walter. *African Mining and Metallurgy.* Menasha, Wis.: George Banta Publishing, 1937.

Clontes, F. W. "Travel and Transportation in Colonial North Carolina." *North Carolina Historical Review,* III (1926), 16-35.

Combes, John D. "Ethnography, Archaeology, and Burial Practices Among Coastal South Carolina Blacks." In *Conference on Historic Site Archaeology Papers*, Vol. 7, pp. 52-61. Columbia, S. C.: Institute of Archaeology and Anthropology, 1972.

Cooley, Rossa Belle. *Homes of the Freed.* 1926; reprint ed., New York: Negro Universities Press, 1970.

Cornet, Joseph. *Art from Zaire: One Hundred Masterworks from the National Collection.* New York: African-American Institute, 1975.

Coulon, Virginia. "Niominka Pirogue Decoration." *African Arts,* vi, no. 3 (1973), 26-31.

Courlander, Harold. *The Drum and the Hoe.* Berkeley: University of California Press, 1960.

———. *Negro Folk Music: U. S. A.* New York: Columbia University Press, 1963.

Cox, Warren E. *The Book of Pottery and Porcelain.* New York: Crown Publishers, 1970.

Craig, James H. *The Arts and Crafts in North Carolina, 1699-1840.* Winston-Salem, N. C.: Museum of Early Southern Decorative Arts, 1965.

Crum, Mason. *Gullah: Negro Life in the Carolina Sea Islands.* Durham, N. C.: Duke University Press, 1940.

Curtin, Philip D. *The Atlantic Slave Trade: A Census.* Madison: University of Wisconsin Press, 1969.

Dabbs, Edith. *Face of an Island.* Columbia, S. C.: R. L. Bryan Corp., 1970.

Davis, Gerald L. "Afro-American Coil Basketry in Charleston County, South Carolina: Affective Characteristics of an Artistic Craft in Social Context." In Don Yoder, ed., *American Folklife,* pp. 151-184. Austin: University of Texas Press, 1976.

Davis, Henry C. "Negro Folklore in South Carolina." *Journal of American Folklore,* xxvii (1914), 241-254.

Day, Gregory. *South Carolina Low Country Coil Baskets* (brochure). Charleston: The Communication Center, 1977.

Day, Gregory, and Day, Kay Young. Field report. Division of Cultural History, Museum of History and Technology, Smithsonian Institution, n. d.

Deas, Alston. "Charleston Ornamental Ironwork." *Antiques of Charleston,* pp. 748-751. Charleston: Historic Charleston Foundation, 1970.

———. *The Early Ironwork of Charleston.* Columbia, S. C.: Bostick and Thornlee, 1941.

Deetz, James. "In Small Things Forgotten." 1977. (Manuscript.)

Densmore, Frances. *Chippewa Customs.* Bulletin 86, Smithsonian Institution, Bureau of American Ethnology. Washington: U. S. Government Printing Office, 1929.

Dickson, Kwamina B. *A Historical Geography of Ghana.* London: Cambridge University Press, 1969.

Dillard, J. L. *Black English: Its History and Usage in the United States.* New York: Vintage Books, 1973.

Dorson, Richard M. *Negro Folktales in Michigan.* Cambridge: Harvard University Press, 1956.

Douty, J. F. "History of Chesapeake Sailing Vessels." Paper presented to the meetings of Naval Architects and Marine Engineers, November 1951 (copy in the Mariners Museum, Newport News, Virginia).

Dover, Cedric. *American Negro Art.* New York: New York Graphic Society, 1960.

Driskell, David C. *Two Centuries of Black American Art.* New York: Alfred A. Knopf, 1976.

Du Bois, W. E. Burghardt. *The Souls of Black Folk.* 1903; reprint ed., New York: Fawcett, 1961.

Dundes, Alan. "African Tales among North American Indians." *Southern Folklore Quarterly,* xxix (1965), 207-219.

Earle, Swepson. *The Chesapeake Bay Country.* New York: Weathervane Books, 1923.

Ellison, Ralph. *Shadow and Act.* New York: Vintage Books, 1972.

Epstein, Dena J. "The Folk Banjo: A Documentary History." *Ethnomusicology,* xx (1976), 347-371.

Evans, David. "Afro-American Folk Sculpture from Parchman Penitentiary." *Mississippi Folklore Register,* vi (1972), 141-152.

———. "Afro-American One-Stringed Instruments." *Western Folklore,* xxix (1970), 229-245.

———. *Traveling Through the Jungle: Negro Fife and Drum Band Music.* Testament Records, T-2223.

Evans, E. Estyn. *Irish Heritage: The Landscape, the People and Their Work.* Dundalk: W. Tempest, 1963.

Faulkner, William. *Go Down Moses.* New York: Random House, 1955.

Fernandez, J. W. *Fang Architectonics.* Working Papers in the Traditional Arts, no. 1. Philadelphia: Institute for the Study of Human Issues, 1977.

Ferrell, Stephen T., and Ferrell, T. M. *Early Decorated Stoneware of the Edgefield District, South Carolina* (exhibition catalog). Greenville, S. C.: Greenville County Museum of Art, 1976.

Ferris, William R., Jr. *Gravel Springs Fife and Drum* (16 mm film). Memphis: Center for Southern Folklore.

———. "'If You Ain't Got It in Your Head, You Can't Do It in Your Hand': James Thomas, Mississippi Delta Folk Sculptor." *Studies in the Literary Imagination,* iii, no. 1 (1970), 89-107.

———. *Made in Mississippi* (16 mm film). Memphis: Center for Southern Folklore.

———. *Mississippi Folk Voices.* Southern Folklore Records, 101.

———. "Vision in Afro-American Folk Art: The Sculpture of James Thomas." *Journal of American Folklore,* lxxxviii (1975), 115-131.

Fine, Elsa Honig. *The Afro-American Artist.* New York: Holt, Rinehart & Winston, 1973.

Finnegan, Ruth. *Limba Stories and Story-telling.* London: Oxford University Press, 1967.

Fogel, Robert William, and Engerman, Stanley L. *Time on the Cross: The Economics of Negro Slavery.* Boston: Little, Brown & Co., 1974.

Folk Art in America: A Living Tradition (exhibition catalog). Atlanta: High Museum of Art, 1974.

Frazier, E. Franklin. *The Negro Family in the United States.* 1939; reprint ed., Chicago: University of Chicago Press, 1966.

Fry, Gladys-Marie. "Harriet Powers: Portrait of a Black Quilter." In Anna Wadsworth, ed., *Missing Pieces: Georgia Folk Art 1770-1976* (exhibition catalog), pp. 16-23. Atlanta: Georgia Council for the Arts and Humanities, 1976.

Georgia Writers' Project. *Drums and Shadows: Survival Studies Among Georgia Coastal Negroes.* Athens: University of Georgia Press, 1940.

Glassie, Henry. "Folk Art." In Richard M. Dorson, ed., *Folklore and Folklife: An Introduction,* pp. 253-280. Chicago: University of Chicago Press, 1972.

———. *Folk Housing in Middle Virginia: A Structural Analysis of Historic Artifacts.* Knoxville: University of Tennessee Press. 1975.

———. "The Nature of the New World Artifact: The Instance of the Dugout Canoe." In Walter Escher, *et. al.*, eds., *Festschrift fur Robert Wildhaber,* pp. 153-170. Basel: G. Krebs, 1972.

———. *Pattern in the Material Folk Culture of the Eastern United States.* Philadelphia: University of Pennsylvania Press, 1968.

———. "Types of the Southern Mountain Cabin." In Jan Harold Brunvand, *The Study of American Folklore: An Introduction,* pp. 338-370. New York: W. W. Norton, 1968.

Glave, E. J. "Fetishism in Congo Land." *The Century Magazine,* XLI (1891), 825-836.

Gluck, Julius F. P. "African Architecture." In Douglas Fraser, ed., *The Many Faces of Primitive Art: A Critical Anthology,* pp. 224-243. Englewood Cliffs, N. J.: Prentice-Hall, 1966.

Goldenberg, Joseph P. *Shipbuilding in Colonial America.* Charlottesville: University of Virginia Press, 1976.

Goldwater, Robert. *Bambara Sculpture from the Western Sudan.* New York: University Publishers, 1960.

Greer, Georgeanna H. "Preliminary Information on the Use of the Alkaline Glaze for Stoneware in the South: 1800-1920." In Stanley South, ed., *The Conference on Historical Site Archaeology—Papers 1970,* Vol. v, 145-170. Columbia, S. C.: Institute of Archaeology and Anthropology, 1971.

Hall, Carrie A., and Kretsinger, Rose G. *The Romance of the Patch Work Quilt in America.* New York: Bonanza Books, 1935.

Hall, Edward T. "The Language of Space." *Landscape,* x, no. 1 (1960), 41-45.

Handler, Jerome S. "A Historical Sketch of Pottery Manufacture in Barbados." *The Journal of the Barbados Museum Historical Society,* XXX (1963), 129-153.

———. "Pottery Making in Rural Barbados." *Southwestern Journal of Anthropology,* XIX (1963), 314-334.

Hansen, H. J., ed. *European Folk Art in Europe and the Americas.* New York: McGraw-Hill, 1967.

Hatch, Charles E., Jr. *The Ballard House and Family.* Division of History, Office of Archaeology and Historic Preservation, U.S. Department of the Interior, 1969.

Herskovits, Melville J. *Cultural Anthropology.* New York: Alfred A. Knopf, 1955.

———. *Dahomey: An Ancient West African Kingdom.* 2 vols. New York: J. J. Augustin, 1938.

———. *The Myth of the Negro Past.* 1941; reprint ed., Boston: Beacon Press, 1958.

———. "On Some Modes of Ethnographic Comparison." Reprinted in Frances S. Herskovits, ed., *The New World Negro: Selected Papers in Afroamerican Studies,* pp. 71-82. Bloomington: Indiana University Press, 1966.

———. "Problem, Method and Theory in Afroamerican Studies." Reprinted in Frances S. Herskovits, ed., *The New World Negro: Selected Papers in Afroamerican Studies,* pp. 43-61. Bloomington: Indiana University Press, 1966.

Heyward, Du Bose. *The Half-Pint Flask.* New York: Farrar and Rinehart, 1929.

Heywood, Duncan Clinch. *Seed from Madagascar.* Chapel Hill: University of North Carolina Press, 1937.

Holstein, Jonathan. *The Pieced Quilt: An American Design Tradition.* New York: Gallahad Books, 1973.

Honour, Hugh. *The European Vision of America* (exhibition catalog). Cleveland: The Cleveland Museum of Art, 1975.

Hornell, James. *Water Transport: Origins and Early Evolution.* 1946; reprint ed., London: David and Charles, 1970.

Hornung, Clarence P. *Treasury of American Design.* 2 vols. New York: Harry N. Abrams, 1950.

Horowitz, Elinor Lander. *Contemporary American Folk Artists.* New York: J. B. Lippincott, 1975.

Hurault, Jean. *Africains de Guyanne: La vie matérielle e l'art de Noirs Refugies de Guyanne.* Paris: Mouton, 1970.

Ingersoll, Ernest. "Decoration of Negro Graves." *Journal of American Folklore,* v (1892), 68-69.

Jahn, Janheinz. *Muntu: The New African Culture.* New York: Grove Press, 1961.

James, George Wharton. *Indian Basketry.* 1909; reprint ed., New York: Dover, 1972.

Jones, Leroi. *Blues People: Negro Music in White America.* New York: William Morrow, 1963.

Kahn, Martin C. *Djuka: The Bush Negroes of Dutch Guiana.* New York: Viking Press, 1937.

Kan, Michael. "American Folk Sculpture: Some Consideration of Its Ethnic Heritage." In Herbert W. Hemphill, Jr., ed., *Folk Sculpture U.S.A.,* pp. 55-71. New York: The Brooklyn Museum, 1976.

Kent, Kate P. "Appliqué." In Linn Shapiro, ed., *Black People and Their Culture: Selected Writings from the African Diaspora,* pp. 58-62. Washington: Smithsonian Institution, 1976.

Klamkin, Marian, and Klamkin, Charles. *Woodcarvings: North American Folk Sculptures.* New York: Hawthorn Books, 1974.

Knipmeyer, William B. "Folk Boats of Eastern French Louisiana." In Don Yoder, ed., *American Folklife,* pp. 105-149. Austin: University of Texas Press, 1976.

Koch, Adrienne, and Peden, William, eds. *The Life and Selected Writings of Thomas Jefferson.* New York: The Modern Library, 1944.

Lamb, Venice. *West African Weaving.* London: Duckworth, 1975.

Lamb, Venice, and Lamb, Alastair. *West African Narrow Strip Weaving.* Washington: Textile Museum, 1975.

Larsen, Peter, and Larsen, Elaine. *Boy of Dahomey.* New York: Dodd, Mead & Co., 1970.

Latrobe, Benjamin H. B. *Impressions Respecting New Orleans.* Edited by Samuel Wilson, Jr. New York: Columbia University Press, 1951.

Lawson, John. *Lawson's History of North Carolina.* 1714; reprint ed., Richmond: Garret and Masse, 1937.

———. *A Voyage to Carolina.* 1709; reprint ed., Ann Arbor: University Microfilms, 1966.

Leuzinger, Elsy. *Africa: The Art of Negro Peoples.* New York: Crown Publishers, 1960.

Lewis, Pierce. "Common Houses, Cultural Spoor." *Landscape,* XIX, no. 2 (1975), 1-22.

Lipman, Jean, and Winchester, Alice. *The Flowering of American Folk Art 1776-1876*. New York: Viking Press, 1974.

Lister, Raymond. *Decorative Wrought Ironwork in Great Britain*. Rutland, Vt.: Charles E. Tuttle Co., 1957.

Lomax, Alan. *Folksong Style and Culture*. Washington: American Association for the Advancement of Science, 1968.

———. *The Roots of the Blues* (record). Atlantic, SP-1348.

Long, Worth. "Leon Rucker: Woodcarver." In Linn Shapiro, ed., *Black People and Their Culture: Selected Writings from the African Diaspora*, pp. 33-34. Washington: Smithsonian Institution, 1976.

Lornell, Kip, and Moore, J. Roderick. "Clarence Tross: Hardy County Banjoist." *Goldenseal*, II, no. 3 (1976), 7-13.

McConnell, Roland C. *Negro Troops of Ante-Bellum Louisiana: A History of the Free Men of Color*. Louisiana State University Studies: Social Sciences, no. 13. Baton Rouge: Louisiana State University Press, 1968.

McCusick, Marshall. *Aboriginal Canoes in the West Indies*. Yale University Publications in Anthropology, no. 63, 1960.

MacGaffey, Janet. "Two Kongo Potters." *African Arts*, IX (1975), 28-31.

MacGaffey, Wyatt. "The West in Congolese Experience." In Philip D. Curtin, ed., *Africa and the West*, pp. 49-74. Madison: University of Wisconsin Press, 1972.

Made of Iron (exhibition catalog). Houston: University of St. Thomas Art Department, 1966.

Merriam, Alan P. "African Music." In William R. Bascom and Melville J. Herskovits, eds., *Continuity and Change in African Cultures*, pp. 49-86. 1959; reprint ed., Chicago: University of Chicago Press, 1970.

Messenger, John C. "African Retentions in Montseratt." *African Arts*, VI, no. 4 (1973), 54-57.

Mier, August, and Rudwick, Elliot. *From Plantation to Ghetto*. New York: Hill and Wang, 1970.

Mitchell, George. *Blow My Blues Away*. Baton Rouge: Louisiana State University Press, 1971.

Montgomery, Charles J. "Survivors from the Cargo of the Slave Yacht *Wanderer*." *American Anthropologist*, X (1908), 611-623.

Mullin, Gerald W. *Flight and Rebellion: Slave Resistance in Eighteenth-Century Virginia*. New York: Oxford University Press, 1972.

Murdock, George Peter. *Africa: Its Peoples and Their Culture History*. New York: McGraw-Hill, 1959.

Nassau, Robert Hamill. *Fetishism in West Africa*. London: Duckworth, 1904.

Newman, Thelma R. *Contemporary African Arts and Crafts*. New York: Crown Publishers, 1974.

Nketia, J. H. Kwabena. *Drumming in Akan Communities of Ghana*. Legon: University of Ghana Press, 1963.

Nunoo, Richard B. "Canoe Decoration in Ghana." *African Arts*, VII, no. 3 (1974), 32-35.

Odell, Scott. "Folk Instruments." *Arts in Virginia*, XII, no. 1 (1971), 31-37.

Oliver, Paul. *Savannah Syncopators: African Retentions in the Blues*. New York: Stein and Day, 1970.

One String Blues (record). Takoma Records, B-1023.

Parrish, Lydia. *Slave Songs of the Georgia Sea Islands*. 1942; reprint ed., Hatboro, Pa.: Folklore Associates, 1965.

Parsons, Elsie Clews. *Folk-Lore of the Sea Islands, South Carolina*. Memoirs of the American Folk-Lore Society, X (1923).

Pearson, Barry Lee. "The Late Great Elmore James." *Keystone Folklore*, XVII (1972), 162-172.

Peek, Philip M. "Afro-American Material Culture and the Afro-American Craftsman." 1970. (Manuscript.)

Perdue, Robert E., Jr. "'African' Baskets in South Carolina." *Economic Botany*, XXII (1968), 289-292.

Perry, Regenia A. *Selections of Nineteenth-Century Afro-American Art* (exhibition catalog). New York: The Metropolitan Museum of Art, 1976.

Peterkin, Julia. *Roll, Jordan, Roll*. New York: R. O. Ballou, 1933.

Peterson, Charles E. "The Houses of French St. Louis." In John Francis McDermott, ed., *The French in the Mississippi Valley*, pp. 17-40. Urbana: University of Illinois Press, 1965.

Phillips, Ulrich B. "The Slave Labor Problem in the Charleston District." *Political Science Quarterly*, XXII (1907), 416-439.

Polley, Robert L. *America's Folk Art*. Waukeha, Wis.: Country Beautiful Corporation, 1971.

Porter, James A. "Four Problems in the History of Negro Art," *Journal of Negro History*, XXVII (1942), 9-36.

———. *Modern Negro Art*. 1943; reprint ed., New York: Arno Press, 1960.

Price, Richard. "Caribbean Fishing and Fishermen: A Historical Sketch." *American Anthropologist*, LXVIII (1966), 1363-1383.

Puckett, Newbell Niles. *The Magic and Folk Beliefs of the Southern Negro*. 1926; reprint ed., New York: Dover, 1969.

Ramsay, John. *American Potters and Pottery*. New York: Tudor Publishing Co., 1947.

Raponde-Walker, Andre, and Sillens, Roger. *Rites et Croyances des Peuples du Gabon*. Paris: Presence Africaine, 1962.

Rattray, R. S. *Akan-Ashanti Folktales*. London: Oxford University Press, 1930.

Rogers, Mary. "The Navigation of the Lough Erne." *Ulster Folklife* (1960), pp. 97-103.

Roscoe, Lynda. "James Hampton's Throne." In *Naives and Visionaries* (exhibition catalog), pp. 12-19. Minneapolis: Walker Art Center, 1974.

Schadler, Kurt Ferdinand. *African Art in Private German Collections*. Munich: Münchner Buchgewerbehaus, 1973.

Scheub, Harold. "The Art of Nongenile Mazithatha Zenai, A Gcaleka Ntsomi Performer." In Richard M. Dorson, ed., *African Folklore*, pp. 115-142. Garden City, N.Y.: Doubleday, 1972.

Seemes, Raphael. *Captains and Mariners of Early Maryland*. Baltimore: Johns Hopkins Press, 1937.

Shapiro, Linn, ed. *Black People and Their Culture: Selected Writings from the African Diaspora*. Washington: Smithsonian Institution, 1976.

Shuey, Mary Willis. "Charleston *Signed* Ironwork." *The Reading Puddle Ball*, IV, no. 1 (1935), 4-7.

Sieber, Roy. *African Textiles and Decorative Arts* (exhibition catalog). New York: The Museum of Modern Art, 1972.

——. "Kwahu Terracottas, Oral Traditions, and Ghanaian History." In Douglas Fraser and Herbert M. Cole, eds., *African Art and Leadership,* pp. 173-183. Madison: University of Wisconsin Press, 1972.

Sieber, Roy, and Rubin, Arnold. *Sculpture of Black Africa: The Paul Tishman Collection* (exhibition catalog). Los Angeles: County Museum of Art, 1968.

Simmons, Albert. "Architectural Trends in Charleston." *Antiques of Charleston,* pp. 545-555. Charleston: Historic Charleston Foundation, 1970.

Smith, John. *The true travels, adventures, and observations of Captaine John Smith.* 1630; reprint ed., Amsterdam, N.Y.: Da Capo Press, 1968.

Stampp, Kenneth M. *The Peculiar Institution: Slavery in the Ante-Bellum South.* New York: Vintage Books, 1956.

Starobin, Robert S. *Industrial Slavery in the Old South.* New York: Oxford University Press, 1970.

Stavisky, Leonard Price. "Negro Craftsmanship in Early America." *American Historical Review,* LIV (1949), 315-325.

Stoney, Samuel Gaillard. *This Is Charleston: A Survey of the Architectural Heritage of a Unique American City.* Charleston: Carolina Art Association, 1944.

Stow, Charles Messer. "A Strange Face from Whately." *Antiques,* VIII, no. 2 (August 1925), 77.

Sylestine, Rosabel. *Coushatta Pine Needle Basketry* (exhibition handout). New Orleans: Cabildo Museum, 1973.

Taggart, Ross E. *The Burnap Collection of English Pottery.* Kansas City, Mo.: Nelson Gallery—Atkins Museum, 1967.

Talbot, P. Amaury. *In the Shadow of the Bush.* New York: George H. Doren, 1912.

Teleki, Gloria Roth. *The Baskets of Rural America.* New York: E. P. Dutton, 1975.

Thompson, Robert Farris. "Abatan: A Master Potter of the Egbado Yoruba." In Daniel Biebuyck, ed., *Tradition and Creativity in Tribal Art,* pp. 120-182. Berkeley, University of California Press, 1969.

——. *African Art in Motion: Icon and Act in the Collection of Katherine Coryton White.* Berkeley: University of California Press, 1974.

——. "African Influence on the Art of the United States." In Armstead L. Robinson, Craig C. Foster, and Donald H. Ogilvie, eds., *Black Studies in the University: A Symposium,* pp. 128-177. New Haven: Yale University Press, 1969.

——. *Black Gods and Kings: Yoruba Art at UCLA.* Los Angeles: Museum and Laboratories of Ethnic Arts and Technology, 1971.

——. "Cyrus Bowens of Sunbury: Portrait of an Afro-American Artist." *Massachusetts Review* (forthcoming.)

——. "From Africa." *Yale Alumni Magazine,* XXXIV, no. 2 (1970), 16-21.

Torian, Susan H. "Ante-Bellum and War Memories of Mrs. Telfair Hodgson." *Georgia Historical Quarterly,* XXVII (1943), 350-356.

Turner, Lorenzo Dow. *Africanisms in the Gullah Dialect.* Chicago: University of Chicago Press, 1949.

Twining, Mary Arnold. "Afro-American Baskets from the Sea Islands." Paper presented at the meetings of the African Studies Association, San Francisco,

Vaissiere, Pierre de. *Sainte Domingue (1629-1789): La societe et la vie Creoles sous L'ancien Regime.* Paris: Librarie Academique, 1909.

Verger, Pierre, and Cruz, Clement da. "Musée historique de Ouidah." *Etudes Dahoméennes* (6-26), n.s. no. 13 (1969), pp. 6-26.

Vlach, John Michael. "Affecting Architecture of the Yoruba." *African Arts,* X, no. 1 (1976), 48-53.

——. "Philip Simmons: Afro-American Blacksmith." In Linn Shapiro, ed., *Black People and Their Culture: Selected Writings from the African Diaspora,* pp. 35-57. Washington: Smithsonian Institution, 1976.

——. "The Shotgun House: An African Architectural Legacy." Pt. I, *Pioneer America,* VIII, no. 1 (1976), 47-56; Pt. II, *Pioneer America,* VIII, no. 2 (1976), 57-70.

——. "Sources of the Shotgun House: African and Caribbean Antecedents for Afro-American Architecture." Ph.D. dissertation, Indiana University, 1975.

Wadsworth, Anna, ed. *Missing Pieces: Georgia Folk Art 1770-1976* (exhibition catalog). Atlanta: Georgia Council for the Arts and Humanities, 1976.

Watkins, C. Malcolm. "A Plantation of Differences—People from Everywhere." In Peter C. Marzio, ed., *A Nation of Nations,* pp. 54-82. New York: Harper & Row, 1976.

West, Pamela. "The Rise and Fall of the American Porch." *Landscape,* XX, no. 3 (1976), 42-47.

Wiggins, William H., Jr. "The Wooden Chains That Bind: A Look at One Shared Creation of Two Diaspora Carvers." In Linn Shapiro, ed., *Black People and Their Culture: Selected Writings from the African Diaspora,* pp. 29-32. Washington: Smithsonian Institution, 1976.

Williams, Geoffery. *African Designs from Traditional Sources.* New York: Dover, 1971.

Willis, William S. "Divide and Rule: Red, White, and Black in the Southeast." *Journal of Negro History,* XLVIII (1963), 157-176.

Wood, Peter H. *Black Majority: Negroes in Colonial South Carolina from 1670 Through the Stono Rebellion.* New York: W. W. Norton, 1974.

——. "'It Was A Negro Taught Them': A New Look at Labor in Early South Carolina." *Journal of Asian and African Studies,* IX (1974), 159-179.

Yetman, Norman. *Life Under the "Peculiar Institution": Selections from the Slave Narrative Collection.* New York: Holt, Rinehart & Winston, 1970.

Zetterstrom, Kjell. *House and Settlement in Liberia.* Robertsport, Liberia: Tubman Center of African Culture, 1970.

Illustration Credits

PHOTOGRAPHS

Muriel and Malcolm Bell, Jr.: *11a, b, c, d, 12, 13, 98**

John O. Brostrays (Historic American Building Survey): *82*

Alex Bush (Historic American Building Survey): *88*

Judith W. Chase: 31, 97, 98

Greg Day: 95

Jack Delano (Farm Services Administration): *95, 97*

Arthur Drexler (Museum of Modern Art): 61

Jerome Drown: 42, 60

Susan Einstein: 65

Cheryl Evans: *6, 8*

Geza Fekete: *18*

Roland L. Freeman: 14, 33, 67

Nicholas C. Hlobeczy: 15, 18, 22, 23, 36, 40, 45, 46, 47, 48, 50, 53, 56, 59, 66, 80

Dorothea Lange (Farm Services Administration): *84*

Martin L. Linsey: 1, 2, 3, 4, 5, 8, 9, 11, 12, 13, 17, 20, 24, 27, 29, 30, 32, 38, 39, 49, 51, 52, 57, 58, 63, 64, 68, 69, 71, 75, 79, 81, 82, 88, 91, 92, 94, 96, 99, *4, 17, 21, 22a, 23a, 24, 30, 31, 32, 37, 38, 48, 49, 50, 51, 52, 53, 54, 55, 56, 57, 58, 59, 60, 61, 62, 63, 64, 78, 79a, 80, 81, 89, 96*

Los Angeles County Museum of Art: 70

Geraldine T. Mancini: 93

Charles Metzger (*African Arts*): 86

Leigh Richmond Miner (1864-1935): *2, 44, 83*

Jane Moseley: 21, 34, 35, 54, 55

Frederick Ramsey, Jr.: *99*

Arthur Rothstein (Farm Services Administration): *66, 69*

Smithsonian Institution: *5, 47*

Joseph Szaszfai (Yale University Art Gallery): *46*

Frank J. Thomas: 44, 62

Doris Ulman: *45, 90*

John Michael Vlach: 85, *3, 67, 74, 76, 94*

Theodore Webb: *85*

Edward Whitman: *10*

Marion Post Wolcott (Farm Services Administration): *83*

DRAWINGS

A. D. Iselin: *65b, 75b, 77b, 79b*

John Michael Vlach: *7* (after Frederick Usher), *27a, b, c, d, 28, 40, 65a, 68, 70, 71, 72, 75a, 77a*

Reference is to catalog numbers and figure numbers (in italics).

Lenders to the Exhibition

Jim Aldridge
Dr. and Mrs. Ernst Anspach
William Arnett
Augusta-Richmond County Museum,
 Augusta, Georgia
Dr. Mildred Hart Bailey
Dr. and Mrs. William Bascom
Muriel and Malcolm Bell, Jr.
James A. Birch
Charles and Joan Bird
George O. Bird
Dr. James T. Bryson
Dr. John A. Burrison
Center for Southern Folklore, Memphis
The Charleston Museum, Charleston,
 South Carolina
The Cleveland Museum of Art
Kenneth Combs
Greg Day
David and Cheryl Evans
Mr. and Mrs. Richard C. Farver
Franklin Fenenga
The Ferrell Collection
The Roland L. Freeman Collection
 of the Mississippi Folklife Project, Jackson
John Gordon Gallery, New York City
Mr. and Mrs. Harvey Granger, Jr.
Georgeanna H. Greer
The Herskovits Collection
Richard H. and Kathleen L. Hulan
Indiana University Art Museum
Indiana University Museum
The Links of Cleveland, Inc.
Janet and Wyatt MacGaffey
Mississippi State Historical Museum, Jackson
Roderick and Betsy Moore
Museum of African Art, Washington
Museum of Cultural History,
 University of California, Los Angeles
Museum of Fine Arts, Boston
The National Museum of History and
 Technology, Smithsonian Institution
New York State Historical Association,
 Cooperstown

The Old Slave Mart Museum, Charleston,
 South Carolina
Abby Aldrich Rockefeller Folk Art Center,
 Williamsburg, Virginia
Mrs. George M. Saunders, III
Philip Simmons
The John Wesley Stipe Family
Mary Arnold Twining
John Michael Vlach
The Katherine White Collection
Dr. and Mrs. William H. Wiggins, Jr.
Yale University Art Gallery